ANTE PACEM

ANTE PACEM

Archaeological Evidence
of Church Life
Before Constantine

BY

G R A Y D O N F. S N Y D E R

MERCER

ISBN 0-86554-147-7

All books published by Mercer University Press are produced on
acid-free paper that exceeds the minimum standards set by the
National Historical Publications and Records Commission.

Library of Congress Cataloging in Publication Data
Snyder, Graydon F.
Ante pacem.

Includes bibliographies and index.
1. Christian antiquities. 2. Christian art and
symbolism. I. Title.
BR131.S58 1985 270.1 84-27328
ISBN 0-86554-147-7 (alk. paper)

CONTENTS

TO LOIS

Indefatigable in her enthusiasm for travel, living abroad, language studies, esoteric menus, careful photography, out-of-the-way archaeological sites, early Christian life—and, therefore, this book.

ABBREVIATIONS

AAMz Abhandlungen der Akademie der Wissenschaften und der Literatur Mainz

ACIAC Atti del congresso internazionale di archeologia cristiana

AIRF Acta instituti Romani Finlandiae

AJA American Journal of Archaeology

ANRW Aufstieg und Niedergang der römischen Welt

APARA Atti della pontificia accademia romana di archeologia

AuC Antike und Christentum

BA Biblical Archaeologist

BAC Bullettino di archeologia cristiana

BJRL The Bulletin of the John Rylands Library

DACL Dictionnaire d'archéologie chrétienne et de liturgie

DPARA Dissertazioni della pontificia accademia Romana di archeologia

HTR Harvard Theological Review

JAC Jahrbuch für Antike und Christentum

JEA Journal of Egyptian Archaeology

JTS Journal of Theological Studies

LCI Lexikon der christlichen Ikonographie

NBAC Nuovo bullettino di archeologia cristiana

NTS New Testament Studies

PEQ Palestine Exploration Quarterly

PIAC Pontificio istituto di archeologia

PTR Princeton Theological Review

RAC Reallexikon für Antike und Christentum

RGG³ Religion in Geschichte und Gegenwart, 3te Auflage

RivAC Rivista di archeologia cristiana

RPARA Rendiconti della pontificia accademia romana di archeologia

RQS Römische Quartalschift

RSR Recherches de science religieuse

RWAW Rheinisch-Westfälische Akademie der Wissenschaften

SBFLA Studii biblici Franciscani liber annuus

VetChr Vetera Christianorum

VigChr Vigiliae Christianae

ZKG Zeitschrift für Kirchengeschichte

ZKTh Zeitschrift für Katholische Theologie

ZNW Zeitschrift für die neutestamentliche Wissenschaft

ZThK Zeitschrift für Theologie und Kirche

ACKNOWLEDGMENTS

This study began about eighteen years ago, partially in response to conversations with Nils Dahl regarding research lacunae in early Christianity, and partially because of a continuing interest both in archaeology and the history of the early Church. For their consistently helpful assistance in this project, I am deeply appreciative to the Pontifical Institute of Christian Archaeology, the German Archaeological Institute, and the American Academy, all of Rome. Research in Rome was made possible, in part, by grants from the Association of Theological Schools and sabbatical support made available from Bethany Theological Seminary.

I am grateful to the F. J. Dölger Institut of Bonn for professional courtesies and the use of the Velletri sarcophagus photograph (plate 17). Similar assistance was given by the library of the Rheinisches Landesmuseum, Trier, which also furnished the photographs of the Noah and Albana sarcophagi (plates 16 and 19). The Rheinisches Landesmuseum of Bonn kindly allowed me to photograph the martyrium exhibit (plate 37).

Figures 1, 2, 3, 5, 12, 28, 41, and 46 were taken from Krautheimer, *Early Christian and Byzantine Architecture*, by permission of Penguin Books, Ltd. From O'Connor's *Peter in Rome*, Columbia University Press granted permission to use figures 31, 32, 33, 34, 35, 36, 37, 38, 39, 40, 42, and 47 (Columbia University Press, 1969. Reprinted by permission). J. J. Augustin, Inc., granted permission to use figures 6, 7, and 8 from Kraeling, *The Christian Building*. Figures 9, 10, and 11 are illustrations from *Archaeology, The Rabbis, and Early Christianity* by Eric M. Meyers and James F. Strange (Abingdon, 1981. Used by permission). Figures 13 and 16 come from SCALA/Art Resource, New York. Permission to use figures 20, 21, 22, 23, and 24, taken from Dyggve's *History of Salonitan Christianity*, was granted by the Institute for Comparative Research in Human Culture, and by Universitets Forlaget, both of Oslo. The Pontifical Institute of Christian Archaeology, Rome, kindly granted permission to use figures 14, 17, 18, and 27. Permission to reproduce figure 15, from Gunton's *Rome's Historic Churches*, was given by Allen and Unwin. In addition to the photograph of the Bonn martyrium, the Rheinisches Landesmuseum of Bonn granted permission to print figure 19 from the *Bonner Jahrbuch*. The maps of Phrygia—figures 44 and 45—were drafted by Gary Bisbee for *The "Christian for Christians" Inscriptions of*

Phrygia. Finally, I want to thank Jeanine Wine for adapting figures 4, 16, and 25, and Randall Birkey for drafting figures 26, 29, 30, and 43, and Nancy Wiles Holsey for assisting with the index.

Graydon F. Snyder
Bethany Theological Seminary
22 September 1984

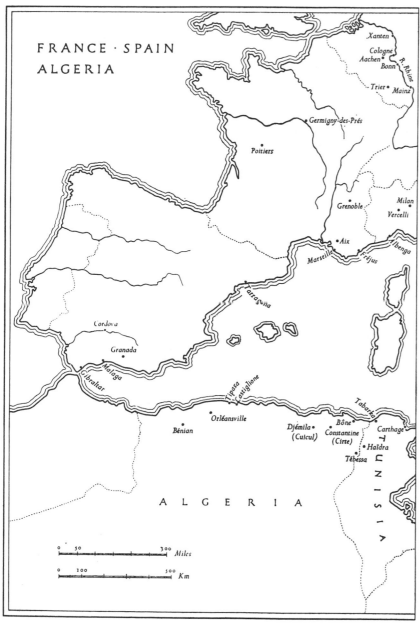

Figure 1.

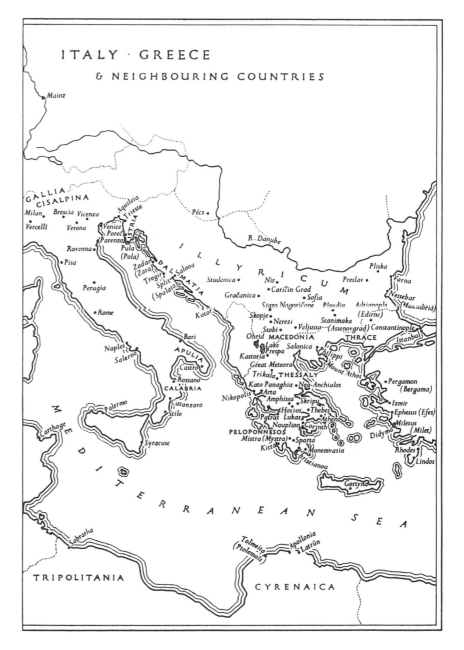

Figure 2.

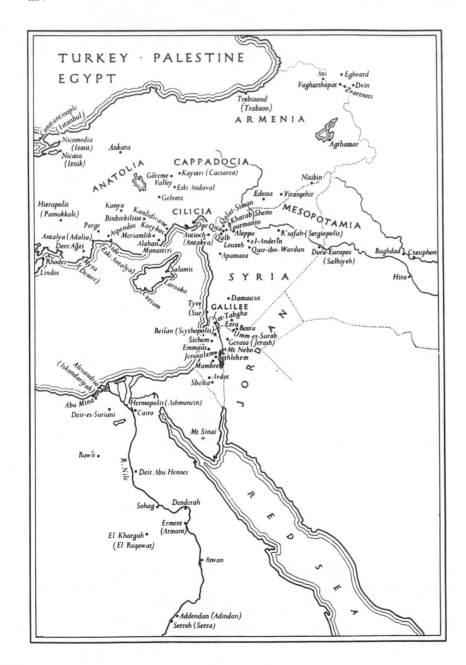

Figure 3.

INTRODUCTION

There is no introduction or sourcebook for early Christian archaeology now available in the English language. One of the intentions of this volume is to fill to some extent this void in historical research. At the same time there are several other specific intentions that limit rather sharply the general topic "early Christian archaeology."

The first intention involves chronological parameters. Three major social alterations were involved in the early formation of the Christian faith. First, the new Christian faith, as proclaimed by the apostle Paul, so universalized Judaism that it became acceptable for Gentiles without losing its basic Jewish world view. One might even say the new Christianity relativized all past social and ethnic particularities. The apostle Paul placed the new existence "in Christ" beyond social conditions: neither male nor female, neither Jew nor Greek (Gentile), neither slave nor master (1 Cor. 7:17-24; Gal. 3:27-28). The teleological orientation of early Christianity actually suspended all past social concretizations (1 Cor. 7:29-31), though suspension eventually became understood as a social openness to other cultures and an acceptance of whatever developments resulted from that social integration (Eph. 2:15-16). The universalization of Judaism through Christianity was the primary explosion in the formation of the so-called Christian world.

The second major social disruption occurred as the new "suspended" faith took actual form in the Greco-Roman culture to which it had proclaimed such social openness. That process started simultaneously with the first explosion. In those selfsame letters that proclaimed social suspension, Paul had to discuss whether the new Christian community should follow Jewish, Gentile, or some other set of customs in such matters as eating, dressing, marrying, and worshiping. Subsequent literature reflects the same concerns. However, early Christian literature does not, indeed could not, indicate the actual social development that occurred. Pre-Constantinian literature reflects primarily a polemic against culture, yet the early Christians did have to make decisions regarding eating, dressing, marrying, burying, language usage, political involvements, worshiping, and other everyday procedures. What were these decisions? They could not have been suspended indefinitely. While answers to these questions might be inferred from certain types of early Christian literature, it is

only in nonliterary data that one can catch a glimpse of what actually happened, regardless of the polemical concerns of the Christian leaders as expressed in written form. Unfortunately such data is scarce, so scarce that earlier scholars dated the material too early or supposed that Christian remains from the first two centuries had been totally eradicated.

In more recent times it has become clear that another option would better explain the strange lack of data. Christian people of the first two centuries did indeed leave us material remains and archaeologists have uncovered them. They simply cannot be distinguished from the remains of the non-Christian culture. As this study will show, distinctively Christian archaeological data does not appear until about 180. Distinguishable funerary art, inscriptions, letters, symbols, and perhaps buildings surface just at the end of the second century. It took over one hundred years for a clearly Christian culture to take a form different from that of the social matrix. Whatever estimate one makes of the profuse Christian literature of that time, it took over a century for the new community of faith to develop a distinctive mode of self-expression. So the second important date for the development of a Christian culture would be that climactic "moment" when the nascent Christian culture first appeared. For purposes of discussion, that moment is dated as 180, though obviously we may include in this study materials that antedate this debut of Christian culture.

The third sociological explosion in early Christianity came when the rather tentative Christian culture was thrust into a universal role as the formal religious expression of the Roman Empire. Since this social alteration set the stage for what we know as "orthodox" Christianity, data for this period has been much more accessible than that of the pre-Constantinian era. To be sure, elements of Christianity as we now know it did exist prior to Constantine, but the public, universal structure first was formulated and expressed in the fourth century.

Because post-Constantinian (early Byzantine) material can be found more readily and because the shift from the third century to the fourth has such profound importance for the history of Christianity, this study will deal only with the pre-Constantinian material as it faces the fourth century.

A second alteration to the term "early Christian archaeology" involves the type of data described. Strictly speaking, archaeology may be defined as the study of an ancient people by means of their discovered remains. In recent years archaeology has meant to many, especially those interested in biblical archaeology, those findings that result from excavations. This study will deal with archaeology in the broader sense of any remains that are nonliterary. By literary is meant any document written by an author and circulated in some fashion whether the author so intended or not. Such documents would properly be studied under the rubric *patrology*.

With these parameters set, this work intends to describe all data that—with some degree of assurance—can be dated prior to Constantine (313), that appears to be Christian, and that cannot be classed as literary. With each category an appropriate bibliography will be listed and an interpretation given.

CHAPTER ONE

HISTORY AND METHODOLOGY
OF EARLY CHRISTIAN ARCHAEOLOGY

I. A HISTORY OF THE DISCIPLINE

Carl Andresen. *Die Kirche in ihrer Geschichte: Einführung in die Christliche Archäologie.* Göttingen: Vandenhoeck and Ruprecht, 1971.

Giuseppe Bovini. *Gli studi di archeologia cristiana.* Bologna: Patron, 1968.

Giuseppe Ferretto. *Note storico-bibliografiche di archeologia cristiana.* Città del Vaticano: Tipografia Poliglotta Vaticana, 1942.

Edwin A. Judge. " 'Antike und Christentum': Toward a Definition of the Field. A Bibliographical Essay." *ANRW* 2:23:1:3-58.

Pasquale Testini. *Archeologia cristiana.* Roma: Desclée, 1958, 64-72.

Just as biblical archaeology inherently implies Palestinian archaeology, so early Christian archaeology refers primarily to Rome. That is not to say that one finds evidence for early Christianity only in Rome. It does mean that in the Mediterranean world of the third century, most cultural expressions emanated from Rome, the political center. To study early Christian archaeology in nearly any place other than Rome, such as Arles, Trier, or Aquileia would be simply to study the development of Roman Christianity in that particular locale. Exceptions to that fact are very rare, therefore very important.

Furthermore, the initiation and development of the science of early Christian archaeology cannot be dissociated from the development of classical Roman archaeological studies of ancient Rome. To this day there are very few scholars in the field who were not trained in Rome or who were not associated with one of the national academies there.

The Roman school of early Christian archaeology started in 1632 with the publication of *Roma sotterranea* by Antonio Bosio. Bosio interpreted what he had discovered in terms of the Latin

and Greek fathers, church councils, letters of the popes, ancient liturgies, lives of the saints, and other such materials (Testini, 66).

The real founders of the science of early Christian archaeology came in the nineteenth century: Giuseppe Marchi (1795-1860) and Giovanni B. de Rossi (1822-1894). In 1837 Marchi had already published a collection of early Christian inscriptions.[1] In 1840 he had projected a monumental series that would cover early Christian architecture, pictures, and finally sculptures. By 1844 he had published the first work on architecture[2] and had passed on the task of collecting and editing inscriptions to his disciple and newly named secretary of the Vatican Library, Giovanni B. de Rossi.

While Marchi may have provided the vision for the nascent science of early Christian archaeology, it was de Rossi who collected and published the first great mass of data. De Rossi traveled extensively from 1853-1861 collecting the materials available throughout the Mediterranean area, while simultaneously pursuing the program laid out by Marchi. Between 1857-1861 he published the first volume of *Inscriptiones christianae urbis Romae*[3] and in 1864 published the first of three volumes on early Christian art entitled *La Roma sotterranea cristiana*.[4]

Concomitant with these scholarly developments, the Vatican took steps to promote the study and collection of early Christian materials. In 1757 Benedict XIV had instituted a Museo di archeologia cristiana in the Vatican. Pius IX moved beyond collecting by appointing in 1852 a Commissione de archeologia sacra that would be responsible for all early Christian remains. Eventually the responsibility for excavations, instruction, and publications became associated with the Pontifico istituto di archeologia cristiana, founded by Pius XI in 1925.

From that initial work by de Rossi and the papal commissions arose a "school" of early Christian archaeology extending throughout Europe. The school included Garucci, Armellini, Stevenson, Marucchi, de Waal, Grisar, Kirsch, Wilpert, Martigny, Le Blant, Duchesne, Delattre, and Bulic—to name a few. Besides the many monographs, series, and encyclopedias published by the above-named individuals, the commissions published such vital serials as the *Bulletino di archeologia cristiana*, the *Nuovo bulletino di archeologia cristiana*, and the *Rivista di archeologia cristiana*, today the primary journal in the field. The commissions have also been instrumental in establishing and organizing the periodical congresses on early Christianity, and publishing the all-important acts of these meetings. Especially important for the purposes of this book was the most recent congress on pre-Constantinian archaeology in 1975.

From the data gathered by this group has come an enormous literature, as will be evident in the various subsequent bibliographies. Particularly useful have been the various dictionaries, encyclopedias, and catalogues. Martigny used the works of de Rossi to assemble and edit in 1865 his *Dictionnaire des antiquités chrétiennes* (Paris: Hachette, 1865). That work inspired the work of William Smith and Samuel Cheetham in editing *A Dictionary of Christian Antiquities* (London: John Murray, 1875). No more encyclopedias of early Christian archaeology have appeared in English, but the French *Dictionnaire d'archéologie chrétienne et de liturgie*, edited by F. Cabrol and H. Leclercq (Paris: Letouzey et Ané, 1924-1953), has become the classic in the field. The "Roman school," at a later stage of development, also contributed heavily to the useful *Enciclopedia cattolica* (Città del Vaticano, 1948-1954).

Building on the works of de Rossi and then later the works of Josef Wilpert on frescoes and sarcophagi,[5] the dream of Marchi

[1]Giuseppe Brunati, *Musei Kircheriani inscriptiones ethnicae et christianae* (Mediolani: Poliaania, 1837).

[2]Giuseppe Marchi, *Monumenti delle arti cristianae primitive nella metropoli del cristianismo* (Roma: Puccinelli, 1844).

[3]Giovanni B. de Rossi, *Inscriptiones christianae urbis Romae* (Roma: Libraria Pontificia, vol. 1, 1857-1861; vol. 2, 1888). The project was taken up anew in 1922. For bibliographical data on these new seven volumes, see the section on inscriptions.

[4]Giovanni B. de Rossi, *Roma sotterranea cristiana*, 1-3 (Roma: Cromo-litografia pontificia, 1864-1867).

[5]Josef Wilpert, *Die Malereien der Katakomben Roms* (Freiburg: Herder, 1903), and *I sarcofagi cristiani antichi*, 1-3 (Città del Vaticano, 1929-1936).

has nearly been realized. Antonio Ferrua of the PIAC has almost completed the critical publication of the Christian inscriptions of Rome (volume 7 of *ICUR* appeared in 1980). Aldo Nestori, also of the PIAC, has catalogued as completely as possible all the fresco art found in the Christian catacombs of Rome.[6] Deichmann, Brandenburg, and Bovini have catalogued, described, and furnished photographs of all Christian sarcophagi in the area of Rome.[7] And Richard Krautheimer has minutely described every early Christian church of Rome in his great *Corpus basilicarum*.[8]

These encyclopedias and catalogues have made the following study on pre-Constantinian archaeology possible. Without them, no one could survey the data and draw any conclusions that were independent of the "school" itself. Regardless of this, the science of early Christian archaeology need no longer be inextricably associated with Rome and a "school" there. The discovery in the 1920s of a Christian house church in Dura-Europos by French and American archaeologists has revolutionized the discipline. Not only did it furnish us with the only certain pre-Constantinian church edifice and show that catacomb art was not to be limited to a sepulchral function, but it also brought to the interpretative level scholars who heretofore had no connection with the "Roman school."

The "Roman school" presented the archaeological data of early Christianity in the light of patristic literature and early church tradition. After the turn of the century, some alternative methods of interpretation developed. Chief among these was the work associated with the great historian Hans Lietzmann. Working with Franz Joseph Dölger, they established in Bonn, Germany, a research group that sought to understand early Christian remains in the light of the culture of the Mediterranean world (Judge, 4-14). Through the prodigious work primarily of Theodor Klauser,

the Bonn group has initiated publication of both the *Reallexicon für Antike und Christentum* (Stuttgart: Hiersemann, 1950-) in ten volumes to date (letter G), and the essential serial *Jahrbuch für Antike und Christentum* (volume 1, 1958-).

II. METHODOLOGY OF INTERPRETATION

Carlo Cecchelli. "Per una compressione integrale della iconografia," *ACIAC* 5 (1957): 371-79.

Erich Dinkler. *Die ersten Petrusdarstellung*. Marburg: Sonderdruck aus dem *Marburger Jahrbuch für Kunstwissenschaft* 11, 1939.

F. Gerke. "Ideengeschichte der ältesten christlichen Kunst." *ZKG* 59 (1940): 1-120.

Helmut Lother. *Realismus und Symbolismus in der altchristlichen Kunst*. Tübingen: Mohr, 1931.

Orazio Marucchi. *The Evidence of the Catacombs*. London: Sheed and Ward, 1929.

Keith N. Schoville. *Biblical Archaeology in Focus*. Grand Rapids: Baker, 1978, 98-103.

Victor Schultze. "Christus in der frühchristlichen Kunst." *Strena Buliciana*. Zagreb/Split: Zaklada Tiskare Narodnih Novina, 1924, 331-36.

Paul Styger. "Die Methode der Katakombenforschung." Separatdruck aus *Monatrosen* Nr. 1/2, October 1930, 1-14.

Roland de Vaux. "On Right and Wrong Uses of Archaeology." *Near Eastern Archaeology in the Twentieth Century*. Edited by James A. Sanders. New York: Doubleday, 1970, 64-80.

Josef Wilpert. *La fede della chiesa nascente secondo i monumenti dell'arte funeraria antica*. Città del Vaticano: PIAC, 1938.

——————————. *Erlebnisse und Ergebnisse im Dienste der christlichen Archaeologie*. Freiburg: Herder, 1930.

[6]Aldo Nestori, *Repertorio topografico delle pitture delle catacombe Romane* (Città del Vaticano, 1975).

[7]Friedrich Wilhelm Deichmann, ed., *Repertorium der christlich-antiken Sarkophage*, vol. 1 (Wiesbaden: Steiner Verlag, 1967).

[8]Richard Krautheimer, *Corpus basilicarum christianarum Romae*, vols. 1-4 (Città del Vaticano, 1937-1977).

The "Roman school" has established a rather firm style of interpreting archaeological data. The item or subject first must be re-

searched in biblical and patristic literature. Then references from the *Liber Pontificalis* and pilgrim itineraries are amassed so that a literary interpretation or history of the subject can be portrayed. Only then will the archaeological data be inserted into the literary structure. Assuming the nonliterary data will support the literary reconstruction, archaeological materials are used to supplement the tradition or even prove its validity. In case of conflict between the literary and the nonliterary data, the literary tradition will be preferred, though resolution of the conflict would be highly desirable.

While often very useful and informative, this method of interpretation has several critical weaknesses. First, it presupposes a continuity of tradition that may lead to both chronological and interpretative difficulties. The earliest representatives of the "Roman school" assumed first-century Christianity would be reflected in the archaeological data. More specifically, they assumed early (that is, late-first- and early-second-century) wealthy and noble converts became patrons of the new faith and established those cemeteries and house churches that later became the catacombs and churches of the Constantinian era. In other words, just as leadership and tradition of the fourth century stood in direct continuity with the biblical heritage, so the places of assembly and cultic practices of the public, Constantinian era stood in a direct line with the practices of the first-century Roman faith community. Consequently, earlier scholars of the "Roman school" tended to date the evidence far too early. As indicated in the introduction, scholars would now generally agree that data regarding early Christianity will first appear only about the end of the second century. To be sure, there are still some scholars who insist on harmonizing the literary tradition with the archaeological data, or more pointedly, producing archaeological data that will confirm presupposed traditions. One thinks here of P. E. Testa on the presence of the cross in early Palestinian remains,[9] or M. Guarducci on the graffiti under St. Peter's.[10]

The second error common to a doctrine of unbroken continuity comes from the opposite direction.[11] Later developments are read into the earlier stages. If the dating of artifacts cannot be accurate and if developmental continuity has been presupposed, post-Constantinian theological understandings will be found in pre-Constantinian material. Indeed, until recently[12] scholars have not attempted to distinguish clearly between the third and fourth centuries despite the obvious social revolution that occurred. So interpreters of the data of the third century have found understandings of the Eucharist, of Mary, of Peter, of Christological functions and other dogmatic, organizational, and cultic elements that actually only arose later.

It was Paul Styger who first insisted that scientific dating must precede any attempts to interpret the material. He wrote his revolutionary essay as a response to Josef Wilpert's American lectures on his own conclusions about archaeology and the faith after a lifetime of work in the field. Styger argued, for example, that art must be dated by comparing the style of the artisan with contemporary styles, or by the date of inscriptions found in the same area, or by the level of the catacomb. Dinkler made the same plea in his study of Peter in early Christian art, as he noted how much of the later Petrine tradition was foisted on early art quite unrelated to Peter. Without such precision in dating, a sense of historical development or change becomes impossible.

A second weakness of the "Roman school," that of the interpretative context, creates even more problems than the chronological errors. As early as 1880 V. Schultze argued that a painting should be understood in terms of its immediate context rather than according to patristic or dogmatic norms. But the "Roman school" has fairly consistently read the data against the backdrop of ecclesiastical tradition. Martigny, in the first edition of his encyclopedia, wrote that Christian archaeology was more than a faithful guide into historical origins; it was a participation in the

[9]Emmanuele Testa, *Il simbolismo dei Guideo-Cristiani* (Pubblicazioni dello Studium Biblicum Franciscanum, N. 14; Gerusalemme: PP Franciscani, 1962).

[10]Margherita Guarducci, *I graffiti sotto la confessione di San Pietro in Vaticano*, vols. 1-3 (Città del Vaticano: Libreria Editrice Vaticana, 1958).

[11]Brilliantly stated by John Henry Newman, *An Essay on the Development of Christian Doctrine* (London: Pickering, 1878).

[12]As in the 9th congress of scholars involved in Christian archaeology. See *ACIAC* 9 (1978).

society of primitive believers.[13] And that early society stands in continuity with the present day. Cecchelli admits that de Rossi was "animata dalla religiosita" (372). Pietro Kirsch defined "archeologia cristiana" as a scientific method of dealing with early Christian remains, monuments, and traditions so as to furnish the most complete picture of early Christian thought and religious rites.[14] Wilpert and Marucchi have shown how the primary elements of the Roman Catholic faith have been verified by the data of early Christian archaeology.

Helmut Lother, in describing the history of methodology, believes Christian archaeology was caught in a "dogmatische-lehrhafte Tendenz" for its first fifty years (6). In the 1930s and 1940s that *Tendenz* broke open. Some, such as Dölger, Sühling, or Goodenough in Jewish art, sought a *religionsgeschichtlich* context for early Christian art and symbols. Dölger sought the meaning for the fish in universal religious symbolism, as did Sühling for the dove.[15] But the major tide of change has shifted toward the interpretation of early Christian remains as signs of a popular religion in the context of other popular religions of the time (Lother, 5; Dinkler, 5-6). Consequently the interpretive edge today rests with the Bonn school, which proposes to study early Christian remains contextually as a *Volkreligion.*

For the sake of comparison, it is useful to note that so-called biblical archaeology followed a somewhat similar development. Like Rome, Palestine too had its pilgrims who were curious about the Holy Land and who left us accounts of their travels. Sometime after the start of excavations at Pompeii (1748) and Herculaneum (1738), a strong interest developed in ancient treasures. That interest shifted to the Middle East about the beginning of the nineteenth century. Because of the language barriers involved, biblical archaeology developed somewhat more slowly than early

Christian archaeology. Once that problem was solved, however, and the topography of Palestine determined, the stage was set for a scientific approach to archaeology in that area. In 1890 W. M. Flinders Petrie solved the problem of chronology by the dating of pottery. Shortly after, national and religious academies were established in Jerusalem to further research, direct excavations, publish findings, and train personnel. As a science, biblical archaeology, or Palestinian archaeology as it is now called, approaches archaeology in general as a companion discipline. Nevertheless, interest in biblical archaeology has depended on an ideological intent: to prove or illustrate the validity and/or accuracy of the Bible. De Vaux notes that the purpose of the American-based Palestine Exploration Society (founded in 1870) to illustrate and defend the Bible still lingers with us as a major reason for supporting biblical archaeology. De Vaux argues that text and monument are two different means of "recovering historical actuality" (70). The historian must decide how the two relate to each other in reconstructing a historical situation.

III. CONTEXTUAL METHODOLOGY

Robert Banks. *Paul's Idea of Community.* Grand Rapids: Eerdmans, 1980.

Walter Bauer. *Orthodoxy and Heresy in Earliest Christianity.* Edited by R. A. Kraft and G. Krodel. Philadelphia: Fortress, 1971.

Stephen Benko and John O'Rourke. *The Catacombs and the Colosseum.* Valley Forge: Judson Press, 1971.

Peter Brown. *The Making of Late Antiquity.* Cambridge: Harvard University Press, 1978.

John Elliott. *A Home for the Homeless.* Philadelphia: Fortress, 1981.

John Gager. *Kingdom and Community.* Englewood Cliffs NJ: Prentice-Hall, 1975.

Robert Grant. *Early Christianity and Society.* San Francisco: Harper and Row, 1977.

[13]*Dictionnaire des antiquités chrétiennes* (46).

[14]G. P. Kirsch, "L' archeologia cristiana," *RAC* 4 (1927): 49-57.

[15]Franz Dölger, *IXΘYC. Das Fisch Symbol in frühchristlicher Zeit* (Münster: Aschendorffschen Verlagsbuchhandlung, 1928), and Friedrich Sühling, *Die Taube als religiöses Symbol im christlicher Altertum (RQS,* Supplementheft 24, 1930).

E. A. Judge. *The Social Pattern of the Christian Groups in the First Century*. London: Tyndale Press, 1960.

Howard Kee. *Christian Origins in Sociological Perspective*. Philadelphia: Westminster, 1980.

Helmut Koester. *Introduction to the New Testament, History, Culture, and Religion of the Hellenistic Age*. Volume one. Philadelphia: Fortress, 1982.

_____. *Introduction to the New Testament, History and Literature of Early Christianity*. Volume two. Philadelphia: Fortress, 1982.

Ramsay MacMullen. *Paganism in the Roman Empire*. New Haven: Yale University Press, 1981.

Abraham Malherbe. *Social Aspects of Early Christianity*. Baton Rouge: Louisiana State University Press, 1977.

Wayne Meeks. *The First Urban Christians*. New Haven: Yale University Press, 1983.

Robert Redfield. *Peasant Society and Culture*. Chicago: University of Chicago Press, 1956.

Robin Scroggs. "The Earliest Christian Communities as Sectarian Movement." *Christianity, Judaism and Other Greco-Roman Cults*. Edited by J. Neusner. Leiden: Brill, 1975, 2:1-23.

_____. "The Sociological Interpretation of the New Testament: The Present State of Research." *NTS* (1979-1980): 164-79.

Melford E. Spiro. *Buddhism and Society*. London: Allen and Unwin, 1971.

Gerd Theissen. *Sociology of Early Palestinian Christianity*. Philadelphia: Fortress, 1978.

_____. *Social Setting of Pauline Christianity*. Philadelphia: Fortress, 1982.

Robert Thouless. *Conventionalization and Assimilation in Religious Movements as Problems in Social Psychology*. Oxford: Oxford University Press, 1940.

Robert L. Wilken. *The Christians as the Romans Saw Them*. New Haven: Yale University Press, 1984.

Both biblical archaeology and early Christian archaeology, as disciplines, have suffered from the methodological conviction that archaeological data will supplement what has been historically reconstructed from the "sacred" literature, that is, the Bible or patristic writings and ecclesiastical documents. At the heart of this methodological error lie three mistaken assumptions about the "sacred" literature:

1. It is assumed the literature represents rather accurately the historical situation when actually it may have a tendentious purpose.
2. It is assumed the literature speaks *cum solo voce* when actually other voices have been ignored, repressed, or assimilated.
3. It is assumed the literature represents a reflective or literary level of popular religion whereas actually literature and practice often stand in tension with each other.

Having supposed the literature was fairly accurate in its perception, church historians have for centuries described an early church that first was pure and then, by a gradual erosion of faith and practice, fell into heretical schisms. Walter Bauer, in his classic study of orthodoxy and heresy in the pre-Constantinian church, shattered this naive presupposition. He showed that varieties of Christianity existed side by side from the beginning. Orthodoxy and heresy as we know them did not then exist. Literature of the second century that would represent this heterodoxy was repressed by later writers who wished to portray early Christianity as an "orthodoxy" speaking with a single voice. Such a suppression accounts for the surprising lack of literature from time to time and also indicates that "orthodoxy" did not really exist until one of the varieties of early Christianity had gained ascendancy. Heresy was that variety of Christianity that was repressed rather than the factor that eroded pristine orthodoxy. Recent discoveries of some of that lost literature verify Bauer's thesis in general, even if they do not support the accuracy of his reconstruction. Any historical reconstruction of early Christianity must then take into consideration the late emergence of ecclesiastical orthodoxy,

the pluralistic character of the earliest faith communities, and the literary suppression of that heterodox situation.

Complex as this seems, even more problematic has been the relationship between the literary evidence and the archaeological evidence. As indicated, both early Christian archaeologists and biblical archaeologists have assumed the essential unity of the two bodies of data. In recent years this assumption has changed rather radically. De Vaux speaks for Palestinian archaeologists who find here two sets of data that must be evaluated separately. Klauser speaks for early Christian archaeologists who suppose archaeological data belong to the practice of popular religion rather than the ecclesiastical tradition of the received literature. If archaeological data belong to the realm of popular religious practice, then the interpreter, or historian, must state clearly how the evidence of archaeology does relate to the literary material, or, to state it another way, how the popular religion relates to ecclesiastical tradition. The issue raised belongs not to the disciplines of patristics, history, or theology, but to the sociology of religion.

On this particular issue a classic division exists between those who believe the tradition informs, creates, and alters the social matrix (Max Weber),[16] and those who believe the social matrix gives birth, through a lengthy social process, to universal truths (Emile Durkheim).[17] If one followed the Weberian analysis, then popular religion would indeed be the concretization or socialization of revealed truths. In such a case biblical archaeologists and early Christian archaeologists have good reason to read the archaeological evidence in light of the Bible or the received tradition. A Durkheimian analysis, on the other hand, would argue that time-tested social practices are elevated to universal beliefs. In that case the Bible and tradition should be read as products of the social context. I have already observed the problems with a Weberian analysis of early Christianity: it fails to perceive the functional context of the archaeological data. A Durkheimian analysis can understand doctrine only as expressions of social and class development: it fails to understand the function of revelation, tradition, and charismatic leadership in social change.

In 1940 Robert Thouless described two ways that a social matrix responded to the impact of a religious revelation. In one the social unit made the revelation conform to social needs and norms while keeping the revelation fairly intact. He called this process "conventionalization" and cited Hinayana Buddhism as an example. In the other process the social matrix sorts out what it can use and pulls that into its own already existing religious structures. Thouless called that "assimilation" and cited Mahayana Buddhism as an example. Neither form of Buddhism has remained "true" to the revealed Buddhism, and both conform to sociological norms. In fact, according to Thouless, all time-tested religions of the world will demonstrate similar sociological patterns as practiced and show far more similarity than in their respective revealed literatures.

It was Robert Redfield, of the University of Chicago, who first described the relation between revelation and social matrix, between religious text and people, as a tension within the social matrix itself. He found in village life two societies: first, those with education, wealth, prestige, or position who adhered to the tradition, the revelation, the sacred book; and second, those who labored, carried on commerce, and performed services, who adhered to religion as practiced in the social matrix, that is, acted according to sociological norms rather than revealed norms. Innumerable studies from the "Chicago school" have demonstrated this basic tension between those who follow the great tradition and those who practice the local tradition. Somewhat like Thouless, Spiro showed how the world-denying Buddhism had been adapted for local use as a life- and world-affirming religious practice. It was McKim Marriott[18] who readapted the Thouless argument and suggested there was in a social matrix constantly a process of "universalization," the acceptance of local belief and practice in the revealed body of truth, and "parochialization," the adaptation

[16]Max Weber, *The Sociology of Religion* (Boston: Beacon Press, 1963).

[17]Emile Durkheim, *The Elementary Forms of Religious Life* (London: Allen and Unwin, 1915).

[18]McKim Marriott, "Little Communities in an Indigenous Civilization," in *Village India*, ed. M. Marriott (Chicago: University of Chicago Press, 1955) 197-200.

of revealed truth to local social needs. Both Weber and Durkheim were correct. From this I would suggest the following processes are always at work as a revealed body of truth affects a social situation:

1. Some elements of the great tradition are being accepted in the social matrix.
2. Some elements of the great tradition are being accepted in the social matrix in a non-normative manner.
3. Some elements of the social matrix are being adapted by the great tradition.
4. Some elements of the social matrix are being accepted by the great tradition in a non-normative manner.

Needless to say, some elements of the great tradition are never useful to the social matrix, and likewise some aspects of the social matrix remain unacceptable to the great tradition. These principles will guide us as we look at the data of early Christian archaeology.

While this study ought not be considered a "sociology" of the early Church, there are sufficient similarities between this work and recent interest in sociological interpretation of the New Testament to warrant some reflection on the relationships.

The most obvious difference lies in the nature of the data. In this study there is a resolve to use only archaeological data as derived from the early Christians themselves. For a study of the New Testament, there is no such possibility. It is a basic assumption of this study that there never will be such data available for the study of the New Testament period. Consequently, interpreters of the New Testament must use it as a mirror for sociological information by deriving from it data only incidental to its formation. Meeks and Theissen have been especially useful in pointing out the sociological information to be gleaned from the letters of Paul. In addition, Meeks especially has placed this information in a social context derived from contemporary literature and archaeological data. The result has been a highly fruitful resource for our interpretation of the apostle Paul.

Useful as these studies are, there is little possibility of joining theirs with the present work. The difference of more than one hundred years cannot be lightly dismissed. Grant comes closer to

an interface by using directly the literature of the early Church as a means of determining the social position of the first Christians. His work points to a next step: the critical comparison of archaeological findings with the literature. Is some early Christian literature (e.g., Shepherd of Hermas) closer to the local church than, for example, the apologists? Or could the method exemplified by Meeks and Theissen be used to study Tertullian and Clement? How would these results match the findings of this study?

Peter Brown also brilliantly uses the literature to understand the faith of the common folk; but again, like Grant, he depends more on the literature than the archaeological data. Nevertheless, his insights, especially in regard to the piety of extended family and meals for the dead, often match what can be found in the archaeological material.

This work makes no attempt to utilize non-Christian literature as a source for understanding the local church. Wilken has given us a very useful study in that direction. To be consistent, however, one should extend as much wariness toward non-Christian literature as toward Christian sources. MacMullen has recognized this fact (9). His attempt to understand paganism from data other than literary has great merit; a next step ought to be to read contemporary non-Christian data in comparison with the material offered in this work.

As Scroggs indicates in his very helpful interpretive article, many who look for sociological interpretations of the New Testament find an upwardly mobile lower class seeking a rightful place in the Hellenistic society, or a sect moving toward broader social status. One can see comparable elements in the local church of the third century: sociological suspension or tension (Elliot), egalitarianism, voluntarism, and a close-knit fellowship. On the other hand, one sees little in this data to indicate millenarianism, or radical social upward mobility.

Scroggs rightly calls the method of this study an alternative to the general consensus. By acknowledging a dialectic between revelation and assimilation, we see in the material not only the use of Greco-Roman practices to express nascent Christian culture, but we also see how Christianity absorbed the pluralistic Roman world into a single force—a single Jesus, so to speak. The

"revelation" (Jesus) used the social symbols and practices for its own purposes. That single, flexible, and assimilative force was correctly recognized as a threat to the tolerant pluralism of the Roman Empire. When the nascent culture appeared (ca. 180), it was then seen as inimical to the social aims of the Romans. It was then that Christians were accused of being atheists, that is, of not believing in the dominant pluralism (MacMullen, 2). It was shortly after that appearance in 180 that the tension became violent (the persecutions of the mid-third century). This conflict was not simply the upward swing of disenfranchised Christians, but also the power of a symbol (Jesus) that could absorb the divinities and social structures of the Roman world. Eventually it did just that.

CHAPTER TWO

EARLY CHRISTIAN SYMBOLS

Patrick Bruun. "Symboles, signes et monogrammes." *Acta instituti Romani Finlandiae*. Helsinki, 1963, 1:2:73-166.

E. R. Goodenough. *Jewish Symbols in the Greco-Roman Period*. New York: Pantheon Books, 1953-1968, 1-13.

Lexicon der christlichen Ikonographie. Edited by Engelbert Kirschbaum. Freiburg: Herder, 1968-1972.

Enciclopedia cattolica. Città del Vaticano, 1948-1954.

Dictionnaire d'archéologie chrétienne et de liturgie. Edited by F. Cabrol and H. Leclercq. Paris: Letouzey et Ané, 1924-1953.

One must begin with signs and symbols since they surely precede more extensive art forms and did, at least in the case of early Christian art, become the basis, both artistically and iconographically, for pictorial art. At the same time, one hesitates to start a study with that which creates the most difficulty in terms of origin, date, and interpretation.

It is assumed here that a sign or symbol, like a metaphor in linguistic expression, reflects the multiple social conflicts or paradoxes in which the producing group finds itself. Signs are much more than quickly produced means of communication. They represent that which cannot be expressed easily by words or even narrative. In fact, the presence of narrative art normally indicates the resolution of conflicts into a common story. One would not expect to find, and indeed does not find, narrative art prior to the peace of Constantine. The assumption that narrative art develops normally in art history, as Grabar supposes of early Christian art,[1] misses the social, structural importance of symbols. And, as indicated in the section on methodology, one must avoid supposing there is a theological meaning to a symbol that can be adduced from contemporary or even later theological literature. Polemical authors wished to defend, explain, or upgrade the faith practices of the people. It must not be assumed, as do the editors and writers of iconographical dictionaries and studies, that the

[1]André Grabar, *The Beginnings of Christian Art* (London: Thames and Hudson, 1967).

literary usage and the popular symbolic expression—even though chronologically simultaneous—are actually identical. Indeed, one would suppose that extensive, forcible discussions in the literature regarding a sign would necessarily imply an attempt to alter the meaning of it. One thinks, for example, of Tertullian's discussion of the crown symbol (*de corona*, 14-15). Finally, it is assumed in this study that signs have social origins and implications rather than private, mystical meanings. If this is true, then the work of E. R. Goodenough on Jewish and Christian symbols, however learned and useful, would be a prime example of studies that actually could divert us from the important communal meaning of early Christian art, as well as divert us from the task of understanding how nascent Christianity became a universal and hence public religion by the fourth century.

Patrick Bruun has provided a very complete list of early Christian signs and symbols. Unfortunately for our purposes, he did not distinguish between those that were pre-Constantinian and those that came after the peace, nor did he attempt to chronicle the changes that occurred as a symbol moved from early folk religion to public faith. In an attempt to correct that perspective, I will deal here only with those symbols that are demonstrably pre-Constantinian, and will attempt to show the iconographical development of each one. Finally, I will comment on at least one symbol, the cross, which had a formative influence in orthodox Christianity; in my opinion, however, it ought not be considered pre-Constantinian. That discussion is controversial and of critical importance for our understanding of the early faith. So the absence of this symbol will be considered. The following signs predate the fourth century in Christian usage: 1) lamb, 2) anchor, 3) vase, 4) dove, 5) boat, 6) olive branch, 7) the Orante, 8) palm, 9) bread, 10) the Good Shepherd, 11) fish, and 12) vine and grapes.

I. THE LAMB

F. Gerke. "Der Ursprung der Lämmerallegorien in der altchristlichen Plastik." *ZNW* 33 (1934): 160-96.

H. Leclercq. "Agneau." *DACL* 1:1:877-905.

——————. "Bélier." *DACL* 2:1:650-58.

Red. "Lamm, Lamm Gottes." *LCI* 3:7-14.

Example: The sarcophagus at S. Maria Antiqua

The use of the lamb in early Christian art raises immediately the issue of the social meaning of religious symbols. After the peace the lamb appeared primarily as a symbol of the crucified Christ (Ravenna, Gallia Placida). But before the peace the lamb appeared usually with the figure of the Good Shepherd or in a context that could be associated with the Good Shepherd, though not exclusively so; it can be found independently. On the sarcophagus at S. Maria Antiqua lambs appear on the vine above the head of Jonah. In none of the pre-Constantinian examples would there be any hint of the later *agnus dei* (based on Revelation 6:5?). Even more pointedly, there are no early Christian symbols that elevate paradigms of Christ suffering (the *teologia crucis*) or even motifs of death and resurrection. In early Christian art, when Jesus does appear, he overcomes illness, political and social difficulties, and death. He does not succumb to environmental threats. In a social situation in which persecution, harassment, prejudice, class hatred, and illegal treatment were always imminent possibilities, the earliest Christians stressed deliverance and victory rather than death and resurrection. Thus lambs appear in bucolic scenes, often with the Good Shepherd, rather than in sacrificial or liturgical contexts. If, as I will argue for the Good Shepherd symbol, such scenes reflect the presence of a philanthropic community, then the lambs, probably rather imprecisely, reflect the presence of the religious actor in that community. In terms of symbolic, structural conflict, the lamb refers to a kinship community both present and past (sepulchral art), where such community did not exist in a blood sense. When, after the peace of Constantine, the natural kinship community and the faith kinship community became one, the need for such a symbol disappeared. Only then did the lamb take on its powerful, biblically based redemptive meaning, the lamb of God, and only then did the lamb as religious

actor become restricted to the apostles (see the apse of S. Apollinare in Classe, Ravenna).

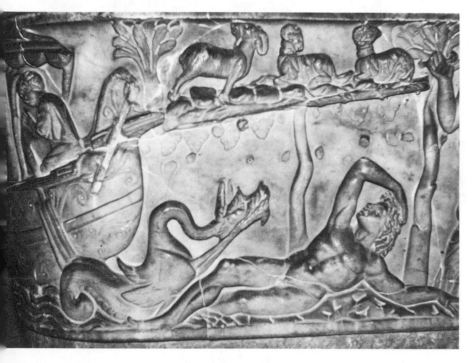

Plate 1. Sarcophagus located in Sta. Maria Antiqua, Rome. Section shows Jonah under the vine, on which are several lambs. (Except where noted, all photographs are from the collection of Graydon F. Snyder.)

II. THE ANCHOR

Leo Eizenhöfer. "Die Siegelbildvorschläge des Clemens von Alexandrien." *JAC* 3 (1960): 51-69.

J.-P. Kirsch. "Ancre." *DACL* 1:2:1999-2031.

P. Stumpf. "Anker." *RAC* 1:440-43.

Example: Priscilla epigraphs #s 44, 45, 84, 106

The anchor appears frequently on *tituli* of the third century and then, after the peace, basically disappears. One must assume that

the anchor had some critical importance during the third century for a situation that no longer existed in the late fourth century. Some have explained this by supposing the anchor was a disguised cross that, when the cross became publicly acceptable, lost its usefulness. Since, as was observed of the lamb, third-century popular faith did not utilize symbols of suffering and dying, one cannot accept the anchor as a hidden reference to later or even contemporary literary reflections on the redemption of the cross. Others find in the anchor a reference to Hebrews 6:19, a symbol of hope. Clement mentioned the anchor as an acceptable symbol *(paed.* 3, 11, 2), but did not even hint at a meaning, except that by context he associated it with fish, ships, and fishing. Apparently the early Christians created this symbol *de novo*, for it had very little metaphorical meaning in the non-Christian culture.

Understood in terms of social conflict, the anchor, fish, and ships are all things that can endure in an alien environment. Therefore, the anchor implies security in a hostile, if not negative, culture.

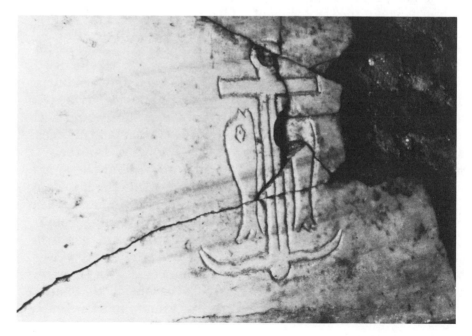

Plate 2. A marble titulus *with two fish and an anchor, Rome.*

III. THE VASE

T. Klauser and S. Grün. "Becher." *RAC* 2:37-62.

H. Leclercq. "Calice." *DACL* 2:2:1595-1645.

Red. "Kelch." *LCI* 2:496-97.

Example: SICV #93

While some have seen in the vase a eucharistic *calix*, it is now generally agreed that the *calix* does not appear in Christian art until well after the peace. They can be seen in the mosaics of S. Vitale and S. Apollinare in Ravenna, perhaps for the first time in Christian history. The art and symbols of third-century Christianity simply do not reflect the ἀνάμνησις eucharist. The art does portray a eucharist, but that consists of fish, loaves of bread, baskets of bread, and wine. In terms of biblical origins, the eucharist so pictured probably refers to the "feeding of the five thousand." Within the Roman culture this "breaking of bread" meal assimilated the general cultural practice of eating with the dead. Consequently, since most Christian art has been found in burial areas, much of third-century Christian archaeological data refer to burial, eating with the dead, with extended family, and with special dead, the martyrs. Artistic representations of this meal are frequent, as are the signs: fish, bread, and wine. But there is no indication the vase was used for holding wine at the agape meal. The wine appears in a glass or tumbler. This is not to deny that the vase could have served as a container or pitcher. For the most part, however, the vase appears with a dove feeding from it. I will argue that because the dove symbolizes the pax of the Christian community, then the vase must "contain" the source of that pax. Very likely that would be a liquid connected with the *refrigerium*, the kinship meal of the early Christians. The acclamations of this drinking together became the primary marks of early Christian funerary inscriptions (*in pace* and *vivas*), and the cups or glasses later became treasured objects of art (the gold glasses).

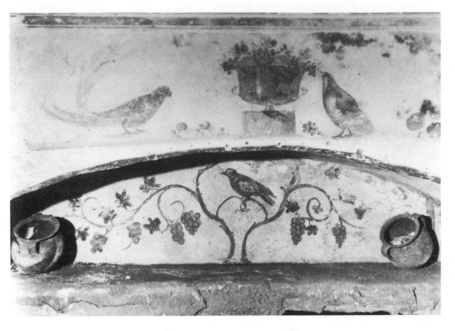

Plate 3. A vase on an arcosolium *from one of the borderline mausolea in the* arenario *under S. Sebastiano, Rome.*

IV. THE DOVE

P. Bruun, 86-92.

Eizenhöfer, 53-55.

Kurt Galling. "Taube." *RGG*[3].

E. R. Goodenough, 8:27-46.

J.-P. Kirsch. "Colombe." *DACL* 3:2:2198-2231.

J. Pöschke. "Taube." *LCI* 4.

Friedrich Sühling. *Die Taube als religiöses Symbol im christlicher Altertum. RQS*, Supplementheft 24, 1930.

Example: Priscilla epigraph #198

In contrast to the *de novo* nature of the anchor in Christian symbolism, the dove has an incredibly rich and ancient tradition. This

tradition and its extensive usage in Christian history have been amply described by Goodenough and Sühling. As both insist, early Christian usage must have derived from an earlier iconographical history. Among the various interpretations attributed to the dove, most prominent are those of femininity, sexuality, and love (*eros*), either human or divine. It can be used as a divine representation, appears in many religious actions, and can signify the human soul. Goodenough and Sühling wish to interpret the early Christian use of the dove in *religionsgeschichtlich* terms. Though this bypasses the immediate social function of the symbol, their studies have greatly elucidated the rich meaning of the dove figure.

Scholars now generally agree that before the peace the dove did not represent the departed person. It was heavily associated with the acclamation *in pace*, which probably originated as a salutation in the meal for the dead (note especially its use on later drinking glasses) and with the olive branch which, by common agreement, also refers to peace (q.v., 18). From a number of early *tituli,* Bruun has produced the following chart on the relationship between the dove and *in pace.*

	WITHOUT *IN PACE*	WITH *IN PACE*
Dove alone...	45	37
Dove with olive branch or tree	21	30
Dove with Christogram	17	24
Dove with other symbols.............................	16	15

Bruun's sample includes both Constantinian and pre-Constantinian inscriptions, so that one cannot use this data to draw absolute conclusions about the dove symbol. But if the doves from the fourth century are eliminated (those with a Christogram), 82 of 164 doves appear with *in pace* and 103 appear with some peace symbol. One could hardly deny that the early Christian dove symbol represented peace to many religious actors. It must have signified that peace and satisfaction derived from faith ∩nd the faith community as one faced death, or cultural and existential entrap-

ment. As such, it stands very close to the Orante. In later public art peace symbols referred more to the ultimate peace of the soul than to personal and corporate peace in the face of conflict. Pictorial scenes of conflict involving the dove and the Orante began to disappear after the fourth century, and these two symbols lost their original meaning. But in the third century the dove and the Orante were nearly always used in conflict situations such as Noah and the Ark, Daniel and the Lions, and the Three Young Men in the Fiery Furnace.

One major exception remains. On the sarcophagus in S. Maria Antiqua, for example, one finds a dove descending over the baptized Jesus. Is not this dove the representation of the Holy Spirit? Perhaps so, but such an answer assumes there is in the Baptism of Jesus at least one narrative scene prior to Constantine. If that is not true, then Jesus is used in the baptism as a miracle worker who overcomes the alien environment represented by the water. In such a case, the dove again symbolizes faith and peace for the community as experienced in Jesus. (See the section on the Baptism of Jesus, ch. 4).

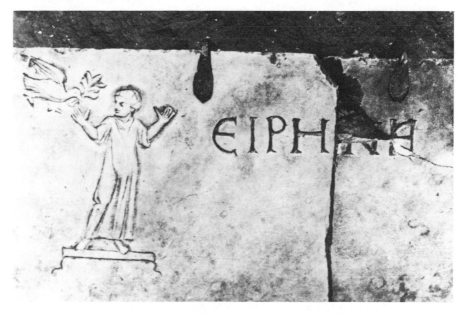

Plate 4. A titulus for Eirene with dove, olive branch, and Orante, Rome.

Goodenough has stressed strongly the sexual element of dove iconography. Therefore, he sees the dove as a sign of eros and perhaps agape. If the vase does belong to the *refrigerium* and the dove frequently drinks from the vase, it could be inferred that the peace of the dove does derive from a new sense of family given by God in the faith community.

V. THE BOAT

Eizenhöfer, 62-66.

E. R. Goodenough, 8:157-65.

H. Leclercq. "Navire." *DACL* 12:1:1008-21.

Georg Stuhlfauth. "Das Schiff als Symbol der altchristlichen Kunst." *RivAC* 19 (1942): 111-41.

Example: Paul and Thecla fragment

Stuhlfauth has collected numerous examples of ships in early Christian art. Unfortunately for our purposes, he does not distinguish between the third and fourth centuries, but there is no reason to disagree with his conclusion: the ship was a popular symbol during those two centuries and then lost its usefulness (129).

Like the dove, the boat has considerable non-Christian background. It serves primarily as the vessel that conveys the departed person to the other world. Since early Christian art was found primarily in sepulchral situations, it was logical to assume such a meaning for the boat. But other contextual considerations would lead us to expect other alternatives. There is nothing in the pre-Constantinian data to make us suppose the deceased person was going elsewhere. Quite the contrary, there is every reason to suppose the deceased was present at the burial site. The family ate with the dead; the community ate with and called upon the special dead. The dead were very much present; they were localized, so to speak. Only much later in Christian history does one project an afterlife for the deceased.

So the use of a boat in early art does not imply soul passage. In Noah and the Ark, Noah is portrayed as an Orante safe from the waters. Likewise, Jonah in the boat is pictured as an Orante safe from the storm. While blind acceptance of literary interpretations should be avoided, one must note that the early church fathers spoke of the boat as a symbol of the Church. In its origin the ship—like the anchor, and sometimes the fish—referred to security in the midst of an alien environment. When that alienation no longer existed the ship, like the anchor, lost its popularity in Christian art; however, in patristic literature the ship, by logical extension, would refer to the church as the sole means of salvation.

Plate 5. Fragment of a sarcophagus for the presumed Christian, Paulus. Museo del Palazzo dei Conservatori, Rome.

VI. THE OLIVE BRANCH

H. Leclercq. "Arbres." *DACL* 1:2:2691-2709.

Sühling, 217-39.

Example: Sarcophagus, Museo Pio cristiano #119

The olive branch occurs frequently with the dove, as the chart on page 17 indicates, though sometimes it stands alone, especially on

tituli. In pictorial art the olive branch is nearly always found with Noah and the Ark, sometimes with Jonah, and sometimes with the Three Young Men in the Fiery Furnace. By common agreement among most writers and contextual observers, the olive branch has a symbolic equivalence to pax. That peace relates not only to the dead and the *refrigerium*, but also to that structural gift of peace at the moment of conflict or threat, as seen in the pictorial art. Theologically speaking, it approximates grace.

VII. THE ORANTE

Fabrizio Bisconti. "Contributo all' interpretazione dell' atteggiamento di orante." *VetChr* 17 (1980): 17-28.

Mary L. Heuser. "Gestures and Their Meaning in Early Christian Art." M.A. thesis, Radcliffe, 1954.

Theodor Klauser. "Studien zur Entstehungsgeschichte der christlichen Kunst." *JAC* 2 (1959): 116-45 ; 3 (1960): 112-33.

H. Leclercq. "Orant, Orante." *DACL* 12:2:2291-2322.

Alice Mulhern. "L'orante, vie et mord d'une image." *Les dossiers de l'archéologie* 18 (1976): 34-47.

W. Neuss. "Die Oranten in der altchristlichen Kunst." *Festschrift zum sechzigsten Geburtstag von Paul Clemen*. Bonn: Cohen, 1926, 130-49.

E. Sauser. *Frühchristliche Kunst*. Innsbruck: Tyrolia Verlag, 1966, 199-218.

G. Seib. "Orans, Orante." *LCI* 3:352-54.

M. Sotomayor. "Notas sobre la Orante, y sus accompanates en el arte paleocristiana." *Analecta sacra Tarraconiensia* 34 (1961): 5-16.

E. Stommel. *Beiträge zur Ikonographie der konstantinischen Sarkophagplastik. Theophaneia* 10; Bonn: Hanstein, 1957.

P. C. J. Van Dael. *De dode*. Amsterdam: Academische Pers., 1978.

Example: Sarcophagus at S. Maria Antiqua

The term *Orante* refers to a standing female figure with arms stretched above her head. Her head is nearly always covered with a veil, and she wears a tunic of that period (*orans tunicata et velata*). Since she frequently represents male figures in early Christian art, the constant use of female clothing seriously affects our interpretation of pictorial art (Bruun, 133-34).

In the Christian culture that emerged about A.D. 180, no symbol occurs more frequently and integrally than this female figure with lifted arms. Not only does she exist as a separate symbol, but she is also the main figure in almost every biblical scene, both fresco and sculpture. She is Noah in the ark; Jonah in the boat and Jonah spewed out of the *ketos* (sea monster); Daniel between the lions; Susannah saved by Daniel; the three young men in the fiery furnace; and occasionally Lazarus. She must be the most important symbol in early Christian art. At least three observations must be made in order to understand the Orante symbol (Neuss, 133).

First, there was no distinction between the Orante as a symbol and the Orante in pictorial art: she is a female figure with female clothing. Only rarely can one find a clearly masculine Orante. Since the female Orante has no integral meaning in most biblical, pictorial art (except as Susannah), one must conclude that the Orante symbol has been inserted into biblical scenes. To put it in terms of this thesis, in the encounter between the translocal (biblical or revealed tradition) and the local (social matrix), the Orante has come from the local tradition but has adapted a translocal scenario. The Orante therefore has retained its cultural meaning (Klauser, *JAC* 2:116).

Second, the Orante had a long history as a cultural symbol. At the time of early Christianity, there were two primary uses visible to the Christian: coins and sepulchral art. On coins it occurred as the obverse of coins struck from the time of Trajan to the time of Maximian. Frequently the inscription *pietas* or *pietas aug* appears with the Orante.[2] The purpose of such propaganda on imperial coins can be debated,[3] but there can be little doubt about

[2]Theodor Ulrich, *Pietas (Pius) als politischer Begriff im römischen Staate bis zum Tode des Kaisars Commodus* (Breslau: M. and H. Marcus, 1930).

[3]C. H. Dodd, "The Cognomen of the Emperor Antoninus Pius," *The Numismatic Chronicle*, 4th ser., 11 (1911): 6-41.

the meaning of the Orante as *pietas*. C. H. Dodd, in a study of Roman coins, has shown that *pietas* on imperial coins must refer to filial piety. Possibly Antoninius was called Pius because of the respect he had shown his father-in-law.[4] In any case *Pietas* coins with symbols other than the Orante also point to filial piety.[5] Apparently it was the imperial intention to use the Orante symbol to extend this family virtue (local) to *pietas erga patria* and *pietas erga deos* (translocal).[6] Presumably, the second visible usage of the Orante, in sepulchral art, also referred to the piety of familial loyalty (Klauser, *JAC* 2:123-27).

Third, the Orante occurs both in sepulchral art and ecclesiastical art (e.g., Dura-Europos and SS. Giovanni and Paulo). Whatever meaning accrued in the catacombs must also have been valid in the context of the faith community. In its original social context, the Orante referred to the security of filial piety. The symbol was used by the earliest Christians in reference to the new, adopted family—the Church. Through pictorial art, as will be seen, this sense of community security or peace was located in biblical scenes of threat such as Noah, Jonah, and Daniel. This corporate sense of peace accounts for the presence of the symbol in both funerary art and the *domus ecclesiae*. Before Constantine there is no reason, either in the art itself or in the social context, to suppose the Orante refers to the soul of the dead person as the "Roman school" so often maintained. Quite the contrary, the familial understanding of the Orante fits quite well with the popular Roman understanding of death and the notion of the dead as extended family. The Christian symbol differs primarily in that the faith community family was a religious association, not an extended blood relationship.

VIII. THE PALM OR TREE

J. Flemming. "Baum, Bäume." *LCI* 1:258-68.

——————. "Palme." *LCI* 3:364-65.

E. R. Goodenough, 8.

T. Klauser. "Baum." *RAC* 2:23-34.

H. Leclercq. "Arbres." *DACL* 1:2:2691-2709.

——————. "Palm, Palmier." *DACL* 13:1:947-61.

Lars-Ivar Ringborn. *Paradisus Terristris. Myt, Bild och Verklighet. Acta Societatis Scientiarum Fennicae*, Nova Series C. 1, No. 1; Helsinki, 1958.

Example: Priscilla epigraphs #s 153, 197

The palm occurs ordinarily as a branch, though occasionally as a

Plate 6. Sarcophagus of Sta. Maria Antiqua. Close-up of the Good Shepherd, the Orante, and the deceased reading.

————————

[4]Ibid., 11.

[5]Ibid., 20-21.

[6]Ibid., 25, and Ulrich, *Pietas*, 5-10.

tree. It can stand alone, or with other symbols, and it appears frequently in pictorial representations, and in decorations. Ringborn has a remarkable collection of samples from early Christian art. The palm, as an ancient symbol, can move two ways: either as a sign of victory, that is, a presentation to the victor, or as a sign of life. It is likely that early Christianity assimilated both elements. As a palm branch on *tituli,* it may be associated with symbols of victory over death. As a tree, however, whether a palm or indistinguishable genus, it is seen most frequently in the context of the Good Shepherd. There is a strong tendency to suppose the Good Shepherd symbol derives primarily from the paradisiacal Orpheus myth in which the tree carries a connotation of satisfactory existence. The tree, especially the palm, has similar references to life in Jewish art and literature. Goodenough considers the palm a pagan intrusion in both Christianity and Judaism, but Ringborn traces the use of the tree back to the Genesis myth (23).

Plate 7. Incomplete titulus *showing tree, dove, and anchor.*

IX. THE BREAD

F. Eckstein and A. Stuiber. "Brotformen." *RAC* 2:626-30.

F. Eckstein and T. Klauser. "Brotstempel." *RAC* 2:630-31.

George Galavaris. *Bread and the Liturgy.* Madison: University of Wisconsin Press, 1970, 3-82.

E. R. Goodenough, 5:62-98.

T. Klauser, J. Hausleiter, and A. Stuiber. "Brot." *RAC* 2:611-20.

H. Leclercq. "Pain." *DACL* 13:436-61.

Example: Sarcophagus in the Velletri Museum (see plate 17)

Bread cannot be easily isolated as a pre-Constantinian symbol. It does always occur in meal scenes, and as a meal symbol with fish and a tumbler of wine (e.g., the famous combination symbol from the crypt of Lucina, S. Callisto, Rome). In portrayals of the meal the artist paints bread as a small round object, of which several are placed in a basket. Normally there are five or seven baskets (compare the New Testament stories of the Feeding of the Five Thousand, Mark 8:1-10). Apart from the meal, bread still appears in a basket, such as in the crypt of Lucina where it is found on the back of a fish with a glass on the side. Before the peace, individual loaves of bread were rare, perhaps even nonexistent. When they do appear, they are circles with two intersecting lines (the bread stamp).

As Goodenough has indicated, small round objects are extremely common in religious art. Even baskets of round objects are fairly common, especially in the Judaism of that time. The bread (with a basket) apparently must symbolize a religious meal, or kinship meal, for nearly every unofficial religion in the Mediterranean world. The same is true for Christianity. Not only did the bread refer to the agape meal, and the meal for the dead, but it also was a means of charity within the fellowship.[7]

[7]Bo Reicke, *Diakonie, Festfreude und Zelos* (Uppsala: Lundequistska, 1951); see Jerome, *epist.* cxxv, 20.

The association of fish, bread, and wine in a religious meal (with a set number of baskets) forces one to consider the distinction between the eschatological meal (as found in the Didache and perhaps 1 Cor. 10) and the ἀνάμνησις meal of 1 Cor. 11.[8] Does not the meal found so frequently in early Christian art reflect much more the eschatological meal, or agape, than the Christianized Passover meal, or ἀνάμνησις? As will be seen in the discussion of the meal itself (64-65), central to the liturgy of the early Christian community was a koinonia meal that did not recall the sacrifice of Jesus Christ. Yet the artistic details do not correspond directly to the New Testament narrative of the Feeding of the Five Thousand either. Nor could one easily imagine the small *panino* as the unifying loaf of the *Didache* account *(Did.* 10-12). The bread, fish, and wine signify a meal celebrated in the Roman social matrix prior to Christianity. Its iconography likely derives from such multiple sources as mystery religions, Judaism, and the New Testament.

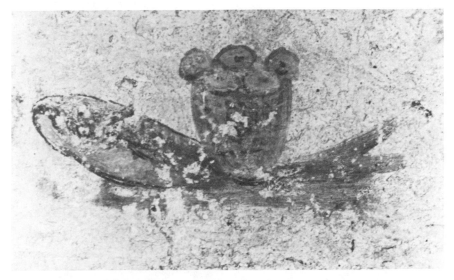

Plate 8. Fresco from the Catacomb of St. Callixtus. The bread and fish symbolize the very common agape or refrigerium.

[8]Hans Lietzmann, *Messe und Herrenmahl*, 3d ed. (Berlin: W. de Gruyter, 1951).

After the peace bread will appear as individual "rolls" with diagonal marks, eventually bearing the cross symbol, and other stamps. The bread on the communion table in the apse of S. Vitale in Ravenna would be an excellent late example. On the other hand, baskets of bread (with the fish and wine) continued through the Byzantine era as the iconography of the Christian meal, even when that referred to the Last Supper (as in the mosaic of the Supper in S. Apollinare in Classe, Ravenna).

X. THE GOOD SHEPHERD

Lucien de Bruyne. "La decoration des baptistères paléochrétiens." *ACIAC* 5 (1957): 341-69.

Ernst Dassmann. *Sündenvergebung durch Taufe, Busse und Martyrerfürbitte in den Zeugnissen frühchristlicher Frömmigkeit und Kunst.* Münster: Aschendorff, 1973, 374-85.

Robert Eisler. *Orpheus—The Fisher*. London: Watkins, 1921, 51-74.

Theodor Kempf. *Christus der Hirt*. Rome: Officium Libri Cathol., 1942.

T. Klauser. "Studien zur Enstehungsgeschichte der christlichen Kunst." *JAC* 1 (1958): 20-51; 3 (1960): 112-33.

H. Leclercq. "Pasteur (Bon)." *DACL* 13:2:2272-2390.

A. Legner. *Der Gute Hirt*. Düsseldorf: L. Schwann, 1959.

——————. "Hirt, Guter Hirt." *LCI* 2:289-99.

Johannes Quasten. "Der Gute Hirte in frühchristlicher Totenliturgie und Grabeskunst." *Miscellanea Giovanni Mercati. Studi e testi* 121. Città del Vaticano: Biblioteca Apostolica Vaticana, 1946, 1:373-406.

——————. "Das Bild des Guten Hirten in den altchristlichen Baptisterien und in den Taufliturgien des Ostens und des Westens." *Pisciculi.* F. J. Dölger dargeboten. Münster: Aschendorff, 1939, 220-44.

Sauser, 290-371.

Walter Nikolaus Schumacher. *Hirt und "Guter Hirt."* *RQS* Supplementheft 34, 1977.

Alfred Stuiber. *Refrigerium Interim. Theophaneia* 11. Bonn: Hanstein, 1957, 151-67.

Example: Sarcophagus at S. Maria Antiqua, Rome

The Good Shepherd as an independent symbol consists of a male shepherd figure with an animal of the sheep family over his shoulders. The Orante and the Good Shepherd are the only two early Christian symbols in human form. Both are very early and both are extensively used. After the peace, the Good Shepherd became the most popular representation of Jesus Christ. In contrast to the Orante, as a Christological symbol the Good Shepherd has endured to this day as a sign of Christianity. In the beginning it did not refer to Jesus or to any Christian person or entity. Like the Orante, the Good Shepherd (or Buon Pastor) had an ancient history in artistic symbolism. It stems directly from the ancient figure of the good shepherd, the *criophorus*. André Parrot has traced the Near Eastern use of the *criophorus* as far back as 1000 B.C.E.[9] Also like the Orante, there has been little attempt to adapt the *criophorus* to Christian or New Testament contexts. The animal of the ancient figure was an adult male with horns. Normally the pre-Constantinian Christian symbol keeps that horned animal, so that any conscious attempt to portray Jesus and the lambs (Luke 15:4-17 or John 10) seems most unlikely.

In other, more pictorial settings, the Good Shepherd has a flock. In such cases the background details remind one of the paradisiacal representations of Orpheus. The presence of milk pails and musical instruments makes this all the more certain (see the Good Shepherd at Dura-Europos for a scenic portrayal).

Quasten rightly refuses to interpret these early Christian symbols in terms of ecclesiastical liturgy. But he does wish to see the Good Shepherd in light of funeral liturgy. Consequently, he has concluded that the Good Shepherd portrayed a ψυχοπομπός (guardian of the dead souls), who defended the faithful against demonic forces. Because of Dura-Europos we now know that early Christian art dare not be limited to funeral interpretations. Since the Good Shepherd and the Orante were used in the *domus ecclesiae*, Quasten's observations about the frequency of the Good Shepherd in baptistries would be more to the point.

Plate 9. Sarcophagus of Sta. Maria Antiqua with a closer view of the Baptism of Jesus and the Good Shepherd.

Klauser supposes the *criophorus* of early Christianity derived from Hermes, the humanitarian god. So as the Orante referred to *pietas*, the criophorus pointed to *philanthropia*. The connection with Hermes—that is, the Hermes Criophorus—seems quite likely given the additional fact that, as noted, the bucolic shepherd also appears in catacomb art and on sarcophagi.[10] Unfortunately any connection between Hermes Criophorus, the Christian Good Shepherd, and the religious experience of *philanthropia* lacks a solid data base. Most useful has been the central presence of the Good Shepherd in the baptistry at Dura-Europos. As de Bruyne and Quasten indicate, this and the continued presence of

[9]André Parrot, "Le 'Bon Pasteur.' A propos d'une statue de Mari," *Mélanges syriens*, vol. 1 (Paris: Geuthner, 1939) 171-82.

[10]H. Sichtermann, "Hermes," *Enciclopedia dell'arte antica*, 4:4.

the Good Shepherd figure in Christian baptistries would indicate the joining of individuals to a caring community. It seems probable, then, that Klauser has good reason to interpret the Orante as the peace of *pietas* and the Good Shepherd as *humanitas*. The early Christians pulled these two powerful symbols from their Roman social matrix to express their primary feelings about the Christian faith: it constituted a caring community (Good Shepherd) in which one found kinship peace in times of turbulence (the Orante). After the peace of Constantine, the Good Shepherd shifted to portray the one who gave us that "care."[11]

XI. THE FISH

Franz Dölger. *IXΘYC. Das Fisch Symbol in frühchristlichen Zeit.* Münster: Aschendorff, 1928.

Eizenhöfer, 55-62.

J. Engemann. "Fisch." *RAC* 7:959-1097.

E. R. Goodenough, 5:3-61.

H. Leclercq. "IXΘYΣ." *DACL* 7:2:1990-2086.

Charles R. Morey. "The Origin of the Fish Symbol." *PTR* 8 (1910): 93-106, 231-46, 401-32; 9 (1911): 268-89; 10 (1912): 278-98.

G. B. de Rossi. *De christianis monumentis* ἰχθύν *exhibentibus. Spicilegium Solesmense*, tom. 3. Paris, 1855.

E. Sauser. "Fisch." *LCI* 2:35-39.

Example: Priscilla Epigraph #309

The symbol of the fish tests the historian's methodology to the utmost. No symbol in early Christianity has so complex a history as well as such numerous strongly held interpretations. It occurs so frequently in decorations, on *tituli*, and in inscriptions that many consider it the most frequent and distinctive of all Christian symbols. It can occur independently, especially on *tituli*, or among a group of nautical symbols, especially with the anchor. It is practically always found in meal symbolism, so that fish, bread, and wine form nearly a composite symbol.

These two uses of the fish (nautical and communal meal) ought not be confused. Their fusion by current scholarship has led to the complexities that face us. The nautical fish probably should be considered a *de novo* symbol. To be sure, there are fish symbols throughout the Mediterranean religious world, but none like this. There should be no reason to separate the fish from the anchor as a symbol of life in an alien environment. Without using Clement as an interpreter, his famous statement should be clear at this point:

> Let our seals be the dove, or the fish, or a ship sailing before a fair wind, or the lyre for music, which seal Polycrates used, or a ship's anchor, which Seleucus carved on his device, and if there be a fisherman, he will recall an apostle and children drawn from the water *(paed. 3, 11).*

The appropriate symbols are the three nautical ones—ship, anchor, and fish (and fisher?), along with the dove as a sign of peace and the lyre as a part of the Good Shepherd structure. There is no early indication in the art that the nautical fish should be identified with Jesus Christ. If anything, the fish are the religious actors. The famous stela of Licinia, now at the Museo Nazionale, Rome, does have the inscription IXΘYC ZΩNTΩN above two fish separated by an anchor. Surely we have in this undated (though certainly early) inscription a metaphorical allusion to the fish as Christians, but hardly an indication that IXΘYC refers to the one Fish, Jesus Christ. In fact, the contrary would be true (Morey, 10 [1912]: 278).

This is not to deny that in patristic literature Jesus has been identified with the Fish. The acrostic (IXΘYΣ), or Jesus Christ, Son of God, Savior, must surely be pre-Constantinian, though its origin is more uncertain than many would admit. Most assume Tertullian was familiar with the acrostic when he wrote *de baptismo.* In the first chapter he says,

But we little fish, according to our ἰχθύν Jesus Christ, are born

[11]T. Klauser, *JAC* 10 (1967): 99.

in the water, nor are we saved in any other manner than by remaining in the water.

Though the acrostic has been destroyed by the use of the accusative case (ν for ς), there could be no cogent explanation for Tertullian's shift to Greek at this point unless he knew his readers would catch the implication. There is yet another indication that the ἰχθύς acrostic was known during the third century. Starting with line 217 in book eight of the Sybilline oracles, there is a thirty-four-line poem, each line of which starts with a letter that eventually forms the full ΙΧΘΥΣ acrostic with the addition of seven lines that spell ΣΤΑΥΡΟΣ, or cross. The Oracles were compiled at various times. This particular section comes from a part of the book that might date from the late second or third century. However, the poem is independent and could well belong to the late third or fourth century.

Just as prevalent as the nautical fish is the communal meal fish. There is no early representation of the meal without fish. Though fish may exist independently, bread and wine seldom are found without fish. A good example would be the famous *Fractio Panis* scene in the Capella Greca of Priscilla where fish and baskets of bread appear on the table (see plate 11). The New Testament origin of the story goes back to the Feeding of the Five Thousand, but that does not imply the meal itself derives from a dominical ordination. Goodenough suggests the fish meal was a Jewish *cena pura*, a meal of preparation. But evidence for such a Jewish meal is weak, and evidence for any connection with the Feeding of the Five Thousand and the agape meal of the early Christians likewise does not come easily. Very likely we are dealing with a common meal (fish, bread, and wine) that eventually took on great religious significance for the early Christians. One of the earliest witnesses for the fish meal would be the Epitaph of Abercius (q.v., 139-40), which if considered genuinely pre-Constantinian (and I believe it is), refers to the "food, the Fish from the Fountain, the very great, the pure, which the holy virgin seized" (lines 13-14). Again, if genuinely Christian, this inscription does take Jesus Christ to be the Fish as food from the Fountain. Though a portion of the language here may be somewhat nautical,

presumably the fish belongs much more to the category of the meal. In any case, we have in the Abercius inscription a fairly certain indication that in the Asia Minor area the eaten fish could be identified with Jesus Christ. No such consideration occurs in the art, nor does any other piece of literature put it so bluntly. The Pectorius inscription of Autun does build an acrostic poem on ΙΧΘΥΣ, but the fish is not eaten, and presumably the inscription should be dated well past the Constantinian era.[12]

Apart from the inscriptions, the earliest identification of Christ with the fish comes from Paulinus of Nola (*epist.* 13, 11 [written ca. 396]).

> I see the congregated people so arranged in order on the couches and all so filled with abundant food, that before my eyes arises the richness of the evangelical benediction and the image of the people whom Christ fed with five loaves and two fishes, Himself the true bread and fish of the living water.

If one accepts the two-fish hypothesis, the following reconstruction becomes possible. A nautical fish developed *de novo* which, along with other sea symbols, referred to the alien nature of the environment. When that alienation disappeared, the nautical fish became a Christological symbol with baptismal implications. Very likely that baptismal interpretation did start with Tertullian, but it was not accepted at a local level or even mentioned widely in the literature until after the peace. At the same time a meal with fish, given great value by Jesus in a remarkable story, became the primary kinship or fellowship meal of the early Church. Very early that fish was given the acrostic value in patristic literature and inscriptions. Only well after the peace was identification of that fish made with Jesus Christ in a sacramental sense (the Abercius inscription is still in doubt, however).

The situation has become nearly classic for our study. Two fish symbols arose from the social matrix. Both were powerful symbols of the faith in its early years, but survived in Byzantine Christianity only because both became Christological symbols in reference to the cultic structure, one recalling baptism (nautical

[12]Morey, *PTR* 9 (1911): 282-89.

fish) and one recalling the Eucharist (the meal fish). The later complexities of the symbol came about when scholars united the two fish and attempted to read early patristic and later sacramental implications into the art of the second and third centuries.

XII. THE VINE AND GRAPES

J.-P. Kirsch. "Colombe." *DACL* 3:2:2210.

——————. "Raisin." *DACL* 14:2:2055-60.

H. Leclercq. "Vigne, Vignoble." *DACL* 15:2:3113-18.

Corrado Leonardi. *Ampelos. Il simbolo della vite nell' arte pagana e paleocristiana*. Roma: Edizioni Liturgiche, 1947.

Otto Nussbaum. "Die Grosse Traube, Christus." *JAC* 6 (1963): 136-43.

A. Thomas. "Weintraube." *LCI* 4:494-96.

Example: Mausoleum M under St. Peter's (see plate 31)

While the vine has deep meaning in Judaism and Christianity (John 15) as a source of life, even a communal source of life (Isaiah 6; Clement, *paed.* 2:2; 19:3), and was prominent in the social matrix with other religions such as the Dionysian cult, there is little reason to suppose the vine in early Christianity serves much more than a compatible decorative function. The most extensive use of the vine in the material we have assembled would be the beautiful green vine in Mausoleum M under St. Peter's. It stands out against a gold sky with the Christ Helios driving across it.

The grape or a bunch of grapes has more significance. Grapes often appear with the dove. It would be appropriate to equate in meaning the bunch of grapes with an olive branch. Since grapes normally indicate wine, the grapes of early Christian art likely refer to the wine of the agape meal. Leonardi has shown how quickly in patristic literature the grape was identified with Christ. At first Jesus was the basis or stock for the vineyard (community of faith as in the Gospel of John), but soon he became a suffering grape. In Clement, Christ is the great grape who suffered for us. But as Nussbaum indicates, only after the peace was Christ the crucified grape, a clear symbol of the redemptive sacrifice in a cultic setting. Again, an early symbol survived only when it took on Christological, cultic meaning in the literary tradition.

XIII. THE CROSS

Lucien de Bruyne. "La 'crux interpretum' di Ercolano." *RivAC* 21 (1944/45): 281-309.

Carlo Cecchelli. *Il trionfo della croce. La croce e i santi segni prima e dopo Costantino*. Roma: Edizioni Paolini, 1954.

Erich Dinkler. "Bemerkungen zum Kreuz als Tropaion." *Mullus*. *JAC* 1 (1964): 71-78.

——————. "Das Kreuz als Siegeszeichen." *Signum Crucis*. Tübingen: J. C. B. Mohr, 1967, 55-76.

——————. "Kreuz." *RGG*[3] 4:46-47.

——————. "Kreuzzeichen und Kreuz." *JAC* 5 (1962): 93-112.

——————. "Zur Geschichte des Kreuzsymbols." *ZThK* 48 (1951): 148-72.

Franz J. Dölger. "Beiträge zur Geschichte des Kreuzzeichens II." *JAC* 2 (1959): 15-29.

Jack Finegan. *The Archaeology of the New Testament*. Princeton: Princeton University Press, 1969, 220-60.

H.-U. Hädeke. "Der Kruzifixus." *RGG*[3] 4:47-49.

G. de Jerphanion. "La croix d'Herculaneum." *Orientalia christiana periodica* 7 (1941): 5-35.

H. Leclercq. "Croix et crucifix." *DACL* 3:2:3045-3131.

M. Maiuri. "La croce di Ercolano." *Pontificia Accademia Romana di Archaeologia* 15 (1939): 193-219.

Annarosa Saggiorato. *I sarcofagi paleocristiani con scene di passione*. Bologna: Patron, 1968.

Ekkart Sauser. *Frühchristliche Kunst*. Innsbruck: Tyrolia Verlag, 1966, 218-89.

Robert H. Smith. "The Cross Marks on Jewish Ossuaries." *PEQ* (1974): 53-75.

E. L. Sukenik. "The Earliest Records of Christianity." *AJA* 51 (1947): 351-76.

Max Sulzberger. "Le symbole de la croix et les monogrammes de Jesus chez les premiers chrétiens." *Byzantion* 2 (1925): 337-448.

E. Testa. *Il simbolismo dei Giudeo-Cristiani*. Pubblicazioni dello Studium Biblicum Franciscanum, N. 14, Gerusalemme: PP Franciscani, 1962, 230-360.

Vasilios Tzaferis. "The Archaeological Excavation at Shepherd's Field." *Liber Annuus* 25 (1975): 5-52.

——————. "Christian Symbols of the Fourth Century and the Church Fathers." Ph.D. Thesis, Hebrew University, Jerusalem.

Like the Orante and criophorus, the sign of the cross has been a symbol of great antiquity, present in nearly every known culture. Its meaning has eluded anthropologists, though its use in funerary art could well point to a defense against evil. On the other hand, the famous *crux ansata* of Egypt, depicted coming from the mouth, must refer to life or breath. The universal use of the sign of the cross makes more poignant the striking lack of crosses in early Christian remains, especially any specific reference to the event on Golgotha. Most scholars now agree that the cross, as an artistic reference to the passion event, cannot be found prior to the time of Constantine.

Basically the Christian cross first appears in the Constantinian sign, though it is impossible to determine when the sign became a symbol of the cross—that is, when the ChiRho became a ☧ Dinkler considers the first-known symbolic cross, a *crux im-*

missa, to be the one on a mid-fourth-century sarcophagus cover in the Vatican. From about the same time, we have a cross in narrative art on the Passion sarcophagus, also in the Vatican (Deichmann, *Repertorium*, #449). The first clear crucifixions are known to us from the fifth century (the wooden door of S. Sabina in Rome and the ivories at the British Museum, *DACL* 3:2:3067-70). Persons who deny this consensus may find three other lines of argument for the pre-Constantinian cross: 1) evidence contrary to the consensus; 2) appropriation of crosses from the social matrix; and 3) the presence of cryptocrosses in Jewish art, Christian art, inscriptions, and literature.

There are primarily two items that some scholars proffer as pre-Constantinian Christian crosses. In 1938, in connection with the two-hundred-year celebration of excavations at Herculaneum, a house, appropriately called *Casa del Bicentenario*, was unearthed and made available to the public. In a second-story room the excavators found a bare spot in the form of a cross. Obviously some cross-shaped object, previously attached to the wall, had been knocked off or taken off prior to the eruption of A.D. 79.

There were likely Christians in Herculaneum. Abundant evidence for a Jewish presence has been found. No reason would exist to doubt a Christian presence, nor any reason to doubt that those Christians would have met in houses like the *Casa del Bicentenario*. But this so-called cross could have been anything attached to the wall by two cross pieces. And if it were a cross, it would simply appear to us as a surd in the development of early Christian art: it came three hundred years too soon.

Another possibility would be the so-called Palatine cross. In 1856 a drawing was found in the servants' quarters of the Imperial Palace in Rome that depicts a certain Alexamenos gesturing with his right hand toward a cross with a donkey crucified on it. A graffito below the cross reads:

ΑΛΕ
ΧΑΜΕΝΟC
CΕΒΕΤΕ
ΘΕΟΝ

Presumably this inscription should be translated, "Alexamenos,

worship god." Though no fixed date can be given for this drawing, again one can easily assume such a derogatory cartoon did indeed mock the Christian kerygma. Its use by an opponent of the faith hardly proves that the cross was an early Christian symbol (*DACL* 3:2:3051-52).

Figure 4. A graffito found on the Palatine in Rome. The drawing may be a caricature of the crucifixion.

A second approach to the problem of the late appearance of the cross in early Christianity has been to appropriate crosses found in the social matrix. E. L. Sukenik startled many in 1947 with his claim to have found the earliest record of Christianity: an ossuary with the name Jesus and some cross marks. The discovery simply called attention to the fact that crosses were very common in the Mediterranean social matrix, as early Christian writers themselves were well aware (Ezekiel 9:3-8; Barnabas 9:8; Tertullian, *scorpiace*, 1). Most examples of crosses with possible Christian implications have been found in Palestine (Finegan). The Roman material seems singularly devoid of a symbol otherwise fairly popular. One ought not deny the existence of these common cross signs in the Mediterranean area, nor reference to them by early Christian writers, but they have no connection with the crucifixion of Jesus. In Roman-style Christian art that implication first appears at the earliest in the fourth century and certainly by the fifth. Tzaferis finds no Christian crosses in Palestine before mid-fourth century.

Plate 10. Supposed cross pattern in the Casa del Bicentenario, Herculaneum.

A third method has been to uncover cryptocrosses. Testa especially sees a cross in many decorations. Even more popular is the assignment of the cross symbol to anchors, ships' masts, and the like (*DACL* 3:2:3058; Sauser, 219-22). Others, such as Guarducci, believe early Christians signaled their faith by writing the Greek tau—T—larger than the other letters, or by using common abbreviations like XP to express their hidden allegiance to Christ. It would be as difficult to disprove the meaning of a cryptosymbol as to prove it. The burden of proof lies with those who find private meanings.

While there may very well be a place in early Christian art for the protective cross of the social matrix, there is no place for the kerygmatic cross. Among the symbols classified in this chapter, none signifies suffering, death, or self-immolation. All stress victory, peace, and security in the face of adversity. The Jesus iconography follows the same pattern. There is no place in the third century for a crucified Christ, or a symbol of divine death. Only when Christ was all powerful, as in the iconography of the Emperor, could that strength be used for redemption and salvation as well as deliverance.

CHAPTER THREE

PICTORIAL REPRESENTATIONS

Hans Achelis. "Altchristliche Kunst." *ZNW* 12 (1911): 296-320; 13 (1912): 21-46; 14 (1913): 324-48; 16 (1915): 1-23.

Ernst Dassmann. *Sündenvergebung durch Taufe, Busse und Martyrerfürbitte in den Zeugnissen frühchristlicher Frömmigkeit und Kunst.* Münster: Aschendorff, 1973, 183-447.

Erich Dinkler. "Älteste christliche Denkmaler. Bestand und Chronologie." In *Signum Crucis.* Tübingen: J. C. B. Mohr, 1967, 134-78.

Friedrich Gerke. *Spätantike und frühes Christentum.* Baden-Baden: Holle Verlag, 1967.

Michael Gough. *The Early Christians.* London: Thames and Hudson, 1961.

André Grabar. *The Beginnings of Christian Art.* London: Thames and Hudson, 1967.

——————. *Christian Iconography.* Princeton: Princeton University Press, 1968.

Walter Lowrie. *Art in the Early Church.* New York: Harper, 1947.

Charles R. Morey. *Early Christian Art.* Princeton: Princeton University Press, 1941; 2d edition, 1953.

Louis Reekmans. "La chronologie de la pienture paléochrétienne. Notes et réflexions." *RivAC* 49 (1973): 271-91.

Ekkart Sauser. *Frühchristliche Kunst.* Innsbruck: Tyrolia Verlag, 1966.

Eduard Stommel. *Beiträge zur Ikonographie der konstantinischen Sarkophagplastik. Theophaneia* 10. Bonn: Hanstein, 1954.

Alfred Stuiber. *Refrigerium Interim. Theophaneia* 11. Bonn: Hanstein, 1957, 120-92.

Paul Styger. *Die römischen Katakomben.* Berlin: Verlag für Kunstwissenschaft, 1933.

J. Wilpert. *Die Malereien der Katakomben Roms.* Freiburg: Herder, 1903.

Pre-Constantinian pictorial art is limited to three media: frescoes, mosaics, and sarcophagi. Since this field can be almost com-

pletely circumscribed, all examples will be precisely located and a bibliography listed. In chapter 4 each picture will be described and evaluated.

I. FRESCOES

Aldo Nestori. *Repertorio topografico delle pitture delle catacombe Romane*. Città del Vaticano, 1975.

G. B. de Rossi. *La Roma sotterranea cristiana*. Roma: Cromo-litografia pontificia, 1864-1877.

J. Wilpert. *Die Malereien der Katakomben Roms*. Freiburg: Herder, 1903.

Frescoes—two-dimensional paintings on a plaster surface—were painted on the walls of houses, public institutions, and burial rooms. It had been assumed that Christians of the first and second centuries decorated their buildings with Christian paintings now lost to us. But early Christians must have employed the same motifs, styles, and pictures as their non-Christian neighbors. Toward the end of the second century, paintings began to appear that could be identified with the emerging Christian culture. Of course, even these paintings closely resembled their non-Christian antecedents in iconography, if not intent. So one can expect color, style, and decorations as well as subject matter to derive from contemporary pictorial art. The earliest identifiable Christian art comes from the catacombs, primarily in Rome. When first discovered, this art was interpreted in terms of traditional theology, especially as it related to death and salvation. Fortunately more recent discoveries, particularly the baptistry of Dura-Europos, have made it clear that frescoes of the same type and subject matter as those found in the Roman catacombs existed elsewhere in the Mediterranean world and in nonsepulchral localities. Those sites which are, by consensus, pre-Constantinian and contain pictorial (only) art are:

A. The Baptistry at Dura-Europos, Syria (now at Yale University, New Haven, Connecticut; see figure 8)

Carl H. Kraeling. *The Christian Building. Excavations at Dura-Europos*, 8, pt. 2; Locust Valley NY: J. J. Augustin, 1967.

Ann Perkins. *The Art of Dura-Europos*. Oxford: Clarendon Press, 1973, 52-55.

Subjects: The Woman at the Well, Jesus and Peter Walking on Water, The Healing of the Paralytic, Adam and Eve, David and Goliath, Women at the Tomb.

B. The Sacrament Chapels at St. Callixtus (Rome)

A. Nestori. *Repertorio*, 102-103.

J. Wilpert. *Die Malereien der Sakraments-kapellen in der Katakombe des hl. Callistus*. Freiburg: Herder, 1897.

Subjects: Chapel A² (*Repertorio* #21): Moses Striking the Rock, Jonah Cast into the Sea, Jonah at Rest, Baptism of Jesus, Resurrection of Lazarus, Meal with Bread, Fish and Seven Baskets.

Chapel A³ (*Repertorio* #22): Sacrifice of Isaac, Moses Striking the Rock, Jonah Cast into the Sea, Jonah Cast out of the Fish, Jonah at Rest, Baptism of Jesus, Healing of the Paralytic, Woman at the Well, Meal.

Chapel A⁴ (*Repertorio* #23): Jonah Cast into the Sea, Jonah at Rest.

Chapel A⁵ (*Repertorio* #24): Moses Striking the Rock, Jonah at Rest.

Chapel A⁶ (*Repertorio* #25): Moses Striking the Rock, Jonah Cast into the Sea, Jonah Cast out of the Fish, Jonah at Rest, Resurrection of Lazarus.

C. The Double Chamber of the Lucina Area (St. Callixtus Catacomb, Rome)

Nestori. *Repertorio*, 99, #1 and #2.

Wilpert. *Malereien*, Taf. 26:1, 29:1.

Subjects: Jonah at Rest, Daniel in the Lion's Den, Baptism of Jesus, Bread, Fish, and Wine (*bis*).

D. The Flavian Gallery in the Domitilla Catacomb (Rome)

Nestori. *Repertorio*, 118, #4.

Wilpert. *Malereien*, Taf. 5:1.

Subjects: Daniel in the Lion's Den, Noah in the Ark.

E. The Capella Greca in the Priscilla Catacomb (Rome; see figure 17)

Nestori. *Repertorio*, 27-28, #39.

J. Wilpert. *Fractio Panis*. Freiburg: Herder, 1895.

Subjects: Noah in the Ark, Sacrifice of Isaac, Moses Striking the Rock, Three Young Men in the Fiery Furnace, Accusation of Susannah, Susannah and Daniel, the Wise Men, Healing of the Paralytic, Resurrection of Lazarus, a Meal with Bread and Fish.

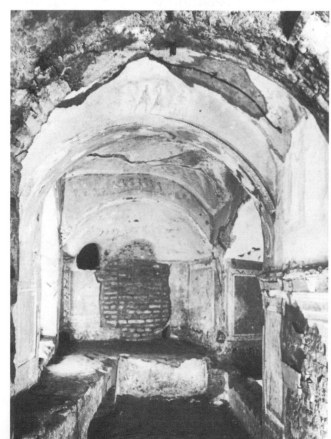

Plate 11. The Capella Greca of the Catacomb of Priscilla, Rome. Contains the oldest examples of early Christian fresco art. Seen here are the three Wise Men on the arch, the agape meal above the apse, and part of the Susannah cycle on the right wall.

It should be noted that this list has been very conservatively compiled. Styger has listed more locations that he considers pre-Constantinian; but despite his constant plea for accurate dating, his chronology is considered too early. P. Testini correctly lists a number of catacomb areas that are second and third century.[1] But in terms of biblical subjects, the above list remains very acceptable. Hugo Brandenburg, assessing the state of research on pre-Constantinian Christian art for the seventh congress of Archeologia Cristiana, mentions approximately the same list of locations and subjects.[2] Clearer and more generally accepted methods of dating the catacombs would undoubtedly yield more examples. Contested material, like the rich new catacombs on Via Latina in Rome, have been omitted because they may be too late.[3] The atypical and, therefore, controversial material, such as that from the Hypogeum of the family of Aurelii, cannot be assigned to the Christian community with certainty.[4]

Along with these possible additional materials from Rome, one must consider early Christian art in other locations where the time lapse between them and Rome gives us a post-Constantinian date, but a pre-Constantinian style. Most prominent on that list would be the earliest hypogea in the catacombs of St. Gennaro in Naples.[5] The frescoes there repeat what has been found in Rome as third-century materials. Achelis and Fasola have estimated that catacombs 1 and 2 are third century.[6] The painting in these two or three hypogea consists primarily of decorations and

[1]Pasquale Testini, *Le catacombe e gli antichi cimiteri cristiani in Roma* (Bologna: Cappelli, 1966) 143-69.

[2]Hugo Brandenburg, "Überlegungen zum Ursprung der frühchristlichen Bildkunst," *ACIAC* 9:1 (1978): 331-60.

[3]A. Ferrua, *Le pitture della nuova catacomba di Via Latina* (Città del Vaticano, 1960).

[4]Jerome Carcopino, *De Pythagore aux Apotres* (Paris: Flammarion, 1956) 85-221.

[5]Hans Achelis, *Die Katakomben von Neapel* (Leipzig: Karl W. Hiersemann, 1936); and Umberto M. Fasola, *Le catacombe di S. Gennaro a Capodimonte* (Roma: Editalia, 1975).

[6]Achelis, *Die Katakomben*, 81; Fasola, *Le catacombe*, 18.

symbols of the type already discussed in chapter 2, but there is at least one clear Adam and Eve that should be added to our list. A far less clear David and Goliath, if accepted, would support the presence of the same picture in Dura-Europos as a normative biblical scene.[7] Other collections of frescoes follow the same pattern of subjects as already listed.

Several decades ago Styger listed the following biblical scenes from early catacomb locations in Rome: Noah in the Ark, the Sacrifice of Isaac, Moses Striking the Rock, three sections of the Jonah cycle, the Three Young Men in the Fiery Furnace, Daniel in the Lion's Den, three sections of the Susannah cycle, the Wise Men, the Baptism of Jesus, the Healing of the Paralytic, the Healing of the Woman with the Flow of Blood, the Woman at the Well, and the Resurrection of Lazarus. Though taken from a slightly different set of sources, this list agrees with his except for the Woman with the Flow of Blood. To his list should be added the unique scenes of Dura-Europos: Jesus and Peter Walking on the Water, Adam and Eve, David and Goliath, and the Women at the Tomb.

II. MOSAICS

B. M. Apollonj-Ghetti, A. Ferrua, E. Josi, E. Kirschbaum. *Esplorazioni sotto la confessione di San Pietro in Vaticano*. Città del Vaticano, 1951, 1:37-42, Tavole B and C; 2, Tavole 10-12.

Gian Carlo Menis. *I mosaici cristiani di Aquileia*. Udine: del Bianco, 1965.

W. Oakeshott. *The Mosaics of Rome*. London: Thames and Hudson, 1967, 59-60; plates 3 and 4.

W. F. Volbach. *Early Christian Mosaics*. New York: Oxford University Press, 1946.

The only pre-Constantinian mosaics clearly Christian in character are those found in Mausoleum M of the Vatican necropolis. During the excavations of the 1940s this small mausoleum, previously non-Christian in character, was found to be the only Christian edifice in the entire necropolis other than the *tropheum* of Peter. The ceiling is completely covered with Christian mosaics. While most of the mosaic material on the side walls has fallen off, there remains enough of the artist's pattern to know that the Good Shepherd, Jonah Cast out of the Boat, and the Fisherman once decorated the "converted" family-burial edifice. On the ceiling one finds in full glory the striking mosaic of Christ in a sun chariot crossing the yellow-golden sky, his crown shooting out rays into a green field of vines.

Since Christians of the third century were not building new churches but rather taking over existing architectural structures, it seems unlikely that many pre-Constantinian mosaics exist or that more will be found. On the other hand, as more and more ancient churches are excavated, early pavement mosaics, which once served as the floor of the first church, are being uncovered. Some of these are "borderline" chronologically. An especially good example would be the church at Aquileia, Italy (see under *domus ecclesiae*, 73-74). In 314 the Council of Arles named as bishop of Aquileia a certain Teodoro. The great mosaic floor of the present cathedral at Aquileia dates from the time of Teodoro. But the pavement of the earlier church, to the north of the present structure, may well antedate 314. In any case, that pavement well exemplifies the problems of early Christian art. The artisans hired by the church authorities used non-Christian iconography and decoration, yet attempted to please their Christian buyers. One finds on the floor of the north hall a cock fighting a turtle (Menis, tav. 1), a ram with the inscription CYRIACE VIBAS (Cyriacus Live; tav. 2); a lobster and a squid (tav. 3); a parrot (tav. 4); birds (tavole 5, 7, 9, 11, and 37); a goat (tavole 6, 8); a donkey (tav. 10); a rabbit (tav. 31); a young goat with a basket of bread or some other round objects (tav. 35); and a horse (tavole 36, 38). Like many pavements of synagogues in Palestine, this early Christian floor has confounded interpreters. Those who have searched for patristic, literary counterparts have demonstrated incredible creativity.

[7]Fasola, *Le catacombe,* Tav. 2.

Nevertheless, the pavement of the north church at Aquileia may be the very first instance of artisans attempting to create a Christian floor. Indeed, the north church may be the first Christian edifice created *de novo*. We find here, as in the cathedral itself, artisans representing a cross between the Roman world and the emerging Christian culture. The only possible, and highly improbable, pre-Constantinian Christian symbols here would be the vase between the cock and the turtle, or the basket of bread with the goat. The many attempts to find cryptomeanings in the pavement must be considered spurious.

III. SARCOPHAGI

Giuseppe Bovini. *I sarcofagi paleocristiani*. Città del Vaticano, 1949.

Freidrich W. Deichmann and Theodor Klauser. *Frühchristliche sarkophage in Bild und Wort*. Drittes Beiheft zur *Antike Kunst*, 1966.

F. W. Deichmann, G. Bovini, and H. Brandenburg. *Repertorium der christlich-antiken Sarkophage*, vol. 1. Wiesbaden: Steiner Verlag, 1967.

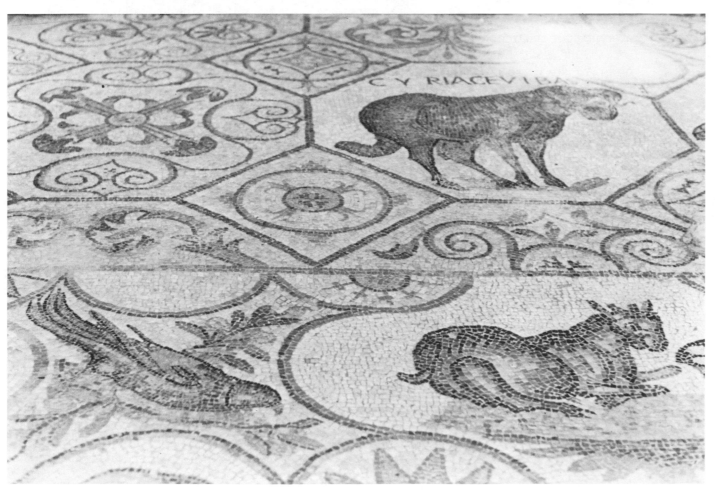

Plate 12. Mosaic art and Cyriace vibas inscription from the floor of the south hall in Aquileia.

Eduard Stommel. *Beiträge zur Ikonographie der konstantinischen Sarkophagplastik. Theophaneia* 10. Bonn: Hanstein, 1954.

G. Wilpert. *I sarcofagi cristiani antichi.* Roma: PIAC, 1929-1936.

Burial in a sarcophagus (literally, flesh eater) was not at all uncommon in the northern part of the Mediterranean world, though the use of a loculus in a burial chamber or burial area was far more common. Since, as will be seen, kinship was maintained in part by family burial, mausolea or family burial plots were nearly essential. The sarcophagus, carved as it was out of stone, ensured the presence of the dead far longer than other types of burial, so one is not surprised to find a comparatively large number of sarcophagi among the early Christians. In their remarkable and exhaustive catalog of Roman Christian sarcophagi of the third and fourth centuries, Deichmann, Bovini, and Brandenburg list 1,041 separate items. Of these, 129 are pre-Constantinian. Most of these are quite simple, known to us as Christian only by an inscription, an Orante, or a Good Shepherd. Their date has been determined by a dated inscription, location in a dated catacomb, style of artisanship, style of imagery (hair, clothing, or the like), and iconographical development. Of the 129 sarcophagi or fragments, 48 contain scenes of early Christian pictorial art. Of course, many non-Christian and Christian symbols or decorations also occur.

Theodor Klauser has listed eleven sarcophagi generally considered pre-Constantinian, including four from Deichmann's *Repertorium*. A description of each one, with bibliography, follows:

A. Kaiser Friedrich Museum (Berlin)

Picture: JAC 1 (1958): tav. 8, 3; Wilpert, tav. 54, 3.

Description: Jonah resting in the center with an Orante to the left and a Good Shepherd to the right with pastoral scenes in between.

B. Sta. Maria Antiqua (Rome)

Deichmann. *Repertorium*, #747.

Th. Klauser, *JAC* 4 (1961): 128-45.

C. R. Morey. "The Christian Sarcophagus in Sta. Maria Antiqua." *Supplementary Papers of the American School of Classical Studies, Rome* 1 (1905): 148-56.

M. Simon. "Notes sur le sarcophage de Santa Maria Antica." *Mélanges d'archéologie* 53 (1936): 130-50.

Picture: JAC 3 (1961): Tafel 6; Dassmann, *Sündenvergebung*, Tafel 35a.

Description: The Teaching of the Law stands in the center, with a Good Shepherd immediately to the right and an Orante immediately to the left. Continuing left is a Jonah cycle, first Jonah resting, then Jonah cast out of the ketos, and finally Jonah in the boat. To the extreme left side stands a river god. To the right of the Good Shepherd there is a baptism of Jesus with a dove descending. Jesus is young, nude, and quite small next to the large, older, bearded John the Baptist. A pastoral scene concludes the right end.

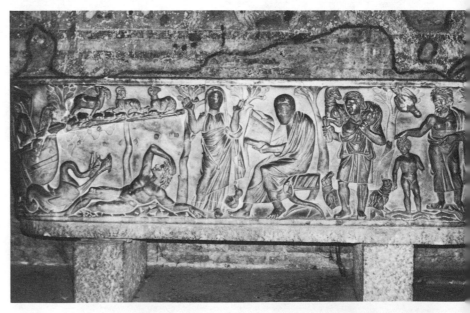

Plate 13. *The sarcophagus located in Sta. Maria Antiqua, Rome. Likely the oldest example of early Christian plastic art.*

C. Museo Pio cristiano #119

Deichmann. *Repertorium*, #35.

Picture: JAC 4 (1961): Tafel 11; Dassmann, *Sündenvergebung,* Tafel 36.

Description: The center lower level consists primarily of a large, detailed Jonah cycle with the boat to the left manned by three men, the middle of whom is casting Jonah into the waiting mouth of the ketos. A second ketos, to the right of center, spews out Jonah who then rests, Endymion-like and nude, under a large vine. To the far right of the Jonah at rest is a pastoral fisher scene. To the far left is a scene with two fishers and a basket. Between the right ketos and Jonah resting there is a small Noah in the Ark with a dove bearing an olive branch. On the uppper, thinner level to the left is a Resurrection of Lazarus with four observers, including two women (Mary and Martha). To the right of this scene, above the sail of the ship, is apparently a *sol invictus*. To the right of that we find Moses striking the rock with four figures at the rock. In the center is placed the Harassment of Moses, in which he is chased by two men and two other men are lying on the ground. At the upper far right is a shepherd with a sheep looking out of a stall.

D. Ny Carlsberg 832 (Copenhagen)

Gerke. *Sarkophage*, 39-47.

Ny Carlsberg Glyptotek, Billed-Tavler til kataloget over antike kunstvaerker (Kopenhagen, 1907-1941).

Picture: Wilpert, *I sarcofagi*, 59, 3; Gerke, *Sarkophage*, Tafel 2.

Description: There are Good Shepherds on both ends of the front. To the left of center is Jonah Cast into the Sea. There are two sailors in the boat, the one to the left rowing and the one to the right casting out Jonah (not an Orante). In the center Jonah, as an Orante, appears to be swallowed by one of two tails of the ketos. To the right, lower level, Jonah has been cast out onto the land, and above that he rests, Endymion-like, under a bush. A putti on the vine holds a basket.

E. Jonah Sarcophagus, British Museum (London)

Marion Lawrence. "Three Pagan Themes in Christian Art." In *De Artibus Opuscula XL*. Edited by Millard Meiss. New York: New York University Press, 1961.

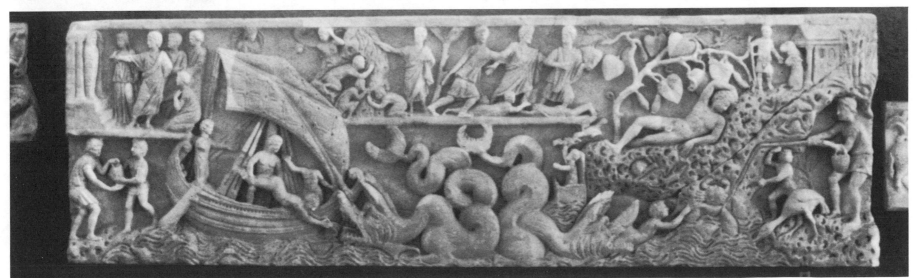

Plate 14. A pre-Constantinian sarcophagus now found in the Museo Pio cristiano, the Vatican. Item #119.

H. Rosenau. "The Jonah Sarcophagus in the British Museum." *Journal of the British Archaeological Association* 3:24 (1961): 63-65.

Picture: Lawrence, "Pagan Themes," Tab. 100-101.

Description: A complete Jonah cycle on the front.

F. Sarcophagus of Hertofile in the Thermal Museum (Rome)

Bovini. *I sarcofagi*, 111-12.

Deichmann. *Repertorium*, #778.

Gerke. *Sarkophage*, 346.

Picture: Wilpert, *I sarcofagi*, 53, 3; Gerke, *Sarkophage*, Tafel 26.

Description: On the cover to the right of the inscription, one sees a meal with five men sitting, one standing to the left, and one in low relief behind the man standing. There are five large loaves of bread before the table. The man standing is distributing large loaves from a basket. The bread is stamped with a cross mark. There are whole fish on the table and two of the men have cups for drinking (wine). To the left of the inscription is a complete Jonah cycle. Jonah stands in the boat as an Orante. One man rows. The ketos faces a Jonah at rest, who is more vertical than usual.

G. Julia Juliane Sarcophagus in the Museo Pio cristiano (Rome)

Bovini, *I sarcofagi*, 155.

Deichmann. *Repertorium*, #46.

Gerke. *Sarkophage*, 84-86.

Picture: *JAC* 3 (1960), Tafel 8; Dassmann, *Sündenvergebung*, Tafel 35 (b).

Description: A Good Shepherd to the far left and an Orante to the far right. To the left of the center inscription, Jonah is being cast out of the boat. Two men are in the boat. One is operating the boat and may have a half-Orante gesture. The other is casting out the nude Jonah. Above

the boat to the left is a dove with an olive branch flying toward a small Noah in the Ark to the right of the mainsail. Noah has the Orante gesture. To the right of the inscription is a pastoral motif with sheep and vines.

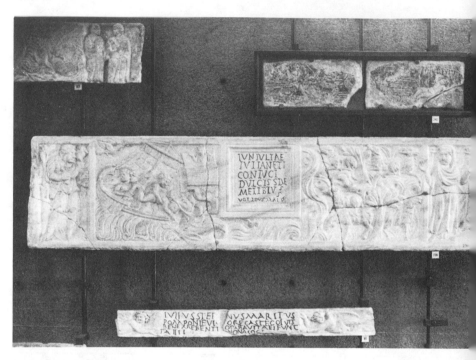

Plate 15. The sarcophagus of Julia Juliane, Museo Pio cristiano, the Vatican. Item #236.

H. Noah Sarcophagus, Rheinisches Landesmuseum (Trier)

F. Gerke. *Sarkophage*, 300-306.

Heinrich Laag. "Der Trierer Noahsarkophag." *Festschrift für Alois Thomas*. Trier: Selbstverlag des Bistumsarchivs, 1967, 233-38.

Wilhelm Reusch, ed. *Frühchristliche Zeugnisse*. Trier: Unitas-Buchhandlung, 1965, 18, #2 (with pictures).

Picture: F. Gerke. *Sarkophage*, Tafel 47: Dassmann, *Sündenverge-bung*, Tafel 37.

Description: A seated person at each end is making a garland. Each has a basket at his feet. In the center is a large Noah in the Ark, with eight people and some animals. A dove with an olive branch approaches Noah from the left.

I. Sarcophagus in the Velletri Museum

F. Gerke. *Sarkophage*, 73-81.

T. Klauser. *JAC* 3 (1960): 117-18.

Picture: *JAC* 3 (1960), Tafeln, 7, 10; Dassmann, *Sündenvergebung*, Tafel. 38.

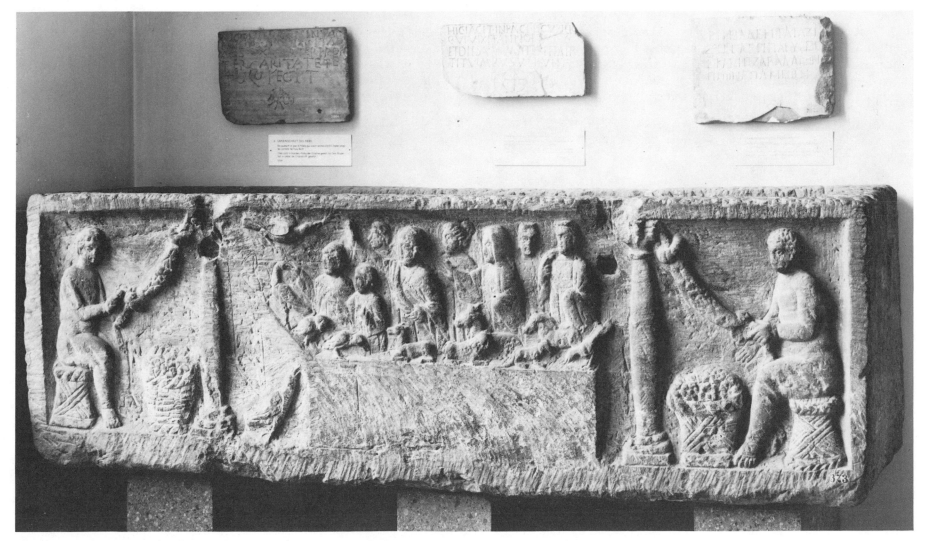

Plate 16. The Noah sarcophagus. (Courtesy of the Rheinisches Landesmuseum, Trier.)

Description: To the left there is a full-sized Good Shepherd and to the right a seated shepherd figure. In the center stands a full-sized Orante. Above to the left of the Orante is a Reading of the Law (Sermon on the Mount?), but in fuller relief and more central, one sees a nude Daniel, as an Orante, between two lions. To the right of the Orante there is an Adam and Eve, and even farther right a Noah in the Ark with a dove carrying an olive branch. Below these two occurs the Multiplication of the Loaves and Fishes, or at least, a young man with five baskets of bread and a loaf in each hand. The bread has been stamped with cross lines. To the left of the Orante, below Daniel in the Lion's Den, we find a full Jonah cycle. Jonah "dives" out of a boat rowed by one person, then is spewed out of the mouth of the ketos, and finally reposes, somewhat more upright than the normal "Endymion" style.

J. Jonah-Sarkophag, Prinz-Paul-Museum-Garten (Belgrade)

F. Gerke. *Der Trier Agricius-Sarkophag*. Beiheft, *Trierer Zeitschrift* 18 (1949).

Picture: Gerke, *Trier*, Tafeln 4, 7.

Description: On the left is a Good Shepherd, to the right Jonah Cast out of the Boat. To the right in the boat is a rower and in front of him one man at the mast. Jonah is diving out to the left. Somewhat below center we find a ketos and other fish. Jonah is being spewed out of the mouth of the ketos to the base of a palm tree. There is a figure, or putti, riding on the head of the ketos just to the left of center.

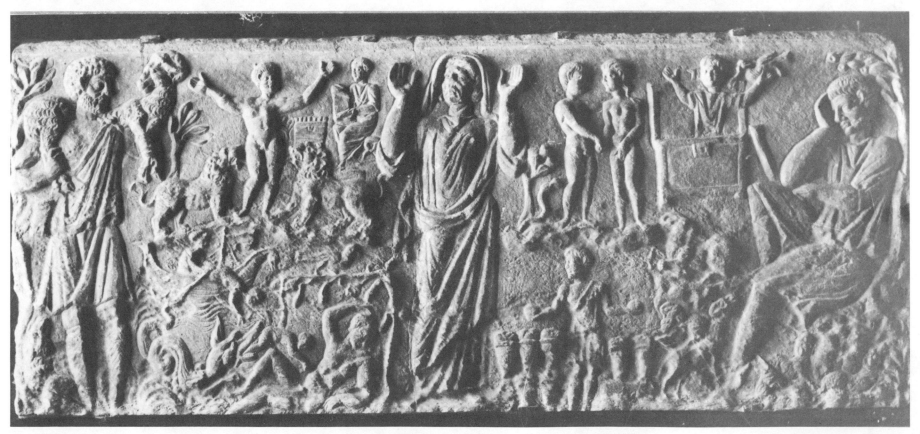

Plate 17. The Velletri sarcophagus now found in the Museum, Velletri, Italy. (Courtesy of the F. J. Dölger-Institut, Bonn.)

K. Le Mas d'Aire Sarcophagus, L'eglise Sainte Quitterie du Mas, Aire-sur-l'Adour, France

F. Gerke. *Sarkophage*, 306-10.

F. van der Meer. "A propos du sarcophage du Mas d'Aire." *Mélanges offerts à Mademoiselle Christine Mohrmann*. Utrecht: Spectrum, 1963.

Picture: JAC 4 (1961), Tafel 11; Dassmann, *Sündenvergebung*, Tafel 39.

Description: On the cover, to the immediate left of the inscription plate, there is a Healing of the Paralytic in which the paralytic is carrying his bed. To the left of that is Abraham Sacrificing Isaac. Abraham is about to kill the kneeling Isaac as a ram appears to the far left. To the right of the plate, Jonah is being spewed out by the ketos. Farther right is the unique Tobit and the Fish. On the front of the sarcophagus itself, one finds in the center a Good Shepherd with a female figure to the right. To the right of those center figures occurs an Adam and Eve, and farther right a young Jesus cures the boy possessed by a demon. To the left of the figures is a young man, then Daniel in the Lion's Den, and finally the Resurrection of Lazarus.

Since Klauser prepared his list another pre-Constantinian sarcophagus has been discovered in Trier. Although it does not add materially to the list of pictorial subjects, it does represent well the shift from non-Christian culture to Christian culture. The excavators believe this polychromatic sarcophagus was made for a certain widow Albana who gave Christian instruction in her house. The date would be approximately 270.

L. The Albana Sarcophagus, Quirinius-Kapelle, Friedhof St. Matthias, Trier

Heinz Cüppers. "Das frühchristliche Gräberfeld von St. Matthias." In *Trier: Kaiserresidenz und Bischofsitz*. Mainz: Verlag Philipp von Zabern, 1984, 205-206.

Picture: *Trier: Kaiserresidenz und Bischofsitz*, 170-71, 178, 209.

Description: The sarcophagus itself is decorated with the usual flowers and putti. The cover has portrait busts on the two long sides. On one end of the cover is portrayed the couple eating a meal for the dead. The

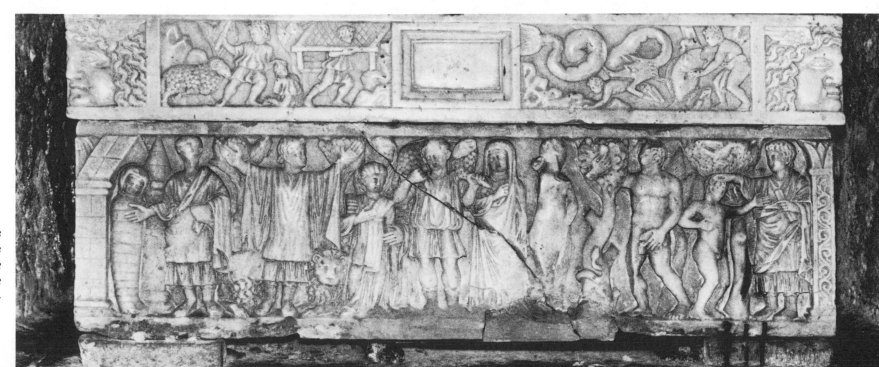

Plate 18. The Mas d'Aire sarcophagus located in L'eglise Sainte Quitterie du Mas, Aire-sur-l'Adour, France.

meal consists of fish and bread represented iconographically like the agape.

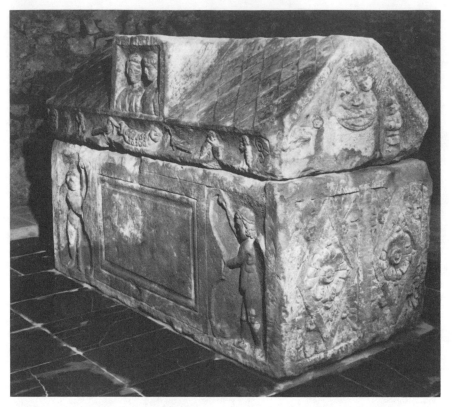

Plate 19. The Albana sarcophagus, Quirinus-Kapelle, Friedhof St. Matthias, Trier. (Courtesy of the Rheinisches Landesmuseum, Trier.)

To this list of artistic representations should be added the pictorial subjects of the remaining forty-four Roman sarcophagus fragments listed in Deichmann, and the fragments from other localities listed also by Klauser.

Besides the four sarcophagi among the primary eleven, the *Repertorium* reference numbers of the remaining forty-four fragments and the biblical representations found on them are:

#83 Jonah cycle
#115 Ascension of Isaiah (footnote 30 in Klauser)
#124 Three Young Men in the Fiery Furnace
#150 Baptism of Jesus; Meal
#152 Jonah cycle; Multiplication of Loaves and Fishes
#154 Jonah cycle
#409 Jonah Cast into the Sea
#412 Sacrifice of Isaac
#482 Jonah Cast into the Sea; Jonah at Rest
#483 Jonah at Rest
#499 Jonah cycle
#522 Jonah at Rest
#523 Jonah and the Ketos; Jonah at Rest
#550 Jonah at Rest
#591 Jonah cycle; Meal (footnote 27 in Klauser)
#594 Jonah Cast into the Sea
#603 Jonah at Rest
#615 Jonah cycle
#616 Jonah Cast into the Sea
#617 Jonah cycle
#657 Jonah Cast into the Sea
#767 Woman with the Flow of Blood
#773 Moses and the Bush; Jesus and the Lame Man; Jesus Teaching; Multiplication of the Loaves and Fishes (footnotes 32 and 33 in Klauser)
#777 Baptism of Jesus; Healing of the Crippled Person
#794 Jonah cycle; Meal
#796 Jonah cycle
#811 Resurrection of Lazarus; Susannah (?)
#831 Jonah and the Ketos; Jonah at Rest
#834 Jonah cycle; Three Young Men in the Fiery Furnace; Noah in the Ark
#881 Jonah at Rest
#890 Jonah Cast out of the Boat; Meal (bread stamped)
#891 Jonah cycle
#892 Jonah Cast out of the Boat
#893 Noah in the Ark
#894 Three Young Men in the Fiery Furnace; Jonah Cast out of the Boat (footnote 36 in Klauser)
#914 Jonah at Rest
#940 Jonah Cast out of the Boat
#942 Jonah cycle; Meal (bread stamped)
#958 Jonah cycle (footnote 28 in Klauser)

#980 Sacrifice of Isaac
#985 Jonah and the Ketos; Jonah at Rest
#996 Jonah Cast out of the Boat; Jonah and the Ketos (footnote
 41 in Klauser)
#997 Jonah cycle (footnote 42 in Klauser)
#1037 Jonah at Rest

Those fragments listed by Klauser—but not in Rome, therefore not in the *Repertorium*—are as follows:

1. Lucca, Wilpert, Taf. 116,3 (footnote 25 in Klauser)
2. Pisa, Wilpert, Taf. 88,1/3.5/7 (footnote 26 in Klauser)
3. Naples, Wilpert, Taf. 164,5 (footnote 29 in Klauser)
4. Antinori, Wilpert, Taf. 300,3 (footnote 34 in Klauser)
5. Corsetti, Wilpert, Taf. 163,1 (footnote 37 in Klauser)
6. Louvre, Wilpert, Taf. 53,2 (footnote 39 in Klauser)
7. Naples, Wilpert, Taf. 185,1 (footnote 40 in Klauser)

When that tabulation has been completed, we arrive at the following table for the subjects of pre-Constantinian pictorial representations and their comparative frequency.

BIBLICAL REPRESENTATION	FRESCO	MOSAIC	11 SARC	ROMAN FRAG	OTHER	TOTAL
1. Giving Life to Eve					1	1
2. Adam and Eve	1		2		1	4
3. Noah in the Ark	3		3	2		8
4. Sacrifice of Isaac	2		1	2		5
5. Harassment of Moses			1			1
6. Moses Striking the Rock	4		1			5
7. Moses and the Bush				1		1
8. Ascension of Elijah				1		1
9. Jonah Cast into the Sea	4	1	8	23	2	38
10. Jonah and the Ketos	1		8	17	2	28
11. Jonah at Rest	5		7	25	5	42
12. Tobit and Fish			1			1
13. Three Young Men in the Fiery Furnace	1			3		4
14. Daniel in the Lion's Den	2		2		2	6
15. Susannah and the Elders	3			1		4
16. David and Goliath	1					1
17. Wisemen	1					1
18. Baptism of Jesus	3		1	2		6
19. Jesus Teaching			1	1		2
20. Healing of the Paralytic	2		1			3
21. Healing of the Demon Possessed			1			1
22. Healing of the Lame				1		1
23. Healing of Crippled				1		1
24. Multiplication of the Loaves and Fishes			1	1		2
25. Woman at the Well	2					2
26. Resurrection of Lazarus	2		2	1		5
27. Walking on the Water	1					1
28. Women at the Tomb	1					1
29. Fisherman		1	2			3
30. Woman with Flow of Blood			1			1
31. Christ Helios		1				1

In comparing these figures with Klauser and Sauser, it should be noted that in this tabulation a complete Jonah cycle has been counted as three.

CHAPTER FOUR

PICTORIAL INTERPRETATIONS

As can be seen, the pictorial representations of the third-century Christians consist primarily of symbols, normally with a long history in the social matrix, placed in the context of the revelation—or Scripture—of the new religion. Interpreters of early Christian art have nearly always relied on patristic literature as an interpretative basis for the various biblical scenes. Some, like Paul Styger, have rejected patristic and traditional interpretations in favor of the biblical meaning itself. In light of my methodological considerations, neither of the approaches will be appropriate. There is a dialectical tension between the symbol of the social matrix and the biblical scene of the revealed religion, a tension that depends on the social and religious situation of the group that produced the pictorial representation. To determine meanings based on this methodology cannot be an easy task. While considering what previous interpreters have said, I will attempt to read these pictures in terms of the social context as it was influenced by the Christian faith.

From these previous data, there can be no doubt that the primary artistic representation of early Christianity was the Jonah cycle. For interpretative reasons, then, it would be appropriate to start with this set of scenes.

I. THE JONAH CYCLE

Lucien de Bruyne. "Refrigerium interim." *RivAC* 34 (1958): 112-14.

E. Dassmann. *Sündenvergebung*, 222-32, 385-97.

Antonio Ferrua. "Paralipomeni di Giona." *RivAC* 38 (1962): 7-69.

Marion Lawrence. "Three Pagan Themes in Christian Art." *De Artibus Opuscula XL*. Edited by Millard Meiss. New York: New York University Press, 1961, 323-34.

H. Leclercq. "Jonas." *DACL* 7:2:2572-2631.

Otto Mitius. *Jonas auf den Denkmalern des christlichen Altertums*. Freiburg: J. C. B. Mohr, 1897.

J. Paul & Red. "Jonas." *LCI* 2:414-21.

E. Sauser. *Frühchristliche Kunst*, 111-15.

E. Stommel. *Ikonographie*, 42-58.

——————. "Zum Problem der frühchristlichen Jonasdarstellungen." *JAC* 1 (1958): 112-15.

A. Stuiber. *Refrigerium*, 136-51.

Five major interpretations of the Jonah cycle have been proffered by scholars in the field of early Christian archaeology. Many have supposed the Jonah cycle represents narrative art, and as such, tells the story of the Old Testament Book of Jonah. Apart from the cycle of Susannah, it is the only series in third-century Christian art. Therefore, the narrative interpretation certainly is attractive. But the Jonah cycle, though somewhat coherent in itself, has little in common with the narrative account of the Old Testament. In the first scene Jonah stands in a boat as an Orante, about to be cast into the sea. Sometimes he has already been cast out, or perhaps has dived out, but still frequently maintains an awkward Orante gesture. Occasionally the ketos, or sea animal in Greek, receives the cast-out Jonah, and one can imagine, or even see, terror in the form of Jonah; but normally the ketos is spewing Jonah out and once more Jonah normally maintains the Orante gesture. Occasionally this second scene in the cycle has been so attenuated that the spewed-out Jonah actually becomes the Jonah at Rest. This "third" Jonah lies nude under a tree or vine with obvious pastoral decor in the background. Sometimes, as in Sta. Maria Antiqua, lambs play in the vine or somewhere nearby. There is little in these three scenes to indicate that the biblical story of Jonah is being told. To be sure, if one knows the biblical story, one recognizes the boat, the ketos, and the vine. But there is no call of God, no refusal, no Nineveh, no preaching, and no pouting Jonah under the vine. Narrative art after the peace of Constantine was much more attentive to the details and more true to the intent of the story than this (for example, mosaics of Maria Maggiore in Rome). It has been generally accepted now that the Jonah cycle, or for that matter any other pictorial representation of pre-Constantinian Christianity, does not narrate the biblical story to which it is related.

A second line of approach has been to understand the cycle through New Testament and patristic, or later noncanonical, interpretations of the Jonah story. Jesus spoke of the sign of Jonah as a prophetic paradigm of the resurrection (Matthew 12:38-40). Patristic literature continued in much the same direction (see the literary examples in Mitius, *Jonas*, 6-7; Dassmann, *Sündenvergebung*, 222-32). The attractiveness of this thesis lies in the sepulchral nature of the art. What better hope for the early Christian in the face of death than the New Testament sign of Jonah, signaling resurrection from the ketos after three days? But the artisans of the third century did not know that was the primary meaning of the cycle. They emphasized primarily the Jonah at Rest. Often Jonah and the ketos occurred simply in shorthand. Hence the so-called sign could hardly be considered the central concern of the cycle.

The nudity of the Jonah at Rest, in a context of pastoral serenity, has given rise to the third interpretation. Some, primarily Stuiber, take the nude Jonah to be a classical reference to the soul of the deceased. For them the very popular Jonah at Rest refers to the soul in the so-called *refrigerium interim,* or state of betweenness. Clearly the nude Jonah in a pastoral scene, with posture and gestures like the popular Endymion, must have referred in some sense to peace at the time of death. As I have already noted, however, the early Christians, as well as their non-Christian neighbors, give little indication of belief in an afterlife in some other realm. Their burial practices and continued meals with the dead point to an awareness of the presence of the daemon of the dead person. Stuiber must rely on particular, incidental patristic quotations to defend his thesis. Nevertheless, the nudity of Jonah does present a problem. His iconographic predecessor, Endymion, sometimes was nude, but usually not. But on closer examination, he normally has been modestly covered by the veil of his divine consort, Selene. Otherwise Endymion likewise was nude. Without that consort to cover him, the artisans reverted to the obvious convention of what was always intended to be a nude figure. So the Christian nude Jonah only reflects what is already known: the

primary symbols were taken from the social matrix, but the setting belongs to the great tradition.

Marion Lawrence, more than anyone else, has pressed for an identification of Jonah with the popular pagan sepulchral figure Endymion. Endymion occurs frequently on non-Christian sarcophagi, reclining nearly nude and apparently put to sleep by Night, a winged woman, and attended by Selene, the moon goddess. She can be identified by a veil billowing over her head. Sometimes her apparel also covers the lower part of Endymion's body. Presumably Endymion is resting from a rather vigorous relationship with Selene. Often the Endymion scene has a pastoral quality to it. Surely the artisans who drew Jonah had Endymion as the iconographical model. Yet Endymion can in no way be equivalent to Jonah. The mythological background of the Endymion story is totally missing (except for the pastoral scene). There is a new setting that redefines the Endymion symbol. The cycle speaks of peace in an alien environment (the Orante in the boat in the water); peace in the face of harassment (an Orante saved from a fierce animal); and peace in an ultimate paradisiacal sense (Endymion at rest). Endymion, as a symbol of repose, especially at death, has replaced the paradisiacal Good Shepherd who represents the living fellowship.

Ferrua has surveyed these various interpretations and finally has rejected them for another line of interpretation—the cultic. He calls to mind that ancient prayer for the dead that mentions most of the Old Testament scenes found in early Christian art:

> *nihil enim in praeceptis tuis parui,*
> *exaudi me orantem, sicut exaudisti Jonam de*
> *ventri ceti.*
>
> From the *Second Oratio of Cyprian*
> (*DACL* 12:2:2333)

No doubt there is some direct correlation between such prayers as these and early Christian art. The scenes mentioned are almost invariably the same scenes as found in the catacombs. But does the ancient prayer reflect the art or does the art reflect the ancient prayer? Since the discovery of the church at Dura-Europos,

one must be very careful about supposing a funeral setting for early Christian art.

In sum, one notes that the biblical scene provides a scriptural backdrop for a symbol taken from the social matrix. Jonah in the Boat can be compared to Noah in the Ark: both are Orantes in a threatening environment. Jonah coming out of the ketos can be compared to Daniel between the Lions: both are Orantes escaping a deadly situation. Jonah at Rest is closer to the context of death. One would have expected a Good Shepherd in a pastoral scene, under the vine, as in the third part of the cycle. Instead, another figure of well-being, Endymion, was taken from the social matrix to represent peace and well-being (Gerke, *Sarkophage*, 33; Dassmann, *Sündenvergebung*, 384; W. N. Schumacher, *Hirt*, 47-55).

Plate 20. Jonah Cast from the Boat. Sta. Maria Antiqua sarcophagus.

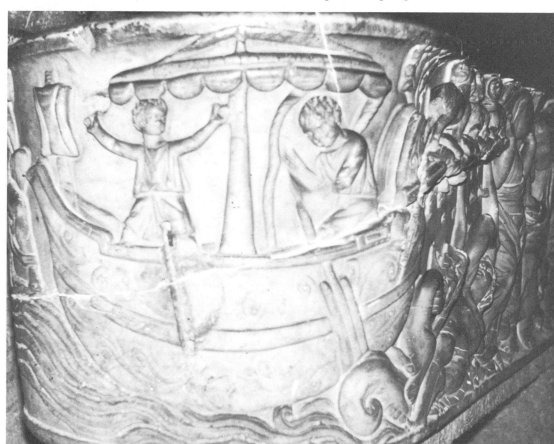

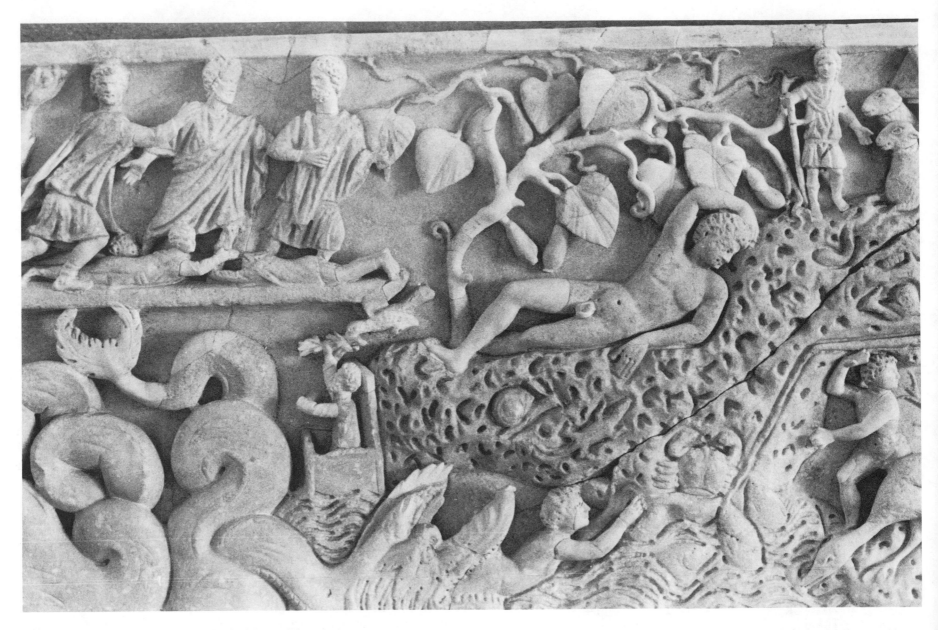

Plate 21. The Jonah cycle and Noah. Museo Pio cristiano #119.

After the peace of Constantine the Jonah cycle waned sharply in popularity. When the environment was no longer hostile to the Christian, when the Christian community was no longer harassed qua Christian, then the pictorial symbol of a peaceful Orante amidst critical (biblical) situations no longer served a useful purpose. It lost its value in the social matrix. Furthermore, there was no general usefulness for the Orante in the ecclesiastical tradition. So the Orante in general and surely Jonah in particular could not take on a larger meaning in the public faith. Since so-called biblical and patristic understandings of the Jonah story apparently were not attached to the art, the Jonah cycle disappeared. The most popular element of early Christian symbolism thus did not pass over from the earliest church into the post-Constantinian structure.

II. NOAH IN THE ARK

L. Budde. "Die rettende Arche Noes." *RivAC* 32 (1956): 41-58.

R. Dant & Red. "Noe (Noah)." *LCI* 4:611-20.

Dassmann. *Sündenvergebung*, 208-22, 411-19.

J. Fink. *Noe der Gerechte in der frühchristlichen Kunst.* Münster-Koln: Böhlau, 1955.

Peter Franke. "Bemerkungen zur frühchristlichen Noe-ikonographie." *RivAC* 49 (1973): 171-82.

R. P. J. Hooyman. "Die Noe-Darstellung in der frühchristlichen Kunst." *VigChr* 12 (1958): 113-35.

H. Leclercq. "Arche." *DACL* 1:2:2709-32.

Hugo Rahner. "Antenna Crucis, III. Das Schiff aus Holz." *ZKT* 66 (1942): 196-227; 67 (1943): 1-21.

Stuiber. *Refrigerium*, 175-78.

This picture consists normally of an Orante standing in a boxlike ark. Nearly always a dove with an olive branch flies toward Noah or has alighted on his outstretched hand. The Trier sarcophagus constitutes a clear exception: on it Noah stands with seven other persons (see plates 16 and 21). This attention to biblical detail and the narrative as such makes one suspect the sarcophagus is post-Constantinian or nearly so. At times there is no attempt to hide the femininity of the Orante in the ark. The Noah story offered the early Christian artisan an opportunity to express piety and peace in a boat that withstood the alien environment.

Fink, on the basis of some later iconographic and patristic (Cyprian) connections with the later figure of Job, interpreted Noah as a symbol of penance. This interpretation of Noah has been appropriately critiqued by Hooyman, who in turn accepts the literary interpretation of the Noah story as a reference to baptism (1 Peter 3:20-21 and Tertullian, *de bapt.* 8, 3). For him, then, the dove refers to the Holy Spirit rather than the peace associated with the Orante. For Budde, Noah in the Ark refers to the Christian community, a frequent allusion in later patristic thought. The fact that Noah in the Ark did not survive the "peace" would indicate none of these interpretations correctly perceives the pre-Constantinian picture. After the "peace" an Orante in conflict lost its value. Noah and the Ark did appear occasionally as an object of ecclesiastical art, but only as a narrative element in the history of the great tradition (for example, the great mosaic of Monreale, Sicily).

III. DANIEL IN THE LION'S DEN

J. Danielou. "Daniel." *RAC* 3:581-83.

Dassmann. *Sündenvergebung*, 258-70, 425-38.

H. Leclercq. "Daniel." *DACL* 4:1:221-28.

H. Schlosser. "Daniel." *LCI* 1:469-73.

Stuiber. *Refrigerium*, 183-84.

In this biblical scene an Orante stands between two lions who face him/her. Like Jonah and the ketos, this scene represents the pie-

tas, or peace, which can come from God through the faith community whenever one faces individualized threat from external sources. In the Capella Greca, Daniel has a palace behind him. Biblical details are normally lacking in the very earliest art; perhaps this alludes to the threat of the Roman state. In any case the lions do not harm Daniel the Orante.

IV. SUSANNAH AND THE ELDERS

Dassmann. *Sündenvergebung*, 270-73.

Hanspeter Schlosser. "Susanna." *LCI* 4:228-31.

_____. "Die Daniel-Susanna-Erzählung in Bild und Literatur der christlichen Frühzeit." *Tortulae*. Edited by W. N. Schumacher. *RQS*, Supplementheft 30, 1966, 243-49.

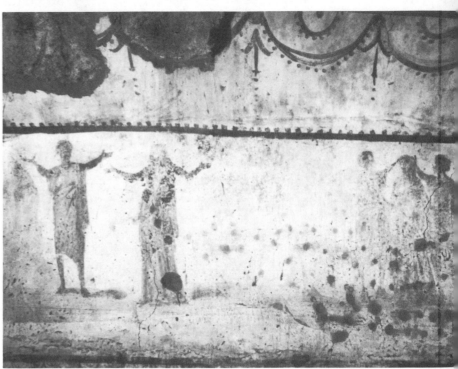

Plate 23. Susannah (Orante to left) Rescued by Daniel from Elders. Part of the cycle in the Capella Greca.

Though rather infrequent as a theme in the earliest Christian art, the Susannah story has clear similarities to Daniel in the Lion's Den and Jonah spewed out of the ketos. She appears as an Orante between two elders who have falsely accused her of com-

Plate 22. Daniel between the Two Lions. Mas d'Aire sarcophagus.

mitting adultery. The Orante gesture indicates her *pax* despite the harassment, which could end in capital punishment. A cycle of Susannah stories occurs once in the material assembled here. In one, Daniel himself vindicates Susannah. This one scene and the theme of Moses Striking the Rock are the only two Old Testament representations in which a human savior occurs. Otherwise, that role is reserved for Jesus in New Testament scenes.

Schlosser has assembled the early Christian literary references to Susannah, and they are highly allegorical in nature. The cycle itself did occur fairly often in the fourth century, but after the "peace" this Orante figure in a harassment situation no longer served a social function and therefore was dropped as an iconographical representation.

V. THE SACRIFICE OF ISAAC

F. Cabrol & H. Leclercq. "Abraham." *DACL* 1:1:111-27.

Dassmann. *Sündenvergebung*, 184-96.

T. Klauser. "Abraham." *RAC* 1:18-27.

E. Lucchesi Palli. "Abraham." *LCI* 1:20-35.

Alison Moore Smith. "The Iconography of the Sacrifice of Isaac in Early Christian Art." *AJA*, 2d ser., 26 (1922): 159-73.

Isabel Speyart van Woerden. "The Iconography of the Sacrifice of Abraham." *VigChr* 15 (1961): 214-55.

The representation of the Sacrifice of Isaac shows the shift in the meaning of a pictorial representation as well as any other early Christian scene. The picture was beloved both in late Judaism and early Christianity. It appears to the right of the Torah Shrine of the Dura-Europos synagogue. As the chart (p. 43) indicates, the Sacrifice of Isaac was not frequent before Constantine, although after the "peace" it became a central element in Byzantine art.

Perhaps because the story was so beloved in Jewish circles (or did its popularity in Christianity create the Jewish usage?), very early in Christian literature it became the Old Testament counterpart and paradigm for God's sacrifice of his son, Jesus (Irenaeus, *adv. haer.* 4, 10, 1). As van Woerden shows so well, this sacrificial meaning came into the artistic representation after the peace of Constantine. The scene became narrative in character and stressed the sacrifice (as Christ on the cross). Before that, Isaac was not on the altar. The very first portrayal (Chapel 3 of St. Callixtus) presents Abraham and Isaac as Orantes. An olive tree and a sheep (ram?) stand nearby. As such, this scene does not differ greatly from Jonah and the Ketos, Noah in the Ark, Daniel in the Lion's Den, and Susannah; all have Orante figures caught in some difficult situation.

Plate 24. The Sacrifice of Isaac. Mas d'Aire sarcophagus.

Unfortunately, this thesis cannot be substantiated as thoroughly as desired. The details of the Sacrifice in Capella Greca are not at all clear. The two Roman fragments (Deichmann, *Repertorium*, #412 and #980) are totally obscured. The best example in the sarcophagi, Mas d'Aire, has already moved toward narration and a sacrificial offering (much as the Trier sarcophagus has Noah in narration). But one can still assume from the meager evidence that the Sacrifice of Isaac does not differ in kind from the others. Abraham and Isaac are actually Orantes delivered from a difficult situation. Unlike the other Old Testament harassment scenes, this one was altered to show the sacrifice of Christ, an element of orthodox theology. After the "peace" it grew in importance.

VI. MOSES STRIKING THE ROCK

Dassmann. *Sündenvergebung*, 196-208.

C. O. Nordström. "The Water Miracles of Moses in Jewish Legend and Byzantine Art." *Orientalia Suecana* 7 (1958).

H. Schlosser. "Moses." *LCI* 2:282-97.

Stuiber. *Refrigerium*, 182-83.

Moses Striking the Rock (Exodus 17:3-6; Numbers 20:10-11) gives us another early Christian motif of deliverance. However, a significant change has occurred. Moses does not appear as an Orante, but rather stands before a rock, strikes it with a wand, and watches the water pour out to waiting people. Moses is not de-

Plate 25. Moses Striking the Rock. Museo Pio cristiano, #119.

livered from the danger of starvation and thirst; he delivers with his wand. This scene, then, stands closer to the New Testament pictorial representations with their portrayal of Jesus as a deliverer and wonder-worker (with a wand). As if to underscore this difference, Moses Striking the Rock eventually was absorbed into a New Testament structure. It was the source of the popular post-Constantinian Peter Striking the Rock. Of course, there is no such New Testament story, but by replacing the iconography of Moses with the iconography of Peter the lines were kept distinct: the state of deliverance is found in Old Testament scenes and the act of delivering in the New Testament (see Stommel, *Ikonographie*, 81-83). The gift of the water could simply be a deliverance from threatened dehydration or starvation or any other threat facing the early Christians. Deliverance from physical or environmental threat fits well with Old Testament pictures. However, there is no need to shy away from cultic meanings simply because that might not be supported in the literature. The deliverance could refer to religious redemption, perhaps to the act of entering the community through baptism. This could account for both the anomaly of Moses as a deliverer as well as the singular shift of the scene to the bishop of Rome, Peter, the prototype of baptizers.

In post-Constantinian art Moses Striking the Rock faded away and was replaced by a narrative cycle about Moses that included particularly the Burning Bush and the Giving of the Law—both favorites in contemporary Jewish art.

VII. ADAM AND EVE

H. Achelis, *ZNW* 16 (1915): 16-17.

A. Breymann. *Adam und Eva in der Kunst des christlichen Alterthums.* Wolfenbüttel: J. Zwissler, 1893.

Dassmann. *Sündenvergebung*, 232-58, 397-405.

Sigrid Esche. *Adam und Eva.* Düsseldorf: Schwann, 1957.

Dieter Korol. "Zum Bild der Vertreibung Adams und Evas in der neuen Katakombe an der Via Latina und zur anthropomorphen Darstellung Gottvaters." *JAC* 22 (1979): 175-90.

H. Leclercq. "Adam et Ève." *DACL* 1:1:509-19.

H. Schade. "Adam und Eva." *LCI* 1:41-70.

L. Troje. *AΔAM und ZΩH. Sitzungberichte Heidelberger Akademie der Wissenschaften.* Phil.-hist. Klasse, 1916.

Plate 26. Adam and Eve. Early fourth-century sarcophagus cover. Musée d'Art Chrétien, Arles, France.

Nude or nearly so, Adam and Eve stand with a tree between them. Normally a snake is curled around the trunk of the tree. The scene was popular in early Christianity and has remained so to this day. For the most part in Christian history, including the patristic period, it has referred to the sin of this first-created pair; therefore,

it has been termed original sin, a sin redeemed only by the sacrifice of Christ on the cross. But there is no indication in these first portrayals of any such meaning. The serpent does not appear to threaten. Adam and Eve do not seem threatened and do not respond to threat as Orantes. In short, there is no sign of deliverance or threat. Troje has utilized legendary and heretical material to show that Adam and Eve could represent the redeemed state, or paradise. Esche considers the earliest art as paradisiacal (30-32). One need not move to heterodox literature to prove the case. Based on the iconographical value of the tree and the two figures, this must be a paradise motif much like Jonah at Rest and the Good Shepherd. It portrays the gift of peace for woman and man in the created world and the social order. The scene picks up the details of the Genesis 3 story, but only uses such elements as the snake for pastoral background.

VIII. THE THREE YOUNG MEN
IN THE FIERY FURNACE

Carlo Carletti. *I tre giovani ebrei di Babilonia nell' arte cristiana antica. Quaderni di "Vetera Christianorum."* Brescia, 1975.

Dassmann. *Sündenvergebung*, 258-70, 425-38.

B. Ott. "Jünglinge, Babylonische." *LCI* 2:464-66.

Stommel. *Ikonographie*, 81-87.

The Three Young Men in the Fiery Furnace (Daniel 3), along with Daniel, Noah, Susannah, and Jonah, was one of the more popular Old Testament themes in early Christian art. It portrays the three friends of Daniel as Orantes in the midst of overpowering flames. The containing structure for these flames normally is a cubicle that looks like an open-pit oven. The picture appears with Noah (Deichmann, *Repertorium*, #834), Jonah (#894), an olive branch and dove (#124), or by itself. In later instances the dove appears in the furnace with the three young men; sometimes even a fourth person is seen (as in #834). The fourth figure, presumably the redeemer figure, is not portrayed as an Orante. The Three Young Men surely represent survival and peace in a very hostile environment. Quite possibly this scene, as with Daniel and Susannah (that is, the Daniel cycle), points primarily to political harassment.

In the fourth century, and later, the scene moved to a narrative account that included Nebuchadnezzar and the dramatic refusal

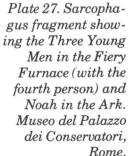

Plate 27. Sarcophagus fragment showing the Three Young Men in the Fiery Furnace (with the fourth person) and Noah in the Ark. Museo del Palazzo dei Conservatori, Rome.

of the Three Young Men to submit (Carletti, *I tre giovani*, 113-14). Even so, eventually this picture, like the other "Orante" types, fell into disuse.

Of the remaining Old Testament pictures listed, one can see the nascent formation of cycles. The two of Moses and the one of Eve eventually fit into cycles on these two subjects. Tobit and the Fish, and David and Goliath were infrequent in the early stages and did not become very popular later. They follow the same general theme of the Old Testament scenes: deliverance from difficult situations. I will return to the Ascension of Elijah when I deal with the Christ Helios.

It now appears clear that Old Testament stories provided the artistic possibility of representing peace (the Orante) in moments of extreme threat (Noah and the Flood, Jonah in the Sea, Daniel and the Lions, Susannah and the Elders, the Three Young Men in the Fiery Furnace). There are, in addition, some scenes of paradisiacal hope (Jonah at Rest, Adam and Eve). In at least one case, the Old Testament leans toward the New Testament by portraying Moses as the deliverer instead of the delivered (Moses Striking the Rock).

IX. JESUS

P. Beskow. *Rex Gloriae. The Kingship of Christ in the Early Church.* Stockholm: Almquist and Wiksell, 1962.

Friedrich Gerke. *Christus in der spätantiken Plastik*, 3d ed. Mainz: Florian Kupferberg Verlag, 1948.

Johannes Kollwitz. "Christus, Christusbilden." *LCI* 1:355-71.

_____. "Christusbild." *RAC* 3:2-24.

_____. *Das Christusbild des dritten Jahrhundert.* Münster: Aschendorff, 1953.

Marion Lawrence. "City-Gate Sarcophagi." *The Art Bulletin* 10 (1927): 1-45.

H. Leclercq. "Jesus-Christ." *DACL* 7:2:2393-2468.

Charles Pietri. *Roma christiana. Bibliothèque des écoles francaises d'Athènes et de Rome* 254 (1976) 1413-42.

Josef Sauer. "Das Aufkommen des bärtigen Christus-typus in der frühchristlichen Kunst." *Strena Buliciana.* Zagreb/Split: Zaklada Tiskare Narodnih Novina, 1924, 303-29.

Since the major difference between the Old Testament and New Testament in early Christian art lies in the presence of a deliverer (Jesus) rather than a delivered (Orante), it is necessary to consider the nature of the Jesus iconography, even though, in contrast to the Orante, no single Jesus symbol can be deduced from the evidence. There are three possible portrayals of Jesus prior to Constantine: the Good Shepherd, the *traditio legis*, and the New Testament scenes. I have already indicated that the Good Shepherd does not take on Christological implications until the late Constantinian period; but the second possibility, the *traditio legis*, does raise serious questions. In fact, the discussion of this scene raises most of the problems found in the interpretation of early Christian art. The *traditio legis* consists of a seated older man with a partial sidewise posture facing left. A book roll is found in his left hand. This scene occurs very frequently on non-Christian sarcophagi and in mausolea. It also appears on pre-Constantinian Christian sarcophagi, as on the one in Sta. Maria Antiqua. Presumably in these instances it represents the dead person or some personal function of the deceased (that is, a fiduciary or pedagogical relationship). This non-Christian iconography was used by post-Constantinian artisans to show Jesus Christ giving the law and the power to perhaps the Roman Church or to Peter. Even a young, beardless Jesus can be found in this scene (for example, the sarcophagus of Junio Bassus in St. Peter's). This shift in iconography, from non-Christian piety to a Christ who has founded the Church, reflects the remarkable revolution within Christianity between the third and fourth centuries.

The major category of Jesus portrayals can be only the New Testament scenes. Friedrich Gerke has outlined the iconographic development of Christology with considerable chronological precision.

I.	Christus philosophicus	280-310
II.	Miraculum Domini: Christ the Wonder Worker	
	A. Christus heroicus	300-320
	B. The Seasonal Christ	312-340
	C. Christus puer	330-360
III.	Victoria Christi	340-370
IV.	Maiestas Domini	380-410

Gerke's outline has proven very useful. It shows the movement from Jesus the wonder-worker to the post-Constantinian victorious Christ and finally to Christ the King. These artistic stages represent, of course, concomitant alterations in the political and social structure of the state and the Church along with the Church's understandable shifts in stated Christology.

My major quarrel with Gerke's outline concerns the first category, Christ the philosopher. Most of the earliest representations of Jesus are as a young boy (the Baptism of Jesus on the sarcophagus of Sta. Maria Antiqua). If one considers that the *traditio legis* is a representation of the social matrix with no Christological significance until after the "peace," then there are very few examples of an older Jesus in third-century Christian art. Gerke has used for his primary evidence the two polychromatic sarcophagi pieces, #67606 and #67607 of the Museo Nazionale Romano (Deichmann, *Repertorium*, #773). In these two Jesus clearly has a beard, but Deichmann in his *Repertorium* fails to support Gerke with a consensus date for these two pieces at the beginning of the fourth century.

Considerable work has been done on this developmental problem. Sauer tried to show innumerable examples of a bearded Jesus prior to A.D. 313. However, just as Gerke inappropriately used the *traditio legis*, so Sauer inappropriately used the Good Shepherd and other material incorrectly dated (see the lists from Wilpert in *DACL* 7:2:2403-12). As Lawrence says (29-30), Sauer's argument, when properly corrected, makes a fine substantiation for the assertion that the first bearded Christ in Rome comes in the apse of Sta. Pudentia (late fourth century). Lawrence does not have all the evidence either, though. If my data is correct, there are a few bearded and consequently older Jesus representations before Constantine. The very first era of Christian art demonstrates a pluralism. From that pluralism arose an artistic consensus—Jesus was consistently portrayed as a young wonder-worker. That consensus occurred about the beginning of the Constantinian era, as Gerke's study shows.

Bearded or not, the Jesus of the pre-Constantinian era was a wonder-worker. Jesus is the subject of all the New Testament scenes (assuming the Wise Men point to the birth and the Women at the Tomb point to his death). The majority of those scenes portray him as a deliverer. Only the baptism of Jesus threatens that general perception. In these wonders Jesus often uses a wand, as did Moses in striking the rock (S. Callixtus, Chapel A[6]), or he points with his hand (sarcophagus of Mas d'Aire), or he touches with his hand (Deichmann, *Repertorium*, #773).

This all fits well with the observations made here. Jesus does not suffer or die in pre-Constantinian art. There is no cross symbol, nor any equivalent. Christians did find themselves in difficult circumstances, including death. Yet the symbols show them being delivered from those circumstances, or at peace despite them. Their faith in Jesus Christ centers on his delivering power. Moreover, their Christology fits more the heroic figure of Mark (without a cross) than the self-giving Christ of the Apostle Paul.

Why then did the artists of the Constantinian era pick up this beardless wonder-worker as their single representation of Jesus? Why did Jesus not immediately become the victorious Christ? As we will see in the section on architecture, Constantine did not attempt to suppress the popular Christianity of his time. Quite the contrary, Constantine wished to engage the support of popular Christianity. He constructed better locations for their very popular celebrations with the dead and with the saints. Likewise in terms of popular Christology, Constantine benefited from the popular perception of Jesus as a wonder-worker. Only later, as a result of the political victory of Christianity, did that boy Jesus become

the King, at which time he could be portrayed as one who handed over the power (the *traditio legis*).

In light of this development, I will now look at the Baptism of Jesus, Jesus Healing, the Resurrection of Lazarus, the Wise Men, the Multiplication of the Loaves and Fishes, the Fisherman, Jesus Teaching, the Woman at the Well, and Christ Helios. I will consider the popular "Meal" with the Multiplication of the Loaves and Fishes.

X. THE BAPTISM OF JESUS

Lucien de Bruyne. "L'imposition des mains dans l'art chrétien ancien. Contribution iconologique à l'histoire du geste." *RivAC* 20 (1943): 113-278.

_____. "L'initiation chrétienne et ses reflets dans l'art paléochrétien." *RSR* 36 (1962): 27-86.

Dassmann. *Sündenvergebung*, 99-103, 348-52.

H. Leclercq. "Baptême de Jesus." *DACL* 2:1:346-80.

Red. "Taufe Jesus." *LCI* 4:247-55.

J. Strzygowski. *Iconographie der Taufe Christi*. Münster, 1885.

A. de Waal. "Die Taufe Christi auf vorkonstantinischen Gemälden der Katakomben." *RQS* 10 (1896): 335-49.

J. Wilpert. *La fede della chiesa nascente secondo i monumenti dell'arte funeraria antica. Collezione "Amici delle catacombe."* Città del Vaticano, 1938.

During the third and fourth centuries one of the most popular biblical scenes was surely the Baptism of Jesus. One of the oldest portrayals of the baptism (S. Callixtus, A²; *Repertorio*, #1) shows Jesus as a clothed adult being baptized by a somewhat larger John the Baptist. A dove hovers nearby. Still, this early scene must be understood as an exception. On the sarcophagus of Sta. Maria Antiqua (see plate 9) and in Chapel A³ Jesus was drawn as a small, nude youth being baptized by a very large adult, bearded John the Baptist, who stands well above the little Jesus and is laying a hand on his head. A dove hovers nearby or may even be descending into the scene. The artisans of the early Church repeated this scene time and time again.

Why the popularity? Wilpert (90) claimed there was no relationship between the New Testament picture and the later baptism of catechumens. More recent interpreters believe otherwise (Dassmann and de Bruyne). The Baptism of Jesus comes early in the known art material. The first art was not narrative, as we have seen. It would be highly unlikely that this is a biblical picture. And there are no non-Christian antecedents to the Baptism of Jesus such as can be found for the *traditio legis* or Jonah at Rest. Hence its popularity cannot be due to usage in the social matrix. An analogous situation would be the agape meal. The Multiplication of the Loaves and Fishes is a New Testament pictorial representation. Even more frequent are pictures of the agape meal as celebrated in the early Church. In addition, there are some individual signs like bread, fish, and wine. Where in the early art do we encounter initiation or baptism? Has the Baptism of Jesus as a New Testament picture been utilized to convey the baptism of the local church member? If so, this would explain the nudity of the Jesus figure, the size and age of John the Baptist in comparison to the smallness of Jesus, and the laying on of the hands. The dove would represent the descent of the Spirit in the New Testament picture, while the imposition of the hands on Jesus would represent Church practice regarding the gift of the Spirit (de Bruyne).

Even so, there are problems. If the fish does not represent Christ before Constantine, it seems unlikely the dove would represent the Holy Spirit. As we have seen, the dove functions as a peace symbol. Furthermore, the New Testament pictures stress deliverance. Even the cultic Feeding of the Five Thousand was a form of deliverance from hunger and poverty. Perhaps the Baptism of Jesus should be understood as the capstone of the deliverance pictures: Jesus delivers from the alien environment, water.

In Ignatius, Eph. 18:2, the author spoke of the baptism as a cleansing or healing of the water for us. Actually, then, the little nude Jesus must be the boyish wonder-worker of the healing scenes, who for his first "sign" heals the water, which represents the environment. The dove then symbolizes the peace achieved, a peace that can be symbolized by the Orante, fish, and anchor. Jesus as the deliverer would never be seen as an Orante, the delivered. The presence of river gods in the scenes, and the resemblance of John the Baptist to them, could strengthen this picture of Jesus who enters the alien water and eliminates the threat of the social environment. Needless to say, the Christian initiate of the third century could have understood baptism in the same way.

After the peace the Baptism of Jesus remains as an art form, but only as a narrative portrayal. The adult Jesus can no longer symbolize the baptism of the actor; if that connection was there, it too has been lost (Dassmann, 351).

XI. THE WISE MEN

Hans Aurenhammer. *Lexikon der christlichen Ikonographie.* Volume 1. Wien: Verlag Brüder Hollinek, 1959-1967, 117-27.

K. Baus. *Der Kranz in Antike und Christentum. Theophaneia* 2. Bonn: Hanstein, 1940, 194-201.

Dassman. *Sündenvergebung*, 316-22.

Th. Klauser. "Aurum Coronarium." *Mitteilungen des deutschen archaeologischen Instituts. Römische Abteilung*, bd. 59, 1944 (1948), 129-53.

——————— . "Aurum Coronarium." *RAC* 1:1010-20.

H. Leclercq. "Magie." *DACL* 10:1:994-1061.

Adolf Weis. "Drei Könige." *LCI* 1:539-49.

Events connected with the birth of Jesus have been popular subjects in Christian art from the beginning. The manger scene does not occur before Constantine and, in my opinion, neither does the annunciation. But the adoration of the Magi, or the Wise Men, can be found occasionally, and their portrayal was fairly standard. Three men in Persian dress are hurrying toward an object, not necessarily present in the first examples. They presumably carry gifts, especially the *aurum coronarium*, a crown of gold.

Plate 28. The Wise Men Approaching Mary. Capella Greca.

In the ancient world the gift of a crown of gold was given by representatives of foreign powers or by leading citizens to celebrate a military victory or possibly some other crucial event in the life of a king or emperor. In the social matrix of the early Church, the iconography of the Wise Men represented the giving of the gold crowns, or respect, to the Roman emperor. Like the Baptism

of Jesus, the representation of the three Wise Men was a capstone symbol. In the face of the all-powerful Roman Empire, it asserted the strength of the young Jesus in the political situation. From that might have come the assertion that Jesus could deliver from difficult circumstances and that the Christian (Orante) could be secure even in times of political harassment (Daniel in the Lion's Den, Susannah and the Elders). After the peace this picture continued in popularity, but took on a narrative function, adding the mother on a throne and a baby Jesus on her lap—much like the iconography of Isis and Horus.

XII. JESUS THE HEALER

Dassmann. *Sündenvergebung*, 301-13.

W. Jaeger. "Blindenheilungen." *LCI* 1:304-307.

According to the data given in chapter 3, there are five healing scenes in early Christian art: the healing of the paralytic, the demon possessed, the lame man, the crippled man, and the woman with the flow of blood. Of these, the healing of the paralytic seems to have been the most popular. On the walls of the Baptistry of Dura-Europos, Jesus is shown pointing with his right hand toward a bed with the paralytic lying on it. To the left of that scene, the man is carrying his bed. That scene is far more complete than usual. Usually there is only a man carrying a bed (sarcophagus of Mas d'Aire). In the other healing scenes Jesus is touching or pointing to the person. In the case of the woman with the flow of blood, she is kneeling and touching the tunic of Jesus.

The New Testament scenes of Jesus healing speak for themselves. Jesus was a deliverer. Within the faith community the early Christians found either healing or means of dealing with illness and infirmity. These pictures express that situation.

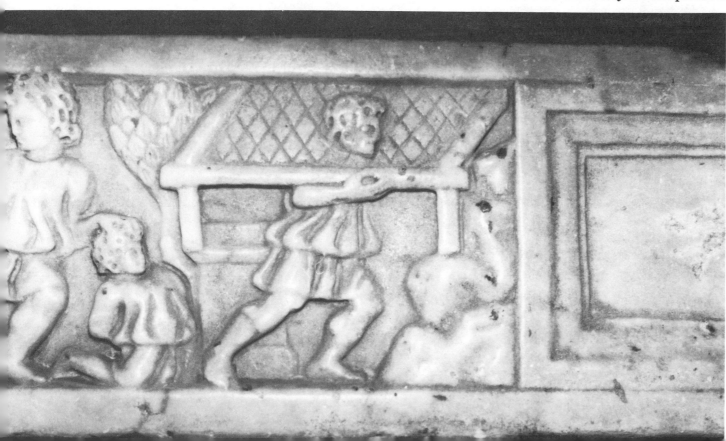

Plate 29.
Healing
of the Paralytic.
Mas d'Aire sarcophagus.

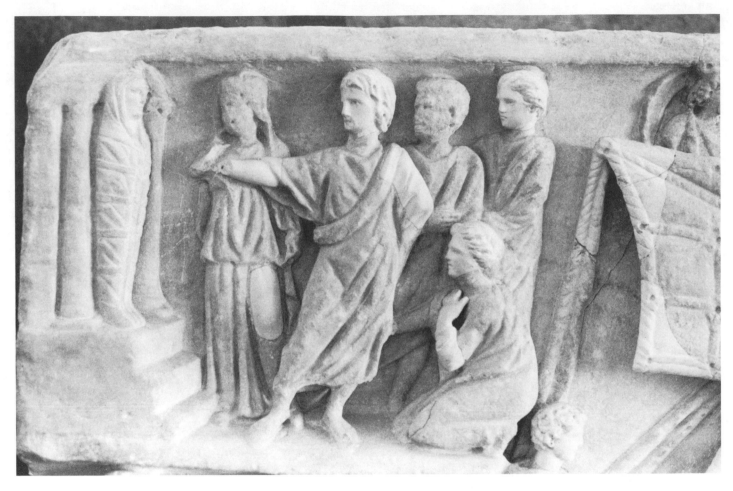

Plate 30. The Raising of Lazarus. Museo Pio cristiano, #119.

XIII. THE RESURRECTION OF LAZARUS

H. Aurenhammer. *Lexikon*, 249-58.

Dassmann. *Sündenvergebung*, 283-89, 405-10.

Alfred Hermann. "Ägyptologische Marginalien zur spätantiken Ikono-
graphie." *JAC* 5 (1962): 60-92.

H. Leclercq. "Lazare." *DACL* 8:2:2009-86.

E. Male. "La résurrection de Lazare dans l'art." *Revue des arts* 1 (1951): 45-52.

H. Meurer. "Lazarus von Bethanien." *LCI* 3:33-38.

A. Peraté. "La résurrection de Lazare dans l'art primitif." *Mélanges G. B. de Rossi. Mélanges d'archéologie et d'histoires*. Paris: Ernst Thorin, 1892, 271-80.

Stommel. *Ikonographie*, 81-87.

Stuiber. *Refrigerium*, 185-86.

A. de Waal. "Die biblischen Totenerweckungen an den christlichen Grabstätten." *RQS* 20 (1906): 27-48.

Along with the Baptism of Jesus, this ranks at the top of New Testament representations. From the beginning the iconography was clear and simple. Jesus stands looking at an aedicula (mausoleum? heroon for Peraté, 272). In the doorway or on the steps of the aedicula stands or lies Lazarus. Normally he is drawn wrapped like a mummy, though in some of the early instances (St. Callixtus) he merely has a cloth over him. Jesus points to him with his right hand or with a wand. Later, as in the sarcophagus of Museo Pio cristiano #119, the two sisters of Lazarus are standing nearby.

Scholars speak of the Resurrection of Lazarus with one voice. There is no question (Stommel, 83; Stuiber): the resurrection of Lazarus is indeed sepulchral art. It portrays the resurrection hope for the dead buried in the catacombs. And surely we must agree that above all, Jesus delivers from death. That must account for the popularity of the scene in catacomb art. Furthermore, it depicts the present reality of resurrection rather than belief in another world. In the social matrix the people believed the dead remained in the houses or places prepared for them. They ate with the dead, talked to them, asked for their assistance. In the case of special dead, they revered and honored the daemon of the dead present in the aedicula or heroon. The resurrection motif supports neither a view of otherworldly immortality nor a view of end-time judgment and resurrection. The presence of the dead was made possible through the redeeming act of the wonder-worker Jesus. These resurrected dead then were part of the extended Christian family.

XIV. THE WOMAN AT THE WELL

Dassmann. *Sündenvergebung*, 289-98.

Red. "Samariterin am Jakobsbrunnen." *LCI* 4:26-30.

Sauser. *Frühchristliche Kunst*, 133-37.

The Samaritan woman, or the Woman at the Well (John 4), occurs twice in our material. At Dura-Europos she simply is standing next to the well. In St. Callixtus she appears as an Orante by the well while Jesus points to it. The scene is the New Testament counterpart to Moses Striking the Rock. Jesus "delivers" the woman by granting her an unusual accession to the water. After Constantine the more frequent scene was Peter Striking the Rock. Presumably the difficulty for the woman was not a great thirst. Consequently, as with Moses and Peter, it would be appropriate to see here a cultic symbol in which Jesus grants the water of life to the congregation, which could refer to baptism, the agape, or both.

XV. JESUS TEACHING

J. Kollwitz. "Christus als Lehrer und die Gesetzesübergabe an Petrus." *RQS* 44 (1936): 45-66.

H. Leclercq. "Magistere du Christ." *DACL* 10:1:1114-21.

Sauser. *Frühchristliche Kunst*, 372-401.

There are at least two sarcophagus sculptures of this period that cannot be taken as the traditional *traditio legis*. On the Velletri sarcophagus (see plate 17), to the left of the Orante, we find a smallish, seated figure with an open scroll. The second instance—Deichmann, *Repertorium*, #773—is only partial, so the iconography cannot be certain, except that the figure (Jesus?) has a scroll. These and the occasional bearded Jesus follow the iconography of the wandering philosopher. Gerke, then, was right in seeing Jesus as "Christus philosophicus" in the earliest Christian art. Though not as frequent as the wonder-worker type, the teaching Jesus had a function in the early faith community. While it implies the authority of Jesus, it stresses more the function of Jesus as mediator of revelation or authoritative teaching vis-à-vis Moses, or the itinerant philosophers of the ancient Roman world.

In the fourth century the teaching picture shifted to Jesus with the disciples. No doubt that led to the portrayal of Jesus surrounded by apostles similar to the iconography of the emperor surrounded by officers of the Empire. Eventually the Jesus Teaching scene became the much-used portrayal of *maiestas domini*.

XVI. CHRIST HELIOS
AND THE ASCENSION OF ELIJAH

"Tiberias, Hammath." *Encyclopedia of Archaeological Excavations in the Holy Land* 4:1178-84.

Kurt Aland. "Das Verhältnis von Kirche und Staat in der Frühzeit." *ANRW* 2:23:1:60-246 (106-39).

Dassmann. *Sündenvergebung*, 279-82.

Franz Joseph Dölger. *Die Sonne der Gerechtigkeit und der Schwarze*. Münster: Aschendorff, 1918, 1-20.

_____. *Sol Salutis*. Münster: Aschendorff, 1925.

F. Gerke. *Sarkophage*, 91-94.

Donald L. Jones. "Christianity and the Roman Imperial Cult." *ANRW* 2:23:2:1023-54.

H. Laag. "Sonne." *LCI* 4:175-78.

M. Lawrence. "Three Pagan Themes," 331-34.

E. Lucchesi Palli. "Elias." *LCI* 1:607-13.

Johannes Straub. *Vom Herrscherideal in der Spätantike*. Stuttgart: Kohlhammer, 1964, 129-34.

Worship of the sun was a principal imperial cult prior to Constantine. It was promoted under Antoninus Pius; a temple to Sol Invictus was established by Elagabalus (often known by the appropriate name Heliogabalus) during his reign (A.D. 218-222). Concern for the sun god was revived by Aurelian, who, among other things, established the winter solstice, 25 December, as *natalis solis invicti* (birthday of the unconquered sun). The early Christians and Hellenistic Jews felt it necessary to deal with Sol Invictus well before the peace of Constantine. We find in the synagogue of Dura-Europos a fresco panel of Elijah in a quadriga chariot dropping a mantle to Elisha. The iconography can hardly be distinguished from Sol ascending in his quadriga with an ocean or river god standing below. There could hardly be any rationale for depicting the Ascension of Elijah in Jewish and early Christian art except as an attempt to take over the popularity of Sol Invictus. The one instance in our data—Deichmann, *Repertorium*, #115—has the same portrayal as Sol in non-Christian art and in Jewish art. Early Christianity continued to battle with and to assimilate Sol Invictus. Sometime between 274 and 336 it managed, especially under Constantine (the first "Christian" emperor), to assimilate the *natalis solis invicti* as the birthday of Jesus, the Sun of Righteousness.

In some ways, Christians also "lost" to the imperial Sol Invictus. The sun god was surely adopted when Constantine saw the cross over the sun at the Milvian bridge in 312. The first churches were oriented toward the rising sun, and the Christians of the Byzantine era bowed toward that sun. Baptisms were oriented so that the convert arose toward the sun. Most important, the imperial Christ became iconographically Christ Helios. For this reason the mosaic of Mausoleum M came as a shock to the excavators. Here, some few years before Constantine, or at least early in his reign, we find a Christian Sol Invictus—not one assimilated by the Elijah story, but one that has assimilated the early Christian Jesus. It is not identical with Elijah: there is no figure below; it is a biga, not a quadriga; and the chariot is high in the yellow sky. But unmistakably Jesus rides a chariot across the sky with sun rays streaming from his head. The Byzantine Jesus, who rules the world from the heavens, also is pictured against the gold or yellow sky and a nimbus covers his head. In order to become the public religion of the Empire, Christianity had to give up the Ascension of Elijah (see the beautiful carving on the wooden doors of Sta. Sabina in Rome) and make of Jesus the emperor of the universe, Sol Invictus.

It may not be surprising, though it is certainly confusing, to learn that Judaism also adopted Sol Invictus and used Elijah in a similar way. For example, the floor of the synagogue at Hammath, Tiberias, has a marvelous Helios, surrounded by four female seasons, riding a chariot in the center of a zodiac.

XVII. THE FISHERMAN

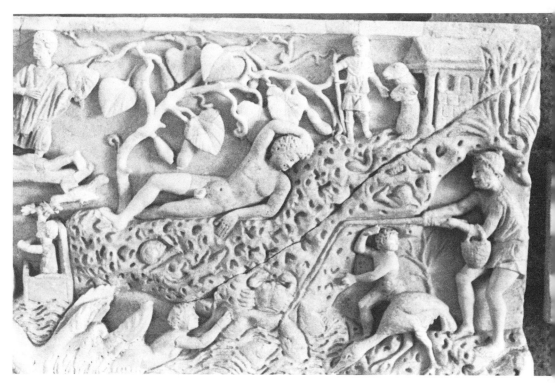

Plate 32. The Fisherman. Museo Pio cristiano, #119.

Plate 31. The mosaic of Christ Helios in Mausoleum M under St. Peter's, Rome.

L. de Bruyne. "L'initiation chrétienne et ses reflets dans l'art paléochrétien." *RSR* 36 (1962): 27-86.

Dassmann. *Sündenvergebung*, 353-56.

Robert Eisler. *Orpheus—The Fisher*. London: Watkins, 1921.

J. Engemann. "Fisch, Fischer, Fischfang." *RAC* 8:959-1097.

H. Leclercq. "Pêcheur." *DACL* 13:2:2877-82.

B. Ott. "Fischer, Fischfang." *LCI* 2:40-42.

The fisher may not be a biblical representation, nor does it have a significant history as a religious symbol in the social matrix of the Roman Empire. Eisler's thesis that the fish symbols go back to Orpheus has not convinced most scholars. The fisher does occur as a decoration. It may be there is no other meaning in early Christianity than that. Its presence in a full panel with Jonah and Christ Helios in Mausoleum M of St. Peter's does give one pause. If the fish represents the religious gift of life in an alien environment, then the fisherman could be one who furnishes that possibility. On the other hand, such a deliverance motif would have solicited the figure of Jesus, and in none of our three instances is that true. However, some do take it as an initiation or baptism symbol, and others as a redemption symbol, while others still take the fisher to be Christ despite the lack of iconographical similarity.

XVIII. THE MULTIPLICATION OF THE LOAVES AND FISHES (THE MEAL)

Th. Klauser. "Das altchristliche Totenmahl nach dem heutigen Stande der Forschung." *Theologie und Glaube* 20 (1928): 599-608.

Hans Lietzmann. *Mass and Lord's Supper*. Leiden: Brill, 1979.

Bo Reicke. *Diakonie, Festfruede, und Zelos.*

Sauser. *Frühchristliche Kunst*, 137-54.

Stuiber. *Refrigerium*, 124-36.

The Multiplication of the Loaves belongs with the other deliverance scenes of the New Testament (see plate 17). People are hungry, as the Woman at the Well was thirsty, so Jesus multiplies the available food, five loaves and two fishes (Mark 6:30-44 and parallels). There is much more to the representation than that, however. Whereas the cultic significance of the Baptism of Jesus, Moses Striking the Rock, and the Woman at the Well remains somewhat conjectural, here the function of the Feeding of the Five Thousand has been clearly signaled. The fish and loaves occur consistently in the very frequent early Christian portrayals of a meal. Unquestionably the early Christians celebrated a meal together that was based on the Multiplication of the Loaves. The nature of that meal has been much debated. Because the same elements, fish and loaves, continued into the post-Constantinian

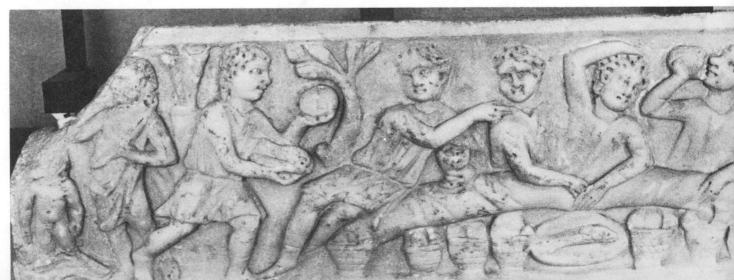

Plate 33. Sarcophagus fragment showing the agape (seven baskets of bread, fish, and wine), and to the left, the Baptism of Jesus. Museo Pio cristiano, #123.

iconography of the Last Supper, many have supposed the meal found so frequently in early Christian art was indeed the Eucharist, or even an attenuated version of the New Testament Lord's Supper. Others, more convinced by the sepulchral location of the meal representations, suppose these have a more eschatological flavor: they refer to the final messianic banquet or to the meal of the "in-between state," the *refrigerium interim*.

Since the 1920s three things have occurred that make a more precise identification of the meal possible. The work of Hans Lietzmann on the two forms of the early Christian Eucharist—the ἀνάμνησις on the one hand, and the eschatological meal, or agape, on the other—has made scholars more aware of a meal in the New Testament and the early Church that did not originate from or remain attached to the Passover meal of the Synoptic Gospels. Bo Reicke then demonstrated convincingly the antecedents of such a meal and the meal's continued function in the life of the Church. Second, the discovery of the *triclinium* underneath S. Sebastiano made it abundantly clear from an archaeological perspective that eating with the family dead and the special dead was of unusual importance to the early Christians.

From that discovery it eventually became clear that the first edifices of Christianity were *martyria*, or places for the faithful to eat with the special dead. These martyria were then expanded by Constantine to form church buildings as we know them. The meal for the dead was one of the most powerful forces in the early Church. Indeed, it was a powerful force in the social matrix, considered with or without Christianity. Though the historical relationships are not clear, the Multiplication of the Loaves coalesces with the agape meal of the New Testament, which in turn has become identified with the meal for the dead in the social matrix. That meal was frequently portrayed in the art of the early Christians. Finally, the discovery of the importance of popular religion, as discussed in the methodological section, has made scholars realize that the history of the Church cannot be understood apart from powerful religious elements of the local community. This has revived interest in such practices as the meal for the dead and the use of relics.

As a net result of these considerations, the meal can be seen as a continuation of the non-Christian meal for the dead in light of the New Testament paradigm of the Feeding of the Five Thousand. This meal was so formative that the medieval Catholic synthesis could not have occurred without assimilating it. Consequently, even the art of the post-Constantinian Church (see the New Testament picture of the Last Supper at S. Apollinare in Classe, Ravenna) incorporated the loaves and the fish even in depictions of the ἀνάμνησις meal.

CHAPTER FIVE

EARLY CHURCH BUILDINGS

Hugo Brandenburg. *Roms frühchristliche Basiliken des 4. Jahrhunderts*. München: Wilhelm Heyne Verlag, 1979.

Heinz Kähler. *Die frühe Kirche*. Kult und Kultraum. Berlin: Gebr. Mann Verlag, 1972.

Carl H. Kraeling. *The Christian Building. Excavations at Dura-Europos* 8, part 2. Locust Valley NY: J. J. Augustin, 1967.

Richard Krautheimer. *Early Christian and Byzantine Architecture*. The Pelican History of Art. Harmondsworth: Penguin Books, 2d ed., 1975.

Charles Pietri. *Roma christiana*. Recherches sur l'Eglise de Roma, son organisation, sa politique, son idéologie de Miltiade a Sixte 3 (311-440), 1 and 2. *Bibliothèque des Écoles Françaises d'Athènes et de Rome*, #224. Rome: École Française de Rome, 1976.

Antonio Quacquarelli. "Note sugli edifici di culto prima di Costantino." *VetChr* 14 (1977): 239-51.

At the heart of the Christian faith is its meeting, the assembly of the faith community. Christianity stresses the formation of "kin-ship" community either where it had not existed before (1 Peter 2:10) or where it had been disrupted by the Jesus revolution (Mark 10:23-31). Early Christians undoubtedly met in private homes (Colossians 4:15), though it should not be forgotten that Christians, like the Jews (Acts 16:13), also met in open places (Pliny, *Letters*, 117), markets, and hired halls (Acts 20:8). There is no literary evidence nor archaeological indication that any such home was converted into an extant church building. Nor is there any extant church that certainly was built prior to Constantine. Consequently, we have no evidence regarding the intentional structure of a Christian meeting place prior to the "peace." But there are homes that were restructured to accommodate the Christian assembly. Such buildings, now called the *domus ecclesiae*, or, in Greek, οἶκος ἐκκλησίας, must have been extraordinarily frequent as the size of the church catholic grew. It is amazing that we do not have more remains of such house churches. In reality, we do undoubtedly have the remains of such house churches but cannot recognize them. As it now stands we have only one edifice we can confidently categorize as a pre-Constantinian *domus ecclesiae*, the church at Dura-Europos. But we will also include a discussion

of alleged house churches, such as the Domus Petri of Caphar-naum, the double church at Aquileia, and all the pertinent *tituli* churches of Rome.

I. THE CHURCH AT DURA-EUROPOS

Carl H. Kraeling. *The Christian Building. Excavations at Dura-Europos* 8, part 2. Locust Valley NY: J. J. Augustin, 1967.

In the year 256, the city of Dura-Europos, in modern day Syria, was finally taken by the attacking Sassanians. In order to prevent that final collapse, the Roman garrison had greatly strengthened the western defenses of the city wall. First, fill was utilized to widen the wall. This fill covered the so-called "Wall" street, which ran adjacent to the city wall, and it was held in place by mud bricks. In the next stage of defense the houses and buildings next to Wall Street were also covered to form a wider wall and establish other defensive structures. Finally, the buildings next to this parapet were leveled so that the Roman garrison could carry out its defensive maneuvers.

In 1928 Dura-Europos was excavated by the French Academy of Inscriptions and Letters and by Yale University. In the first report involving the Christian building, the report of the 1930-1931 season, the field director mentioned an "edifice of Tower 17." In 1932 the pictorial nature of the Baptistry made it clear that a *domus ecclesiae* had been discovered. Because of the location of the house church next to Wall Street on Block M8, the rear, or west end, of the building was nearly completely preserved, while the east end, or front, was almost totally leveled. Kraeling's final report on the church building at Dura-Europos was published posthumously in 1967.

As far as pre-Constantinian church practice architecture is concerned, no more important discovery has been made. Instead of having to work through the enormously complex task of unraveling the architectural history of a building like SS. Giovanni e

Paolo in Rome, one finds here a "photograph" of a *domus ecclesiae* as it was in the year 256 (fig. 5). For that reason it deserves more than usual attention; it is one of a kind.

60 FEET

20 METRES

Figure 5. An isometric drawing of the house church in Dura-Europos.

The excavators of the Christian church have reported finding three stages of development on the site: an earlier dwelling, a private house, and the house adapted for use as a *domus ecclesiae*. Since the private house itself shows no history as a location for Christian activities, there is nothing to be learned, for our purposes, in the excavations of the earlier dwelling. Before being adapted for Christian usage, the house, nearly 18 meters square and 5.2 meters high, consisted of eight rooms and a courtyard (fig.

6). One entered the house on the northeast corner by means of a vestibule (8). An immediate screening wall forced the person to turn right to enter the courtyard. This device assured privacy without an actual door.

Opposite the entrance to the courtyard were three rooms created by the continuation of the walls of the courtyard (3, 4A, and 4B). To the right, or west, of the courtyard were two rooms (5 and 6) that would have housed the living areas of the women. The room at the northwest corner did not follow the system found on the south side. It was narrow, like the vestibule, and longer. Presumably, since the latrine also fronted it, it was the least desirable room in the house. It may have been used for storage and sleeping quarters for a female servant. Its east end joined a stairwell to the roof. Finally, to the left or east of the courtyard was a long, narrow portico.

If one accepts the graffito (#10 in the collection, p. 148) found on the first layer of plaster in room 4 as the date of the building of the house, then sometime between 232-233 and 256 the house was converted or adapted for use as a Christian meeting place. A number of important changes were made, of which only the major parts will be mentioned (see fig. 7).

Figure 6. Plan of the house in Dura-Europos used as a church.

The courtyard was tiled (covering the latrine and the cesspool) and benches 0.50 meters wide and 0.42 meters high were installed around the walls. The wall between 4A and 4B of the main living area was demolished, leaving a hall 5.15 meters wide and 12.9 meters long, large enough to accommodate about 65 to 75 persons. The room remained decorated as before with a Bacchic plaster frieze and a new coat of plaster. At the east end was a rhomboidal-shaped podium or *bēma* about 0.97 meters from the wall, 1.47 meters long, and 0.20 meters high. To the left of this was a molded mass of plaster containing an aperture at the top. There is nothing to indicate what object it held.

Basically the west room (5) was only slightly modified, but the small, irregular room of the female servant (6) was totally transformed to become the baptistry. We will only give a schematic account of the highly articulate and detailed account in the final report. The ceiling was lowered, apparently for aesthetic purposes, although that created an "Upper Room" accessible by the stairs. Then the baptismal font, consisting of a basin and a canopy, was

Figure 7. Plan of the house church in Dura-Europos.

constructed on the west wall (see fig. 8). The canopy was supported by two columns made of rubble and plaster. The baptistry was entered by stepping up to the basin.

SOUTH WALL

NORTH WALL

Figure 8. The baptistry of the house church in Dura-Europos.

The vault of the canopy and the ceiling of the baptistry were painted a dark blue with stars formed by rays and dots. The can-

opy wall contained the Good Shepherd, with Adam and Eve below the figure of the shepherd. To the left of the baptismal canopy, on the south wall, is the Woman at the Well and David and Goliath farther to the left, both on the upper register. To the right of the canopy, on the north wall, we find on the upper register the Healing of the Paralytic and the Peter and Jesus walking on water near a boat. On the lower level are several women, approaching what appears to be a tomb (see fig. 8).

Finally a bench was added to the north exterior wall of the house. Except for this bench the house could not have been distinguished exteriorly from its neighbors. Such outside benches were rather rare but not unknown in residential areas. Presumably the Christian community felt a need to accommodate the growing community even outside.

II. THE DOMUS PETRI IN CAPHARNAUM

Virgilio Corbo. *The House of St. Peter at Capharnaum. Publications of the Studium Biblicum Franciscanum,* Collectio minor, No. 5. Jerusalem: Franciscan Printing Press, 1969.

Eric M. Meyers and James F. Strange. *Archaeology, the Rabbis and Early Christianity*. Nashville: Abingdon, 1981, 128-30.

Emmanuele Testa. *I graffiti della casa di S. Pietro. Publicazione dello Studium Biblicum Franciscanum,* No. 19. Jerusalem: Franciscan Printing Press, 1972.

Although the presence of special Christian buildings in Capharnaum has been known since the early part of this century, it has only been within the past two decades that serious archaeological efforts have been made to determine precisely what is there. Amidst a group of poor habitations from the first century, one hall stands out as having been venerated (fig. 9). Its walls were plaster, stronger than normal, and marked with religious graffiti.

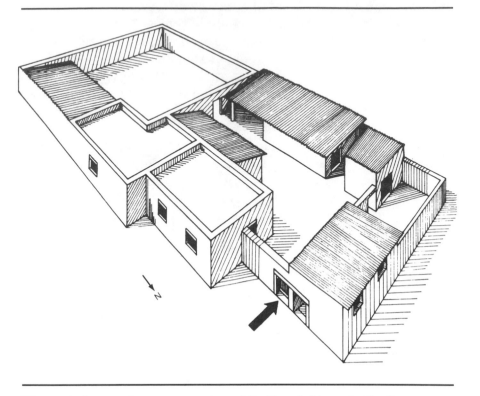

Figure 9. Isometric reconstruction of St. Peter's house in Capharnaum.

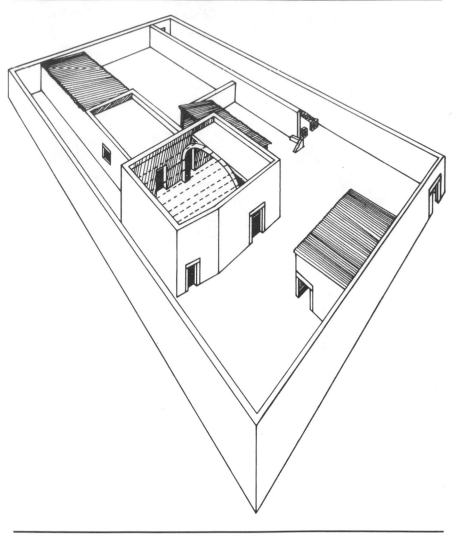

Figure 10. Isometric reconstruction of the house church in Capharnaum.

About the fourth century an insula was built around this hall, and through the fifth century it continued to be venerated as a holy place by pilgrims, who also left graffiti (fig. 10). Around the middle of the fifth century a church was constructed consisting of two concentric octagons with a portico on five sides (fig. 11). An examination of the graffiti indicates all are later than the "peace." Testa is certain there are earlier ones to be discovered, but no positive results are forthcoming (Testa, 138-41).

Without any graffiti, frescoes, or special furniture and arrangements, even if the Domus Petri were a pre-Constantinian house church, there is little to learn from it. It would offer only one unique quality: we have no other example of a *domus ecclesiae* developing into a church edifice.

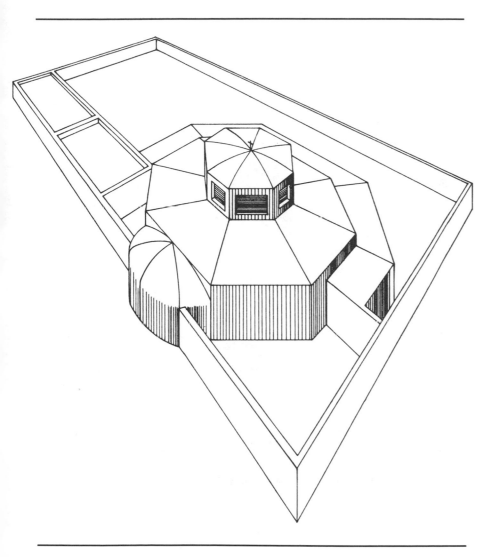

Figure 11. Isometric reconstruction of the fifth-century octagonal church built over the house church in Capharnaum.

III. THE DOUBLE CHURCH AT AQUILEIA

Giuseppe Bovini. *Le antichita cristiane di Aquileia*. Bologna: Patron, 1972.

G. Brusin. "Contributo all'interpretazione dei mosaici cristiani nella zona della basilica di Aquileia." *ACIAC* 5 (1957): 433-55.

G. Brusin and P. L. Zovatto. *Monumenti paleocristiani di Aquileia e di Grado*. Udine: Deputazione di storia patria per il Friuli, 1957.

G. U. S. Corbett. "A Note on the Arrangement of the Early Christian Buildings at Aquileia." *RivAC* 32 (1956): 99-106.

Josef Fink. *Der Ursprung der ältesten Kirchen am Domplatz von Aquileja*. Münster: Böhlau, 1954.

H. Kähler. *Die frühe Kirche*, 40-53, 136.

Mario Mirabella Roberti. "Considerazioni sulle aule teodoriane di Aquileia." In *Studi Aquileiesi*. Aquileia: Associazone nazionale per Aquileia, 1953, 209-44.

Sergio Tavano. *Aquileia cristiana*. Udine: Friulane, 1972.

Along with the church at Dura-Europos and SS. Giovanni e Paulo in Rome, the complex under and adjacent to the cathedral of Aquileia offers us the most useful data for pre-Constantinian church architecture. In 1893 excavations were started to the north of the present cathedral, attributed to the Patriarch Poppo (1019-1042) and consecrated in 1031. About 1909 a mosaic was discovered approximately one meter below the floor of the cathedral. This floor was totally uncovered so that it can now be seen as the floor of the cathedral itself. Further work during and after the war period brought to light a second mosaic around the foundation of the campanile north of the eleventh-century cathedral. Thorough excavations revealed two churches side by side—the south one, under the Poppo church, was about 37.4 meters by 20.4 meters, while the north one measured about 37.4 meters by 17.25 meters. Both had three aisles and no apse. The two churches were joined by a rectangular hall 28.8 meters by 13.67 meters.

When the mosaic of the south church was uncovered, a mosaic inscription was found dedicating the church to Bishop Theodoro (308-319?) who had attended the synod at Arles as a bishop (A.D. 314).

*Theodore felix
[a]diuvante deo
omnipotente et
poemnio caelitus tibi
[tra]ditum omnia
[b]aete fecisti et
gloriose dedicas
ti.*

In 1957 Giovanni Brusin and Paulo Lino Zovatto published a thorough study of the complex. They proposed that the east end of the north building had in fact been an oratorio, or hall, presumably built over a *domus ecclesiae* (Brusin, 22), some foundations of which were also found between the south church and the campanile. This hall, 17.25 meters by 19.25 meters, built prior to either the north or south hall, would, of course, nearly have to be pre-Constantinian. If this were true, then the oratory of Aquileia would be the earliest-known building constructed by Christians for their assembly.

But archaeological scholarship has not been satisfied with this reconstruction. The architectural divisions proposed do not, for example, show up in the sunken mosaic floor, nor in the wall divisions (Roberti). And if the north and south buildings are indeed matching double church buildings, the west mosaic of the north building would be more appropriate for traffic than the east, so-called earlier, section (Corbett).

The problems of the earliest Christian edifices at Aquileia have not been solved. It is unlikely that we can garner much information regarding a *domus ecclesiae* under the north or east building. There are several homes or buildings involved in that

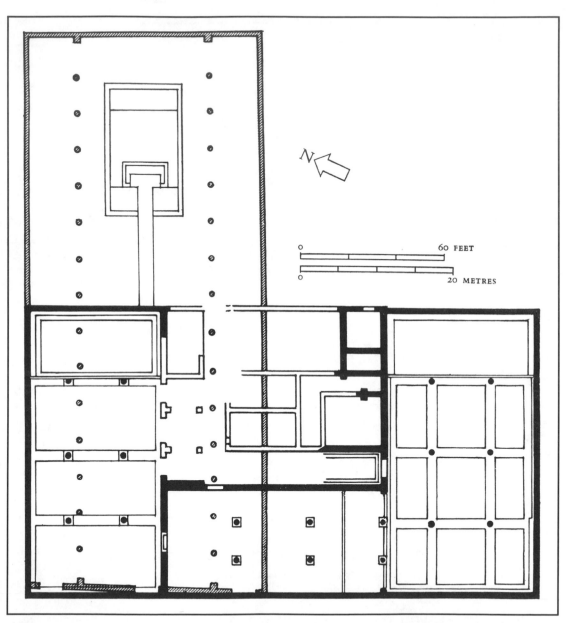

Figure 12. The double cathedral of Aquileia, building plans from ca. 313-319 and ca. 400.

complex. But once again it seems very unlikely that we have an example of a church being built in the place of a previous *domus ecclesiae*, or privately owned place of worship (only SS. Giovanni e Paolo may demonstrate that type of continuity).

Despite our most skeptical estimates, it must be said that Aquileia still may offer us, in the double church of Theodoro, the earliest Christian-planned building. It may be chronologically the first, or it may be "earlier" than Constantinian buildings because it was conceived outside the Constantinian sphere of influence. The two buildings are simply halls with mosaic floors almost totally lacking in Christian symbolism except for a Jonah and Good Shepherd in the south building (see p. 34). Because of the Jonah and Good Shepherd, the south hall, for good reason (see pp. 23-24), has been associated with baptism and instruction of the catechumenates, while the north building was used more for the Christian assemblies.

There is no reason to suppose this set of buildings had a cemeterial beginning, though the strange inscription *cyriace vibas* leaves one with an unsettled feeling that all is not yet known about Aquileia.

IV. THE *TITULI* CHURCHES OF ROME

Walther Buchowiecki. *Handbuch der Kirchen Roms*. Wien: Verlag Brüder Hollinek, 1967, vols. 1-3.

Klaus Gamber. *Domus ecclesiae*. Regensburg: Verlag Friedrich Pustet, 1968.

Christian Huelsen. *Le chiese di Roma nel medio evo*. Firenze: L. S. Olschki, 1927.

Johan Peter Kirsch. *Die römischen Titelkirchen im Altertum*. Paderborn: Verlag von Ferdinand Schöningh, 1918.

Richard Krautheimer. *Corpus basilicarum christianarum Romae*. Città del Vaticano: PIAC, 1937-1977, vols. 1-5.

——————. *Early Christian and Byzantine Architecture*.

——————. *Rome*. Princeton NJ: Princeton University Press, 1980.

Charles Pietri. *Roma christiana*.

Figure 13. Ecclesiastical map of Rome.

Rene Vielliard. *Recherches sur les origines de la Rome chrétienne*. Rome: Edizioni di storia e letteratura, 1959.

It has been supposed through the centuries that the Christians at Rome possessed (hence the use of the legal term *titulus*) a number of the private edifices that eventually became the basilicas of Rome. These ancient *tituli*, as they are called, now are honored to have a cardinal assigned to them. The twenty-five churches were referred to in ancient literature by the ancient name or patron, such as *titulus Clementis*. Today these churches are named with the first owner as a saint, for example, S. Clemente, or else a later saint or saints have replaced the original name. For example, SS. Giovanni e Paolo was the *titulus Byzantis*. Almost all of the title churches of Rome incorporate in them pre-Constantinian buildings so that earlier generations could reasonably suppose each church developed from a *domus ecclesiae*. Unfortunately the documentary evidence (*Liber pontificalis*, pilgrim itineraries, and other records) does not in any case substantiate this assumption. Therefore, one cannot assume that the presence of prior construction in an early church implies that the earlier building was also used as a place of assembly. On the other hand, there are architectural reasons, in some instances, to suppose that there could be a connection. The *tituli* that might show some connection to a pre-Constantinian place of worship are:

1.	*Titulus Clementis*	S. Clemente
2.	*Titulus Anastasiae*	Sta. Anastasia
3.	*Titulus Byzantis*	SS. Giovanni e Paolo
4.	*Titulus Equitii*	SS. Silvestri e Martini
5.	*Titulus Chrysogone*	S. Chrysogone
6.	*Titulus Sabinae*	Sta. Sabina
7.	*Titulus Gaii*	Sta. Susanna
8.	*Titulus Crescentianae*	St. Sixtus
9.	*Titulus Pudentis*	Sta. Pudentiana

A. *Titulus Clementis*

Eduardo Junyent. *Il titolo di S. Clemente in Roma*. Roma: PIAC, 1932.

_____. "La primitiva basilica de S. Clemente." *RivAC* 7 (1928): 231-78.

R. Krautheimer. *Corpus*, 1:117-36.

Joseph Mullooly. *Saint Clement*. Rome: G. Barbera, 1873.

The history of the church of S. Clement represents well the complexity of historical reconstruction when archaeological data has been included. The present church already lies several meters below street level in Rome. In 1852 Mullooly discovered a second basilica below the present one. The ground floor of the present S. Clement rested at the capital level of the lower basilica. The older church was divided into two side aisles and a nave by two rows of columns. The nave was fronted by an apse to the west. Directly below the earlier basilica yet another building was discovered with walls of tufa. The function of this lowest building, which was certainly not a house, has as yet not been determined. It dates from the end of the first or the beginning of the second century. Somewhat later, a residence was built next to this "public" building. At some time, possibly the second quarter of the third century, the courtyard of this private residence was transformed into a Mithraeum, or more likely a Mithraic school. Meanwhile the "public" building became a residence with its ground floor above the tufa walls. No earlier than about 390, this third-century house was transformed into what we know as the lower basilica, with the neighboring house of the second century and its Mithraeum utilized in the construction of, or buried under, the apse and choir.

One might be tempted to see here a gradual development from the house of Clement to the present-day church of S. Clemente, but evidence for such a continuity with the first century is lacking. To the contrary, nothing on the site could go back to the first-century Clement. The religious use of the most ancient residence was Mithraic, not Christian. The persons who built the third-century house over the "public" building might have been Christian, but there is no evidence for such. Very likely the first Christian presence here was the lower basilica. Reluctantly one must conclude that the *titulus Clementis* did not include a *domus ecclesiae* in its substructure.

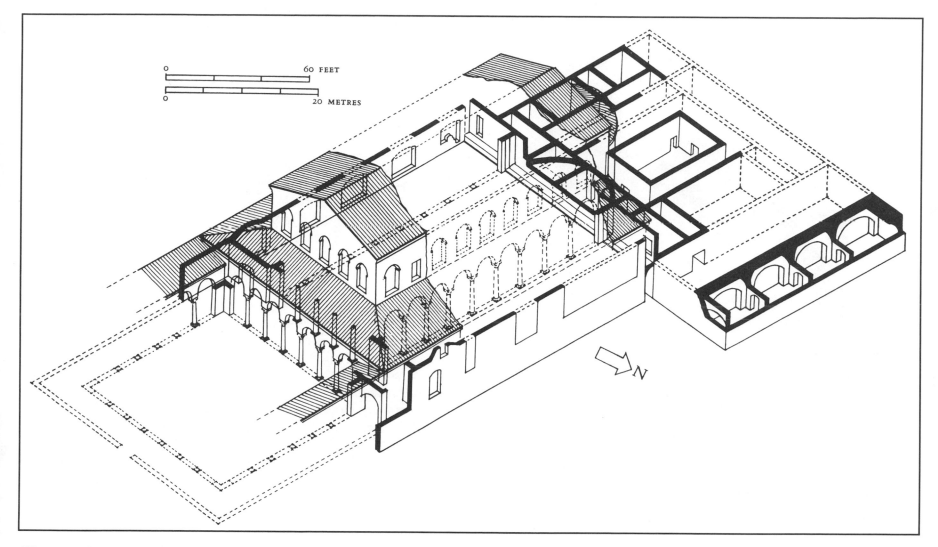

Figure 14. Isometric reconstruction of S. Clemente, Rome, ca. 380.

If the latest Roman house on the site (the third-century house) were indeed a *domus ecclesiae*, we learn only that there was in it a large hall with openings in both outside walls. With only that information, neither its function nor its appearance can be determined.

B. *Titulus Byzantis*

B. M. Apollonj-Ghetti. "Problemi relativi alle origini dell'architettura paleocristiana." *ACIAC* 9 (1978): 491-511.

A. M. Colini. "Storia e topografia del Celio nell'antichita." *APARA* (Memorie) 7 (1944).

R. Krautheimer. *Corpus*, 1:267-303.

A. Prandi. *Il complesso monumentale della basilica celimontana dei SS. Giovanni e Paolo*. Città del Vaticano, 1953.

Margherita Cecchelli Trinci. "Observazioni sul complesso della 'domus' celimontana dei SS. Giovanni e Paolo." *ACIAC* 9 (1978): 551-62.

SS. Giovani e Paolo ranks with the *domus ecclesiae* of Dura as one of the two most important complexes of pre-Constantinian church architecture. Though less certainly a *domus ecclesiae* than Dura, the reconstructed architectural development of this complex gives us more insight into the growth of congregational life and worship than any other architectural site.

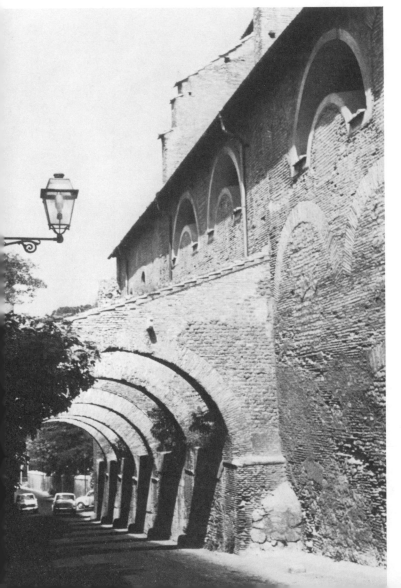

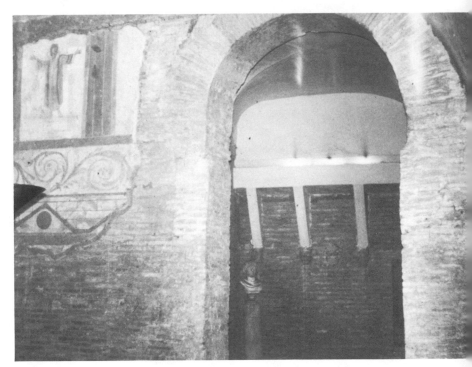

Plate 34. Wall of SS. Giovanni e Paolo adjacent to the Clivus Scauri. *The large arches below represent approximately the first-century shops. The bricked-in windows at the top show the supposed development of a Christian hall above the shop complex.*

Plate 35. Room where second-century Christians met. SS. Giovanni e Paolo, Rome.

SS. Giovanni e Paolo was built in a housing and business complex, or *insula*, located on the western slope of the Caelian hill alongside of and with an axis parallel to the ancient *Clivus Scauri*. The *insula* was divided by a small lane (S in fig. 15), which also came up the hill to intersect with the *Clivus Scauri* above the complex. To the north of this land was a most unusual building containing a commercial bathhouse (U in fig. 15) and a residence.

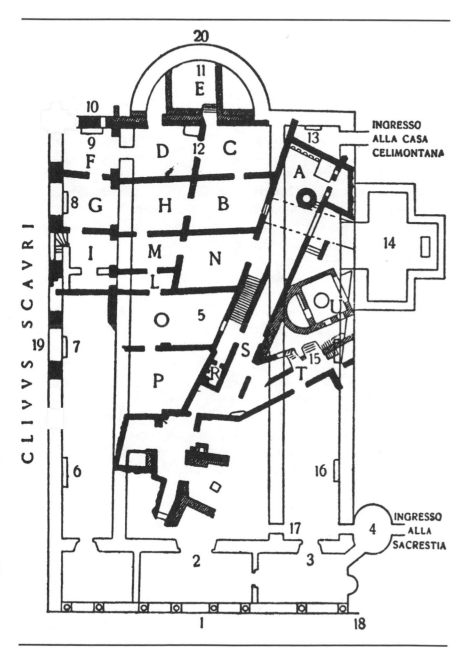

Figure 15. Plan of SS. Giovanni e Paolo.

Probably another residence existed down the hill to the west of the bath. On the south side of the lane, next to the *Clivus*, the major building was a shop-apartment complex with an independent house to the east. All of these buildings, constructed in the first third of the second century, contributed to the development of the basilica, though the independent house on the southeast side of the lane remained that way until the basilica was completed ca. 410 (Krautheimer, 301).

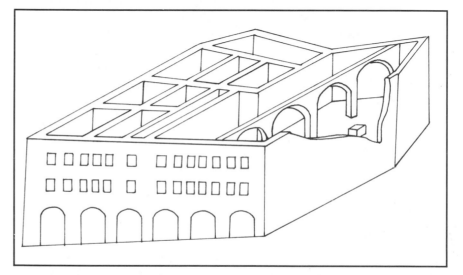

Figure 16. Isometric reconstruction of SS. Giovanni e Paolo, ca. 300.

We are concerned primarily with the shop-apartment complex facing the *Clivus Scauri*. About the middle of the third century some unusual changes occurred in the structure of the building. In front of the five shops a façade was built that extended directly to the *Clivus*. The arcades inside the façade (F, G, I in fig. 15) were not constructed to correspond directly with the shops. At the same time the window structure of the apartment (still visible in the south foundation wall of the basilica; see fig. 16) did not correspond with the ordinary structure of a building used for residences. The windows of the west end do indicate that there were

small rooms behind them, but those of the east end are so spaced as to give light and ventilation to a large hall. Furthermore, in the large hall the second floor was removed, making the hall two stories high. Below the hall appropriate support changes were made and a corridor (L in fig. 15) developed between shops three and four that gave access to the back room of shop three (N in fig. 15). One feels certain that here is a development, like that of Dura, in which an apartment complex has been transformed into a meeting place for the Christian community. But the changes noted do not in themselves prove a "Christian" transformation.

At the beginning of the fourth century the room in shop three was painted with frescoes that are almost surely Christian in nature. At least in the southeast corner of that room one finds an Orante quite like those in early Christian symbolism. At the same time a monumental stairway was built on the north side of the shop-apartment complex. It led from shop three to the upper meeting hall. These fourth-century changes must have been Christian. They allowed Christians to enter through the corridor in shop four to the room of shop three and go up the stairs in the lane to the meeting hall in the upper floors.

Toward the middle of the fourth century another momentous change occurred. A *confessio* (R in fig. 15) was installed below the floor of the hall at the top of the stairs, so that one walked around the new structure, with its relics of SS. John and Paul, up to the hall itself. Krautheimer believes the *confessio* emerged into the floor of the hall about a meter high and there served as the basis for the altar. He also believes a *mensa* existed in the hall prior to the installation of the *confessio*. Both of these theories are somewhat speculative.

C. *Titulus Equitii* and *Titulus Sylvestri*

Bruno M. Apollonj-Ghetti. "Le chiese titolari di S. Silvestro e S. Martino ai Monti." *RivAC* 37 (1961): 271-302.

Edmondo Coccia. "Il 'titolo' di Equizio e la basilica dei SS. Silvestro e Martino ai Monti." *RivAC* 39 (1963): 235-45.

R. Krautheimer. *Corpus*, 3 (1967): 87-124.

C. Pietri. *Roma cristiana*, 1:17-21.

R. Vielliard. *Les origines du titre de St-Martin-aux-Monts*. Rome: PIAC, 1931.

The Roman hall that lies to the west of present-day S. Martino ai Monti has frequently been cited as the most likely *domus ecclesiae* in Rome (Vielliard, *Recherches*, 35; *Les origines*, 24-46). The building consists of a rectangular hall 17.20 meters by 14.20 meters covered by six cross vaults, which then create six compartments. To the west of this third- or fourth-century building were added two chambers and another compartment. To the east of the hall, which shows no sign of Christian usage, stands another building of which we can only discern the west wall. In the sixth century this building was joined to the hall, creating yet another set of compartments. The door in the west wall of this building was enlarged, a door made in the east wall of the Roman hall, and paintings and niches so placed that traffic moved through the old Roman hall into the adjacent (now annexed) building that today lies under S. Martino ai Monti. When one considers this archaeological history in light of the literature of the period (the *Liber pontificalis*), it would seem likely that Pope Symmachus (514-519) built a church over the *titulus Equitii*, presumably the possession of a presbyter Equitius, and that about the same time the adjacent Roman hall came to be known as *titulus Sylvestri*.

If this reconstruction (see Krautheimer and Pietri) is accurate, then the Roman hall could not possibly have been a *titulus* before the sixth century, while the real *titulus Equitii* remains buried under the present S. Martino ai Monti. The sixth-century additions that united the two buildings still remain a puzzle, but in any case, nothing regarding third-century Christianity can be learned here.

D. *Titulus Anastasiae*

E. Junyent. "La maison romaine du titre de S. Anastasie." *RivAC* 7 (1930): 91-106.

R. Krautheimer. *Corpus*, 1:42-61.

C. Pietri. *Roma christiana*, 1:461-64.

Ph. B. Whitehead. "The Church of Anastasia in Rome." *AJA* 31 (1927): 405-20.

At first glance the title church Sta. Anastasia appears to have the same origins as SS. Giovanni e Paolo, for it too was built over an *insula* consisting primarily of a shop-apartment complex, which was located on the southwest corner of the Palatine near the Circus Maximus. The buildings were variously altered up to the middle of the third century, but still retained their identity as a shop-apartment complex. In the mid-fourth century, presumably under Bishop Damasus, a church was built into the *insula*. This church, like SS. Giovanni e Paolo, has maintained the previous Roman complex in its foundation walls. But neither archaeological nor literary evidence gives us reason to suppose we have here a *domus ecclesiae*. The name *titulus Anastasiae* was given to the church in the sixth century when the cult of that saint was transferred to Rome from Constantinople.

E. *Titulus Crisogoni*

R. Krautheimer. *Corpus*, 1:144-64.

Maurice Mesnard. *La basilique de Saint Chrysogone a Rome*. Città del Vaticano, 1935.

Though there is no sign here of an earlier private possession, a *titulus*, by Crisogonus or anyone else, still this building must be one of the most instructive in Rome. A Roman house, dating from the second century, was found to the left of the apse of the fourth-century basilica (Mesnard, 24-25). Apparently near the turn of the century (that is, ca. 301), the Christians of that area built a hall 100 Roman feet long (a Roman foot equals 0.296 meters) and 58.5 Roman feet wide. The hall had a monumental east end façade (see fig. 17), or entrance, and two doors on the left or south side. There was apparently no attached furniture or other structural accommodations, since the walls were painted throughout. Later in the

century a division was made at the west end of the building that created two areas—a large one, 78 Roman feet, toward the entrance, and the smaller one, 21 Roman feet, toward the west. Presumably this division marked at least an incipient choir screen. At the same time three doorways were opened on the right (north) wall.

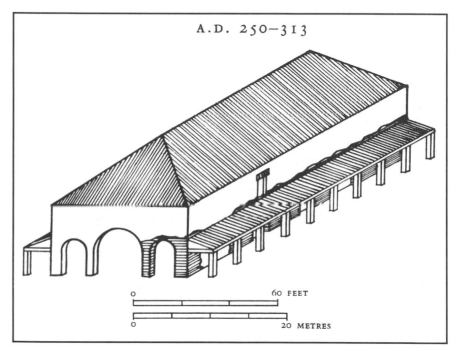

A.D. 250-313

Figure 17. Isometric reconstruction of S. Crisogono.

Toward the end of the fourth century the western wall was demolished and the building lengthened 12.22 meters. An apse was then added. At the entrance, east end, a 25-Roman-feet narthex was created, which produced a hall or single nave 115 Roman feet long. In the front of the apse a *confessio* was inserted and made available to the congregation by an ambulatory-crypt.

If this hall was built in 310, or at least prior to Constantine's own building program, then this, or possibly the north church at Aquileia, must be the earliest-known structure built specifically

for the Christian assembly. We can note that this building specifically designed for Christian usage was a meeting hall just like the smaller areas we have found in Dura or SS. Giovanni e Paolo. There were no special appointments or divisions for liturgical purposes. Only later was it necessary to divide clergy from laity (the screen of the mid-fourth century). The *confessio* and the altar were introduced no earlier than the end of the fourth century or the beginning of the fifth. The cult of the martyr Chrysogonus was known in Rome by the middle of the fifth century and only at the end of that century do we hear of priests from the *titulus Crisogoni*. In summary, the developmental pattern fits well with the pattern observed at SS. Giovanni e Paolo, except that here no evidence exists for a prior meeting room. We might summarize the two patterns as follows:

250-300	private room
280-310	meeting hall
350-380	appurtenances and divisions in the hall
375-400	insertion of *confessio*, cult of the saint, and altar
450-	building of basilica

F. *Titulus Pudentis*

Amato Pietro Frutaz. "Titolo di Pudente." *RivAC* 40 (1964): 53-72.

R. Krautheimer. *Corpus*, 3:277-305.

Antonio Petrignani. *La basilica di S. Pudenziana in Roma*. Città del Vaticano, 1934.

Again, at first glance, Sta. Pudentiana might offer a fine example of a *domus ecclesiae*, but a more thorough examination indicates that this is not possible. Still, the development of this church does offer useful information regarding the meeting of Christians in places other than homes or apartments. The substructure of the façade of the present church is the façade of a Roman house built about A.D. 129. Other elements of the house exist under the nave of the church. A bath was built adjacent to and up the hill from the house about 139. The bath was oblong, about 9 meters wide and 27 meters long. Colonnades of six columns on each long side and two in the curved end created an ambulatory.

Mention of a congregation in this bath first occurs in 384. Toward the end of the century a first phase of remodeling occurred in which the west-end wall of the bath was built into an apsidial curve on which the famous mosaic of Sta. Pudentiana was placed. It cannot be determined when the congregation of Sta. Pudentiana first met in the Baths of Novatianus nor when they gained total possession of the building. One only knows that they met there for some years before the building was transformed into a basilica and the title *titulus Pudentis* was given to it. Again we can see that the Christians of the third and even fourth centuries sought only a meeting place and only late in the fourth century did they seek out formal Christian architectural structures.

V. CEMETERY STRUCTURES

Friedrich Wilhelm Deichmann. "Märtyrbasilika, Martyrion, Memoria und Altargrab." *Mitteilungen des Deutschen Archäologischen Instituts. Römische Abteilung*. Band 77 (1970): 144-69.

Ejnar Dyggve. *Dødekult, Kejserkult og Basilika*. København: P. Branner, 1943.

Paul-Albert Février. "Le culte des morts dans les communautes chrétienne durant le IIIe siècle." *ACIAC* 9 (1978): 211-74.

André Grabar. *Martyrium*. Paris: Collège de France, 1946.

T. Klauser. "Christliche Märtyrerkult, heidnischer Heroenkult und spätjüdische Heiligenverehrung." *Gesammelte Arbeiten*. Münster: Aschendorff, 1974.

——————. "Von Heroon zur Märtyrerbasilika." *Gesammelte Arbeiten*, 275-91

R. Krautheimer. "Mensa-Coemeterium-Martyrium." In *Studies in Early Christian, Medieval and Renaissance Art*. New York: University Press, 1969, 35-58.

J. B. Ward-Perkins. "Memoria, Martyr's Tomb and Martyr's Church." *JTS* 17 (1966): 20-38.

The early Christians had two places of meeting: the *domus ecclesiae* (or hall, marketplace, bath) and the cemetery. The function of the two places differed considerably both liturgically and sociologically. In the church they worshiped by praying, singing psalms, reading the Scriptures, and celebrating the *Tatsache* of the faith through an ἀνάμνησις communion. In the cemetery they celebrated their kinship with the Christian special dead and with each other. At the cemetery there was an emphasis on eating together. Provisions were made for eating and the architectural structure itself developed around a nuclear burial site either of a family progenitor, or more likely for the early Christians, the special dead. Apparently these celebrations were highly social in nature and quite flexible. We note from the graffiti that prayers were addressed to the dead on behalf of the living, various eating and drinking acclamations were made to the deceased, and the meal was eaten in honor of the birthday or death day of the departed person. Though highly social in nature, the meal also served as a means of sharing with the poor. In contrast to the urban meeting place and its ἀνάμνησις, the liturgy of the cemetery centered on the agape meal as adapted through the social matrix of the Roman world. In the ancient world the grave of a special person housed the δαίμων of the deceased. That δαίμων had certain powers and could be consulted. It was especially important in the formation of a community (kinship) and the stabilizing of primary sociological forces. Therefore, ancient people not only established kinship with the dead of their own family, but they also celebrated the presence of the special dead. Several scholars now assume that there is a strong continuity between the ancient "cult of the special dead" and the formation of saints in the early Church. Certainly there is a powerful "cult of the special dead" in the pre-Constantinian Church that cannot be unrelated to the practices of the social matrix. So the practice continued, but architectural and locative continuity are less obvious.

The clearest examples of pre-Constantinian martyria are located in Rome, but others are available. Though hardly any Christian community of the Roman world would have been without a martyrium, most often the extant edifices are post-Constantinian.

A. Catacombs

Umberto M. Fasola and Pasquale Testini. "I cimiteri cristiani." *ACIAC* 9 (1978): 103-39.

P.-A. Février. "Études sur les catacombes romaines." *Cahiers archéologiques* 10 (1959): 1-26; 11 (1960): 1-14.

J. Guyon. "La vente des tombes a travers l'épigraphie de la Rome chrétienne." *Mélanges d'archéologie et d'histoire: Antiquite* 86 (1974): 549-96.

L. Hertling and E. Kirschbaum. *The Roman Catacombs*. London: Darton, Longman and Todd, 1956.

T. Klauser. "Die Kathedra im Totenkult der heidnischen und christlichen Antike." *Liturgiegeschichtliche Forschung* 9 (Münster, 1927).

Louis Reekmans. *Die Situation der Katakombenforschung in Rom*. RWAW, 1979.

Paul Styger. "Die Methode der Katakombenforschung." Separatabdruck aus *Monatrosen*, Nr. 1/2, October, 1930, 1-14.

_____ . *Die römischen Katakomben*. Berlin: Verlag für Kunstwissenschaft, 1933.

Pasquale Testini. *Le catacombe e gli antichi cimiteri cristiani in Roma*. Bologna: Cappelli, 1966.

M. de Visscher. "Le régime juridique des plus anciens cimetières chrétiens a Rome." *Analecta Bollandiana* 69 (1951): 39-54.

With some localities, where particular topographical and geological conditions obtain, it becomes feasible and even advantageous to bury under the ground rather than in mausolea or in ground-level graves. There were several places in the Roman world where catacombs appeared, but by far the best are preserved in Rome. There early Christians made popular a solution to the problem of expensive burial land: they purchased the rights to bury underground in the soft tufa. As this solution continued and various areas were developed, the catacombs of Rome became an incredi-

ble complex with sixty to ninety miles of networking and thousands of burials. The use of the catacombs lasted about three centuries, from the end of the second to the end of the fifth. It is from these catacombs that much of the evidence for early Christianity has been gleaned. The graves or *loculi* were covered with marble or terracota plates called *tituli*. On these we have found most of the symbols and inscriptions mentioned in this work. Occasionally the tunnels pass a larger room called a *cubiculum* in which we find family burials. These are often decorated in the style of the time, sometimes with "Christian" frescoes. A major burial may be marked by a carved-out canopy called an *arcosolium*. These may be decorated with determinative or especially significant frescoes. Some of these private areas have seats or cathedrae carved out, presumably for use in eating with the dead. As a matter of parallel interest, in the Trier area a large number of sarcophagi have a flat area on the lid about 1.5 meters square. Presumably these were for the convenience of eating with the dead (see plate 19).

Since the catacombs have not served as public edifices, we have not generally considered them as legitimate elements of early Christian architecture. However, the contribution of the catacombs to martyria and covered cemeteries ought to be examined briefly. The older "Roman school" (that is, Wilpert) thought the origin of the catacombs paralleled that of the *tituli* of Rome, that is, wealthy first- and second-century Roman Christians donated (gave over the title of) their estates or burial land to the early Church. The burial nuclei would be named, according to this perception, after the donor. So, for example, the Catacomb of Domitilla refers to Flavia Domitilla, granddaughter of the Emperor Vespasian. The nucleus for the immense catacomb network named after her is the Flavian Gallery.

Styger showed that first-century and early-second-century dates for the catacombs were impossible. In his *Die römischen Katakomben* he presented a list of catacombs that are certainly second century. Most scholars today would shift these to the third century, while others would also want to include more recent finds. Oddly enough, none of the catacombs listed as early ever evolved to the covered cemetery complexes so characteristic of the Constantinian era. Those with nuclei that are certainly third century follow.

1. The Catacomb of Priscilla

L. de Bruyne. "La 'cappella greca' di Priscilla." *RivAC* 46 (1970): 291-330.

P.-A. Février. "Études sur les catacombes romaines."

Styger. *Die römischen Katakomben*, 100-45.

Testini. *Le catacombe*, 69-75.

Francesco Tolotti. *Il cimitero di Priscilla*. Città del Vaticano, 1970.

According to Styger, the catacomb of Priscilla contains three quite separate sections that were independent of each other and actually not joined together until the end of the third or beginning of the fourth century. These three sections or regions were: one containing the *hypogeum* of an Acilian family; one containing the *cryptoporticus*, or hidden hall, of a villa; and one built into an *arenarium*, or sandpit. De Rossi connected the three regions and supposed the total started from the Acilian nucleus. The first presumed family convert was Acilius Glabrio, consul in A.D. 91. Glabrio allegedly was killed in a conflict with the Emperor Domitian, so it was easy to suppose that he was a Christian. Many of the Acilians were indeed buried in the *hypogeum,* but the only one surely a Christian was Acilius Rufinus, whose tomb bore the inscription ΖΗΣΗΣ ΕΝ ΘΕΩ. But this epitaph belongs to the late third or early fourth century. So the supposed nucleus of the early patron actually has no Christian history prior to the fourth century. The second section, that of the *cryptoporticus*, does have an earlier Christian history. It contains the Capella Greca with its justly famous frescoes (E of fig. 18). There is almost universal agreement that this nuclear section goes back to the early third century, making the frescoes of the Capella Greca among the earliest examples of Christian art. From this general area de Rossi took the 370 inscriptions we will use as certainly pre-Constantinian (see chapter 6). The third section derived from a period as early as, if not earlier than, the Capella Greca. It consisted of poorer graves with almost no *cubicula* or monumental structures. By confusing

the three separate sections, earlier scholars not only supposed that the entire complex dated back to the first century Acilian family, but they also missed the apparent signs of developing, rather than original, wealth—from poor *loculi* to large, painted *cubicula* and formal burial structures, such as the *hypogeum*.

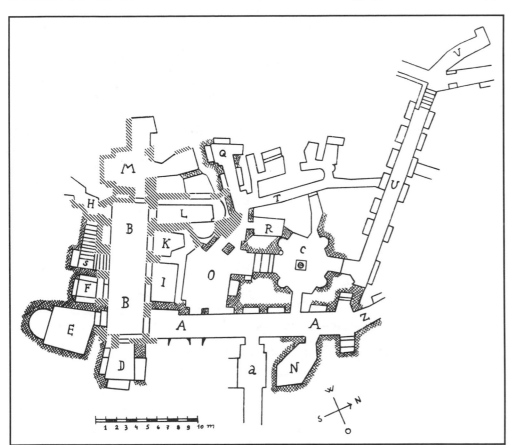

Figure 18. Plan of the Catacomb of Priscilla at the level of the Capella Greca.

2. *The Catacomb of St. Callixtus*

Hugo Brandenburg. "Das Grab des Papstes Cornelius und die Lucinaregion der Calixtuskatakombe." *JAC* 11/12 (1968-1969): 42-54.

A. Ferrua. "Lavori a Callisto." *RivAC* 51 (1975): 213-40.

——————. "Ultime scoperte a Callisto." *RivAC* 52 (1976): 201-19.

Louis Reekmans. *La tombe du Pape Corneille et sa region cemeteriale.* Città del Vaticano: PIAC, 1964.

Styger. *Die römischen Katakomben*, 21-62.

Testini. *Le catacombe*, 61-69.

Joseph Wilpert. *Die Papstgräber und die Caeciliengruft in der Kata-kombe des hl. Kallistus.* Freiburg: Herder, 1909.

Hippolytus, in the ninth book of his *Philosophumena*, noted that Bishop Zephyrinus (bishop of Rome ca. 200-217) gave over the administration of "the cemetery" to a certain deacon Callistus. The importance of this cannot be overlooked. First, it sets a date for the public appearance of Christianity. The Church had property, which was a matter of public knowledge. The date of this important move corresponds roughly with the date we have set for the appearance of a distinguishable Christian culture. Once again we see evidence that Christian art and architecture started to appear at the beginning of the third century. There are two corollaries to this piece of information: the cemetery must have been used prior to 200 and presumably by Christians. But there is nothing to indicate that. The "Roman school" connected the catacomb with Pomponia Graecina (ca. A.D. 56-57), a noblewoman who might have suffered as a Christian. There is no archaeological evidence to connect the catacomb of Callixtus with a crypt of the Pomponians. Like Priscilla, there was a history of the cemetery prior to 200, but no Christian evidences. The noble Roman connection was a romantic explanation for Christian acquisition of the property. The second corollary goes in the opposite direction. Once the Church had "gone public" economically and politically and had established cultural expressions by symbols and art, then the church created monumental

architectural symbols. That is the meaning of the catacomb of St. Callixtus and especially the site popularly known as the "Crypt of the Popes." Following the death of Zephyrinus, eight more bishops were buried in Callixtus: Pontianus (230-235); Anteros (235); Fabian (235-250); Cornelius (251-253); Lucius (253-254); Eutychian (275-283); Caius (283-296); and Eusebius (310). Oddly enough, the tomb of Zephyrinus has never been identified.

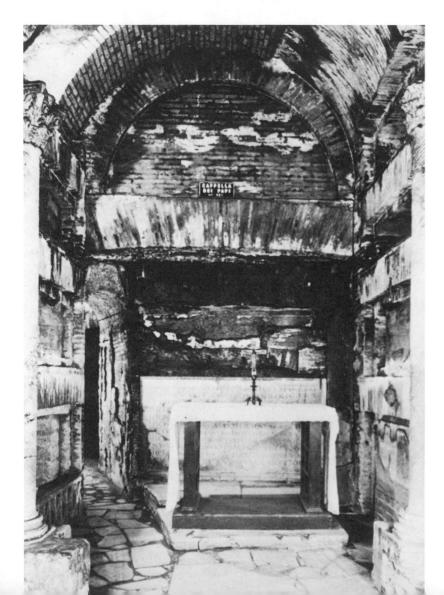

Plate 36.
Crypt of the
Popes in the
Catacomb of
St. Callixtus.

A primary nucleus of this cemetery was the early formation of the burial place for the bishops of Rome. Nearby was developed a series of *cubicula* with frescoes, especially of the meal and symbols of the meal. These so-called *cubicula* of the Sacraments contain much of the earliest art (A^{1-3} and the three extending from the same gallery; see above, p. 32).

A second major nucleus centers around the so-called crypt of Lucinia. There Bishop Cornelius was buried (253), so the area must be somewhat older than his death date. The double chamber of Lucinia contains some of the best preserved of that art we deem surely prior to Constantine (see above, p. 32).

The catacomb of St. Callixtus was the first one explored scientifically. It was discovered by de Rossi in 1849, when he found a portion of Cornelius's inscription in a toolshed above the catacombs. He convinced Pius IX of the value of his find and the probable treasure underneath. The pope bought the vineyard where the slab was found, and in 1854 de Rossi discovered the Crypt of the Popes.

3. The Catacomb of Domitilla

L. Pani Ermini. "L'ipogeo detto dei Flavi a Domitilla." *RivAC* 45 (1969): 119-73; 48 (1972): 235-69.

P. Pergola. "La region dite du Bon Pasteur dans le cimetiere de Domitilla sur l'Ardeatina." *RivAC* 51 (1975): 65-96.

Styger. *Die römischen Katakomben*, 63-99.

Testini. *Le catacombe*, 52-55.

Domitilla takes its name from the granddaughter of the Emperor Vespasian and wife of Titus Flavius Clemens (consul in A.D. 95). There were conflicts with the Emperor Domitian, and tradition has it that one of Domitilla's household assassinated the emperor. Christian tradition has it that the couple was Christian. There is good reason to believe that the land where the catacomb of Domitilla is located was indeed property belonging to the Flavian family. Consequently the nucleus of the Christian catacomb, a gallery originating about the middle of the third century, has been called the *hypogeum* of the Flavians. As Testini shows, this area and the

area of the Flavi Aureli, which contains inscriptions from the Flavian family, had an earlier pre-Christian history. A third area, around the *cubiculum* of Ampliato, probably began about the middle of the second century. None of these earlier areas shows any Christian connection, so the earliest Christian materials do actually come from the so-called *hypogeum* of the Flavians, where frescoes of Daniel in the Lion's Den and Noah in the Ark have been found (see above, p. 33).

It should be noted that a somewhat abortive building program occurred on the site. Early in the fourth century the remains of the martyrs Nereus and Achilleus were placed in a crypt at the third level. Bishop Damasus (366-384) built over the crypt a small basilica, which was enlarged by Bishop Siricius before the end of the century. The purpose of such a basilica outside the walls has not been clearly determined. One would have expected a covered cemetery, but as we have noted, Constantine did not choose to build one over any of the three earliest catacombs. Perhaps it was a belated basilica *ad corpus* much like those associated later with the great covered cemeteries (present-day S. Lorenzo, Sta. Agnese).

We have chosen conservatively to describe only those catacomb areas assuredly pre-Constantinian. We have also taken our examples of early Christian art from these three earliest catacombs. There is some pain in that choice. There are sections of the catacomb of Praetextatus (the *Scala maggiore*) and the catacomb of SS. Marcellinus and Peter that have art assuredly done before the turn of the century. Much of it matches precisely the art of the other three catacombs. But these two do not possess a clearly defined nucleus; some of the art may be fourth century. Another great source, the recently discovered catacomb of Via Latina, has been dated fourth century by Ferrua.[1] The addition of these materials would have altered the statistical chart (p. 43), but the list of illustrations would have remained approximately the same.

Most important to note here is that the Church in Rome went

public at the turn of the second century. It became a public landholder, hired caretakers and diggers for the catacombs (the *fossori*), sold legal titles for the graves through the *fossori* organization, and developed monumental underground architecture for the special dead of the organization (bishops, not martyrs). All this occurred as the first traces of a Christian culture appeared.

B. Martyria

Friedrich Wilhelm Deichmann. "Märtyrbasilika, Martyrion, Memoria und Altargrab." *Mitteilungen des Deutschen Archäologischen Instituts. Römische Abteilung.* Band 77 (1970): 144-69.

Ejnar Dyggve. *Dødekult, Kejserkult og Basilika.* København: P. Branner, 1943.

Paul-Albert Février. "Le culte des morts dans les communautes chrétienne durant le IIIᵉ siècle." *ACIAC* 9 (1978): 211-74.

André Grabar. *Martyrium.* Paris: Collège de France, 1946.

T. Klauser. "Christliche Märtyrerkult, heidnischer Heroenkult und spätjüdische Heiligenverehrung." *Gesammelte Arbeiten.* Münster: Aschendorff, 1974.

––––––––––. "Von Heroon zur Märtyrerbasilika." *Gesammelte Arbeiten*, 275-91.

R. Krautheimer. "Mensa-Coemeterium-Martyrium." In *Studies in Early Christian, Medieval and Renaissance Art.* New York: University Press, 1969, 35-58.

S. Pelekanidis. "Kultprobleme in Apostel-Paulus-Oktogon von Philippi im Zusammenhang mit einem aelteren Heroenkult." *ACIAC* 9 (1978): 393-99.

J. B. Ward-Perkins. "Memoria, Martyr's Tomb and Martyr's Church." *JTS* 17 (1966): 20-38.

The earliest catacombs developed as an alternative to the necropolis at ground level. The ancient nuclei of these catacombs were non-Christian cemeteries that were associated for various reasons with earlier Roman patrons. Despite popular opinion, the catacombs were not the tombs of the martyrs nor the location of

[1] A. Ferrua, *Le pitture della nuova catacomba di Via Latina* (Città del Vaticano, 1960). See also L. Kotzsche Breitenbruch, "Die neue Katakombe an der Via Latina in Rom," *JAC*, Ergänzungsband 4, 1976.

the cult of the special dead. There were martyrs buried in the catacombs, but in the early, large ones veneration of the martyrs was hardly a causative factor in the development. The martyr cult developed more above the ground in special edifices called martyria. Widespread as these must have been, there are only two martyria unrelated to the covered cemeteries that we can consider pre-Constantinian: one at Bonn, in Germany, and a less obvious one at Salona, in Yugoslavia.

1. Bonn: Sts. Cassius and Florentius

W. Bader. "Zur Kritik des Bonner Märtyrgrabes." *Bonner Jahrbücher* 148 (1948): 452-53.

T. Kempf. "Frühchristliche Funde und Forschungen in Deutschland." *ACIAC* 5 (1957): 61-72.

T. Klauser. "Bemerkungen zur Geschichte der Bonner Märtyrergräber." *Gesammelte Arbeiten*, 310-13.

H. Lehner and W. Bader. "Baugeschichtliche Untersuchungen am Bonner Münster." *Bonner Jahrbücher* 136/137 (1932): 3-211.

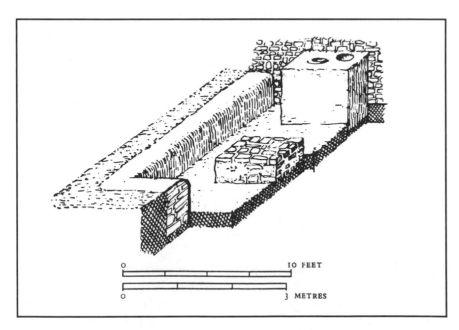

Figure 19. Drawing of the two mensae *under the Münster in Bonn.*

In 1928, excavations were undertaken beneath the Münster at Bonn, Germany. The discovery of a pre-Constantinian martyrium, even though debatable, actually gives us the best picture for understanding the function and structure of this architectural category in early Christianity. On a northeast axis (the Münster itself is on an east-west axis), at the lowest level of the excavation, was discovered a martyrium 3.25 meters by 2.55 meters (fig. 19). On the interior were two *mensae*, a complete one to the north, 0.88 meters high and 0.78 meters to 0.89 meters by 0.74. The south one was incomplete at 0.32 meters high and 0.70 meters by 0.80 meters. On top of the complete *mensa* (fig. 19) was a tile bowl and next to that a molded ring 0.012 meters high and 0.17 meters in diameter.

Obviously the Bonn location portrays very accurately the practice of eating with the dead, and particularly the special dead. In this roofed (Klauser) room people sat and shared their food with the dead (the drinking cup sat in the ring and food was held in a vase [see symbols, p. 16] or dish in the bowl). From literary accounts and pictorial representations we know that food was also shared with the needy.

The excavators were disturbed by their failure to find the original tomb of the martyrs (*BJ* 148 [1948]: 452), but they need not have been. As is clear from the developments in Rome, martyria were not built over the graves, but near them. In Bonn this was also presumably true. Very likely, early in the fourth century a nonmasonary cemetery building was laid out (the burials show an orderly outline on the northeast axis). Toward the end of the century a hall church was built over the martyrium, which had been destroyed by A.D. 300.

The Münster itself was erected on an east-west axis with its high altar over a series of burials to the southwest of the martyrium. The builders of the Münster thought they were building a basilica *ad corpus* over a location that was specifically not the martyrium.

Actually there is nothing to prove the martyrium was Christian. It could have been destroyed because it was a heathen holy place and replaced by a Christian cemeterial building, but that seems unlikely. Even the political attack on the cemetery of the

equites singulares at SS. Marcellino e Pietro (see pp. 96-98) started with the substitution of a Christian nucleus rather than simply iconoclastic destruction. One assumes, then, that we have in the Bonn martyrium at least a place used by third-century Christians to celebrate with a martyr and with the family dead.

2. Salona

E. Ceci. *I monumenti cristiani di Salona*. Volume two. Milan: Edizioni Pleion di Bietti, 1963.

Ejnar Dyggve. *History of Salonitan Christianity*. Oslo: Aschehoug, 1951.

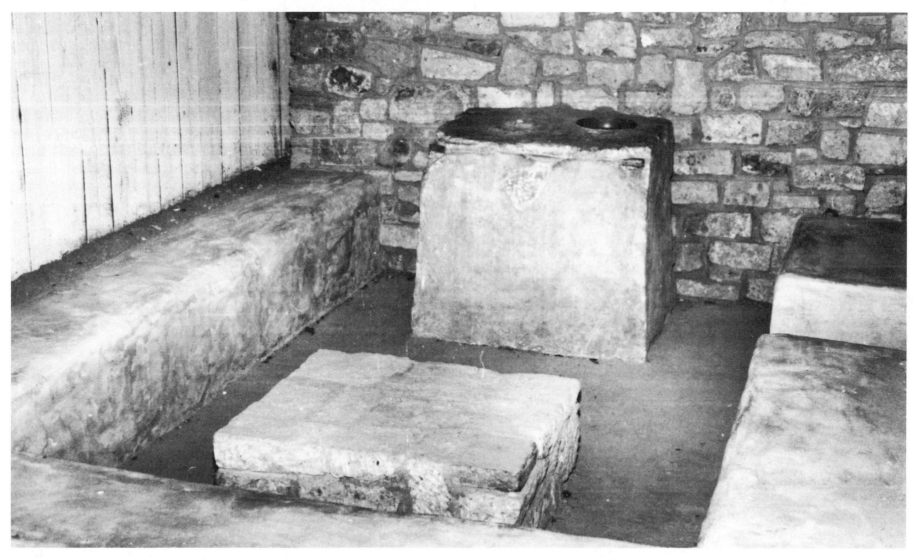

Plate 37. The two mensae *of the Bonn martyrium as set in a reconstruction for the Rheinisches Landesmuseum, Bonn.*

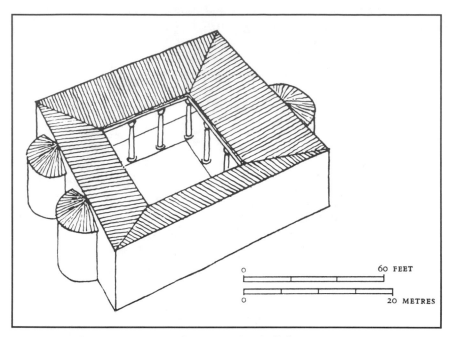

Figure 20. Reconstruction of a memoria *at Salona.*

In Salona the graves of a number of martyrs have been discovered. Most of these were killed during the persecution of Diocletian, that is, around 304 (see Dyggve, 74). These martyrs were buried in ordinary cemeteries in a style not readily distinguishable from the other burials. However, the Christian community was aware of the graves. They sought to be buried near them, sometimes even marking their own graves as *iuxta loca sanctissima* or *martyribus adscita.* And their place of burial was so constructed that the cult of the dead could be held with the martyr and with those buried nearby. Dyggve describes several such edifices (fig. 20). In addition to providing access to the remains of the martyr, a *triclinium* or *triclinium funebre* was constructed so that the *refrigerium* or *solemnia,* as it was known in Salona, could be celebrated. The arrangement consisted of a burial in a stationary *triclinium* (I of fig. 21); or in a sarcophagus with the lid at floor level and appropriate rims and depressions in the lid (II of fig. 21); or, later, in a sarcophagus with a *mensa* set over the lid of the sarcophagus (III of fig. 21). The rims for holding cups, vases, and dishes have already been described in the Bonn martyrium. Some samples of the types of bowls used can be seen in figure 22. The depressions in the lid of the sarcophagus, called *tesellae* in Salona, may have either held the food for the meal or served as the means for injecting the food into the sarcophagus itself. The *tesellae* on the top row of figure 23 are containers, while those on the bottom row show how food was given to the dead. Portable slabs, somewhat like that of the *mensa* in Bonn, were actually made for the purpose of eating with the dead (see fig. 24). In Salona these were called *piscinae,* a term otherwise used for the baptismal font. The *piscinae* were placed directly on the grave or, as seen in III of figure 21, might be placed on a *mensa,* portable or otherwise (as in Bonn). In more elaborate graves, the lid of the sarcophagus was a complete *mensa* (as in fig. 21) or even a *triclinium* itself.

Figure 21. Types of mensae *found in Salona.*

Unfortunately, though Salona provides us with an incredible quantity and variety of material for early Christian archaeology, precision in dating is lacking. We know that the martyrdoms occurred at the beginning of the fourth century and that by the latter part of the fourth century cemeterial buildings were built into the complex. It is difficult to say that before Constantine the

graves of the martyrs were sufficiently differentiated from others to indicate that a cult was practiced. It probably was; but even if it was not, the cultural time lag between Rome and Salona would give us reason to suppose that the architectural and cultic development at Salona was not immediately influenced by political events in Rome. In short, the graves of the martyrs at Salona likely do give us an excellent picture of Christian cemeterial practices before Constantine.

we find fish, bread, and cakes. Presumably the fourth, with access to the tomb, received wine (fig. 25).

Figure 23. Tesellae *found at Salona.*

Figure 25. An agape mensa *top from North Africa. The bowls or plates show a place for fish, bread, cakes, and a* tesella *for wine.*

Figure 24. Portable slabs used in Salona.

The celebration was very social. It strengthened family relationships, either blood or primary, by including extended generations. The service itself included anointing of the stone or *mensa*, antiphonal singing, dancing, the agape or *refrigerium* meal with all the prayers and acclamations attending that. We do assume from the pictures of the meal in Rome and the symbolic portrayals that the meal consisted of fish, bread, and wine. A later *tesella* from Tunis fortunately pictured in the depression or dish what it was expected to hold. In three dishes without access to the tomb

The most powerful community developing force in the ancient world was the cult of the dead. It based the present and future on past loyalties and relationships. Early Christianity entered a social matrix where this was so.

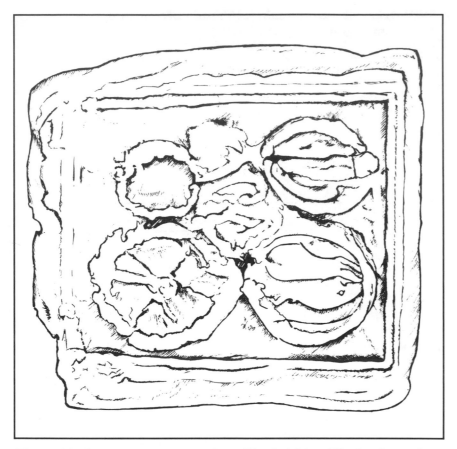

Figure 25. An agape mensa *top from North Africa. The bowls or plates show a place for fish, bread, cakes, and a* tesella *for wine.*

Early Christianity also continued that force. Christians of the third century built edifices to celebrate kinship with the special dead, and their own dead were buried nearby. Christians of the fourth century built larger, public buildings in the cemetery complexes to accommodate the masses who assembled for the cult of the saints. These first buildings, wooden in Bonn and masonry in Rome, parallel the development of assembly halls at the turn of the century (Aquileia and S. Chrysogono of Rome). While none of

these covered cemeteries precede Constantine, their developmental history cannot be ignored. So we turn next to the *coemeteria subteglata*.

C. Covered Cemeteries in Rome

Giuseppe Bovini. *Edifici cristiani di culto d'eta Constantiniana a Roma.* Bologna: Patron, 1968.

Hugo Brandenburg. *Roms frühchristliche Basiliken.* München: Heyne Verlag, 1979.

Friedrich Wilhelm Deichmann and Arnold Tschira. "Das Mausoleum der Kaiserin Helena und die Basilika der heiligen Marcellinus and Petrus an der Via Labicana vor Rom." *Jahrbuch des Deutschen Archäologischen Instituts* 72 (1957): 44-110.

R. Krautheimer. "Mensa-Coemeterium-Martyrium."

Excavations of the past twenty-five to thirty years in Rome have greatly altered our understanding of church architecture, martyrs' graves, celebration of the dead, and early Christian worship. Particularly the excavations under S. Sebastiano and St. Peter's, and the discovery and excavation of Constantine's basilicas at Sta. Agnese, S. Lorenzo, and SS. Marcellino e Pietro have demonstrated the existence of a type of Constantinian building called a "covered cemetery." Four of the buildings, all but St. Peter's, were built with three aisles, a round end opposite the entrance, and a supporting colonnade between the nave and the side aisles. Three of the basilicas were built in catacomb areas near the presumed grave of a martyr but not over that grave. In these three instances, Sta. Agnese, S. Lorenzo, and SS. Marcellino e Pietro, the graves of the martyrs have not been or cannot be further researched. Because of the covered cemetery, data of a pre-Constantinian nature cannot be obtained except for the inference that these graves were known and used as special Christian locations. But S. Sebastiano was built over the *memoria apostolorum* and the *triclinium* for the cult of SS. Peter and Paul. Fortunately, nei-

ther of these was destroyed by the construction of the basilica. At St. Peter's the *raison d'etre* for the basilica involved a special place, the *trophaeum* of St. Peter, rather than a grave. Therefore, provision was made to honor that early edifice. In no case was there an altar over a body (basilica *ad corpus*) and actually there is no evidence of altars at all (though some speak of portable altars of the type noted at Salona). From an archaeological perspective, no permanent altar existed at S. Sebastiano or St. Peter's, while no determination can be made for the other three. At early church councils of the fourth and fifth century, no priesthood for these five buildings was represented. This would support the perception that they were not churches in the hierarchical sense. All five covered cemeteries had massive burials inside or in attached mausolea. In two instances, Sta. Agnese and SS. Marcellino e Pietro, the mausolea were imperial. The presence of these two only underlines our perception that Constantine wished to support the popular religious practices connected with the cult of the dead. And, speaking politically, he must have hoped to curry favor with the Christian community. Three of the complexes, Sta. Agnese, S. Lorenzo, and SS. Marcellino e Pietro, eventually fell into disuse because basilicae *ad corpus* were built over the presumed martyrs' graves about the time of Bishop Damasus (second half of the fourth century) or later. S. Sebastiano was converted into a basilica *ad corpus* and given a saint (Sebastian). It still remains unclear, in fact may always be unclear, what the relationship of St. Peter's is to the remains of the apostle.

Clearly the cemeterial cult of the pre-Constantinian Christians involved proximity to the graves of the saints and martyrs, the special dead. In Rome there is no evidence of a eucharistic celebration in the cemeterial context, and in Salona it was only conjectural. In Rome, Constantine continued the practice of the cult of the dead and sought to be included as one of the significant dead. Only in the later part of the fourth century were graves themselves made the center of the celebrative focus, and not until the next century were there eucharistic celebrations over the remains (relics) of the saints and martyrs. In general this begins to match our perception of the changes that occurred in the development of the Church in the city, the *domus ecclesiae*—that is,

about the end of the fourth century, or the beginning of the fifth, the relics of the martyrs were inserted into the architectural structure of the meeting hall.

In order to gain a complete picture of the third century we will briefly describe Sta. Agnese, S. Lorenzo, and SS. Marcellino e Pietro under the rubric "covered cemeteries." More consideration will be given to S. Sebastiano and St. Peter's since the excavations there have uncovered pre-Constantinian materials. Finally we will say a word about Tor de'Schiavi.

1. Sta. Agnese

Bovini. *Edifici*, 225-69.

Brandenburg. *Roms*, 93-115.

F. W. Deichmann. "Die Lage der konstantinischen Basilika der heiligen Agnes an der Via Nomentana." *RivAC* 22 (1946): 1-22.

R. Krautheimer. *Corpus*, 1:14-38.

R. Perrotti. "Recenti ritrovamenti presso S. Constanza." *Palladio*, n.s. 5 (1955), part 2, 80-83.

Sta. Agnese fuori le mura and Sta. Constanza lie about two kilometers beyond the Aurelian wall on the ancient Via Nomentana as it moves northeast out of Rome. Sta. Agnese itself was built in the seventh century by Pope Honorius I, though a prior building must have been erected between 337 and 349. This fourth-century building was the first architectural attempt to give access to the tomb of the martyr. It was placed in the hill and in that way cut into the extant catacomb. Eventually a basilica with galleries, like in S. Lorenzo and SS. Nereus and Achilleus, was built over the primitive martyrium. We assume the galleries functioned to give more people visual access to the martyr's tomb.

According to the *Liber pontificalis* (1:180) and an inscription copied from the Sta. Agnese cemetery basilica (Krautheimer, 16), the covered cemetery was built at the urging of Constantine's daughter, Constantina, probably while she was a widow (337-351). On the south flank of the great cemeterial basilica (98 meters by

40 meters; the largest of the four), she had constructed a great circular mausoleum that still remains today as Sta. Constanza (in fig. 26 the black indicates extant building).

As for the edifice that preceded the present Sta. Agnese (the building to the north of the covered cemetery in fig. 26), it combined at different periods sets of parallel catacomb galleries. The fourth-century structure contained a wall and an apse set into the catacomb, but unfortunately nothing more can be said. The building had a length of 90 Roman feet and an inside width of 30 Roman feet. It must have consisted of a single nave and an apse. It qualifies as a martyrium edifice built into a pre-Constantinian catacomb as access to the martyr's tomb, but any third-century elements, if they existed, can no longer be traced.

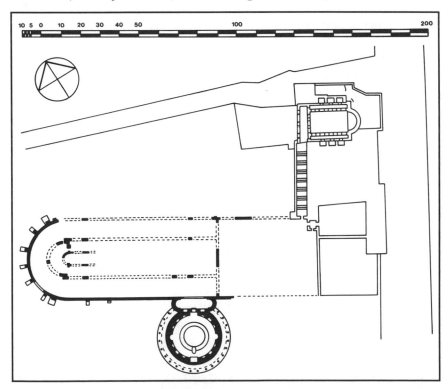

Figure 26. Plan of Sta. Agnese that shows the large coemeteria subteglata, *the attached mausoleum of Sta. Constanza, and the later church of Sta. Agnese built over the catacombs.*

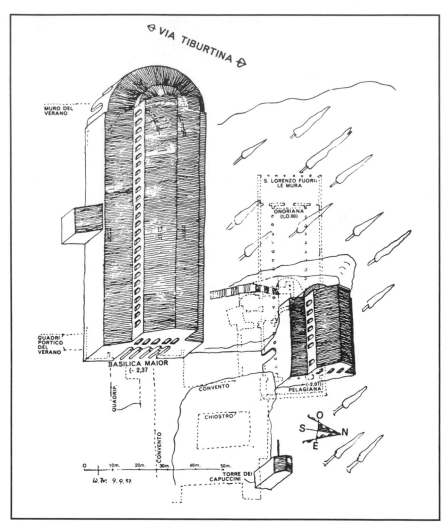

Figure 27. Reconstruction of the S. Lorenzo site showing the relationship of the basilica ad corpus *to the catacomb and the covered cemetery.*

2. S. Lorenzo fuori le mura

Bovini. *Edifici*, 191-224.

Brandenburg. *Roms*, 116-20.

Krautheimer. *Corpus*, 2:1-114.

Richard Krautheimer, Wolfgang Frankl, and Gugliemo Gatti. "Excavations at San Lorenzo f.l.m. in Rome, 1957." *AJA* 62 (1958): 379-82.

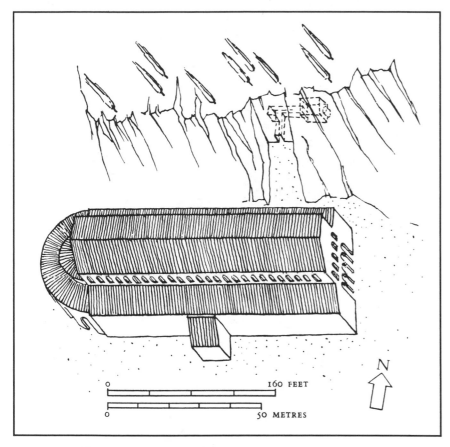

Figure 28. Reconstruction of the coemeteria subteglata *at S. Lorenzo showing its relationship to the catacomb area.*

About one kilometer beyond the wall on the Via Tiburtina, going southwest from the city, stands the complex of S. Lorenzo. Today it consists of a double basilica (back to back, not side by side) and a monastery of the Capuchin fathers attached to the east end of the east church. To the north and east of the church lies a tufa hill; to the west the Via Tiburtina; and to the south the immense plain, Campo Verano, now the municipal cemetery.

The *Liber pontificalis* (1:181) reports that Constantine decorated the tomb of St. Lawrence and built a basilica *supra arenario cryptae*. Until recently this had led to the assumption that the present double basilica, an east church built under Pelagius II (579-590) and a west church built under Honorius III (1216-1227), somehow had covered the Constantinian basilica. Following bomb damage to the basilica during the Second World War, permission was granted to excavate under the church prior to reconstruction. That work was undertaken by R. Krautheimer, E. Josi, and W. Frankl. In 1947-1948 they worked under the Honorarian church. They found extensive fourth-century remains and the apse of the Pelagian church, but no sign of a Constantinian structure. Then in 1950, during the rebuilding of the north wall of the cemetery of Campo Verano, a large apse was discovered. With considerable skill and perhaps some unusual good fortune, the excavators were able to calculate accurately the foundation outline of the building. Several trial digs in the cemetery proved them to be correct. In this way they projected a "covered cemetery" 97.60 meters long inside by 34.20 meters width inside. It was laid out precisely like the covered cemetery of Sta. Agnese and SS. Marcellino e Pietro (fig. 27). This one differed from the others only in that the ambulatory was created by marble columns, not masonry pillars.

The catacomb area, underneath the Honorarian (west) church, probably goes back to the third century, though its relationship to St. Lawrence can no longer be determined. Nevertheless, one could assume an early catacomb nucleus that spread to other galleries over a period of two centuries. The total network was called the Catacomb of Cyrica, after a legendary early donor. A formal set of galleries was constructed over this early nucleus (in the hillside of fig. 28). The construction shows some elegance and appears to be Constantinian (Krautheimer, *Corpus*, 132), so Krautheimer assumes the gallery was built or refurbished by Constantine. Presumably the Pelagian church was built to give access through a *fenestrella* to the tomb at the east end of the gallery. An L-shaped tomb chamber at the west end (see gallery in hillside of fig. 28) took on more importance in the fourth century. From descriptions it appears that other *mensa* tombs were added during that period and one special tomb, with niches for lights, existed. Nothing

more is known. Eventually the "covered cemetery" was destroyed and there remained only the double church built into an eroded hillside over the gallery.

3. SS. Marcellino e Pietro

Bovini. *Edifici*, 160-84.

Brandenburg. *Roms*, 61-71.

Deichmann and Tschira. "Das Mausoleum."

Krautheimer. *Corpus*, 2:191-204.

Three kilometers beyond the present Porta Maggiore on the Via Casilina (old Via Labicana) was a huge imperial property on which now the remains of the basilica of SS. Marcellino e Pietro and the attached Mausoleum of Helena have been identified. At the time of Constantine this area was the exercise area for the *equites singulares* whose barracks were just inside the city wall at the Porta Maggiore. Ironically, and probably deliberately, Constantine used the barracks area as the location for the Lateran, the headquarters for the bishop of Rome. At the exercise area there were several cemeteries, including one for the guards themselves. It is not certain whether among these cemeteries were any third-century Christian catacombs. But tradition maintains that at the beginning of the fourth century the martyrs Marcellinus and Peter were buried there either during the persecution of Diocletian (303-305, according to Damasus), or more likely, at the end of the persecution in 311.

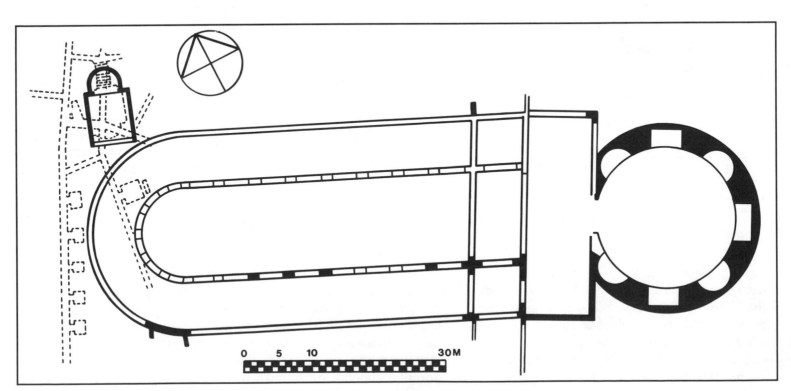

0 5 10 30M

Figure 29. Plan of SS. Pietro e Marcellino.

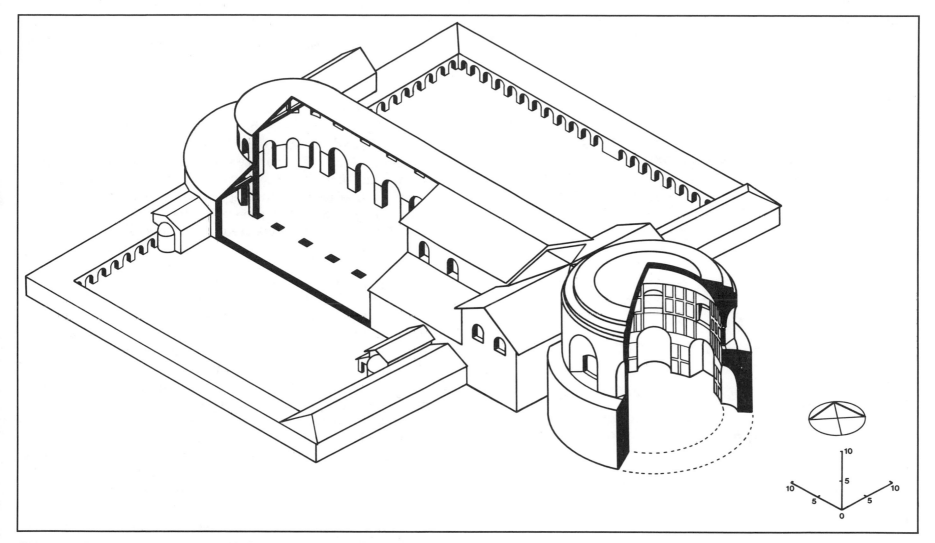

Figure 30. Isometric reconstruction of SS. Pietro e Marcellino.

The monumental circular building attached to the narthex of the covered cemetery was yet another mausoleum (fig. 30). Following the work of Deichmann and Tschira, we now suppose that Constantine constructed this mausoleum for his own burial, but eventually gave it to Helena, his mother (though she did not likely use it).

With an obvious political message attached to his move, Constantine not only built the Lateran over the barracks of the guard but also constructed at the exercise field a huge covered cemetery, 69 meters long and 29 meters wide, in the name of the two martyrs. It was very likely the first of the covered cemeteries built by Constantine. One of the mausolea attached to the basilica at the northwest corner has survived to this day as the chapel of S. Tiburtius (5.56 meters by 6.70 meters, fig. 29). It covered the tombs of the two martyrs. Since it was not actually joined to the covered cemetery but was only tangential, it likely was constructed prior to the cemetery building and could be the causative factor in Constantine's placement of the complex. It would appear that the martyrium was a simple apsed chamber carved out of tufa.

4. S. Sebastiano

Antonio Ferrua. *Guida alla visita della Basilica e della Catacomba di San Sebastiano*. Città del Vaticano: PCAS, 1979.

R. Krautheimer. *Corpus,* 4:95-142.

Hans Lietzmann. *Petrus und Paulus in Rom*. Berlin: Walter de Gruyter, 2d ed., 1927.

Daniel Wm. O'Conner. *Peter in Rome*. New York: Columbia University Press, 1969, 135-58.

Adriano Prandi. *La memoria Apostolorum in Catacumbas*. Città del Vaticano, 1936.

G. F. Snyder. "Survey and 'New Thesis' on the Bones of Peter." *BA* 32 (1969): 2-24.

Paul Styger. *Römische Märtyrgrüfte*. Berlin: Verlag für Kunstwissenschaft, 1935.

_____. "Gli Apostoli Pietro e Paolo ad Catacumbas sulla via Appia." *RQS* 29 (1915): 149-221.

_____. "Il monumento apostolico a San Sebastiano sulla Via Appia." *APARA*, ser. 2, 13 (1918): 3-115; tavole 1-26.

_____. "Scavi a San Sebastiano." *RQS* 29 (1915): 73-110.

Pasquale Testini. "Noterelle sulla memoria Apostolorum in Catacumbas." *RivAC* 30 (1954): 209-31.

Francesco Tolotti. *Memorie degli Apostoli in Catacumbas*. Città del Vaticano: Societa "Amici delle Catacombe," 1953.

Of all the archaeological excavations completed to this date none has been more instructive than the ancient complex under the floor of present-day S. Sebastiano. At the same time the discoveries there cannot be separated from the highly controversial problems that surround the excavations under St. Peter's. Consequently the literature on the subject seems endless. It is important for our purposes that the excavations be presented clearly here. Yet, in light of the massive discussion, only a small part of the research and resultant theories can be mentioned. A very complete bibliography has been prepared by A. de Marco, *The Tomb of St. Peter* (see below, p. 105).

Literature of the Middle Ages always referred to the complex at S. Sebastiano as the *memoria apostolorum*. Pilgrims frequented the basilica several kilometers south on the Via Appia as if they were visiting the martyr tombs of Peter and Paul. Yet from the fourth century on there were major basilicas honoring the two apostles, therefore related in some way to their remains. In short, there was a martyrium for the two great apostles together and then one for each of them. How does one explain this? Could excavations under the three buildings clarify the matter?

De Rossi had assumed the large mausoleum attached to the west end of S. Sebastiano (# 51 in fig. 31) was the *memoria* so revered by the pilgrims. In the 1890s Anton de Waal, a student of de Rossi, did a thorough study of the Platonia, as it was called. He concluded it was the fourth- or fifth-century tomb of a certain Quirinius. De Waal and others then supposed the *memoria* must be under the floor of S. Sebastiano. It was not until 1915 that Paul Styger began to excavate under the main building. The rather immediate discovery of the *triclia* has to be one of the remarkable events in early Christian archaeology. In a moving account it is reported how de Waal gave thanks to God that he had lived to see the *memoria*. But the total excavation involves so much more than

the *triclia* that it would be best to assume the completion of the excavations and then describe a history of the site.

tian burials. The first burials here were not Christian. One burial can be associated with a freedman of Trajan, so one could not an-

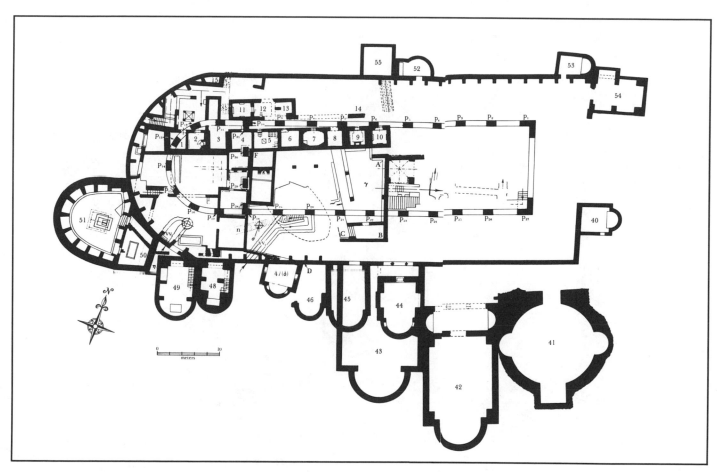

Figure 31. Plan of S. Sebastiano, which includes all levels.

S. Sebastiano was built over a first-century quarry for pozzuolana, a black volcanic deposit used for making cement. At some time in the first century, the quarry was abandoned and its many mine shafts were converted to burial galleries. For some reason this depression, or *arenario* (sandpit), was called a κατάκυμβος in Greek, so its name became the name for all underground Chris-

ticipate a date much after the turn of the century for the conversion to a cemetery. In addition to the galleries, *columbaria* were built along the north wall of the pit (# 1-13), three mausolea were constructed in the pit itself (the dotted area in the center of fig. 31), and later a villa was built to the west of the pit (in the general area of P 28-30 in fig. 31). It is the construction and development

of the mausolea that attracts our attention. On the northwest side of the *arenario* were built the three

Plate 38. The apse of the covered cemetery at present-day S. Sebastiano and the attached mausoleum.

ㄱ ㅇ୨୨੨

rather large mausolea, two of which extended downward farther into the pit (a'-h' of fig. 32). A stairway, which may have been constructed earlier, led downward to the southwest toward a well (s of fig. 32). These existed as pagan burial places until about A.D. 200. In h' a fish and anchor symbol appear. Even more striking, the owners of h' put a portrayal of the meal on the plaster façade, as well as other probable Christian symbols. In the middle mausoleum one grave has IXTOYΣ on it, though no explanation can be given for the transcription or its misspelling. We have here a remarkable case study of this work's thesis. The owners of these three mausolea used non-Christian symbolism for their burials until about 200, when Christian symbols began their rather tentative appearance. We can see this gradual transition, unless one supposes the owners were converted at that time en masse. Sometime around 240 this cemetery *piazzuola* was covered up in order to make way for the *triclia* constructed above it. But prior to that time a cella (β in fig. 33 and the location ϰ in fig. 33) was constructed over the mausolea in such a way that the east edge of the cella rested on the roof of mausoleum a'. There can hardly be any reason for the cella except to facilitate and continue the cult of the dead practiced below. Whatever that reason, about A.D. 250 the large *triclia* to the east of the cella was built over the filled-in *piazzuola*.

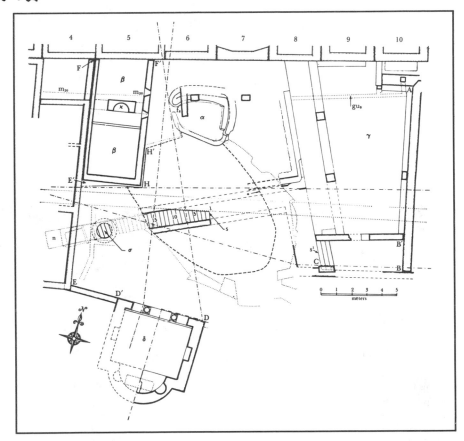

Figure 33. Plan of the memoria *and* triclia *underneath S. Sebastiano.*

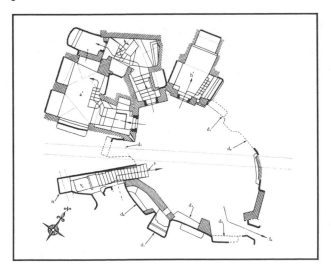

Figure 32. Plan of the piazzuola *underneath S. Sebastiano.*

The west wall of the *triclia*, then, was primarily the cella with its possible cultic appurtenances (H to F' in fig. 33). Its north wall was the backside of the row of *columbaria*. To the east was the famous graffiti wall (B' to A in fig. 33). The structure of this edifice and the graffiti make its purpose quite clear. There is a building partially roofed to house the cult of the dead for this particular cemetery complex. A bench 0.05 meters high and 0.037 meters wide ran along the graffiti wall (see fig. 34). At the end of the wall (A in fig. 33) was a fountain and a smaller bench for holding vases and other utensils. It would seem likely that a bench also ran

along the wall behind the *columbaria*. The graffiti make frequent reference to the meal for the dead held there (the *refrigerium*; see the graffiti on pp. 141-44). These meals were held on the death date of the person so honored. There is no difficulty here except for the nature of the tradition and the names in the graffiti. According to tradition this was the *memoria apostolorum*, the martyrium for Peter and Paul. In the graffiti Peter and Paul were constantly addressed in the intercessory petitions. The tradition was correct; it was here that the cult of Peter and Paul was celebrated. How did that happen? What was the continuing Christian presence here?

Tolotti hypothesized that the pool of water (σ in figs. 31 and 33) at the foot of the stairwell (s to n in fig. 31) was used as a baptistry even before the development of the *arenario* as a cemetery. Others have sought for the tombs of the two apostles in any one of the three mausolea, especially a', over which the cella was built. Others have sought, to no avail, the remains in the cella itself. As yet nothing has been discovered, archaeologically speaking, which would indicate the presence of a special place. To this point in our study we have learned that the continuity of a site, so particular a concern of the "Roman school," has not proven to be true in many instances. We might also note that in Bonn and in regard to the

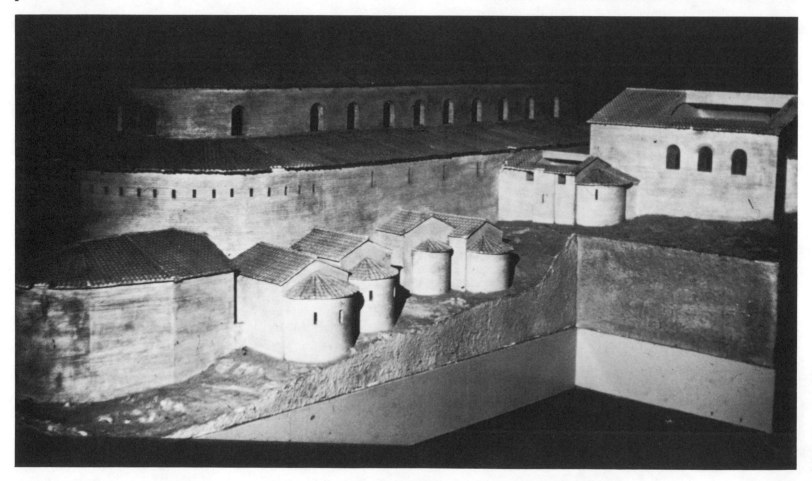

Plate 39. A model of Constantine's covered cemetery at what is now called S. Sebastiano.

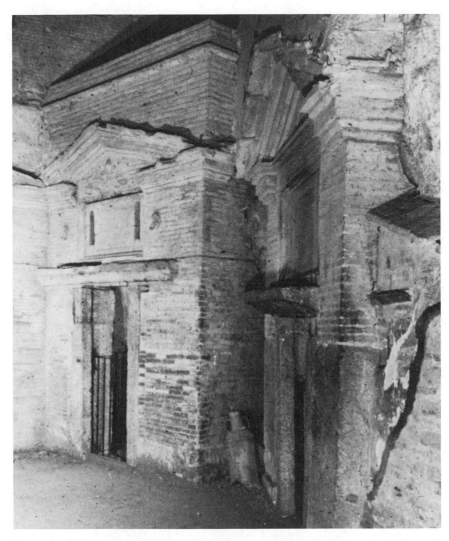

Plate 40. The arenario *from which the complex at S. Sebastiano started. The mausolea are borderline between non-Christian and Christian, or at least, the symbols are borderline.*

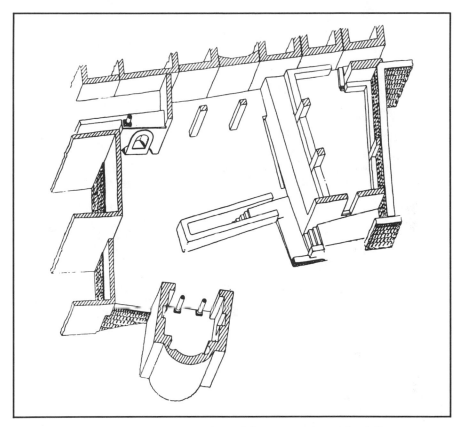

Figure 34. Isometric reconstruction of the memoria *and* triclia.

covered cemeteries of Rome the cemeterial basilica has not been constructed *ad corpus*. It is not necessary that some remains of the burial of Peter and Paul be found under S. Sebastiano, but there must be some causative factor.

To deal with this issue we must also include the excavations under St. Peter's. Suffice it to say that toward the end of his life (perhaps A.D. 349) Constantine built a covered cemetery over the *triclia ad catacumbas*. It was exactly like the three others mentioned, though eventually more mausolea were attached to the outer wall. Some scholars have assumed that Constantine tried to cover the infelicities of the cult of Peter and Paul, but we have seen that Constantine was a champion of the cemetery practices. The edifice that eventually received the remains of St. Sebastian was originally built to further the cult of Peter and Paul on the Via Appia.

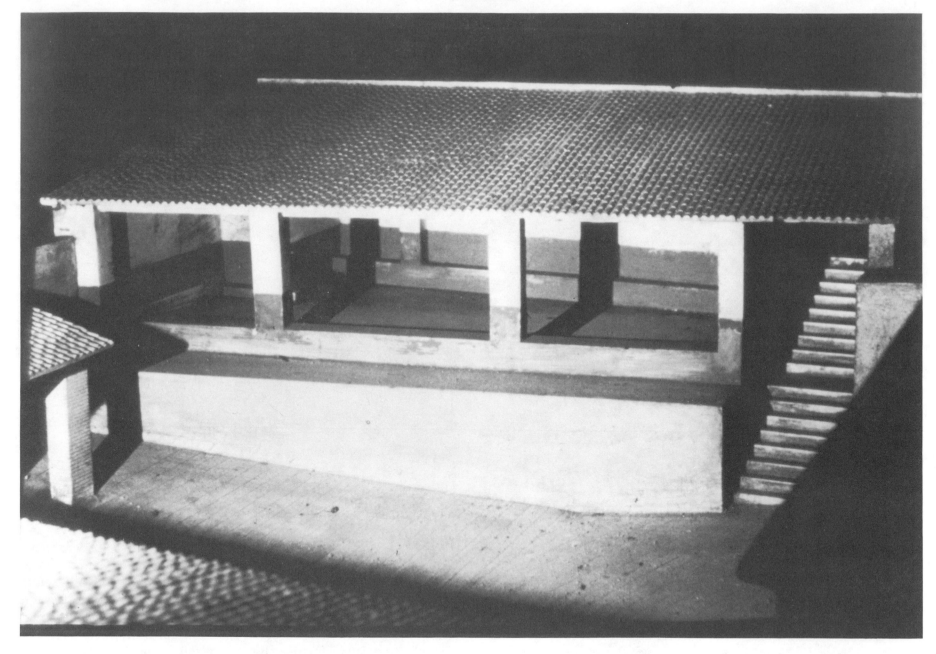

Plate 41. A model of the triclia *underneath S. Sebastiano. The graffiti wall is the far one under the roof.*

5. St. Peter's

B. M. Apollonj-Ghetti, Antonio Ferrua, Enrico Josi, and Englebert
 Kirschbaum. *Esplorazioni sotto la Confessione di San Pietro in Va-*
 ticano. Città del Vaticano: Tipografia Poliglotta Vaticana, 1951, 1-2.

E. Dinkler. "Die Petrus-Rom-Frage." *Theologische Rundschau* 25
 (1959): 189-230, 289-335; 27 (1961): 33-64.

Margherita Guarducci. *The Tomb of St. Peter, the New Discoveries in the*
 Sacred Grottoes of the Vatican. New York: Hawthorn, 1960.

————————. *Le reliquie di Pietro sotto la Confessione della Basilica*
 vaticana. Città del Vaticano: Liberia Editrice Vaticana, 1965.

————————. *Le reliquie di Pietro sotto la Confessione della Basilica*
 vaticana: una messa a punto. Colletti Editore Roma, n.d.

Englebert Kirschbaum. *The Tombs of St. Peter and St. Paul*. New York:
 St. Martin's Press, 1959.

T. Klauser. "Die Deutung der Ausgrabungsbefunde unter S. Sebastiano
 und am Vatikan." *JAC* 5 (1962): 33-38.

Hans Lietzmann. *Petrus und Paulus in Rom*. Berlin: Walter de Gruyter,
 2d ed., 1927.

A. A. de Marco. *The Tomb of St. Peter*. Leiden: Brill, 1964.

Daniel Wm. O'Conner. *Peter in Rome*. New York: Columbia University
 Press, 1969.

A. Prandi. *La zona archaeologica della Confessione Vaticana. I monu-*
 menti del II secolo. Città del Vaticano: Tipografia Poliglotta Vati-
 cana, 1957.

Graydon F. Snyder. "Survey and 'New' Thesis on the Bones of Peter." *BA*
 32 (1969): 2-24.

Hjalmar Torp. "The Vatican Excavations and the Cult of St. Peter." *Acta*
 archaeologica 24 (1953): 27-66.

J. Toynbee and J. Ward-Perkins. *The Shrine of St. Peter and the Vatican*
 Excavations. New York: Pantheon Books, 1957.

John E. Walsh. *The Bones of Saint Peter*. New York: Doubleday, 1982.

The excavation under St. Peter's has to be the most controversial, informative, and debated archaeological dig ever undertaken. The literature on the subject has been enormous, and once again we should note that de Marco's book on the tomb of St. Peter has a complete bibliography up to the time of his writing. St. Peter's was built by Constantine in the mid-fourth century at great cost and with considerable effort. The arguments about the site prior to the building of the great basilica go on endlessly without developing a consensus. We can say that the basilica was built over a non-Christian necropolis (see fig. 35), that a considerable incline marked the west end, and that it was built near the Circus of Gaius and Nero, presumably at the east end. There was always a tradition that the Circus of Nero, and therefore the locus of Peter's martyrdom, was near the Vatican. A plate on Tomb A of the necropolis reads: *uti monvmentvm mihi faciatis in vatic ad circvm ivxta monvmentvm Vlpi Narcissi* ("Make for me a monument near the monument of Ulpius Narcissus in the vatican near the circus"). Whether or not Heracla of Tomb A is closer to the circus than the aedicula of Campo P, one can hardly doubt that a circus lies close to the site.

In 1939 Monsignor Kaas, then the official charged with the care of St. Peter's, was searching in the grottoes for an appropriate place to bury Pope Pius XI and accidentally exposed a vault in the underground area. The new pope, Pius XII, gave permission to excavate under the Constantinian floor, though the work was to be done in secret. The work was supervised by the architectural staff of St. Peter's and a committee of archaeologists including B. M. Apollonj-Ghetti, A. Ferrua, E. Josi, and E. Kirschbaum. Their difficult work took ten years, after which they reported their finds in the famous *Esplorazioni* of 1951. The following description follows their finds rather closely.

The excavators found an extensive Roman necropolis under the Constantinian floor of St. Peter's (fig. 36). Though the mausolea there are among the finest of their kind ever uncovered, there were basically no signs of Christianity. However, two exceptions should be noted. As indicated under mosaics (see above, pp. 34), Mausoleum M contained the only known pre-Constantinian Christian mosaic, that of Christ Helios. In addition, there

were patterns for Jonah Cast out of the Boat and the Fisher. Guarducci would argue for later Christian burials in Tomb H, where she discovered an inscription with a petition to Peter and a reference to Christ or Christians. Her thesis has not been widely accepted (see under inscriptions, pp. 145-46). Other than these two exceptions, there is nothing Christian here until one reaches Campo P at the west end of the necropolis and directly under the altar complex (see fig. 36).

Campo P was a vacant field at the west end of the necropolis at the turn of the first century (I of fig. 37). Such fields are well known in Roman necropoli, in which they often serve as the location for poorer burials. Instead of mausolea or sarcophagi, the method of burial was a jar or terra cotta slabs placed in a triangular position over the body. Between the year 100 and 150, mausoleum S was constructed, and some burials (theta and gamma) were made in the as yet open field (II of fig. 37). Later, but still

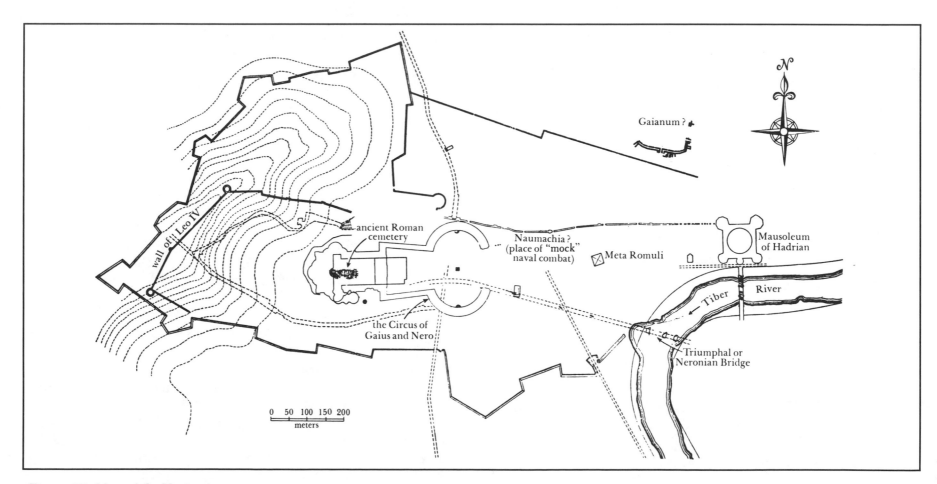

Figure 35. Map of the Vatican area.

prior to the midpoint of the century, the two burial areas R and R' were developed, leaving an incipient *clivus* or alley between S and R-R' (III of fig. 37). Sometime around 150 or 160 the burial area Q was developed. This necessitated two things: (1) Since Q was uphill from the necropolis, a drain was required. That drain was placed under the *clivus*, which now had also become a set of stairs giving access to the elevated Q. The stamps on the drain date this procedure at about 150 or 160. (2) A wall was constructed from S on the east side of the *clivus*. That wall also became the divider between Q and Campo P (IV of fig. 37). Because of its color it has been known as the Red Wall. It was the conviction of the original excavators that the Red Wall was constructed at the same time that the drain was put under the *clivus*. The point is pivotal. The aedicula that apparently honors Peter and has become the architectural focal point for the basilica attaches to the Red Wall at a point where there are three vertical niches (N^1, N^2, and N^3 in ascending order; see fig. 38). These niches were not later constructions, so the date of the incipient aedicula would be A.D. 160. The precise date for the construction of the aedicula (fig. 39) cannot be determined, but about the year 200 a presbyter named Gaius wrote, "I can show you the trophies [*trophaia*] of the apostles, for if you will go to the Vatican or to the Ostian Way, you will find the trophies of those who founded this church" (Eusebius, *EH*, II, 25: 6, 7). If the *trophaia* are to be identified with the aedicula, then literary and archaeological evidence agree. There was a small edifice consisting of a base slab, two columns, and a transverse slab built along the Red Wall in Campo P in front of the niches. The edifice was 1.34 meters from slab to slab and 1.78 meters wide (Figures 39 and 40).

Figure 36. Plan of the Vatican cemetery.

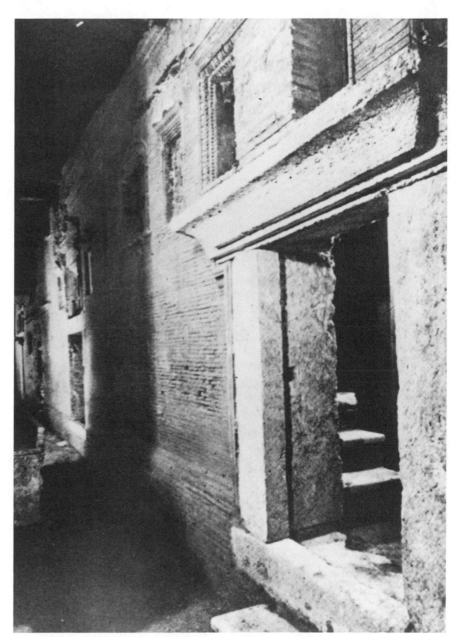

Plate 42. Some of the mausolea uncovered during the excavations under St. Peter's.

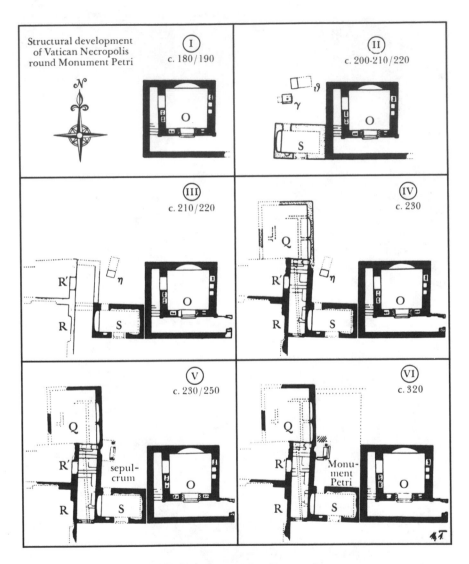

Figure 37. Structural development of the Campo P. area.

According to best estimates, at about the middle of the third century a wall g was placed on the north side of the aedicula. It was the opinion of the excavators that the wall was required to buttress a crack in the Red Wall (see fig. 40). Sometime later a

"balancing" wall was built on the south side (wall S; see fig. 40). Before St. Peter's was built the entire lower structure was encased (h of fig. 38, and the material surrounding the aedicula in fig. 40). St. Peter's was so constructed that the upper part of the aedicula was visible and accessible to the faithful by means of the transept arrangement. The theoretical relationship between necropolis, aedicula, and basilica can be seen in figure 41. Inside wall g the excavators found a loculus or marble box. In their report they state that it was basically empty when they came to it. On the north side of wall g are many graffiti of a Christian origin, primarily Constantinian. These are discussed under inscriptions (see below, pp. 145-47). None of them refers to a cult of Peter in this vicinity.

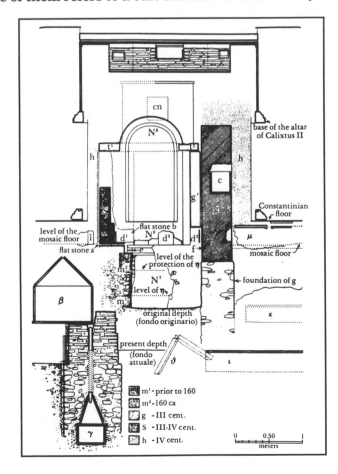

Figure 38. A diagram of the aedicula in situ.

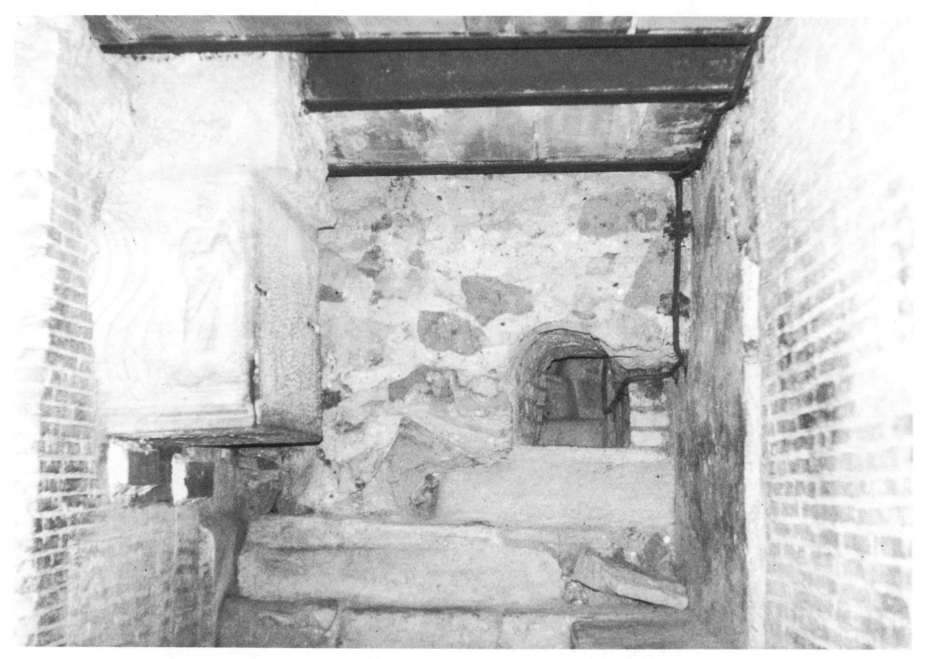

Plate 43. The red wall (to the right) that marks the boundary of Campo P and into which the tropheum *was built. St. Peter's, Rome.*

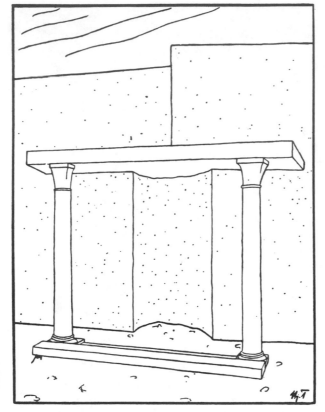

Figure 39. A reconstruction of the aedicula placed against the red wall.

endar of festivals for Rome, the notice for June 29 reads: *"III Kal. iul. Petri in Catacumbas et Pauli Ostense, Tusco et Basso consulibus* (that is, A.D. 258)." The "death date" for the two apostles was identical, and the celebration for Peter was at the *triclia* on the Via Appia. But the date for the martyrdom given is not 64, but 258!

Plate 44. The tropheum from the west side. The left column of the tropheum and the Constantinian encasement may be seen through the gate. The chopped area once held one of the magnificent columns placed around the tropheum by Constantine. These are now just below the dome of St. Peter's.

Despite the simplicity of this description, the problems raised are complex and likely beyond the parameter of rational solution. First, there is the issue of cult practices. While Gaius mentions the presence of a *trophaion* at the Vatican as early as 200, the evidence for a cult or veneration of Peter at the Vatican is nearly nonexistent. Except for the questionable graffiti in Mausoleum H and the enigmatic inscription ΠΕΤΡΙ ΕΝΙ (see inscriptions, p. 145), there is no sign whatever of any association of Peter with the Vatican. And only the late graffiti on wall g even indicate a Christian presence (see inscriptions, p. 147). To the contrary, there is every evidence that the veneration of Peter occurred on the Via Appia. In the fourth-century *deposito martyrum*, a cal-

If there had been a cult of Peter at the Vatican one would also expect that the graves of Christians would have been assembled around the aedicula. As can be seen in figure 42, there were a number of graves in Campo P. Not one shows signs of a Christian burial. But if they were of the second century, there would have been

no signs available! Of special interest have been gamma, theta, and eta. Gamma lies nearly where the tomb of Peter ought to have been, and it is early second century. It has a tube for sharing in the meal for the dead. The grave was that of a small child. Theta and eta have been suggested also, but no positive Christian data can be given. Kirschbaum was at first convinced that the bones discovered under the wall at N[1] were those of Peter and that they had been assembled there during the construction of the Red Wall. Some reports, as well as his, still carry this thesis, but anatomical analysis indicates that the bones were those of a young woman. In summary, there was no grave of Peter at the aedicula and none of the graves there appear to us to be Christian.

This raises the problem of the *loculus*, or marble box (c in fig. 38). The excavators found it basically empty, but at least Ferrua supposed that it had held the bones of Peter prior to the construction of the casing around the aedicula. Indeed it is the present consensus that the purpose of the marble box was to hold the remains of Peter. One wonders why wall g with its *loculus* was not the architectural focus of the basilica and why none of the graffiti on wall g mention the important remains encased therein. Difficult as are these objections, even more serious a problem for the archaeologist is the supposed emptiness of the box. After the official report was published, Professora Margherita Guarducci was asked to study in greater depth the graffiti under St. Peter's. In an exhaustive two-volume work she found crypto references and doctrines not perceived by the first excavators (see under inscriptions, p. 147). In this way she found the cult of Peter that had been missing. She also made a case for the continuity of the site with the early veneration of Peter. Though her case became the Vatican consensus, her work was not accepted in the scientific world. In her words, one day while musing over the problems of the excavation, she asked herself out loud why the marble box was empty. Hearing her question, one of the *sampietrinos* (custodians of St. Peter's) responded that the box had not been empty. He informed her that in 1943 Monsignor Kaas and he had removed the contents before the excavators reached it. Monsignor Kaas had "hidden" that box in another part of the grotto. He died without

Figure 40. A diagram of the aedicula from above.

revealing its whereabouts and no one else had informed the original excavators. Guarducci, whose concern to discover a Petrine presence was well known, then presented this find, the bones of Peter, to the scientific world. They are those of an old man. But the entire story raises questions about Monsignor Kaas, about the quality control of the original excavation, and about the professional credibility of Professora Guarducci. These questions will never be answered. As one excavator has said, "It is out of scientific hands." The bones hidden by Kaas are now visible in the crypt of St. Peter's as the historical bones of the apostle.

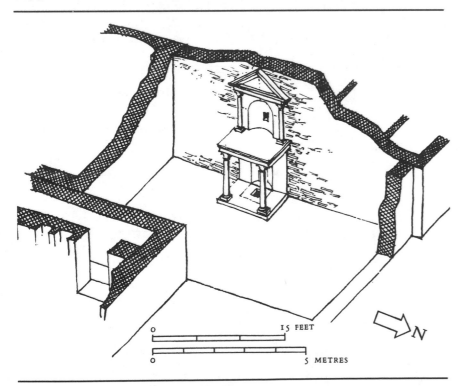

Figure 41. Isometric reconstruction of Campo P.

Guarducci and some few others argue that there always was a veneration of the apostle at the Vatican, but it was hidden from

the authorities through crypto-language and signs. Most other scholars argue for a "translation." The remains of Peter and Paul may have been at the Vatican and Ostiense, but during the persecutions of the mid-third century were "translated" to the site on the Via Appia. There in the *triclia* the veneration occurred, but there was never a lasting site there that could provide us with certain archaeological data. Under Constantine the remains were returned for a short time to the Vatican, too late for a cult to start, but with enough time to build the great basilica. The remains were then transferred to the Lateran before wall g was encased. A third alternative would be to say the remains were lost from the beginning because there was no interest in martyrs in 64. In that case, both the site on the Via Appia and the Vatican are based on incidental relationships to Peter or to events rather than bodily remains or supposed graves.

This study would indicate yet another solution. H. Chadwick has already shown that the conflict between the site on the Via Appia and the two specified locations (St. Peter's and S. Paolo fuori le Mura) resulted from a conflict within the Roman Christian community, a dispute regarding the appropriate ownership and placement of the Peter and Paul tradition.[2] As this study would indicate, the conflict was real. The complex on the Via Appia represented the liturgical apex of the cemetery group. For whatever reason, its attachment to Peter and Paul was officially established in 258. For the official saints' calendar that date has remained to this day. But the hierarchical, city group proposed two other locations for the veneration of the two apostles. These two locations, supposedly related historically to the two apostles (without further work at S. Paolo fuori le Mura, we can only speak confidently of St. Peter's), were honored by Constantine with covered cemeteries about the same time the basilica was built over the *triclia ad katakumbas*.

[2]H. Chadwick, "Pope Damasus and the Peculiar Claim of Rome to St. Peter and St. Paul," *Neotestamentica et Patristica* (Leiden: Brill, 1962) and "St. Peter and St. Paul in Rome," *JTS* 8 (1957): 31-52.

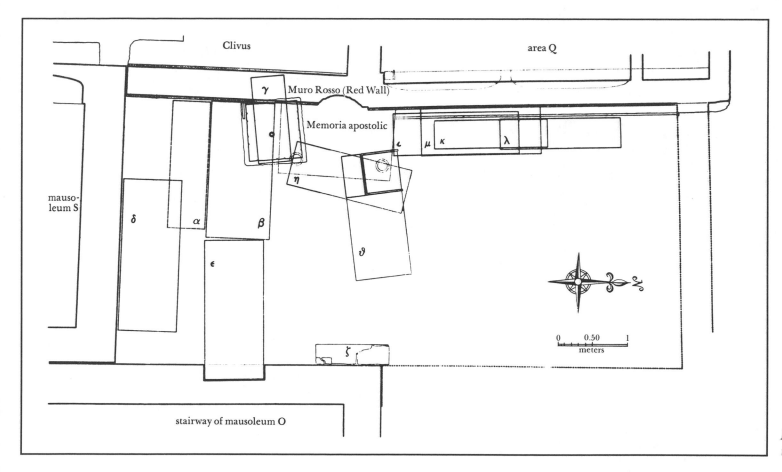

Clivus

area Q

γ Muro Rosso (Red Wall)

Memoria apostolic

ϙ

ι μ κ λ

η

mauso-
leum S

δ α β

ϑ

ε

ζ

0 0.50 1
meters

stairway of mausoleum O

*Figure 42. The position of
the tombs in Campo P.*

Relics of the two apostles were never located on the Via Appia site. The aedicula in Campo P does mark a site venerated by the early Christians, but was never the location of Peter's burial or of a martyrium. When St. Peter's was built the bones of Peter may have been placed (for the first time?) in wall g. Whether the bones of Peter remained in the box now in wall g will likely never be determined. But we can speak more of the ancient conflict. The victory of the city group over the cemetery group was close and hard fought. The conflict between Damasus and Ursinus was especially bloody. To establish unity, a number of compromises had to be effected. We have already seen that, in the latter part of the fourth century, martyr's relics were placed in the *confessio* of the city churches, so that the mass continued the popular cemetery worship. To establish the centrality of the Vatican, certain concessions had to be made. Again it was Damasus who pointed the way. In his famous *Hic habitasse* epigram, placed on the Via Appia, he proclaimed that Peter and Paul had lived at the Memoria Apostolorum.[3] In the same epigram he conceded that the two apostles

[3]The famous metrical inscription reads as follows:
 *Hic habitasse prius sanctos cognoscere debes
 nomina quisque Petri pariter Paulique requiris.*

had come from the East. The concession to Via Appia parallels the concession to Eastern Christianity. By such means Damasus was trying to consolidate Christianity under the leadership of Rome. He also needed to tend to the conflict in Rome itself.

Because of this concession we have been led to believe the two apostles had been buried at the κατάκυμβος. It would be simpler to suppose that the site on the Via Appia resulted from the faith and practice of the cemetery group, especially during times of perse-

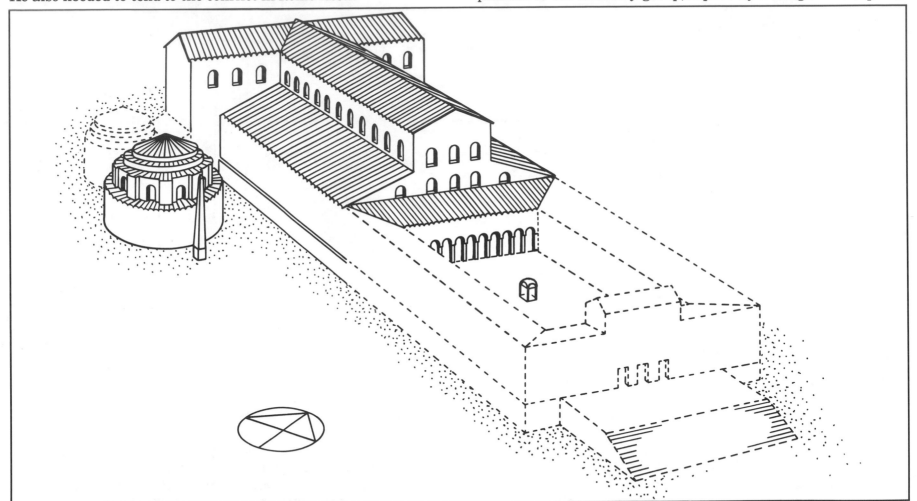

Figure 43. Isometric reconstruction of St. Peter's.

Discipulos Oriens misit, quod sponte fatemur;
sanguinis ob meritum Christumque per astra secuti
aetherios petiere sinus regnaque piorum:
Roma suos potius meruit defendere cives.
Haec Damasus vestras referat nova sidera laudes.

cution. The site at the Vatican was honored, but not utilized as a martyrium. Following the building program of Constantine, the hierarchical group elevated St. Peter's above the site on the Via

Appia. There a church was built with relics of St. Sebastian. Similar martyrial sites were converted to ecclesiastical establishments by building churches somewhat to the side of both the martyrium and the covered cemetery.

Finally, Constantine's St. Peter's (fig. 43), though a five-aisle building with a transept rather than a long building with an ambulatory, still must be considered a covered cemetery. It had no altar until Gregory; it had no priesthood. According to archaeological and literary evidence, it was used for burials and meals with the dead. After all that, the information here regarding Christianity before the "peace" does not amount to much. As with the other covered cemeteries (except for S. Sebastiano), Constantine built over a site that does not in itself appear to have a prior Christian history, even though a causative factor, the Circus of Nero, may be close at hand.

6. Tor de'Schiavi

Bovini. *Edifici*, 185-90.

Brandenburg. *Roms*, 72-77.

This building, outside the walls on the Via Praenestina, has all the marks of the covered cemeteries we have discussed. It consists of an ambulatory-style basilica 66 meters long and 24 meters wide. Immediately to the west of the basilica stands a structure that is round like a mausoleum and quite similar to that of Sta. Constanza and the one at SS. Marcellino e Pietro. The complex was erected in the Constantinian era, but no reason for its construction has as yet been discovered. It is not located in a cemetery.

VI. BAPTISTRIES

Lucien de Bruyne. "La decoration des baptistères paléochrétiens." *ACIAC* 5 (1957): 341-69.

E. Coche de la Ferte and G. Matthiae. "Battistero." *Enciclopedia dell'arte antica*, 2:1158-61.

F. W. Deichmann. "Baptisterium." *RAC*, 1:1157-67.

F. J. Dölger. "Zur Symbolik des christlich. Taufhauses." *AuC* 4 (1934): 153-87.

André Grabar. "Christian Architecture, East and West." *Archaeology* 2 (1949): 96.

A. Khatchatrian. *Les baptistères paléochrétiens*. Paris: École pratique des hautes études, 1962.

H. Leclercq. "Baptistère." *DACL* 2:1:382-469.

Johannes Quasten. "Das Bild des Guten Hirten in den altchristlichen Baptisterien und in den Taufliturgien des Ostens und des Westens." *Pisciculi*. Münster: Aschendorff, 1939, 220-44.

J. Zettinger. "Die ältesten Nachrichten über Baptisterien der Stadt Rom." *RQS* 16 (1902): 326ff.

Grabar has argued that all early Christian architecture could be classified as longitudinal (basilical) for congregational meetings or centered (like the martyria) for cultic practices. Baptistries, as edifices built for cultic practice, are a type of mausoleum that derived their architectural pattern from Roman funerary practices. There can be no question that baptistries did follow a vaulted, centered plan. But whether that plan derives from the mausoleum or from the *piscina* cannot be easily determined. The *piscina*, normally round or octagonal, could have been the fountain of a villa, or the frigidarium of a bath. Unfortunately, archaeology gives us very little help at this point. In his rather exhaustive list of early Christian baptistries, Khatchatrian lists only eight that might have been constructed prior to Constantine. Of these only the baptistry at Dura-Europos can with assurance be identified as third century. It does not resemble either a martyrium or a *piscina*, though it does have the form of a basin. Commenting on the centrality of the Good Shepherd in the baptistry at Dura-Europos, de Bruyne and Quasten have noted how frequently the Good Shepherd symbol occurs in baptismal art. If the Good Shepherd signifies the social-matrix value of hospitality and social fellowship,

then the baptistry derives far more from social initiation practices than theological or liturgical perceptions of dying and rising.

Granted, only the baptistry at Dura can be considered pre-Constantinian (see above, pp. 70-71); however, it would be useful at least to consider the architectural form of some possible third-century baptistries.

A. The House of the Fish in Ostia

Giovanni Becatti. *Case ostiensi del tardo impero*. Roma: La libreria dello stato, 1949, 18-20.

_____. *Scavi di Ostia*, IV. Roma: La libreria dello stato, 1962, 181-83; # 338; tav. cc.

G. Calza. "Nouvo testimonianze del cristianismo a Ostia." *RPARA* 25-26 (1949-1951).

Paul-Albert Février. "Ostie et Porto a la fin de l'antiquite." *Mélanges d'archéologie et d'histoire* 70 (1958): 295-330.

Russell Meiggs. *Roman Ostia*. Oxford: Clarendon Press, 2d ed., 1973, 400, 523.

In Reg. IV, Is. III of old Ostia (Ostia antica) a house, called the *Domus dei pesci* (House of the Fishes), has been considered by some to be a Christian house with a baptistry. The house as it now appears was built in the first half of the third century. Many believe it to be Christian because of the unusual mosaic symbol in its vestibule: a goblet with one fish inside and two outside. Becatti, and even more so Calza, also consider the semicircular font a Christian baptistry. Such a house fits the image of a *domus ecclesiae*. It is attractive to suppose this house was a place of worship, and even of cultic practices, at a time when formal structures were just emerging. As Février indicates, there were surely Christian assemblies in Ostia at the time of this house. But without any graffiti, or distinctive furniture, it would be difficult to make any claims about this house, other than it was possible, or even probable (Février, 312).

B. S. Gregorio in Milan

Giuseppe Bovini. *Antichita cristiane di Milano*. Bologna: Patron, 1970, 282-85.

Gino Traversi. *Architettura paleocristiana Milanese*. Milano: Ceschina, 1964, 37-38.

Paolo Vergone. *L'architettura religiosa dell'alto medio evo nell'Italia settentrionale*. Milano: "Esperia," 1942, 67.

The chapel of S. Gregorio, next to S. Vittore *ad corpus*, was demolished in 1576 and then reconstructed. On the basis of the original design, several scholars have projected the presence of a fourth- or even third-century mausoleum or baptistry. The building was constructed with eight niches, alternately rectangular and semicircular. If this building is pre-Constantinian, it would likely have been a non-Christian mausoleum.

C. Gabia la Grande

Jacques Fontaine. *L'art preroman hispanique*. La Pierre-qui-Vire: Zodiaque, 1973, 395-96.

Manuel Gómez Moreno. "Gabia la Grande." *Misceláneas, historia, arte, arqueologia*. Madrid: S. Aguirre, 1949, 386ff.

Pedro de Polol Salellas. *Arte paleocristiano en España*. Barcelona: Edic. Polígrafa, 1970.

_____. *Arqueologia cristiana de la España romana, siglos IV-VI*. Madrid-Valladolid: Consejo superior de investigaciones cientificas, 1967, 147-82.

In 1920 at Gabi la Grande, Spain, during the excavation of a large Roman villa of a late date, a cryptoportico 15 meters long and 2.50 meters wide was uncovered. At the west end of this porch a corridor led to a room 4 meters square that housed an octagonal

piscina In the room was also discovered an apparent Christ-monogram with an omega. As with the House of the Fishes in Ostia, it could be that this was the home of a third-century Christian family, that Christians assembled there, and that baptisms were performed in the pool. However, to draw that conclusion on the basis of one possible Christian siglum, and a Constantinian one at that, would be questionable.

Plate 45. *Fish and chalice symbol found in a house in Ostia. This may have been the symbol of a house church containing a baptistry.*

CHAPTER SIX

INSCRIPTIONS AND GRAFFITI

E. Diehl. *Inscriptiones latinae christianae veteres.* Berlin: Weidmann, 1923-1931.

A. Ferrua. "L'epigrafia cristiana prima di Costantino." *ACIAC* 9 (1978): 583-613.

F. Grossi Gondi. *Trattato di epigrafia cristiana.* Roma: Universita Gregoriana, 1920.

Carl Maria Kaufmann. *Handbuch der altchristlichen Epigraphik.* Freiburg: Herdersche Verlagshandlung, 1917.

John McCaul. *Christian Epitaphs of the First Six Centuries.* Toronto: W. C. Chewett, 1869.

Orazio Marucchi. *Epigrafia cristiana.* Milano: Ulrico Hoepli, 1910.

H. P. V. Nunn. *Christian Inscriptions.* Eton: Savile, 1951.

Ioannes Baptista de Rossi. *Inscriptiones christianae urbis Romae.* Roma: Libraria Pontificia, 1857-1861; 2:1 (1888); *Supplementum,* fasc. 1, edidit Iosephus Gatti (1915).

Inscriptiones christianae urbis Romae septimo saeculo antiquiores, nova series; 1, edidit Angelus Silvagni (Roma: Libraria Doct. Befani, 1922); 2, edidit Angelus Silvagni (Roma: PIAC, 1935); 3, edidit Angelus Silvagni et Antonius Ferrua (1956); 4, edidit Antonius Ferrua (1964); 5, edidit Antonius Ferrua (1971); 6, edidit Antonius Ferrua (1975); 7, edidit Antonius Ferrua (1980).

Sylloge inscriptionum christianarum veterum musei vaticani. Edited by Henrico Zilliacus. Acta instituti romani finlandiae 1:1-2 (Helsinki, 1963).

Any statement about pre-Constantinian Christian inscriptions offers major difficulties. Most of the inscriptions we possess today come from burial slabs. The vast majority of these have been discovered in the catacombs of Rome, where most *loculi* were closed with a terra cotta or marble slab. From these burial slabs have come thousands of inscriptions, most of which have been catalogued in the *ICUR*. Christian burials in the catacombs were first distinguishable at the beginning of the third century, and they continued until the fifth and sixth centuries. Of these thousands many are surely pre-Constantinian, but it would be difficult to distinguish them from later examples. It is my intention here to

present a conservative list of inscriptions, with some examples of each category, and a summary of the implications.

Dated inscriptions are the most certain sources of information, but often the least satisfactory. Because they are usually longer, and therefore more formal, they often do not represent the average, simple inscription. In the Roman period, dating was accomplished by listing the two consuls for that year. Consequently, a fair degree of accuracy can be maintained. So the first category of inscriptions will be those that can be dated by means of the two consuls or by means of the known death date of the person (the bishops of Rome). Another category will be those inscriptions found on sarcophagi we have already determined to be pre-Constantinian. A third category consists of those in the Vatican museum considered by the editors of *Sylloge inscriptionum Christianarum veterum* to be from this period. A fourth category will be the collection of de Rossi from Priscilla. The 370 inscriptions edited by him are, by general consensus, from a catacomb area of the third century. They certainly appear normatively primitive. I will add to this list a group from Phrygia, first those datable and then those that are so similar as to be considered prior to the peace.

Of as great importance as inscriptions are the informal writings called graffiti. There are several groups of graffiti: those at the *triclia* under S. Sebastiano, those under St. Peter's, and those at Dura-Europos. Some consideration will be given to the cathedral in Trier.

I. DATED INSCRIPTIONS FROM ROME

There are sixty-two inscriptions from the collection at Rome that can be positively dated prior to Constantine. The first four are correctly dated, but were considered Christian only because de Rossi found them in what he thought were early Christian areas. Later editors have dropped them.

	A.D.	
1.	71	*ICUR*, I, #1
2.	107	*ICUR*, I, #2
3.	111	*ICUR*, I, #3
4.	204	*ICUR*, I, #4

	A.D.	
5.	217	*ICUR*, I, #5
6.	230	Kaufmann, p. 235
7.	234	*ICUR*, I, #6
8.	234,53,56,86	*ICUR*, I, *Sup.*, #1380
9.	235	Kaufman, p. 235
10.	235	*ICUR*, I, #7; N.S., II, #6021
11.	236	Kaufman, p. 235
12.	238	*ICUR*, I, #8; N.S., I, #1415
13.	249	*ICUR*, I, #9
14.	250	Kaufman, p. 235
15.	253	Kaufman, p. 235
16.	254	Kaufman, p. 235
17.	260	*ICUR*, N.S., IV, #12522
18.	266	*ICUR*, N.S., VII, #20337
19.	266	*ICUR*, N.S., VII, #20336
20.	266	*ICUR*, N.S., VII, #20335
21.	268 or 279	*ICUR*, I, #10; N.S., III, #8716; Diehl, #3315
22.	269	*ICUR*, I, #11
23.	270	*ICUR*, N.S., VII, #20339
24.	270	*ICUR*, N.S., VII, #20338
25.	273	*ICUR*, N.S., III, #7375
26.	273	*ICUR*, N.S., III, #6496
27.	273	*ICUR*, I, #12; N.S., V, #13885; Diehl, #2805
28.	276	*ICUR*, I, *Sup.*, #1386
29.	277	*ICUR*, I, #13; N.S., III, #8415
30.	279	*ICUR*, I, #14
31.	283	Kaufman, pp. 235-236
32.	287	*ICUR*, I, *Sup.*, #1388
33.	287-304	*ICUR*, I, *Sup.*, #1389
34.	289	*ICUR*, I, Sup., #1390
35.	290	*ICUR*, I, #15; N.S., VII, #19946; Diehl, #2938
36.	290	*ICUR*, I, #16; N.S., IV, #9546
37.	291	*ICUR*, I, #17; N.S., V, #13886; Diehl, #2305
38.	291	*ICUR*, I, #18
39.	292	*ICUR*, I, #19; N.S., VI, #16964; Diehl, #3996
40.	293 or 297	*ICUR*, N.S., IV, #11085
41.	295	*ICUR*, I, #20; N.S., VII, #17416; Diehl, #2786
42.	296	*ICUR*, I, #21; N.S., VII, #17417; Diehl, #2807A
43.	296	Kaufman, pp. 235 and 239
44.	297	*ICUR*, I, #22; N.S., I, #1168

A.D.		
45.	298	*ICUR*, I, #23; N.S., VII, #17418
46.	298	*ICUR*, I, #24; N.S., VII, #19947; Diehl, #3888
47.	298	*ICUR*, I, #25; N.S., I, #1416
48.	298	*ICUR*, I, #26
49.	298	*ICUR*, I, *Sup.*, #1396
50.	300	*ICUR*, I, #1127; I, *Sup.*, #1401; N.S., IV, #9547
51.	300 or 302	*ICUR*, I, *Sup.*, #1402; N.S., III, #8136
52.	301	*ICUR*, I, #27; N.S., VII, #17420
53.	302 and 305	*ICUR*, I, *Sup.*, #1404; N.S., I, #1249
54.	302	*ICUR*, I, #28
55.	304	Kaufman, pp. 129-30
56.	307	*ICUR*, I, #29; N.S., VI, #16965; Diehl, #873
57.	307	*ICUR*, I, #30; N.S., VI, #15767
58.	307	*ICUR*, I, *Sup.*, #1406; N.S., IV, #9549
59.	308	*ICUR*, N.S., V, #13097
60.	307 or 308	*ICUR*, N.S., V, #13887
61.	310	*ICUR*, I, #31; N.S., V, #.....; Diehl, #3355
62.	312	*ICUR*, I, *Sup.*, #1409; N.S., V, #13099

Several of these sixty-two dated inscriptions are simply fragments or even names and dates only. The papal inscriptions consist of a word or two. But several inscriptions are more formal and extensive. We will look at the earliest Roman Christian inscription (#5), the papal inscriptions, and three others selected as examples of this category (#s 12, 21, 37).

A. Inscription of Marcus Aurelius Prosenes (#5)

Bovini. *I sarcophagi*, 14, #1.

Deichmann. *Repertorium*, #929.

Dinkler. *Signum Crucis*, 174.

H. U. Instinsky. "Marcus Aurelius Prosenes, Freigelassener und Christ am Kaisarhof." *AAMz* (1964), nr. 3, 113-29.

Kaufmann. *Handbuch*, 57.

Marucchi. *Epigraphy*, 225, #s 259 and 259 (a).

A. M. Schneider. "Die ältesten Denkmäler der Römischen Kirche." *Festschrift zum Feier des sweihundertjähr. Bestehens der Akad. d. Wiss. in Göttingen*, 2 Phil.-Hist Kl. (1951).

Stuiber. *Refrigerium*, 113.

Location: Sarcophagus at Villa Borghese, Rome.

Edited Text:

Here and elsewhere the letters in parentheses complete the intent of an abbreviation and the letters in brackets indicate how lacunae could be completed.

> *M(arco) Aurelio Augg(usto) lib(erto) Proseneti,*
> *a cubiculo Aug[usti],*
> *proc(uratori) thesaurorum,*
> *proc(uratori) patrimoni, proc(uratori)*
> *munerum, proc(uratori) vinorum*
> *ordinato a divo Commodo*
> *in kastrense, patrono piissimo*
> *liberti benemerenti*
> *sarcophagum de suo*
> *adornaverunt.*

On the upper edge of the right end of the sarcophagus occurs the following additional inscription:

> *Prosenes receptus ad deum*
> *V non(as) [Iul]ias S[ame in Cephalle]*
> *nia Praesente et Extricato II*
> *regrediens in urbe*
> *ab expeditionibus, scripsit Ampelius*
> *lib(ertus).*

Translation:

> For Marcus Aurelius Prosenes, imperial freedman,
> At the imperial cubiculum,
> who was administrator of the treasury,
> administrator of the patrimony, administrator
> of gifts, administrator of wines,
> appointed by the divine Commodus

in Castrensis, a most compassionate patron,
to a most deserving freedman
a sarcophagus for him
they have decorated.

Prosenes was received by God
July 25 at Same in Cephallenia
during the consuls of Praesens and Extricatus II
returning to the city from expeditions. Ampelius has
 written this,
a freedman.

De Rossi, probably inspired by his romantic predilection for highly placed early Christians, identified the inscription as Christian on the basis of *receptus ad deum*. At first glance this would appear insufficient; the formulae most characteristic of early Christianity, such as *in pace*, are missing. Yet when we deal with early Christian letters it will be apparent that the change in the name of the divinity was very likely a mark of nascent Christian culture (see below, p. 149). This inscription does lack any pro forma or conventional reference to the non-Christian deities, such as D M at the heading, an address to the spirits of the dead (*dis manibus*). So one is inclined to suppose this was the sarcophagus of a high-level Christian freedman from the household of Caesar. The inscription was written at a time when Christian characteristics were just beginning to appear.

Sepulchral inscriptions for persons who had been freed from slavery are very common in both Christian and non-Christian burials. As in this inscription, the person freed, Prosenes, takes on the name of the person who did the freeing. Therefore he has taken the name Marcus Aurelius (A.D. 161-180) Prosenes. It was Commodus (180-192), though, who appointed him to the positions listed. In most of the early Christian inscriptions only one name existed, and that one was not a Roman family name (like Prosenes). One assumes these were slaves or persons of slave families. Despite the high frequency of slave names in Christian inscriptions, the condition of slavery was almost never mentioned.

It is striking that, like art and architecture, the first Christian inscriptions in Rome occur at the beginning of the third century. Dated inscriptions 1-4 could be Christian, but are not distinguishable from their non-Christian counterparts. It could be that few people in 217 could have seen that the sarcophagus of Prosenes was "different." One must reflect seriously on the tentative Christian nature of this early third-century inscription, because several decades earlier Phrygian inscriptions were quite explicit in their Christianity.

B. *Tituli* of the Popes (#s 6, 9, 11, 14, 15, 16, 31, 43)

Hertling and Kirschbaum. *The Roman Catacombs*, 49-64.

Marucchi. *Epigraphy*, 192-96.

Testini. *Le catacombe*, 207-208.

Location: Crypt of the Popes, S. Callisto, Rome.

Edited and Translated Texts:

ΟΥΡΒΑΝΟC Ε(πισκοπος)	Urbanus Bishop	231
ΑΝΤΕΡΩC ΕΠΙ(σοκοπος)	Anteros Bishop	236
ΠΟΝΤΙΑΝΟC ΕΠΙCΚ(οπος)	Pontianus Bishop	236
ΦΑΒΙΑΝΟC ΕΠΙ[σκοπος]	Fabianus Bishop	250
ΛΟΥΚΙC	Lucius	254
ΕΥΤΥΧΙΑΝΟC ΕΠΙC(κοπος)	Eutychianus Bishop	283

CORNELIUS	Cornelius	253
Γ[αιο]Υ ΕΠΙ(σκοπος) ΚΑΤ(ατεσις) ΚΑΛ(ενδαρ) ΜΑΙΩ[ν]	Gaius Bishop before the Kalende of May	296

Some of the older works include the inscription of Urbanus because de Rossi allegedly found it on the lid of a sarcophagus in or near the crypt, but it has not proven authentic. Pontianus and Fabianus had the abbreviation MTP added to their inscriptions at a

later date, while *martyr* was added to Cornelius's, which was the only inscription in Latin. Considering the antiquity of the nucleus around the Crypt of the Popes, it would be difficult not to take these as authentic, even though there is no date included. The inscriptions are simple and in keeping with the style of the third century.

Since there is no mention of ecclesiastical offices in other third-century inscriptions and basically no mention of them in third-century letters, one must ask why it occurs with these bishops of Rome. It seems more than coincidental that the bishops connected with the Crypt of the Popes are primarily those who held office during the era of Hippolytus and suffered his scorn. In the ninth book of his *Philosophumena* (especially chapter 8) Hippolytus accused Callistus of seductively influencing Zephyrinus (199-217) to accept him and make him the next bishop of Rome. During the reign of Callistus a small group of people elected Hippolytus bishop of Rome. The schism continued through Urban (222-230), Pontianus (230-235), and Anteros (235-236). Exiled together to Sardinia, Pontianus, who had resigned in favor of Anteros, and Hippolytus apparently reconciled their differences. In August of 236 or 237 the two were buried in Rome; Pontianus, as we know, in Callixtus, and Hippolytus in a cemetery on the Via Tiburtina, as a martyr. It was Fabianus who brought their bodies to Rome and had them buried. The Crypt of the Popes was conceived by Zephyrinus, an opponent of Hippolytus, but organized by his archenemy and victor in the struggle for the bishopric, Callistus. Moreover, the primary burials were those bishops who sat on the cathedra of Rome during this schismatic period. We know that the struggle between church and cemetery, bishop and martyr, became an intense issue in the fourth century. In fact, the key moment for the formation of orthodoxy as we know it was the narrow victory of Damasus, the church candidate, over his cemetery opponent, Ursinus. It was Damasus who extolled the popes and "made" of them martyrs. That division started with Hippolytus, who favored the kind of rigidity that led to martyrdom, vis-à-vis Callistus, who apparently favored accommodation. The Crypt of the Popes marks the effort of the accommodating party to move into martyr territory. It would not be the last time that ecclesi-

astical leaders were elevated to sainthood within the growing Christian cult of the dead.[1]

C. Inscription of Heraclitus (#12)

Bovini. *I sarcofagi*, #2.

Deichmann. *Repertorium*, #117.

Location: Vatican Museum, #117.

Edited Text:

ΗΡΑΚΛΙΤΟΣΟΘΕΟΦΙΛ
ΕΣΤΑΤΟΣΕΖΗΣΕΝΕΤΗ
ΠΑΡΑΗΙΓΕΝΟΣΗΣΕΝΗΜ
ΡΙΒΤΕΛΕΥΤΑΠΡΟΙΑΚΜΑΙ
ΠΙΩΚΑΙΠΟΝΤΙΑΝΩΥΠΑΥΡ
ΞΑΝΘΙΑΣΠΑΤΗΡΤΕΚΝΩΓΛΥΚ
ΥΤΕΡΩΦΩΤΟΣΚΑΙΖΟΗΣ

Translation:

Heraclitus, one who was
dear to God, lived eight years
plus thirteen days; he was ill
twelve days. He expired before the eleventh of the
 kalende of May,
Pius and Pontianus, consuls.
Aurelius Xanthias, father, to a child
so sweet, light and life.

This inscription confirms our observations on the first dated inscription of Rome (#5). The presence of a Good Shepherd on the sarcophagus indicates that we are very likely dealing with a Christian family. At the same time there is little beyond the as-

[1]H. Chadwick, "Pope Damasus and the Peculiar Claim of Rome to St. Peter and St. Paul," in *Neotestamentica et patristica*. Freundesgabe O. Cullmann (Leyden: Brill, 1962) 313-18.

cription "dear to God" that would commend this to us as Christian in nature. The "sweet child" was a normal affirmation. The wish for light and life, however, would be unusual for a non-Christian.

About ten percent of the early Christian inscriptions were in Greek. But Greek cognomina often appeared even in Latin inscriptions. Approximately twenty-five percent of all cognomina

Plate 46. A typical Greek inscription.

were Greek or barbarian. Since most demographers calculate the population of Rome during the second and third centuries as well over one half foreign,[2] one is surprised that Christian inscriptions do not reflect even more foreign cognomina. Since about eighty percent of inscriptions indicate slave names or names of slave origin, one can only conclude that the Christian population quickly changed to names of a Roman nature. Inscriptions in the Jewish catacombs show the same strong tendency.[3] In this inscription the father was freed by a Roman named Aurelius, but his name, that of a yellow-haired slave in Greek comedy, and the name of his son indicate a Greek origin for the family.

D. Inscription of Marcianus (#21)

Marucchi. *Epigraphy*, 103-104.

Testini. *Archeologia*, 418-19.

Location: Callixtus, Rome.

Edited Text:

> Pasto[r et T]itiana /dove with leaf/ e[t] Marciana et /leaf/
> Chr[e]st[e Mar]ciano filio benemerenti
> X (in Iesu Christo), d(omino) n(ostro), fec[eru]nt qui vixit annus
> xii, m(enses) ii et d(ies) . . .
> qui gra [tia]m accepit d(omini) n(ostri) die xii ka[l o]ctobres,
> . . . vio Paterno II Coss et red(d)e (read i) [dit] xi kal [easdem]
> vibas inter sanctis iha

[2]See especially the work of Tenney Frank, "Race Mixture in the Roman Empire," *American Historical Review* (1915/1916): 689-700. See also A. Degrassi, "Dati demografici in iscrizioni cristiane di Roma," *Scritti vari di antichità*, 3 (Venezia: Trieste, 1967) 243-53.

[3]Harry J. Leon, *The Jews of Ancient Rome* (Philadelphia: Jewish Publication Society of America, 1960). J. B. Frey, "L'ancienneté des catacombes juives à Rome," *RPARA* (1936): 185ff; *Corpus inscriptionum iudaicarum*, 1-2 (Città del Vaticano, 1936-1952).

Translation:

> Pastor and Titiana and Marciana and
> Chreste, for son Marcianus well deserving
> in Jesus Christ our Lord, have made this, who lived 12 years, 2
> months and days,
> who accepted the grace of our Lord 12 kalendar of October,
> uio, Paternus II, consuls, and he gave back 11 kalendar (same).
> Live among the saints iha

Moving toward the end of the century, the language of inscriptions became more explicitly Christian. In this one, for the twelve-year-old boy Marcianus, not only do we have reference to Jesus Christ, our Lord, but the "Jesus Christ" has become so common it has been written in symbolic shorthand (X), and the "our Lord" in abbreviation (d n). The Christian culture now has become solidified.

This particular text has considerable value for us because it is one of the few pre-Constantinian inscriptions with a reference to baptism. Marcianus accepted the "grace of our Lord" when he was twelve. Prior to the fourth century, Christian membership was primarily an adult decision that could very well lead to conflict with the surrounding culture, and surely was not an expectation of the social matrix itself. Infant baptism was practiced when the social matrix and the religious community had become one and the same. It would be fallacious sociologically to suppose the Constantinian revolution occurred without preparation and precedence. As this inscription indicates, the faith community and the social matrix were already moving toward one another. The boy Marcianus, though not baptized as an infant, was hardly an adult. In the *SICV* study, which we will use as roughly parallel to this set of inscriptions, fifty-three people out of 127 had died before ten years of age and another twenty-three died during the second decade. Over half of those marked by age had died before twenty. Young men had a median life expectancy of 17.6 years and women 19.4 (some other, more general studies would average about 2.5 years higher).[4] So though Marcianus was comparatively older

[4]H. Nordberg, "Biometrical Notes. The Information on Ancient Christian Inscriptions from Rome Concerning the Duration of Life and the Dates of Birth and Death," *AIRF* 2:2.

than twelve in our culture, still he ought not be considered an adult. The Christian culture was moving toward making family identity and faith identity equal.

The presence of "Chreste" in the inscription also indicates a growing interest in names with a Christian or biblical nature. In the early years such names were remarkably absent from the inscriptions. Of 330 inscriptions in the *SICV*, only eight were biblical; fifteen had divine names like Cyriacus (kurios); three had calendar names like Paschasius; and twelve had virtue names that might or might not have been Christian (such as Agape). Of these, only two should be considered pre-Constantinian—a Redempta (#248), and an Agape (#317). The practice of using Roman names was remarkably enduring. But it stands to reason that as long as Christian initiation was an adult decision, even persons born in Christian families would be named according to the customs of the social matrix. Or put another way, since the naming of children was not a social or liturgical function of the adult Christian community, the children would be named according to Roman societal norms. As the social matrix gradually became Christian, the names would become biblical or Christian in nature. Not only did this family live in a social context where the baptism of young people was encouraged, but another child in the family had a divine name, Chrestus. The matrix was becoming Christian.[5]

There is one odd mitigating circumstance. If I have understood the inscription correctly, Marcianus was baptized the day before he died. We have nothing in our study to indicate baptism was necessary for salvation, or that persons were trapped in inherited

sin. Again, the parents must have so identified the social structure with the faith community that for them it was inconceivable for Marcianus to belong only to the primary familial community. This inscription shows us a step toward the later perception of parish: church and neighborhood are one.

Finally, the "vibas," an acclamation meaning "live!," occurs as frequently as any single item in the early inscriptions. It is a drinking acclamation, so it surely refers as much to the cemetery, or agape, meal as to any overt theological meaning. It is a wish that all is well for Marcianus as he participates in the fellowship of the saints both living and dead.

E. Inscription of Cervonia Silvana (#37)

Location: Capponio Palace, Rome

Edited Text:

> *X Ex Virginio tuo bene*
> *meco (read mecum) vixisti lib(enter) conjuga*
> *innocentissima Cervonia Silvana.*
> *Refrigera cum spirita sancta. Dep(osita) kal(endar)*
> *Apr(il).*
> *Tiberiano Il et Dioni, Coss.*

Translation:

> (In Christ) from Virginius. So nicely
> you lived with me as a freed wife
> most innocent Cervonia Silvana.
> Eat the refrigerium with a holy spirit. Deposited
> Kalendar April.
> Tiberianus II and Dio, Consuls.

The inscription of Marcianus referred to the baptism of a young man. This refers to the practice of eating the meal of the dead in the cemetery. Virginius wishes that his wife would enjoy these meals in perpetuity with a good and holy spirit about her. There are many such "refrigeria" inscriptions, but the most astounding are those found under S. Sebastiano, where the meals were eaten with Peter and Paul. Here Virginius refers to the family meals,

[5]I. Kajanto, "Onomastic Studies in the Early Christian Inscriptions of Rome and Carthage," *AIRF* 2:1; "Les noms," *AIRF* 1:2:40-72; "Women's Praenomina Reconsidered," *Arctos* 7 (1972): 13-30; "The Emergence of the Single Name System," *L'onomastique latine (Colloques internationaux du Centre nationale de la recherche scientifique*, 564 [Paris, 1977]) 421-30. A. Ferrua, "I nomi degli antichi cristiani," *La civiltà cattolica* 117 (1966): 492-98. H. I. Marrou, "Problèmes généraux de l'onomastique chrétienne," *L'onomastique latine,* 431-35. C. Pietri, "Remarques sur l'onomastique chrétienne de Rome," *L'onomastique latine,* 439-45.

though also, by the end of the third century, the meals must have been eaten in the complex where his wife was buried.

There is no mention here of the length of their marriage. In the *SICV* collection the average of twenty-five marriages lasted 11.8 years. From the few samples available, it was also determined that an average age of marriage for a woman was 22.1 years. Most other studies would make that about two years younger, though probably remarriages raised the average. Many conjecture that marriages occurred at about fifteen for women and eighteen for men. Unfortunately firm data are still lacking.[6]

The term *depositum* also characterizes early Christian funerary inscriptions. Some understand the term as a sign of resurrection or even the interim wait of the soul. In the Roman world the legal term signified that which was given over to another for safekeeping. As persons could be given over to the faith community as a *depositum* (Tertullian, *apologeticum* 39, 6), so the dead were given to God and the extended community for safekeeping. There is no way to determine whether the deposit was understood to be temporary.[7]

II. INSCRIPTIONS
FROM PRE-CONSTANTINIAN SARCOPHAGI

In addition to the sixty-two dated Roman Christian inscriptions, there are twenty-one inscriptions on sarcophagi that I have already utilized as pre-Constantinian. These are all Roman and can be found in Deichmann's *Repertorium* (there are no inscriptions on the non-Roman sarcophagi mentioned in chapter 3, section 3). The twenty-one are:

63. Third century	*Rep.*, #118	
64. Mid third century	*Rep.*, #976; N.S. I, #3395; Diehl, #3335	

65. Second third of 3rd century	*Rep.*, #123; Diehl, #3377E	
66. Third fourth of 3rd century	*Rep.*, #957; Diehl, #2313	
67. Last third of 3rd century	*Rep.*, #593	
68. Last third of 3rd century	*Rep.*, #881	
69. Last third of 3rd century	*Rep.*, #831	
70. Last third of 3rd century	*Rep.*, #778; Diehl, #1585	
71. Last third of 3rd century	*Rep.*, #119; N.S. I, #1853	
72. Last fourth of 3rd century	*Rep.*, #918; N.S. I, #3340; Diehl, # 224	
73. End of third century	*Rep.*, #766; N.S. I, #2048	
74. End of third century	*Rep.*, #612; Diehl, #3403	
75. End of third century	*Rep.*, #1031; Diehl, # 258513	
76. End of third century	*Rep.*, #72; N.S. I, #2327; Diehl #4114c	
77. End of third century	*Rep.*, #70; Diehl, #898A	
78. Beginning of fourth century	*Rep.*, #46; N.S. I, #1658	
79. Beginning of fourth century	*Rep.*, #125; Diehl, #4349	
80. Beginning of fourth century	*Rep.*, #514	
81. Beginning of fourth century	*Rep.*, #832	
82. Beginning of fourth century	*Rep.*, #833; N.S. I, #9027	
83. Beginning of fourth century	*Rep.*, #834; Diehl, #3015a	

There is little difference between these and the dated inscriptions. Since they have been found on sarcophagi, it stands to reason the inscriptions will be more formal than the catacomb *tituli* and the persons so honored will reflect a higher class place in society than those with simpler burials. Of the twenty-one instances we will look at three: Numbers 64, 73, and 78.

A. The Inscription of Clodia Lupercilla (#64)

Location: Palazzo Lancellotti, Rome

Edited Text:

> *Clodia Luper*
> *cilla in pace*
> *bene dormit, quae*
> *vicxit annis xxviii,*
> *m(ensibus) vii, d(iebus) viii, mecum*
> *ann(is) viii, m(ensibus) viii, d(iebus) XVIII*

[6]H. Nordberg, "Biométrique et mariage," *AIRF* 1:2:185-210. C. Carletti, "Aspetti biometrici del matrimonio nelle iscrizioni cristiane di Roma," *Augustinianum* 17 (1977): 39-51.

[7]A. Stuiber, "Depositio-catathesis," *Mullus-Festschrift Th. Klauser* (Münster, 1964) 346-51. J. Ranft, "Depositium," *RAC* 3:778-84.

Aurelius Timotheus
coniuc(i) b(ene) m(erenti).

Translation:

> Clodia Luper-
> cilla, in peace
> sleep well, who
> lived 28 years
> 7 months, 8 days; with me
> 8 years, 8 months, 18 days.
> Aurelius Timotheus
> to a well deserving wife.

This undoubtedly Christian inscription includes the "trade-mark," *in pace*, which picks up so many of the symbols of the early church, like the dove, the Orante, and the olive branch (see p. 17). Similar to *vibas,* it came from an eating or drinking acclamation, so that its immediate point of reference lies in community meals, especially the meals for the dead. Otherwise the inscription follows closely the form of non-Christian examples. Both husband and wife have Roman gentilica (family names), but cognomina derived from divinities. Lupercilla was a feminine derivative of Lupercal, and Timotheus, of course, a possible Christian divine name. Presumably the gentilica, Clodia (Claudia) and Aurelius, came from their former owners.

Timotheus included in the inscription for Lupercilla the length of their marriage: eight years, eight months, and eighteen days. I have already noted that in the *SICV* study the average duration for a marriage was 11.8 years. Frequently death at childbirth was the cause for premature termination of the marriage, but no children are mentioned here. We can also see that she was married at age twenty, somewhat younger than the *SICV* data mentioning age twenty-two, but about even with other biometric studies. Simply by reaching adulthood she lived well beyond the median life expectancy of twenty-two.

B. The Inscription of Artemidora (#73)

Location: Museo Nazionale Romano, Rome

Edited Text:

> ΕΝΘΑΔΕ
> ΚΟΙΜΑΤΑΙ
> ΑΡΤΕΜΙΔΩ
> ΡΑ ΕΝ ΕΙ
> ΡΗΝΗ

Translation:

> Here
> sleeps
> Artemido-
> ra. In
> peace.

In this inscription we have a classic Greek Christian epitaph. The ἐνθάδε marks the location. Κοιμᾶσθαι was used almost always to describe the condition of the person in death. Like *depositum*, it indicates a situation that is not permanent. While one could hardly claim a Christian origin for the metaphorical use of κοιμᾶσθαι to refer to death, it was deeply associated with Christian literature and Christian epitaphs. And ἐν εἰρήνη was, of course, the Greek for *in pace*, which I have noted became nearly an identifying mark for Christian burials. The single name Artemidora was a Greek cognomina, derived from an Eastern divinity, Artemis (gift of Artemis). Again, it is typical of third-century Christianity that a person, surely a slave at one time or still, had only a cognomina, and that name was not Christian.

C. The Inscription of Juliana (#78)

Location: Museo Pio cristiano, Vatican, Rome

Edited Text:

> *Ivn(iae) Ivliae*
> *Ivi(read l)ianeti*
> *conivci*
> *dulcissime*
> *Mei(read l)ibus*
> *viii idus Mais.*
> over the Orante on the sarcophagus: *Ivliane*

Translation:

> Junia Julia
> Julianeti
> a wife
> most sweet.
> Melibus.
> Eight days before the ides of May.
> Over the Orante: Juliana

The classical Roman name system included a *gentilicum*, which indicated the general family, such as Julius, Flavius, Aurelius, Antonius, and the like. A second name (last of the three) indicated the specific family within the *gens*. These names frequently ended in "anus" or "ana," like Vibulana or Aelianus. To distinguish individuals in the specific family, a *praenomen* was added to the beginning of the names. These were fairly limited in the period of the Republic. Names like Lucius, Marcus, or Titus were common. So Caius Fabius Vibulanus belonged to the Fabius *gens*, the Vibulanus family (*cognomen*), and was personally distinguished as Caius (*praenomen*). For women the custom was two names, the *genticilium* and the *cognomen*. A study of Roman names during the first and second centuries shows that 71.5 percent of the men had a *tria nomina* system and 82.5 percent of the women had a *duo nomina* appellation (*SICV*, 1:2:40). As is well known, during the Imperial period and up through the beginning of the Christian period, the classical name system was greatly eroded. Eventually only a *cognomen* remained. During that process the *praenomen* was dropped and the *cognomen* became the distinguishing name for the individual. The following chart from *SICV* (1:2:43) shows that development.

		ANTE PACEM		A.D. 313-410		A.D. 410-500		A.D.500-600	
M	tria nomina	18	10.5%	--	--	--	--	--	--
E	duo nomina	54	32.0%	31	9.5%	5	5%	3	4%
N	*cognomen*	98	57.5%	292	90.5%	98	95%	72	96%
	TOTAL	170		323		103		75	

W	duo nomina	80	50%	28	10%	3	3.5%	1	2%
O	*cognomen*	79	50%	245	90%	82	96.5%	47	98%
M									
E	TOTAL	159		273		85		48	
N									

This development of the name system shows quite clearly a dissolution of the class system of the Republic. This social revolution had already started in the first century. It cannot be determined to what extent Christianity participated in an inevitable social development or itself caused a democratic equalization. But it did suit the purposes of the faith community to encompass all persons in the same social structure. The name system shows that quite positively.[8]

Plate 47. The inscription of Julia Juliane. Museo Pio cristiano, #236.

[8]J. Suolahti, P. Bruun, and H. Nordberg, "Position sociale des personnes mentionnees dans les inscriptions," *AIRF* 1:2:167-87. H. G. Thuemmel, "Soziologische Aspekte des frühen christlichen Inschriften-formulars," *Die Rolle der Plebs im spätrömischen Reich* (Berlin, 1969) 71-75.

Junia Julia Juliane had two *gentilicia* and a *cognomen*, Ju-
liana, which itself was formed from a *gentilicium*. From the in-
scription over the Orante we know she was distinguished by her
cognomen, Juliana, so she fits the classical pattern better than
most of the single-name inscriptions of early Christianity.

III. INSCRIPTIONS FROM THE VATICAN MUSEUM

Sylloge inscriptionum christianarum veterum musei vaticani. Edited by
 Henrico Zilliacus. *Acta instituti romani finlandiae* 1:1-2. Helsinki,
 1963.

In 1963 a group of Finnish scholars catalogued and published 330
early Christian *tituli* from the Vatican inscription collection.
These were not associated with sarcophagi in the Vatican, they
were not dated, and they were not listed in *ICUR*. The editors of
SICV have estimated the date of these inscriptions by comparing
their style with datable materials. Twenty-five of the collected in-
scriptions were considered pre-Constantinian. This estimation
may very likely be accurate, but some may not be Christian. Num-
ber 1 from the first century has no Christian characteristics, nor
does #22, from the fourth century. The twenty-five are:

1. First century	*SICV* #320; Diehl, #3116A	
2. Third century	*SICV* #150	
3. Third century	*SICV* #166	
4. Third century	*SICV* #219; Diehl, #279	
5. Third century	*SICV* #267	
6. Third century	*SICV* #311	
7. Third century	*SICV* #317	
8. End of third century	*SICV* #222; Diehl, #4137	
9. End of third century	*SICV* #225	
10. End of third century	*SICV* #248	
11. End of third century	*SICV* #293	
12. End of third century	*SICV* #321	
13. A.D. 290-320	*SICV* #19	
14. A.D. 290-320	*SICV* #20	
15. A.D. 290-320	*SICV* #111	
16. A.D. 290-320	*SICV* #126	
17. A.D. 290-320	*SICV* #199; Diehl, #1578A	
18. A.D. 290-320	*SICV* #284	
19. Beginning of fourth century	*SICV* #56	
20. Beginning of fourth century	*SICV* #65	
21. Beginning of fourth century	*SICV* #93	
22. Beginning of fourth century	*SICV* #169	
23. Beginning of fourth century	*SICV* #191	
24. Beginning of fourth century	*SICV* #249	
25. Beginning of fourth century	*SICV* #283; Diehl, #4250	

This collection contains inscriptions that are less formal than
those that were dated and those found on sarcophagi, though still
not as simple as the average *titulus* of early catacomb areas. As
examples we will look at numbers 3, 15, 16, and 17.

A. Inscription of Flavia Eutychia (#3)

Edited Text:

> *Fl(avia) Eutychia*
> *nonnae [d]ulci[ssimae]*

Translation:

> Flavia Eutychia
> a most dear nurse.

This woman bore the name of an abstraction in Greek (fortune or
prosperity), which surely indicates she was of slave background.
Her other name was the abbreviated *genticilium* of her mistress.
Inscriptions frequently mentioned the occupation of the person or
an incised picture indicated it. This woman was apparently a
nurse in the family structure, unless "nonnae" is part of an incom-
plete name. One wonders if we have in this inscription signals of
a function in the Christian community that would lead later to
nurturing orders of women, but that cannot be determined. Such
orders did begin early, that is, 1 Timothy 4:9 mentions an order of
widows.

B. Inscription of Epictetus (#15)

Edited Text:

> B(onae) M(emoriae)
> Filio innocentissimo Epicteto, qui semper cum
> parentes suos innocentissime vixit.
> Hic vixit annos numero viginti et menses n. q i
> et decessit die vi Idus Aug(ustas). Huic parentes po
> suerunt, id est Victorinus et Cyriacete.

Translation:

> Good Memories
> To a most innocent son, Epictetus, who always with
> his parents lived most innocently.
> He lived twenty years and 7 months,
> and died 6 days before the ides of August. The parents
> arranged this, that is Victorinus and Cyriacete.

This inscription, like so many others, stands on the edge of the Christian culture. The neutral B M stands in the place of the formal *D(is) M(anibus)* of non-Christian inscriptions. *Bonae Memoriae* probably has not been reified into an abbreviation, but has been used to replace the necessary D M. Another indication of Christian origin would be the mother's name—a feminine, latinized adaptation of κύριος, Lord.

C. The Inscription of Hermicus (#16)

Edited Text:

> Benemerenti Hermico
> in pace
> qui vixit cum conpa
> re sua annos lxxx
> depositus Idus Apriles.

Translation:

> To a well deserving Hermicus
> in peace
> who lived with his
> wife 80 years.
> Deposited the ides of April.

The *in pace* marks this as a Christian inscription. Most remarkable is the length of the marriage, eighty years, which far exceeds anything in the *SICV* collection or the others collected here as *ante pacem*. Hermicus has a single *cognomen* derived from a Greek god, Hermes. The mention of the date of death, without the year, reminds the family of the date of the *refrigerium*.

D. The Inscription of Januaria (#17)

Edited Text:

> Ienuarie birgini
> benemerenti in
> pace botis deposita.

Translation:

> To once married Januaria,
> well deserving, in
> peace, deposited with prayer.

The language of the text indicates the influence of common pronunciation on writing: *e* replaced *a* in Januaria, and *b* replaced *v* in *virgini* and *votis*. Again, there is a clear Christian inscription with the *in pace* and *deposita*. The use of *"votis"* is unusual. It likely refers to the offering of food and prayer that went with the *refrigerium*. The use of *virgini* raises considerable problems. Insofar as it follows our normal understanding of the word and its Greek equivalent παρθένος, *virgo* would refer to an *innupta*, an unmarried woman, without reference to any moral or biological considerations. There were, however, in the Roman world inscriptions that mentioned a *virgo sacra*, a *virgo devota*. So an order of virgins, women who had not had intercourse, was known prior to Christianity. Within our period there does not seem to be such an order developing. The problem is further complicated by reference to married virgins. In *SICV* #136 a certain virgin, Sabina, lived with her husband three years and twenty-five days. In Christian and Jewish inscriptions such references are common enough to require either the translation "virginal prior to marriage," "faithful in marriage," or "married only once." The latter seems most ap-

propriate to public statements. Furthermore the term applies also to men. In *SICV* #283, #25 in our list of *ante pacem* inscriptions, a certain Elia Vincentia lived with her *virginium* a day less than a year. No doubt the term referred to a young, unmarried woman, perhaps even a girl, but apparently could include women and men married just once. In contrast with some third-century literature (Acts of Paul), a religious order of virgins does not occur in our pre-Constantinian archaeological data.

IV. INSCRIPTIONS
FROM THE CATACOMB OF PRISCILLA

G. B. de Rossi. "L'epigrafia primitiva priscilliana." *BAC* serie 4, anno 4 (1886): 34-165 [inscriptions 1-257]; anno 5 (1887): 109-17 [inscriptions 258-281]; serie 5, anno 3 (1892): 57-96 [inscriptions 282-370].

While exploring the earliest levels of the catacomb of Priscilla during the latter part of the nineteenth century, de Rossi collected a number of inscriptions that have become, by common agreement, a source for early third-century data. The inscriptions are not dated; they simply come from an area near a nucleus that can be dated prior to Constantine (see above, pp. 84-85). Most of the inscriptions could not otherwise be identified as Christian. Indeed, they may belong to a period in the history of the catacomb when it was non-Christian. It is far more likely, however, that the nondistinguishable inscriptions (#s 2, 3, 4, 6, 7, 13, 15, *ad passim*) were Christian, but cut before Christian characteristics were available.

Eventually some Christian characteristics did begin to appear. They were primarily Christian symbols cut on *tituli* that otherwise bore what appeared to be non-Christian epitaphs. There were anchors (#s 44, 45, 84, 106) and palms (#s 153, 197). Occasionally a dove appeared (#198), or more often a fish (#s 216, 217, 309). Then simple Christian ascriptions became noticeable. Most obvious was *Pax* (#s 24, 87; εἰρήνη, #94) or a fuller bless-

ing, *Pax tecum* (#s 80, 105; εἰρήνη coι [read σοι]), *Pax tibi* (#s 82, 83), and eventually the traditional acclamation, *In Pace* (#s 63, 357; ἐν εἰρήνῃ, #55). Of course, in an undated collection one cannot really see when the Christian marks arose and in what order, but a few other acclamations can be found in this early material: *Pax tecum in do[mino]* (#227); *Vivas* (#255); *In deo* (#228); or *Vivas in deo* (#s 146, 362). And some Christian names can be found: Paulus (#2); Timoteus (#43); Agapetus (#s 55, 366); Petrus (#s 1, 23, 72, 108, 149, 157); Euelpistis (#88); Stefanus (#126); Elpizusa (#143); Susanna (#156); Theodora (#174); Irene (#260); Theodote (#284); Paulina (#285); and Elpis (#331).

A very few Christian terms for burial also can be seen in these early "borderline" inscriptions. Not many formulae occur at all, and the most apparent would be the neutral *posita est* (#s 116, 138, 336). The more characteristically Christian *deposita* or *depositus* does not appear in these early materials. In a few cases (#s 63, 287) *dormit* was used. In a more formal, mutilated (later?) Greek inscription (#330) the reference to dying may be ΑΠΟΔΟΥΣΑ, translated into Latin as *reddidit*, a term used in both cultures that means to give back life to the "creator(s)." The same inscription has reference to ἀνάστασις αἰῶνος, the only one in this entire collection that mentions the resurrection. Only one inscription refers to the meal for the dead, the *refrigerium* (#212), and most do not have the death date (day for celebrating the *refrigerium*).

Some examples of the Priscilla collection are:

32. ΟΝΗCΙΜΟC ΚΑΙ
 CΕΜΝΗ ΓΟΝΕΙC
 ΕΠΙΚΤΗΤΩ ΤΕ
 ΚΝΩ ΓΛΥΚΥ
 ΤΑΤΩ ΕΠΟΙΗ
 CΑΝ

 Onesimus and
 Semne parents
 for Epictetus, a
 child most
 sweet made
 [this].

40. Felicitas [anchor]

63. Marcianus hic
 dormit in pace

 Marcianus sleeps
 here in peace.

105. Zosime
 Paxte [anchor]
 cum

 Zosimus
 Peace be
 with you.

153. Aeliabus Serene et Noricae
 [dove] filiabus pientissimis [palm branch]
 P. Ael. Noricus pater posuit

 For Aelia Serena and Aelia Norica
 most devoted daughters,
 Publius Aelius Noricus, father, placed [this].

In this unusual inscription the two girls are buried by their father, who bears a classical name structure—*praenomen*: Publius; *gentilicium*: Aelius; and *cognomen*: Noricus. It is considered Christian not only because of its location, but because of the dove and palm branch.

225. ΒΑΚΧΥΛΛΙC
 ΒΑΡΒΑΡΑΝΗ
 ΦΙΛΙΑΙ ΒΕ
 ΝΕΜΕΡΕΝ
 ΤΙΦΗΚΙΤ

LATIN: Bakxullis
 Barbarane
 filiae be
 nemeren
 ti fecit.

 Bakxullis
 for Barbarana,
 a daughter well
 deserving,
 made [this].

Most of the inscriptions in the Priscilla are in Greek. Occasionally one like this was written with Greek letters, but in the Latin language.

242. OBPIMOC NECTOPIANH
 MAKAPIA ΓΛΥΚΥΤΑΤΗ
 CYNBIΩ MNHMHC XA(ϱιν)

 Obrimus for Nestoriana,
 a blessed most dear
 wife, in grateful memory.

282. ONHCIMOC
 ΤΙΤΩ ΦΛΑΒΙΩ
 ONI-ICIΦOPΩ TEKNΩ
 ΓΛΥΚΥΤΑΤΩ ΖΗ
 ΕΤΙ-Ι C,

 Onesimus
 for Titus Flavius
 Onesiphorus, a child
 most sweet. He lived
 one year, 6 (months).

312. ΤΕΤΤΙΑΔΕΛΦΕ
 ΕΥΨΥΧΙΟΥΔΙC
 ΑΘΑΝΑΤΟC

 Tettius, a brother.
 Farewell! No one
 is immortal.

The laconic "no one is immortal" occurs often on non-Christian inscriptions or even later Christian epitaphs. Of most interest is the appellation ἀδελφός, the technical term in the New Testament for a participant in the Christian fellowship. Of course, the *titulus* could have been given by a brother or sister of Tettius. The term occurs in the letters, as we shall see, but very seldom in the inscriptions.

V. INSCRIPTIONS FROM THE UPPER TEMBRIS VALLEY

J. G. C. Anderson. "Paganism and Christianity in the Upper Tembris

Valley." *Studies in the History and Art of the Eastern Roman Provinces. Aberdeen University Studies* 20. Aberdeen: University Press, 1906, 183-227.

W. M. Calder. "Philadelphia and Montanism." *BJRL* 7 (1923): 309-54.

_____. "Studies in Early Christian Epigraphy." *JRS* 14 (1924): 85-92.

_____. "Early-Christian Epitaphs from Phrygia." *Anatolian Studies* 5 (1955): 25-38.

Elsa Gibson. *The "Christians for Christians" Inscriptions of Phrygia. Harvard Theological Studies* 32. Missoula: Scholars Press, 1978.

W. M. Ramsay. *The Cities and Bishoprics of Phrygia.* Oxford: University Press, 1895. Reprint. New York: Arno, 1976.

Following the work of William Ramsay, a group of British scholars associated with Aberdeen University continued to edit and examine those Phrygian inscriptions found in the Upper Tembris Valley (see map). Most famous are the Χρειστιανοὶ Χρειστιανοῖς, "Christians for Christians" inscriptions, though the other Christian inscriptions are equally informative and useful. Actually, apart from the fascinating fact of their existence, there is little in the way of content to be gleaned. There are no references to Christian practices or thought, no Christian names. But the existence of so blatantly Christian inscriptions in the middle of the third century, or earlier, serves to elucidate the Roman material and adds much to our understanding of early Christian history. I will present here one dated "Christians for Christians" inscription (Gibson, #16) and four others dated prior to Constantine (Gibson, #s 22, 32, 36, and 42). Though others are undoubtedly pre-Constantinian (a combined list from Gibson, Anderson, and Calder would be: #s 1, 2, 8, 9, 10, 11, 12, 13, 15, 16, 17, 20, 21, 22, 23, 28, 29, 32, 36, and 42 in Gibson), these five will suffice to indicate the nature of the Phrygian material. In addition, we will look at the Abercius inscription in this category.

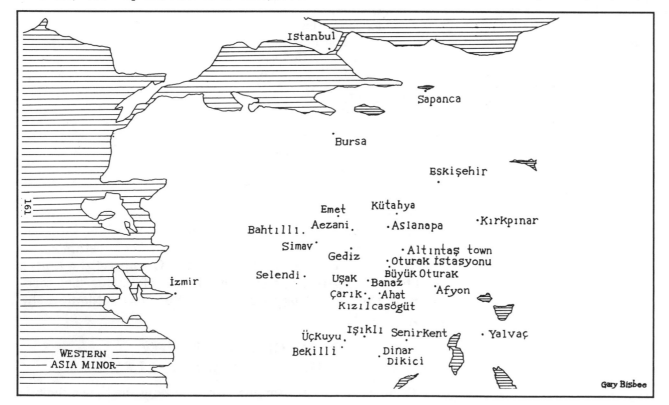

Figure 44. Map of Western Asia Minor.

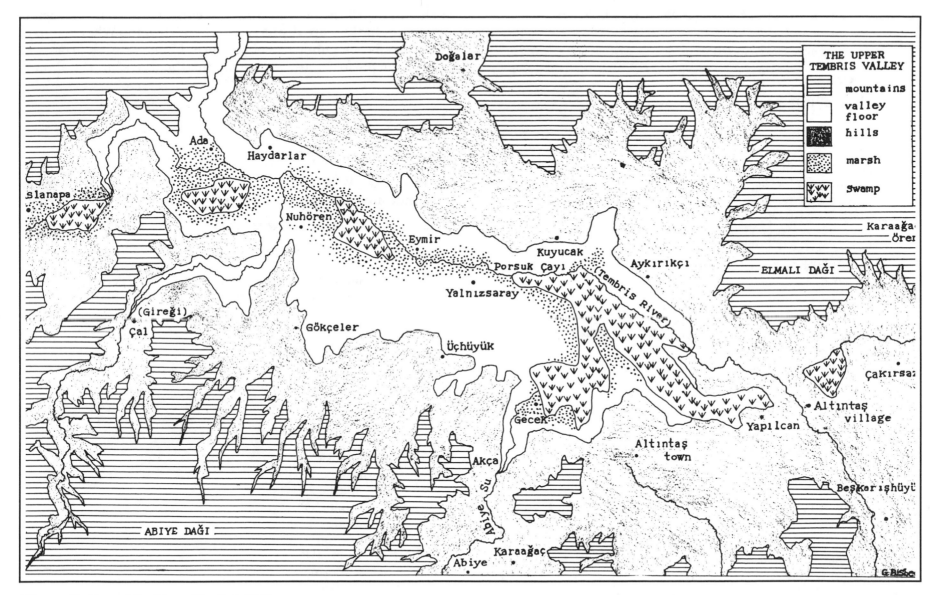

Figure 45. Map of the Upper Tembris Valley.

A. Inscription of Aurelios Satorneinos (A.D. 242/3)

Gibson. *Inscriptions*, 116-19 (#42).

Location: Uckuyu

Edited Text: (of fragment or piece 1 only)

> η[νὸς] ἀ[πιόντος]
> [Ἔ]τους τκζ . . μ ί δ Αὐρ.
> Σατορνεῖνος δ[ὶ]ς
> Χρειστιανὸς [ἐν] θα-
> δε κεῖται κατασκευ-
> άσας αὐτῷ [τὸν αἰώ]-
> [νιο]ν οἶκον [ἔτι ζῶν]
> [ω]ς μηδεν[ὶ ἄλλῳ ἐξ]-
> ὸν ἐ[πει]σε[νέγκειν]
> ἄ[λλον]

Translation:

> In the year A.D. 242/3, the fourth day in the last part
> of the tenth month
> Aurelios Satorneinos, son of Satorneinos,
> a Christian lies
> here, having built
> for himself the eternal
> house, while living,
> so that no one else
> is permitted to bury
> anyone else. . .

The date given is that of 327 in the Sullan era, which translates to 242/3 in our chronology. This is the earliest of the dated Phrygian inscriptions. It is Christian insofar as Aurelius Satorneinos publicly identifies himself as a Christian. Gibson's reconstruction of lines 5 and 6 to read "eternal house" simply refers to the function of the tomb. Frequently a will has been included in the inscription (Gibson, #15), and certainly instructions, as in this case. The stone was found in a garden, apparently broken to pieces by an owner. We have printed here only piece 1, but the fragment of piece 2 indicates the wife had the right to be buried in the tomb.

Piece 4 carried the normal threat or curse regarding violation of the tomb. In this case it was a fine of 502 denarii. What is important here is the public use of the term *Christian* that otherwise does not appear in any archaeological material of the Roman world.[9]

B. The Inscription of Allexandros

Anderson. "Paganism," 214, #11.

W. H. Buckler, W. M. Calder, C. W. M. Cox. "Asia Minor, 1924. Monuments from the Upper Tembris Valley." *JRS* 18 (1928): 21-22, #231.

Calder. "Philadelphia," 337, #2.

Gibson. *Inscriptions*, 56-57, #22.

G. Perrot, E. Guillaume, J. Delbet. *Exploration archéologique de la Galatie et de la Bithynie, d'une partie de la Mysie, de la Phrygie, de la Cappodoce et du Pont*. Paris: Didot, 1862, 127, #90.

Location: Altintas, in the mosque.

Edited Text:

> [τ]λγ´
> Χρειστιανοὶ
> Χρειστιανο[ῖς]
> Αὐρ. Ἀμμεία
> σὺν τῷ γαμβρ[ῷ]
> αὐτῶν Ζωτι-
> κῷ κὲ σὺν τοῖ[ς]
> ἐγόνοις αὐτῶ[ν]
> Ἀλλεξανδρεία
> κὲ Τελεσφόρῳ
> κὲ Ἀλλεξάνδρῳ

[9]Although I note with Dinkler the claims for earlier mention of the term *Christian*, see M. Guarducci, "La più antica iscrizione col nome dei cristiani," *RQS* 57 (1962): 116-25. Dinkler, *Signum Crucis*, 138-39.

συνβίῳ ἐποίη-
σαν.

Translation:

A.D. 248/249
Christians
for Christians.
Aurelia Ammeia
with their
son-in-law Zotikos
and with their
grandchildren,
Allexandreia
and Telesphoros
and for Allexandros
her husband, they
made [this].

Gibson lists about twenty "Christians for Christians" inscriptions, if properly reconstructed. Of these, only this one was dated (333 of the Sullan year). The meaning of the formula has not been determined. It could refer to a more rigid sect, like the Montanists, who insisted on public witness and encounter. It could refer to orthodox Christians as they began to exert social and economic pressure on their non-Christian neighbors. Or it could simply be a rural, monolithic frankness that differed drastically from the urban pluralism that so characterized the *Sitz im Leben* of most of our data on early Christianity.

C. The Inscription for the Family Tomb of Eutyches

Calder. "Philadelphia," 337, #1.

Gibson. *Inscriptions*, 108-10, #36.

Ramsay. *Cities*, 558, #444.

Location: possibly Akmonia (now in the Izmir Museum)

Edited Text:

Ἔτους τξγ' . . . μη(νὸς) Περειτίου ἱ
Εὐτύχης Εὐτύχου Τατ. . . . ι
α γυναικὶ καὶ πατρὶ μνή-
μης χάριν Χρειστιανο . . . ὶ
καὶ ἑαυτῷ. Φελλίνας Τημενοθυρ
 ε
 [ύ]
 ς

Translation:

The year A.D. 278/279, the tenth of the month Pereitios,
Eutyches, son of Eutyches, for Tatia
his wife and for his father, as a
memorial, both Christians,
and for himself [made this]. Phellinas of Temenothyrai.

Phellinas would presumably be the name of the artisan.

D. Inscription for the Family Tomb of Aurelia Julia

Gibson. *Inscriptions*, 103-104.

Location: Akmonia

Edited Text:

ON FASCIA OF MOULDING:

(leaf) ἔτ[ους] ταπ´

ON SHAFT:
Αὐρ. Ἰουλία τῷ
πατ[ρὶ] Α
ΤΟ [καὶ τῇ μητρὶ] Βε-
ρονεικιαν [ῇ] καὶ
τῷ γλυκυτάτῳ

μου τέκνῳ Σεβή-
ρῳ καὶ Μουνδάνῃ
νύμφῃ μνήμης χά-
ριν Χρειστιανοί

Translation:

ON THE FASCIA OF THE MOULDING:

A.D. 296/297

ON THE SHAFT:

> Aurelia Julia, for
> her father. . . . a
> to and her mother
> Beroneikiane and
> for my most sweet
> child Severus
> and Moundane
> my daughter-in-law, as a
> memorial. All Christians.

The name of the daughter-in-law, Moundane, may be the feminine of the name of the heterodox Montanus. But the use of the name elsewhere in the area does not seem to carry that connection. Montanus, formerly a priest of Cybele in Ardabau on the Phrygian border of Mysia, was converted to Christianity and about the year 157 began to preach that the Holy Spirit had come to him and his two women followers, Priscilla and Maximilla. Their ecstatic yet rigorous form of Christianity attracted many, including eventually the great Tertullian. The movement came to be considered heterodox during the last quarter of the second century.

E. Inscription for the Family Tomb of Aurelios Markeianos

Gibson. *Inscriptions*, 37-40.

Location: Kutahya Museum

Edited Text:

BETWEEN THE MEN'S HEADS:

Ἔτους τπθ'　　　389 Sullan Era = A.D. 304/5

ON FASCIA BELOW FIGURES:

Αὐρ. Μαρκειανὸς Μάρκου κέ Δόμνα τέκνῳ Λέοντι
γλυκυτάτῳ ἀωροθανῆ ἐτῶν ˙ ιθ' ˙ κέ ἐαυτοῖς ζῶντες

BELOW FASCIA, NEXT TO OXEN AND CART:

κὲ τὰ τέκνα αὐτῶν
Ἀμμίαντος κὲ Διομή-
δης κὲ Εὔμηλος πατρ-
ὶ ζῶντι κὲ μητρὶ ζώσῃ
κὲ ἀδελφῷ θεθνῶτι
γλυκυτάτοις μνήμη-
ς †άριν

τίος αν
προσάξει †ιρ-
α τὴν βαρύχθ-
ονον ὀρφαν-
ὰ τέκνα λίποι-
το οἶκον †η-
ρον βίον ἔρη-
μον

Translation:

Date: A.D. 304/305

ON THE FASCIA:

> Aurelios Markeianos, son of Markos, and Domna, for Leon,
>> their son
> most sweet, who died prematurely at 18 years,
>> and for themselves
>>> while still living,

BELOW FASCIA:

> and their children Ammiantos and Diomedes
> and Eumelos for [their] father
> while still living and [their] mother while
>> still living
> and (their) brother, already dead,
> all most sweet, as a memorial.

> Whoever
> brings damage
> with a heavy hand,
> may he leave (his) children
> orphans,
> his house seized,
> his life wasted.

The large tau or chi has been interpreted in some circles as a

cross. Generally it is assumed there were no crosses anywhere in Christianity before Constantine. If these are the earliest crosses in Christian symbolism, we have no notion of their meaning, except to suppose that, like the term *Christian*, it publicizes the faith of the deceased. For such formalization one would have to presuppose a prehistory of the symbol as a public Christian insignia. However, there is no hint of that. One would conclude, then, that the cross marks are cultural attempts to ward off evil spirits and have no reference to the cross of Jesus.

F. The Inscription of Abercius

W. H. Calder. "The Epitaph of Avircius Marcellus." *JRS* 29 (1939): 1-4.

Dölger. ΙΧΘΥΣ, 2:454-507.

C. R. Morey. "The Origin of the Fish Symbol." *PTR* 9 (1911): 268-89.

Johannes Quasten. *Monumenta eucharistia et liturgica*, 7:1 (1935) 21-25.

H. Strathmann and Th. Klauser. "Aberkios." *RAC* 1:12-17.

Wolfgang Wischmeyer. "Die Aberkios inschrift als Grabepigramm." *JAC* 23 (1980): 22-47.

Location: Hieropolis; now in the Museo Pio cristiano, Vatican, Rome.

Edited Text:

ἐκλεκτῆς πόλεως ὁ πολείτης τοῦτ' ἐποίησα
ξῶν ἵν' ἔχω καιρῷ σώματος ἔνθα θέσιν.
οὔνομ' Ἀβέρκιος ὢν ὁ μαθητὴς ποιμένος ἁγνοῦ
ὃς βόσκει προβάτων ἀγέλας ὄρεσιν πεδίοις τε
ὀφθαλμοὺς ὃς ἔχει, μεγάλους πάντη καθορῶντας
οὗτος γάρ μ' ἐδίδαξε τὰ ζωῆς γράμματα πιστά.
εἰς Ῥώμην ὃς ἔπεμψεν ἔμεν βασιλείαν ἀθρῆσαι
καὶ βασίλισσαν ἰδεῖν χρυσόστολον χρυσοπέδιλον
λαὸν δ' εἶδον ἐκεῖ λαμπρὰν σφράγειδαν ἔχοντα
καὶ Συρίης πέδον εἶδον καὶ ἄστεα παντὰ Νίσιβιν
Εὐφράτην διαβὰς πάντη δ' ἔσχον ὁμίλους

Παῦλον ἔχων . . . πίστις πάντη δὲ προυῆγε,
καὶ παρέθηκε τροφὴν πάντη ἰχθὺν ἀπὸ πηγῆς
πανμεγέθη, καθαρὸν ὃν ἐδράξατο παρθένος ἁγνή,
καὶ τοῦτο ἐπέδωκε φίλοις ἐσθέειν διὰ παντὸς
οἶνον χρηστὸν ἔχουσα κέρασμα δίδουσα μετ' ἄρτου
ταῦτα παρεστὼς εἶπον Ἀβέρκιος ὧδε γραφῆναι
ἑβδομηκοστὸν ἔπος καὶ δεύτερον ἦγον ἀληθῶς
ταῦθ' ὁ νοῶν εὔξαιτο ὑπὲρ Ἀβερκίου πᾶς ὁ συνῳδός.
οὐ μέντοι τύμβῳ τις ἐμῷ ἕτερόν τινα θήσει,
εἴ δ' οὖν Ῥωμαίων ταμειῷ θήσει δισχίλιά χρυσά
καὶ χρηστῇ πατρίδι Ἱεροπόλει χίλια χρυσά.

Translation:

I, the citizen of a distinguished city, have made this
while still living so that I might have at the appropriate
 time a place here for my body.
My name is Abercius, disciple of the holy shepherd
who feeds his flocks on mountains and plains,
who has great eyes that look into everything.
For he taught me the faithful scriptures of life.
He sent me to Rome to make articulate the kingdom and
 to see a queen with a golden robe and golden sandals.
And there I saw a people with a splendid seal.
And I saw the plain of Syria and passed through all the
 cities,
having crossed the Euphrates. Everywhere I had
 companions
Paul . . . and faith was everywhere my guide and
everywhere she laid before me food, fish from a fountain
 the very great, the pure, which a holy virgin seized,
and she gave this to friends to eat forever,
having a goodly wine, giving it mixed with water, with
 bread.
These things I, Abercius, dictated to be inscribed here
 while standing by.
Truly I was seventy-two years old.
Let everyone in harmony who understands this pray for
 Abercius.
Do not, however, let anyone place another in my tomb;
otherwise he shall pay to the Roman treasury two thou-

sand pieces of gold,
and to my goodly fatherland, Hieropolis, one thousand
pieces of gold.

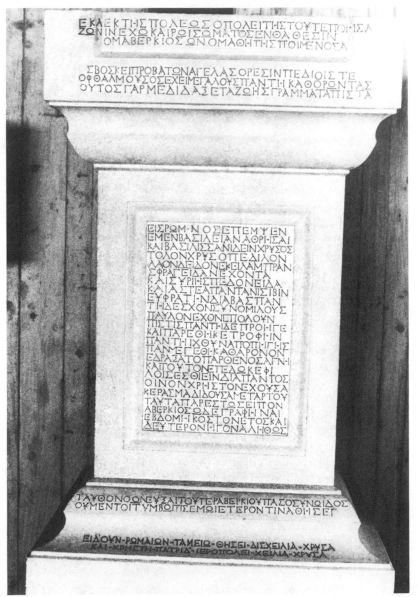

Plate 48. The Abercius inscription as restored. Museo Pio cristiano.

The Abercius epitaph has been known to us through the Life of Abercius in the *Acta Sanctorum*. This legendary life was probably created during the sixth century, though the writer says he copied the inscription from the tombstone. In 1881 Ramsay found the epitaph of a certain Alexander that has lines identical to the opening and closing of the Abercius inscription. That inscription was dated 300 in the Sullan era or A.D. 216. In 1883 Ramsay found walled into the remains of the public bath in Hieropolis two fragments of the original epitaph of Abercius. These two now may be seen in the Vatican Museum (see plate 48). The text offered above has been restored on the basis of the manuscripts, the Alexander epitaph, and the two fragments.

There have been attempts to demonstrate the non-Christian origin of this inscription, but the references to "elect city, holy shepherd, faithful scriptures, faith as a guide, Paul as a companion, a meal of fish, bread, and wine, and a virgin furnishing the fish," all seem too Christian to be ignored. The date of the Alexander epitaph almost certainly forces this inscription back to the turn of the century or earlier. Now that we have seen the Phrygian inscriptions of the third century, the form of the Abercius epitaph seems quite credible, and the public display of one's faith does not appear unusual. The theological affirmations do appear unique and their nature unusual. We have already seen in our discussion of fish (see above, pp. 24-26) that prior to Constantine only this "document" identifies the eaten fish with Jesus Christ. Identification of Jesus with the Good Shepherd was known in literature, but not in the archaeological data. To put it in other terms, the Abercius epitaph should be considered authentic, legitimately in the form of a Phyrgian tomb inscription, but actually of a literary nature. It was written for public use and "distribution." As such its language is no more unusual than that of Ignatius of Antioch, for example.[10]

[10]The quasitheological language of Syrians could be recognized as such throughout the empire. See C. P. Jones, "A Syrian in Lyon," *American Journal of Philology* 99 (1978): 336-51.

VI. GRAFFITI IN THE *TRICLIA* AND SPRING UNDER S. SEBASTIANO

Felice Grossi Gondi. "Di un graffito greco nella triclia di S. Sebastiano sull' Appia." *NBAC* 28 (1922): 27-31.

——————. "Il rito funebre del 'Refrigerium.'" *DPARA*, ser. 2, 14 (1920): 263-77.

M. Robert Marichal. "La date des graffiti de la triclia de Saint-Sebastien et leur place dans l'histoire de l'écriture latine." *RSR* 36 (1962): 111-54.

——————. "Les dates des graffiti de Saint-Sebastien." *Academie des Inscriptions & Belles-Lettres. Comptes Rendus* (1953) 60-68.

O. Marucchi. "Gli ultimi scavi nella basilica di S. Sebastiano e la memoria sepolcrale degli apostoli Pietro e Paolo." *NBAC* 28 (1922): 3-26.

O'Connor. *Peter in Rome*, 150-53.

Paul Styger. "Il monumento apostolico della Via Appia." *DPARA*, ser. 2, 13 (1918).

——————. "La costruzione appartente alla *Memoria Apostolorum* coi suoi graffiti." *DPARA*, ser. 2, 13 (1918).

Styger has assembled all the graffiti found on the walls of the *triclia* under S. Sebastiano. They were scribbled there by Christians who came to celebrate the death date of family members and friends, as well as the death date of the two martyrs Peter and Paul. The prayers written call upon the efforts of Peter and Paul. The importance of these graffiti cannot be overestimated, for they furnish us with a spontaneous picture of the life of the early Church. Styger has assembled twenty-five tablets of inscriptions. He lists by numbers 1 through 190 the separate pieces on tables 6-25. The 32 found on tables 1-5 are discussed separately. Of these 222, most of which cannot be reconstructed, and 8 of which are symbols only, we will include in this study 13 of the most useful.

Some graffiti were found at the bottom of the stairs near the well or spring. Marucchi has published these, and we will include one.

A. Paule ed Petre petite
pro Victore.

Paul and Peter pray
for Victor.

B. ΠΕΤΡΕ ΕΤ
ΠΑΥΛΑΙ
IN METE
Peter and
Paul (keep)
in mind (Tav. I)

This inscription and #J are Latin, but written in Greek.

C. Petro et Paulo
Tomius Coelius
refrigerium feci (Tav. II)

Peter and Paul,
Tomius Coelius
made (this) refrigerium.

D. [Πετρ]ΟCΚΑΙ
[Παυλο]C CYN
THPHCATE
TOYC ΔΟΥΛΟΥC
ΠΝΕΥΜΑΤΑ
ΑΓΕΙΑ CYNTH
PHCAT[.
ΑΝΑΓΙCΜΟΙC
ETE]. (Tav. II)

Peter and
Paul pro-
tect
[your] servants;
holy
spirits, pro-
tect.
a refrigerium
?.

Grossi Gondi ("Di un graffito") maintains that ἀναγισμοῖς would be equivalent to the Latin *refrigerium*.

E. XIII Kal Apriles
refrigeravi
Parthenius in deo et nos in deo omnes (Tav. II)

13 days before the Kalendar of April
a refrigerium was held
Parthenius in God and all of us in God.

F. Paule et Pet
re a petite pro Na
tivu in perpetuum (Tav. III)

Paul and Peter
pray for Nativus
always.

G. X Kal.
Paule Petre in mente
habete Sozomenum
et tu qui legis. (Tav. III)

10 days before the Kalendar of.
Paul, Peter keep in
mind Sozomenus,
and you who peruse (this).

H. Petre et Paule sub
venite Prim[itivo]
peccatori (Tav. VII, #9)

Peter and Paul come
to the aid of Primitivos,
a sinner.

I. Dominus no[ster]
me promisit
martororum
....llucunisio (Tav. VII, #13)

Our Lord,
send me
(one) of the martyrs
.....

J. [παυλ]Ε ΕΤ ΠΕΤ[ρε
ινμεντε ν]OC ABET[ε
ομ]NEC BE.... (Tav. IX, #28)

Paul and Peter
in mind have us
all

K. Petre et Paule
in ment abete
...sinum in r
[ef]ri[g]erium
Peter and Paul
keep in mind
...sinus during the
refrigerium (Tav. X, #42)

L. ...Celgra...
vvius aug....
farsul.......
et Donat..... (Tav. XI, #44)

This inscription has become important for the history of the complex under S. Sebastiano because it might give a firm date for the use of the *triclia* as a *martyrium*. Marichal read the graffito in this manner:

....Celeri...
v idus aug.....
saccul.........
et Donat.......

He then reconstructed it to read:

....Celeri[nus]
v idus Aug[ustas]
Saecul[ari II]
et Donat[o II Cos]

....Celerinus
9th of August
A.D. 260

M. [petre et] Paul[e]
in [mente nos h]abete in

ora[tion]ibus vestris
Antimachum et Gregoriu
m et Gregorium Iuniore[m]
et Ampliata et [V]alerium
et . nta et Anticene
et I .. ta et Euochia
et V eeta...
et (Tav. XII, #55)

Peter and Paul
keep us in mind
during your prayers.
Antimachus and Gregorius
and Gregorius Junior
and Ampliata and Valerius
and . nta and Anticene
and I .. ta and Euochia
and V eeta...
and

N. Petre et Paule immentem habe
te Primum et Primam iu[ga]le eius
et Saturnunam coniugem fil primi (XP)
et Victorinum patrem (eius) in (XP)
semper in aeterno et.... (Marucchi, Tav. IV)

Peter and Paul keep in mind
Primus and Prima his wife
and Saturnina the wife of his first son (XP)
and Victorinus his father in Christ
always forever and....

Orazio Marucchi. "L'ipogeo con i graffiti degli apostoli Pietro e Paolo
scoperto sotto la basilica di S. Sebastiano." *NBAC* 27 (1921): 3-14, tav-
ole 1-6.

In addition to the 222 graffiti on the walls of the *triclia* (primarily
wall A-B' in fig. 33, S. Sebastiano, p. 101), about five discernible

graffiti are found on a plastered wall at the bottom of the steps
leading to the presumed well (s in fig. 33, p. 101). The wall is just
above and to the west of the pool of water at the bottom of the stairs
(sigma in fig. 33, p. 101). The presence of these graffiti indicates
the continued use of the stairs during the life of the *triclia*. The
presence of the XP almost surely implies that the stairs were
functioning during the time of Constantine. If the date of graffito
L should be established as A.D. 260, then we have a minimum pe-
riod of use from 260 to 320. In our discussion of S. Sebastiano (see
pp. 98-104), we set the dates 250 to 345 as the likely maximum
dates of usage for the *triclia*.

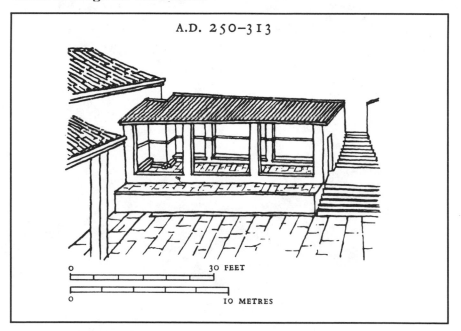

Figure 46. The graffiti wall under S. Sebastiano.

More than any other evidence, these graffiti document the fact
of and characteristics of a large cult of the dead in early Chris-
tianity. Since the discovery of the *triclia*, scholars have been more
observant of and attuned toward the practices of the local Chris-
tian. In the representative graffiti we see that a meal was eaten

either with (I) or for (C) the special dead. Meals (*refrigeria*) obviously were eaten for and with the family dead (Parthenius in E and Celerinus in L). Whether such meals always included Peter and Paul cannot be easily determined, but they often did (K). In addition to the meals, the celebrants of the agape left us copies of their prayers. In these they asked Peter and Paul to pray for the

family dead (A, F, M), or more often to "keep in mind" the dead (B, G, K, M, N), and those holding the *refrigerium* (J). There were other prayers. In D they asked Peter and Paul, holy spirits, to protect them. In H Primitivos asked for them to aid him, for he was a sinner. Presumably the celebrants in both these cases have offered a *refrigerium* for Peter and Paul rather than the family dead.

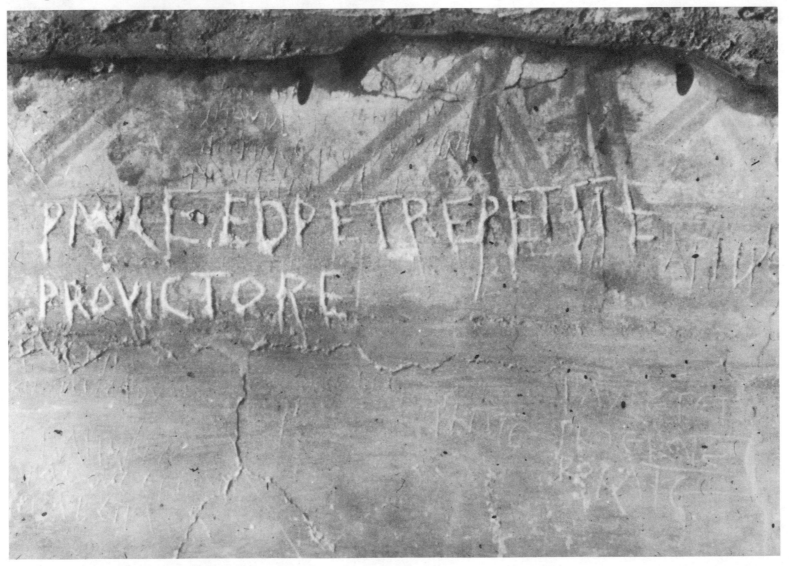

Plate 49. One of the graffiti on the wall of the triclia *under S. Sebastiano.*

The assumption that the presence or daemon of the special dead remained near the place of burial ran strongly through the Greco-Roman social matrix. This presence served not only as a rallying point for community formation (eating and praying with each other and extended families), but also as a means of intervention with the deity. The graffiti on the walls of the *triclia* and the spring point to a religious perception popular throughout the Greco-Roman world that was adapted to Christian special dead and possibly Christian liturgical language.

VII. THE AEDICULA OF ST. PETER

B. M. Apollonj-Ghetti, A. Ferrua, E. Josi, E. Kirschbaum. *Esplorazioni sotto la confessione di San Pietro in Vaticano.* Città del Vaticano, 1951, 1:129-30.

A. Ferrua. "La storia del sepolcro di San Pietro." *La Civiltà Cattolica* 103 (1952): 15-29.

Margherita Guarducci. *Cristo e San Pietro in un documento precostantiniano della necropoli Vaticana.* Roma: Bretschneider, 1953.

——————————. *I graffiti sotto la confessione di San Pietro.* Città del Vaticano: Libreria Editrice Vaticana, 1958, 1-3.

D. W. O'Connor. *Peter in Rome,* 178-83, 200-205.

Jocelyn Toynbee and John Ward Perkins. *The Shrine of St. Peter and the Vatican Excavations.* London: Longmans, Green and Co., 1956.

On wall g, a supporting wall that encompasses the aedicula of St. Peter to the north and possibly serves as a buttress for the "red wall" (see fig. 40), the excavators found a large number of graffiti. The original excavators listed the most important of these (1:129-30). They are the usual acclamations; there are no requests for prayers to the dead, no sign of the *refrigerium,* no veneration of the martyr, and no certain mention of Peter.

There are two possible exceptions to the latter assertion. The excavators did not publish in their original report the discovery in wall g of a fragment that reads ΠΕΤΡ ΕΝΙ. Why this was withheld has never been made clear (Guarducci claims it was never made available to her until papal orders were given), and its interpretation has remained equally obscure. It was suggested at first that it could read ΠΕΤΡ ΕΝ ΙΡΗΝΗ, a misspelled "Peter, In Peace." Guarducci eventually suggested Πετρ(ος) ενι, reading ενι as a form of the verb ἔνειναι, "to be in here" (Guarducci, *Le reliquie di Pietro: una messa a punto,* 58-62). It would then mean "Peter is in here." Assuming it was written after the aedicula was available to the public and not yet encased, this seems like a reasonable solution. In such a case the controversial graffito does not refer to any veneration, but was simply an authentication of the purpose of St. Peter's.[11]

The second possible exception involves a so-called inscription found in a niche of the mausoleo di Valerii (Tomb H, fig. 2 under St. Peter's). Guarducci considers this inscription a pre-Constantinian documentation for veneration of Peter and Christ in the necropolis under St. Peter's. This graffito, more than ΠΕΤΡ ΕΝΙ, would point to a cult. The inscription (fig. 47) was found below two heads, which Guarducci identified as Christ and Peter. Edited, it reads:

> *Petrus roga T xs ns*
> *pro sanc[ti]s*
> *hom[ini]bus*
> *Chrestianis*
> *[ad] co[r]pus tuum sep[ultis].*

As edited by Guarducci, it would translate:

> Peter entreat Christ Jesus
> on behalf of the "holy"
> people.
> Chrestianis,
> buried near your body.

[11]A. Coppo, "Contributo alla lettura del Muro rosso," *RivAC* 38 (1962): 97-118.

Although good pictures of this drawing and inscription exist, the identification of the heads and the reconstruction of the inscription can hardly be considered certain. At best it was nearly illegible and now can be seen only under certain conditions. But granted the correct identification and reconstruction, it still does not furnish much information. This graffito could hardly have been scratched in the elegant tomb of the Valerii while they were using it. Only after the necropolis had been abandoned would such a burial have occurred and the graffito have been made. In that case it simply confirms what we had already known: there was a Petrine shrine here early, but no cult. Two references to Peter appeared at the time the aedicula had already been encased and the necropolis prepared for the construction of Constantine's St. Peter's.

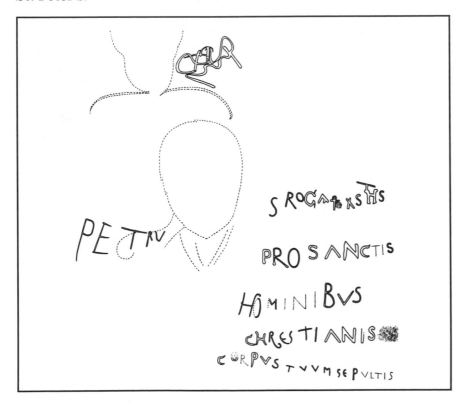

Figure 47. A graffito that may refer to Peter.

Plate 50. The graffiti wall (wall g) and the Constantinian encasement. The opening enters the casseta *where the bones of Peter may have been found by Kaas.*

We have then the remaining fifty-eight graffiti from wall g. They indicate that this location was venerated from about the end of the third century. The frequent use of the XP (at least twelve times), as an abbreviation for Christ, points to a time during the life of Constantine. Of these fifty-eight graffiti the following eight would be the clearest examples (from Guarducci, *I graffiti*, 2:449-60):

A. (XP) Leonia (#2)
B. In X P Butalio vivas (#3)
 Butalius, live in Christ
C. ..Simplici vivite in XP (#6)
 (and?) Simplex, live in Christ
D. Nikasi vibas in XP (#8)
 Nicasus, live in Christ
E. Viktor Gaudentia vivatis in XP (#24)
 Victor to Gaudentia, live in Christ
F. Eunius Bruttius vivan (#26)
 Eunius Bruttius, live
G. Nicasi vibas cum Leontia (#40)
 Nicasus, live with Leontia
H. Pauline vivas (#43)
 Pauline, live

These graffiti are very simple and most of the remainder are nearly unintelligible. They look much like the simplest Priscilla inscriptions and some of the graffiti at the *triclia,* though the formula "in XP" occurs more frequently. We do see one new element: the author of graffito G prays that Nicasus will live with Leontia. We had not noticed before a direct appeal for the continuation of human community. Probably #10 has the same intent (*Florenti vivas in a cu mar(ia) V_x* should read *Florenti vivas in a (?) cum Ar . . .*), though Guarducci has edited it to refer to Mary (Maria). I would also take the *cum sui* of #9 to mean the family of the deceased who are with him. These simple alterations point to a time when the Christian adherence to family can be assumed.

Guarducci attempted to find in these simple graffiti a total complex of Catholic piety, pointing toward Peter. As others have pointed out, her work has been a labor of love that likely will have little scientific or historical reward.

VIII. THE GRAFFITI OF THE *DOMUS ECCLESIAE* IN DURA-EUROPOS

C. Kraeling. *The Christian Building*, 89-97.

In the house church, especially in the baptistry, a number of graffiti were discovered. These are of particular interest because, like the art of the baptistry, they have nothing to do with burial or funerary inscriptions and graffiti. Eighteen items have been discovered. Of these, six are alphabetical or abecedarian (#s 1, 3, 4, 8, 11, and 14). Presumably they were made for apotropaic purposes, #s 3, 4, and 14 only being Christian in character. The presence of such superstitious or magical items indicates how deeply the social matrix informed the Church and was expressed either straight (non-Christian) or lightly Christianized. Of the remaining number only five can be usefully presented here.

A. μνησ]θη Παυλος κ[αι υἱος] Παυλου (#9)
 επι]σκοπον και -λι[ο]ν

 May Paul and [his] son Paul
 be remembered.
 Also care for?

B. Εἷς θεος (#15)
 εν ὀρανω

 One God
 in heaven

E. Peterson. Εἷς Θεός. Göttingen: Vandenhoeck and Ruprecht, 1926, 78.

Despite the language, this inscription does not have to be Christian. One God has been a concern of Jews, perhaps, more than Christians. On the other hand, this could be a general faith statement of the social matrix that was used here as Christian, much as were the apotropaic graffiti.

C. τον Χρισ[τον] μνησκετε (#17)
 Σισεον τον ταπι
 νον

 Christ with you! Remember
 Siseon the humble.

D. ἐτους δμφ (#10)
 μν[ησθη] Δωροθεος

 A.D. 232/3
 May Dorotheos be remembered.

This inscription is important because it was found under the pres-
ent paint coating, giving us a probable date for the building of the
house as a private dwelling.

E. τον Χ(ριστο)ν Ι(ησου)ν ὑμειν (#18)
 μν[η]σκεσθε [. . . Πρ]οκλου

 Christ Jesus be with you.
 Remember Proclus

The prayers are much the same as those of the *triclia* except that
God or Christ must be the subject of "remember" rather than a
martyr; that is, God or Christ is addressed directly at the assem-
bly of the faith community, but at the martyrium they are ad-
dressed through the prayers of the special dead. A new element is
the method of giving a benediction in the accusative case (#s 17
and 18), with or without the recipient in the accusative.

IX. GRAFFITI ON THE CHOIR OF THE LIEBFRAUENKIRCHE IN TRIER

Erich Gose. *Katalog der frühchristlichen Inschriften in Trier*. Berlin:
Verlag Gebr. Mann, 1958.

Theodor Konrad Kempf. "Katalog der frühchristlichen Abteilung des
Bischöflichen Museums Trier." *Frühchristliche Zeugnisse*, 223-67.

Karl Krämer. "Die frühchristlichen Grabinschriften Triers." *Trier Gra-
bungen und Forschungen* 8 (1974): 52.

In 1949 an ancient wall was discovered under the east choir of the
Liebfrauenkirche in Trier. The wall reflected three periods of
building, the earliest dating back to the Constantinian era. Given
the chronological lapse between Rome and the provinces, mate-
rial in Trier from the early Constantinian era would be equivalent
to much we have considered *ante pacem*. On the section of the wall
constructed between 350 and 380, as well as the later or third sec-
tion, were found many graffiti. Of the fifteen on the older wall, we
find the usual acclamations:

Verna Vivas [i]n XP (Fragment 5)
Verna, live in Christ!

Vivas in Domino XP (Fragment 6)
Live in the Lord Christ!

None are directed toward a martyr, and there is no sign of a cem-
etery since the locus of the Liebfrauenkirch was in the imperial
palace area itself.

CHAPTER SEVEN

PAPYRUS DOCUMENTATION

Joseph van Haelst. *Catalogue des papyrus litteraires juifs et chrétiens.* Paris: Publications de la Sorbonne, 1976.

G. H. R. Horsley. *New Documents Illustrating Early Christianity.* Macquarie University: The Ancient History Documentary Centre, volume 1, 1981; volume 2, 1982.

E. A. Judge and S. R. Pickering. "Papyrus Documentation of Church and Community in Egypt to the Mid-Fourth Century." *JAC* 20 (1977): 47-71.

Orsolina Montevecchi. *La papirologia.* Torino: Societa Editrice Internazionale, 1973, 285-334.

C. Wessely. "Le plus anciens monuments du Christianisme écrits sur papyrus." *Patrologia Orientalia* 4 (1908): 199-210; 18 (1924): 343-509.

Just as inscriptions and art were preserved in Rome because of geological and climatic conditions, so in Egypt papyri have been preserved by the peculiarity of that climate. Of the thousands of papyri discovered in Egypt, many are Christian. The same problem of identification exists here, however, as did in Rome: When and how did Christians begin to indicate they were Christian? It would stand to reason that the changes would be minute; therefore, one is inclined to suppose slight alterations are indeed evidence of Christianity. Such alterations would be the use of θεός or κύριος θεός as the name of the divinity called upon, or the piety of a phrase like θεοῦ θέλοντος. The frequent use of ἀδελφός or ἀδελφή as a means of address should signify a person in the Christian community. And, of course, the use of Christian and/or biblical names or the echo of biblical phrases should also mark the document as Christian. All of these criteria are questionable, both generally and specifically. Nevertheless, I will describe and illustrate the situation by using those documents suggested by papyrologists.

I. LETTERS

H. I. Bell. "Evidences of Christianity in Egypt during the Roman Period." *HTR* 37 (1944): 185-208.

Maria Teresa Cavassini. "Lettere cristiane nei papiri greci d'Egitto." *Aegyptus* 34 (1954): 266-82.

G. Ghedini. *Lettere cristiane dai papiri greci del III e del IV secolo*. Milano: *Aegyptus*, 1923.

Mario Naldini. *Il Christianesimo in Egitto*. Firenze: Le Monnier, 1968.

Giuseppe Tibiletti. *Le lettere private rei papiri greci del III e IV secolo d.C*. Milano: Vita e Pensiero, 1979.

I will list each letter individually with indications of initial publication, discussion, date, and provenance. Each will be summarized, but occasionally a sample will be given and translated.

A. Letter to a Brother

23 August 133

Edition: P Mich VIII 482

Naldini. *Il Christianesimo in Egitto*, #1.

Edited Text:

 [.]ν δυνη
 [. . . .]. καὶ εἴ τι θέλις [γράψον μο]ι
 [πάντ]α ἃ θέλις. ἀπ[ό]κιται ἕως [. . .] σή-
 [μερο]ν τὸ κοκκούλιόν σου. καὶ πέπομ-
 [φαν α]ὐτὸν εἰς Συρίαν ἄλλο ἅπαξ καὶ ἀνό-
 [κνως] ἐνήνεχάν μοι αὐτόν.
 ἐρρῶσθαί σοι εὔχομ[αι].
 [.]ω αὐτό. Πετεεῦς ὁ γρὰ-
 [φων μο]ι τὴν ἐπιστολὴν ἀσπά-
 [ζε]τέ σοι λίαν λίαν καὶ τὴν γυναῖ-
 [κά]ν σου καὶ τὴν θυγατέραν σοι
 [καὶ] Βάσσον τὸν ἵππον σοι καὶ
 [. .]γ μι᾽ αὐτὸς [μὲν γά]ρ σε, ἀδελφαί, ἐρω-

 [τῶ] σοι. ἐὰν δ[ὲ θέλη]ς ἐλθῖν καὶ λάβις
 [με] μετ᾽ ἐσοῦ ἔ[ρ]χου, καὶ ὅπου ἐὰν
 [λά]βης μοι ἀκολουθήσω σοι καὶ
 [ὡ]ς φειλῶ σοι ὁ θεὸς ἐμὲ φειλήσι.
 ἐρρῶσθαί σοι εὔχομαι.
 [ἔτους] ιζ αὐτοκράτορος Καίσαρος
 Τρα(ιανοῦ) Ἁδρια(νοῦ) Σεβα(στοῦ), Μ[ε]σορὴ λ Ἑλ-
 λήνων.
 καὶ μὴ ὀκ[νή]σης γράφων ἐπισ-
 τολάς, ἐπὶ ἐχάρην λίαν λίαν
 ὡς σοῦ παραγενάμενος. ἀφ᾽ ἧς
 ἔπεμψές μοι τὴν ἐπιστολὴν
 σέσωμαι.

Translation:

 and if you wish anything,
 write to me
for anything you wish. As of now
your cape is being held. And they brought
it to Syria once and without hesitation
brought it to me.
 I pray for your health.
 him. Peteeus, who wrote
the letter for me, greets
you heartily, and your wife
and your daughter
your horse Basso, and
 for I ask you myself,
brother. If you wish to come and take
me with you, come, and wherever
you take me I will follow you and
as I love you, God will love me.
 I pray for your health.
Year 17 of the reign of Caesar
Trajan Hadrian Sebastos, Mesore 30
of the Greeks.
And do not delay in writing
letters; they have been a very great joy
as though you yourself were here. When
you send me the letter,
I am healthy.

This very early letter was considered Christian because of the reference to θεός in line 17 and the echo of Ruth 1:16 in lines 15-16. If the person addressed is not actually a blood brother, then the ἀδελφός of line 13 refers to a companion in the Christian community. In any case there is an unusual warmth expressed in the letter, even between the scribe and the recipient!

B. A Letter of Sabinus to His Mother and Demetrous
Second Century

Edition: P Mich VIII 493

A personal letter that mentions an action to be taken σὺν θεῷ.

C. A Business Letter
Second Century

Edition: P Harris 104

A crabby letter that begins with θεὸς θέλοι.

D. Pasis to His Brother Orsenuphis
Second Century

Edition: P Bas 18

A private letter ending ἐὰν ὁ θεὸς θέλη.

E. Chaeremon to His Brother Sarapammon
Second Century

Edition: P Princ III

A private business letter including the phrase σὺν θεῷ.

F. Irenaeus to His Brother Apollinarius
Second or Third Century; Faiyum

Editions: BGU I 27; Hunt and Edgar, *Select Papyri*, 1, #113; Naldini, #2; Ghedini, #1.

Edited Text:

[Εἰρηναῖος Ἀπολιναρίῳ τῷ]
[φιλτάτ]ῳ ἀδε[λ]φ[ῷ] πολ[λ]ὰ χαίρει[ν].

Καὶ διὰ π[α]ντὸς εὔχομαί σε ὑγιένειν
καὶ ἐ[γὼ] αὐτὸς ὑγιένω. γινώσ-
κειν σε θέλω ὅτει εἰς γῆν
ἐπέλυθα τῇ ζ τοῦ Ἐπεὶφ
μηνὸς καὶ ἐξεκενώσαμεν τῇ
τῇ τοῦ αὐτοῦ μηνός. ἀνήβην
δὲ εἰς Ῥώμην τῇ κε τοῦ αὐ-
τοῦ μηνὸς καὶ παρεδέξατο ἡ-
μᾶς ὁ τόπος, ὡς ὁ θεὸς ἤθελεν,
καὶ καθ' ἡμέραν προσδεχόμ[ε-]
θα διμισσωρίαν, ὥστε ἕως
σήμερον μηδέναν ἀπολε-
λύσθαι τῶν μετὰ σίτου.
ἀσπάζομαι τὴν σύνβιόν σου
πολλὰ καὶ Σερῆνον καὶ πάν-
τες τοὺς φιλοῦντάς σε κατ' ὄνο-
μα.
 ἔρρωσ[θ]ο. Μεσορὴ θ.
Verso.
Ἀπολιναρί[ῳ] × ἀπὸ Εἰρηναίου ἀδελφοῦ.

Translation:

Irenaeus to Apollinarius his beloved brother,
many greetings. I pray continually
 for your health,
and I am well myself. I want you to know that I
reached land on the 6th of the month Epeiph
and we unloaded on
the 18th of the same month. I went up
to Rome on the 25th of the same
month, and the place
received us, as God willed,
and every day we expect our
dismissal, though up to
now none of the corn
fleet has been released.
Many greetings to your
wife, and Serenus, and all
who love you, each by name
 Goodbye. Mesore 9

Address:
To Apollinarius from his brother Irenaeus.

This neat letter could almost be a model of contemporary letter writing. One can easily discern the usual parts, except for the *parakalō* or request section. The parts are:

1. Greeting: χαίρειν
2. Prayer (or Thanksgiving): εὔχομαι
3. Disclosure: γινώσκειν σε θέλω
4. Petition: παρακαλέω (not present in this letter)
5. Salutations: ἀσπάζομαι

The letter may be considered Christian for several reasons. Irenaeus piously says he will leave Rome "as God wills"; he addresses Apollinarius as ἀδελφός and refers to himself as brother. It has been widely assumed the reference to a τόπος in Rome receiving him as God willed, must be a reference to one of the Christian communities of Rome. The complex term τόπος may indeed be extended to the *collegium* which meets at a place or τόπος, though without the other data, there would be no need to suppose that a *collegium* was Christian. And the use of the terms φίλτατος ἀδελφός, as a form of address, and τοὺς φιλοῦντας to refer to the primary community of Apollinarius, underscores the probability of a Christian origin, but in no way proves it. The occasion of the letter was Irenaeus's trip to Rome with the corn fleet that carried the annual tribute from Egypt to Rome.

G. Business Letter to Ptolemaios
Second or Third Century; Faiyum

Editions: BGU I 246; Ghedini, #2; Naldini, #3

A business letter with some Pauline echoes: ὅτι νυκτὸς καὶ ἡμέρας ἐντυγχάνω τῷ θεῷ ὑπὲρ ὑμῶν, used as a prayer formula just prior to the petition.

H. Letter of Dios
Second or Third Century

Editions: P. Ross. Georg. II 43; Cavassini

A somewhat stylized letter in which the sender speaks of the love of God (θεόφιλε), and then says κἂν θεὸς ἔθελε, he will bring him success and destroy the chaos around him.

I. A Roman Christian to the Brothers at Arsinoe
A.D. 264/282; Faiyum

Editions: P Amh I 3; Ghedini, #4; Cavassini; Naldini, #6

Adolf Deissmann. *Light from the Ancient East*. Revised edition. New York: Harper, 1927, 205-13.

Adolf Harnack. "Zu den Amherst Papyri." *Sitzungsberichte der königlich preussischen Akademie der Wissenschaften zu Berlin* 43 (1900): 984-95.

H. Leclercq. "Lettres chrétiennes." *DACL* 8:2:2782-83.

H. Musurillo. "Early Christian Economy. A Reconsideration of P. Amherst 3(a)." *Chronique d'Egypte* 31 (1956): 124-34.

C. H. Roberts. "Early Christianity in Egypt. Three Notes." *Journal of Egyptian Archaeology* 40 (1954): 92-96.

C. Wessely, 1:135-39; 2:348ff.

II
EDITED TEXT

χ[........]νουν σου ησανν[
ιε[... ἐξο]διάσαι τὴν κριθὴν [...]
ἐκ τοῦ [αὐτοῦ] λόγου [ἵνα] μὴ τό αὐτ[ό]
φροντ[ίσωσι]ν οἷον καὶ εἴρητω ἀ[π]ὸ
ἐνθηκῶ[ν ἀ]ποστελλομένων πρὸς
αὐτὸν ἀ[πὸ] τῆς Ἀλεξανδρείας· καὶ
προφάσε[ις] καὶ ἀναβολάς καὶ ἀνα-
δόσις ποιη[σά]μενος οὐχ οἴομαι αὐτ[ὸ]ν
ταῦτα [ἄ]νε[υ] αἰτίας οὗτος πεφροντ[ι-]
κέναι. εἰ δὲ καὶ ἀὴ νῦν αὐτὴ ἡ περισ-
σάτης ἡ σθμβεβηκθῖα μὴ ποιῆσαι

λόγον, ἱς τὸ καλῶς ἔχον τίνειν εὖ
ἀνέχομαι. εἰ δὲ ἐθ[έ]λετε ἄρτοις πά-
λι πεπρασιν [εκ] εἰς .αιδ.[..].ρον γε-
νέσθαι πρὸς τὴν [..]ε.[.].ν Νῖλων
καὶ τὸν πατέρα Ἀπολλῶνιν εἰς
Ἀθ[.]τ[...].ς ἐπέστειλάν τε

II
TRANSLATION

........
...pay for the grain...
the same price lest
they wonder what was said when
the deposits were sent to
him from Alexandria. And though
I made excuses, caused delays and
put things off, I do not believe
he thinks these things without cause.
If now this superabundance
which has occurred does not make it
possible to pay
the bill, for my own good, I will
endure the cost. And if you wish again
to sell some bread.....
...................Nilos
and my father Apollonis in
A........And they have written

παραχϱ[ῆμ]α τὸ ἀϱγύϱιον ἐξοδιασ-
θῆναι ὑμῖν. ὃ καὶ καταγάγειται
ἰς τὴν Ἀλεξάνδϱιαν ὠνησάμε-
νον ἀόνας παϱ' ὑμῖν ἐν τῷ Ἀϱσινο-
[ε]ίτῃ. τοῦτο γὰϱ συνεθ[έ]μην Πϱει-
μειτείνῳ. ὥστε τὸ ἀϱγύϱιον αὐτ[ῷ]
ἰς
τ[ὴν] Ἀ[λε]ξάνδϱιαν ἐξωδιασθῆναι.
2ª mano
[(ἔτους) ?] ‖ Παῦνι ῆ ἀπὸ Ῥώμης.

the money should be given to you
immediately. Also bring that
to Alexandria, having bought
(linen) among you in Arsinoe.
I have made this contract with
Primitinus, that the money will be
delivered to him at Alexandria.

Year? ‖ Pauni 8, from Rome.

III

EDITED TEXT

καλῶς οὖν ποιήσαντε[ς, ἀδελφοί,]
ὠνησάμενο[ι] τὰ ὀθόνι[α τι-]
νες ἐξ ἡμ[ῶ]ν τονα[c. 10 ll.]
αν σὺν αὐτοῖς ἐξοϱμ[ήσαντες πϱὸς]
Μάξιμον τὸν πάπα[ν καὶ]
τὸν ἀναγν[ώσ]την. καὶ ἐ[ν τῇ πόλει]
πωλήσαντ[ες] τὰ ὀθό[νια ἐξο-]
διάσητε τὸ ἀϱγύϱιον [Πϱειμειτεί-]
νῳ ῆ Μαξίμῳ τῷ πάπ[α ἀποχὴν ἀπο-]
λαμβάνοντ[ε]ς παϱ' αὐτ[οῦ]
ἐπιθήκην .[c. 16 ll.]
πωλου[μέ]νου ἄϱτ[ου κα]ὶ [τῶν ὀθόνι-]
ων τὸ ἀϱγύϱιον, παϱακα[λῶ]
δοὺς αὐτὸ Θεονᾷ, ἵνα σὺν [θεῷ παϱα-]
γενόμενος ἰς τὴν Ἀλεξ[άνδϱιαν ...]
εὕϱω αὐτὸ ἰς τὰ ἀναλώμα[τά μου. μὴ]

οὖν ἀμελήσητε, ἀδελφο[ί, διὰ ταχέ-]
ων τοῦτο ποιῆσαι, ἵνα μὴ [Πϱειμει-]
τεῖνος διὰ τὴν ἐμὴν πϱο[θεσμίαν (?) ἐν]
τῇ Ἀλεξανδϱείᾳ διατϱίψῃ [.]
ἐπὶ τὴν Ῥώμην, ἀλλ' ὡς ἡμᾶς [.......]
ϱατεῖν [[...]] πάπᾳ καὶ τοῖς σὺν α[ὐτῷ ...]
τάτοις πϱο .εν .ς τεισω αὐ[τ......]
καὶ πάντα σ[ύμφω]να τάξω ὑ[μῖν καὶ Ἀ-]
γαθοβούλ[ῳ] .[.....]..σθαι ὑ[.]
[c. 12 ll.].παλατ[c. 8 ll.]

TRANSLATION

You did well brethren
when you bought the linen....
some of you take.....
with you to
Maximos the papa and....
the Lector. And in the city
having sold the linen ... de-
liver the money to Primitinus
or to Maximus, having received a
receipt for it.......
deposit.........
having sold the bread and the linens,
the money, I beseech
give it to Theonas, in order that, with God,
when I come to Alexandria...
I find it (deposited) against my debits.
 Do not
neglect, brethren, to do this
quickly, lest Primitinus,
because of my delay
waste time in Alexandria.....
for Rome, but as us....
.........for the papa and those with him
........... I will offer....
and all agreements quickly for you and
Agathobulus

This may be, as Deissmann suggests (205), the oldest autograph letter of a known Christian. The letter is mutilated and difficult to understand, but there is enough to make it one of the most valuable papyri of the first centuries. The first column has been damaged too severely for cogent reconstruction. There would appear to be a reference to a Dionysius in line 6. This might have been the Dionysius who was bishop of Alexandria from 247 to 264, since the rest of the letter deals with two other bishops of Alexandria.

The writer obviously has a primary concern about a payment due to one Primitinus who will soon be in Alexandria. We cannot determine why the brethren, or faith community, of Arsinoe would be involved. But through the sale of grain (?), bread, and linens, the group should be able to deposit enough to match the debits and make the payment. By addressing the group at Arsinoe as brethren we can be sure we are dealing with a church, so this would be the first extant private letter written to a church. In column III, line 14 the writer may use a nascent Christian piety formula, σὺν θεῷ. But more important is the reference to two bishops of the Alexandrian church. Maximos would be the successor of Dionysius, from 264 to 282. It would appear Theonas was the financial secretary for Maximos at this time, but later himself was bishop (282-300/301).

The financial function of the Church has not been sufficiently appreciated. At the time of Christ the Jewish Temple and its synagogues were probably the largest independent (of Rome) banking institution in the Empire. The account in Acts tells us the Christians threatened that financial function of the Temple with a counterstructure. Our knowledge of how that new financial structure developed has been very minimal. This letter indicates the office of the bishop was available for expediting financial transactions and even holding deposits.

Little can be done with the title "papa." It only indicates that the term "pope" could be used for a bishop other than the bishop of Rome. It fits well, of course, with the early understanding of the faith community as a family—brothers and sisters led by a father or mother.

J. Arrian to Paul
Early Third Century; Great Oasis

Editions: P Bas I 16; Cavassini; Naldini, #4

An affectionate letter from a certain Arrian to a brother by the name of Paul. In addition to these Christian marks, the salutation reads: σε εὔχομαι ὁλοκλή[ρω]ς ἐν κ[υρί]ῳ. As Cavassini and Montevecchi have indicated, the function of κυρίος in epistolary formulae will most clearly characterize a Christian letter. This could be the first extant instance of a reference to Christ, rather than God, in Christian papyri.

K. Besas to His Mother Mary
Early Third Century; Oxyrhynchus (?)

Editions: P Harris 107; Cavassini; Naldini, #5

This is a simple, boyish letter written by a son to his mother, and it contains many Christian elements. He greets her ἐν θεῶι; he prays for her τῷ πατρὶ θεῶι τῆς ἀληθείας καὶ τῷ παρακλήτῳ πνεύματι to preserve her ψυχὴν κα[ὶ] σῶμα καὶ πνεῦμα and for her to have ζωὴν αἰώνιον (he prays to God the Father of truth and to the Spirit Comforter to preserve her "soul" and body and spirit [in the NT only in 1 Thess. 5:23] and for her "eternal life"). Besides these pieties he wishes to have his coat by τὴν ἑορτὴν Πάσχα (the feast of Easter).

Papyrologists date this letter early in the third century. It is unfortunate we cannot be more precise. The Christianity of this letter is not tentative. The young man uses standard Christian formulae (almost clichés). Christian language is beginning to ossify, though not in an "orthodox" fashion!

L. Fragment of a Letter to a "Brother"
Third Century; Oxyrhynchus (?)

Editions: P I and II 11; Cavassini; Naldini, #7

The letter is too mutilated to be reconstructed, but the writer says at one point that οἶδεν . . . ὁ θεός (God knows), and refers to his fellow Christians as ὁ κυρίος μου ἀδελφὸς Πέτρος or Ζημήτριος (Sir brother Peter or Sir brother Zemetrios).

M. Hermapollos to His Mother Eus
Third Century

Editions: P Lund 4; Cavassini; Naldini, #11

A delicate letter with the prayer formula Π[ρὸ] μὲν πάντων εὔχομε τῷ θεῷ περὶ τῆς σ[ῆ]ς ὁλ[οκλ]ηρ[ίας ὑ]γιαίν[ο]υσ[αν] ἀπολαβ[εῖν] (I pray to God for your wholeness, to receive health).

N. Paniskos to His Wife and Daughter
End of Third Century; Philadelphia

Editions: P Mich III 216; Cavassini; Naldini, #14; Hunt and Edgar, *Select Papyri*, 1, #155.

J. G. Winter. "The Family Letters of Paniskos." *JEA* 13 (1927): 59-74.

H. Zilliacus. *Zur Sprache griechischer Familienbriefe des III. Jahrhunderts n. Chr. (PMich. 214-221)*. Societas Scientiarum Fennica. Commentationes humanarum litterarum, 13:3. Helsingfors, 1943.

Paniskos left home to live in Philadelphia. P Mich III 214-221 are the papyri letters written between him and his family. Opening his letter with a prayer τῷ θεῷ, he asks that his wife and daughter will have ὁλοκληρία. This tentative Christian formula should be compared with Mich III 214, his first letter to Plutogenia, his wife (ἀδελφή!), in which he remarks that her sister, with whom he is staying, prays daily for them to the gods (τοῖς θεοῖς . . . καθ' ἑκάστην ἡμέραν).

O. Paniskos to His Wife

Editions: P Mich III 218; Cavassini; Naldini, #15

Paniskos, who complained in P Mich III 217 that Plutogenia did not write to him, writes here to his wife (τῇ συμβίου) to say that ἐὰν ὁ θεὸς θέλι (if God wills), he will come to her.

P. Paniskos to His Brother Aion

Editions: P Mich III 219; Cavassini; Naldini, #16

Paniskos writes to his brother Aion about his daughter, Heliodora.

The prayer formula is Christian. He prays for Aion's ὁλόκληρος from τῷ κυρίῳ θεῷ. In the disclosure formula he lets Aion know that θεοῦ θέλοντος (by the will of God), they were all whole (ὁλοκληροῦμεν).

Q. Plutogenia to Her Mother

Editions: P Mich III 221; Cavassini; Naldini, #17

Plutogenia, now also absent from home, writes back to her mother and salutes her with the prayer we now take to be standard: πρὸ μὲν πάντων εὔχομαί σε ὁλοκληρῖν παρὰ τῷ κυρίῳ θεῷ.

R. Letter of a Bailiff
Third Century; Oxyrhynchus

Editions: P Oxy IX 1220; Cavassini; Ghedini

A business letter in which Hebdormus gives a report to Theon, who may come then for a personal inspection of the fields σὺν θεῷ.

S. Theon to "Mother"
Third Century; Oxyrhynchus

Editions: P Oxy XIV 1678; Ghedini, #7; Naldini, #9

A son writes an illiterate letter to his mother opening with the standard Christian prayer: πρὸ μὲν πάντων εὔχομέ σε ὁλοκληρεῖν καὶ ὑειένειν παρὰ τῷ κυρίῳ θεῷ. He addresses his mother as κυρία μου μήτρη (my lady mother), which raises a question about the relationship. Does "mother" here and elsewhere indicate a feminine function in the faith kinship community? His reference to his mother Heracleia in line twenty nearly forces the recipient to be a respected person who is not his blood mother.

T. Sopratus to His Sister
Third Century; Oxyrhynchus

Editions: P Oxy XIV 1763; Cavassini

A note from Sopratus saying he has been delayed but will come σὺν θεῷ.

U. Eutychis (Taurine) to Her Mother Ametrion
Third Century; Oxyrhynchus

Editions: P Oxy XIV 1773; Cavassini; Ghedini, #8; Naldini, #10

A private letter regarding finances, opening with the standard prayer: πρὸ μὲν πάντων εὔχομαι τῷ θεῷ ὁλοκλήρους ὑμᾶς ἀπολαβεῖν.

V. Artemidorus to the Wife of Apollonio
Late Third Century; Oxyrhynchus

Editions: P Oxy XX 276; Cavassini; Naldini, #18

Aurelius Artemidorus writes to the wife of Aurelius Apollonius (her name has been destroyed) about her husband's pending trial. He hopes the evil eye will not harm the children and finally prays for them all ἐν κυρίῳ θεῷ.

W. Aphynchis to "Brother" Augarus
Third Century

Editions: P Princ II 73; Cavassini; Naldini, #12

A letter from Aphynchis to Augarus, whom he addresses as κυρίος ἀδελφός (Sir brother), and whom he greets with the standard Christian opening: [πρ]ὸ μὲν πά[ν]των εὔχομαί σε ὁλοκλη[ρε]ῖν πα[ρ]ὰ τῷ κυρίῳ θεῷ. He wishes him not to delay sending a boat.

X. Serapion to His Mother Lois
Third Century

Editions: P Rein II 116; Cavassini

Serapion belatedly wanted to greet his mother σὺν θεῷ.

Y. A Letter from Ammonius to Theodosius
Third Century

Editions: P Ryl IV 604; Cavassini

The writer addresses everyone as brother or sister, presumably beyond the limits of a blood relationship, and the recipient has a Christian name. Ammonius wishes the children to be protected

from the evil eye. For the term *protection*, he uses the Greek word ἀβάσκαντος, "secure from enchantments."

Z. Titianus to His Wife
Third Century

Editions: PSI IV 299; Ghedini, #6; Cavassini; Hunt-Edgar, *Select Papyri*, 1, #158; Wesseley, 2: 383-85; Naldini, #8

Edited Text:

> Τῇ κυρίᾳ [ἀ]δελφῇ Τιτιανὸς εὖ πράττειν.
> Τυχὼν τ[οῦ ἀ]νερχομένου πρὸς ὑμᾶς προήχθην
> γράψαι σο[ι τ]ὰ συμβάντα μοι ὅτι κατεσχέθην
> νόσῳ ἐπὶ πολὺ ὡς μὴ δύνασθαι μηδὲ σαλεύεσθαι.
> ὡς δ᾽ ἐχουφίσθη μοι ἡ νόσος, ἐπύθετό μοι ὁ ὀ-
> φθαλμὸς καὶ τραχώματα ἔσχον καὶ δεινὰ
> πέπονθα ἔτι τε καὶ ἕτερα μ[έρ]η τοῦ σώματος
> ὡς καὶ ἐπὶ τομὴν ἤχειν μ[ε] ὀλίγου, ἀλλὰ θεῷ χά-
> ρις. ὁ δὲ πατήρ μου [μέχρι] τ[ο]υτου, δι᾽ ὃν καὶ νο-
> σῶν παρ[έ]μεινα [μέχρι τούτου], νοσεῖˑ καὶ δι᾽ αὐτὸν
> ἔτι ἐνταῦθά εἰμι. μακροψυ[ύ]χ[ει] οὖν, ἀδελφή,
> ἄχρεις
> οὗ ἄν με θεὸς εὐοδώσει [πρὸς] ὑμᾶς. καὶ συνε-
> χῶς τούτου ἕνεκεν ε[ὔχομαι τ]ῷ θεῷ ἕως οὗ ἄν με
> πάλιν πρὸς ὑμᾶς εὐοδώσῃ. ἐνόσησαν δὲ πάν-
> τες οἱ κατὰ τὴν οἰκίαν, ἥ τε μήτηρ καὶ τὰ παιδί-
> α πάντα, ὡς μηδὲ ἔχειν ἡμᾶς ὑπηρεσίαν, ἀλλὰ
> τὰ πάντα συνεχῶς τοῦ θεοῦ δέε[σ]θαι. καὶ αὐτὸς
> δὲ πειρῶμαι, ἐπὰν πλοίου εὐπορηθῶ, καταλα-
> βεῖν ὑμᾶς. ἀσπάζεται ὑμᾶς ὁ κύριός μου
> πατὴρ καὶ ἡ μήτηρ, ἀσπάζο`ν´ται ὑμᾶς οἱ κα-
> τὰ τὴν οἰκίαν πάντες, ἀσ[π]άζομαι τὸν κύρι-
> [όν] μου [ἀδελφὸ]ν καὶ [. κ]αὶ Κύριλλαν
> [.]

(Postscript along the left margin)

> ἐπιστολὴ τοῦ ἡγεμόνος μοι ἐπέμφθηˑ καὶ εἰ μὲν ἠνέχθη
> σοι, εὖ ἂν [ἔχοι. . . . λα-]
> βεῖν ἢ ἀξιωσάτω Μῶρον τὸν ἐπιστολέα τὸν φίλον καὶ
> ἐγλαβέτω

Translation:

> To my lady sister from Titianus, prosperity.
> Having met by chance someone going up to you,
> I am writing to you about the things that have happened
> to me, how I
> was ill for a long time, unable to move about. And as the
> illness abated, my eye became infected
> and I had trachoma, and suffered greatly,
> and yet other parts of my body, so that
> I had to have a little surgery, but thanks be to God!
> And my father up to now, because of whom, even though
> ill
> I have remained this long, is himself ill. It is for his sake
> I am still here. Be patient then, sister, until
> God brings me safely to you. And it is for this
> that I pray unceasingly to God that
> once again he return me safely to you all. Everyone
> was ill at home, my mother and all the
> children, so that there was no one to minister to us, but
> (we) entreated God constantly for everything. But as for
> myself,
> I will try, as soon as a boat is found, to rejoin
> you. My lord father and mother
> greet you all; every one in the house
> greets you all. I greet my lord
> brother and . . . and Cyrilla. . . .

(Postscript along the left margin)

> This letter was sent to me from the praefect; and if it was
> brought to you, good; if not . . .
> let him ask our friend Morus the letter carrier and
> receive. . . .

This letter reflects the language of the late third century; it contains considerable Christian language. The writer gives thanks to God he is still alive (lines 8-9); he prays God will return him to his ἀδελφή safely (lines 12 and 13); and lacking anyone to care for them, the family implores God for assistance (line 17). Again the relationship to a female person causes confusion. She seems to be his wife, but the address and style is more formal than in other letters.

AA. Dios to His Sister Sophrone
Third Century

Editions: S B III 6222; Cavassini

A letter from Dios to someone who seems to be his sister, but may not be. He greets her θεῷ; he speaks of God saving him in a situation (καὶ τοῦ μέλλοντος σοζεῖν με); and he speaks of pleasing her, θεοῦ θέλοντος.

BB. Asclepius to His "Brother" Hierakammon
Late Third Century; Oxyrhynchus

Editions: P L Bat XI 26; Naldini, #13

Asclepius, an official in Oxyrhynchus, writes to his κυρίῳ ἀδελφῷ, Hierakammon, a business letter regarding a wine transaction. He closes with a Christian salutation: ἐρρῶσθαί σε, κύριε ἀδελφέ, ἐν θεῷ πολλοῖς χρόνοις εὔχομαι (I pray many times in God, lord brother, for your health).

CC. Letter of Recommendation to Maximus
Third Century

Editions: P Alex 29 (inv. #317); Naldini, #19

Edited Text:

> Χ]αῖρε ἐ[ν κ(υρί)ῳ]
> [ἀγα]πητὲ ἀδελφὲ
> [. . .] Μάξιμε,
> [. . . .]ας σε προσαγορεύωι˙
> [τ]ὸν ἀδελφὸν ἡμῶ[ν]
> Δ[ίφ]ιλον ἐρχόμενον
> π[ρό]ς σε πρόσδ[εξ]αι
> ἐν [ε]ἰρήνη. δι᾽ [οὗ] σε
> κ[αὶ] τοὺς σύν σοι
> ἐγ[ὼ] καὶ οἱ σὺν ἐμοὶ
> προσαγορεύομεν.
>
> ἐρρῶσθαί σε
> εὔχομαι,
> ἀγαπητὲ
> ἀδελφὲ ἐν κ(υρί)ῳ.

Translation:

> Greetings in the Lord
> beloved brother
> . . . Maximos
> I salute you.
> Our brother
> Diphilos coming
> to you, receive
> in peace, through whom you
> and those with you,
> I and those with me
> salute.
> For your health
> I pray,
> beloved
> brother in the Lord.

This is our only letter from one congregation to another, that is, from an official of one faith community to an official of another on behalf of a person moving from one to the other.

Summary

Gustave Bardy. "La vie chrétienne aux 3ᵉ et 4ᵉ siècles d'après les papyrus." *Revue apologetique* 41(1926): 643-52.

H. I. Bell. "Evidences of Christianity in Egypt during the Roman Period." *HTR* 37 (1944): 185-208.

Maria Teresa Cavassini. "Lettere cristiane nei papiri greci d'Egitto." *Aegyptus* 34 (1954): 266-82.

Giuseppe Ghedini. "I risultati della papirologia per la storia della chiesa." *Papyri und Altertumswissenschaft. Münchener Beiträge zur Papyrusforschung und antiken Rechtsgeschichte* 19 (1934): 264-80.

Orsolina Montevecchi. "Dal paganesimo al Cristianesimo: aspetti dell'evoluzione della lingua greca nei papiri dell'Egitto." *Aegyptus* 37 (1957): 41-59.

B. R. Rees. "Popular Religion in Graeco-Roman Egypt. II. The Transition to Christianity." *JEA* 36 (1950): 86-100.

In addition to the above-described papyri letters, there are eighteen more that are borderline, that is, early fourth century or later. They are:

A. P Berl Zilliacus 12
B. P Univ. Giss 30
C. P Univ. Giss 32
D. P Got 11
E. P Got 12
F. P Gron 17
G. P Gron 18
H. P. Grenf II 73
I. P Oxy XII 1492
J. P Oxy XII 1493
K. P Oxy XII 1592
L. P Oxy XIV 1680
M. P S I VII 895
N. P S I III 208
O. P S I IX 1041
P. P Princ II 102
Q. M. Naldini in *Atene e Roma* N.S. 11 (1966): 27-30; Naldini, #20
R. R. A. Kraft and Antonia Tripolitis, editors, *BJRL* 51 (1968-1969): 155-58.

As elsewhere in the Roman world and in other media, one can see in the papyri letters a slight indication of Christianity about the beginning of the third century. These appeared primarily in the greeting, prayer, and salutation formulae (Cavassini). Eventually certain non-Christian terms like ὁλοκληρία became standard Christian terms (Montevecchi, 55). There was an occasional reflection of the Bible, but these were rare and biblical language itself was rare. Latin Christianity was much more likely to pick up biblical, theological terms (C. Mohrmann).[1] After the movement into the formulae, some expressions of piety like "God willing" appeared. A very few biblical names (Peter, Paul, Lois, Mary) also appeared.

The terms of address within the community were surely "kinship" in nature. Persons referred to each other as brother and sister. The leader of the Alexandrian community was a *papa* or father. We noted the function of a mother, though that was ill defined. In addition to this deep sense of community that was expressed, no doubt, through common meals, worship, and assemblies, the community served as a economic institution. It could act as a bank, both local and international, and twice in our materials (I and W) employment is offered. In others (V and BB) services are being performed. A kinship community also cares for its members financially, as the documents indicate.

Except for the reference to Easter in one letter (K), there are no indications of festival or liturgical practices. The theological statements are few and indiscriminate, giving further evidence for the thesis that faith statements were in a state of flux prior to Constantine. It was Roman, Latin structures that created orthodoxy and its myth of continuity with New Testament times.

II. OFFICIAL DOCUMENTS

E. A. Judge. "Papyrus Documentation," 59-62.

A very few public references to the Church exist in the papyri. One does not learn much from these except to note when the Church first appears as a public institution.

A. Order to Arrest Petosorapis
February 28, 256; Oxyrhynchus

Edition: P Oxy XLII 3035

The order requires the officials of the village of Mermertha to arrest a certain Πετοσορᾶπιν Ὥρου χρησιανόν. It is argued that χρησιανόν simply is a misspelling of χρηστιανός. Since the date of this order precedes the Valerian persecution, it seems probable that Petosorapis was wanted for something other than being a Christian.

B. Record of Investigation
259/260; Oxyrhynchus

[1]Chr. Mohrmann, "Le latin commun et le latin des Chrétiens," *VigChr* 1 (1947): 1-12.

Edition: P Oxy XLIII 3119

J. E. G. Whitehorne. "P. Oxy. XLIII 3119: A Document of Valerian's Persecution?" *Zeitschrift für Papyrologie und Epigraphik* 24 (1977): 187-96.

A letter sent from the Saite nome from an Aurelius Herme to Aelius Gordi[anus] asking that an investigation of χρηστιανοί be conducted. This would appear to be the earliest extant document requiring such an action.

C. List of Street Wardens
(ca.) 295; Oxyrhynchus

Edition: P Oxy 1 43

Streets were named after important buildings on them and wardens were assigned to do night watch in that area. Non-Christian temples had streets named after them and three of them had wardens assigned. Two streets, one northern and one southern, were named after ἐκκλησίαι. They had no wardens. If these were Christian ἐκκλησίαι, it shows public recognition existed.

D. List of Buildings
298-341; Panopolis

Edition: P Gen inv. 108

In the list of buildings of Panopolis, there is a οἰκία ἤτοι ἐκκλισία[ς?] (column d, line 11), which could very likely be a house church. Church professions are also listed for the house owners. At the time of this document, house churches could be publicly recognized as such.

E. Declaration of Church Property
February 5, 304; Oxyrhynchus

Edition: P Oxy XXXIII 2673

A certain Aurelius Ammonius made a declaration of possessions for the ἐκκλησία (a church building, not a faith community). He certified under oath that the church possessed "neither gold nor silver nor money nor clothes nor beasts nor slaves nor lands nor property either from grants or bequests" except for a bronze gate that had been delivered for shipment to Alexandria. One would assume the list consists of standard items the officials expected to find in a church. If so, the poverty reflected in the declaration would not necessarily be normal.

F. Report on the Property of Paul
305/306; Oxyrhynchus

Edition: P Oxy XXXIII 2665

In the records of Oxyrhynchus we find that two members of the town council sought a report on the property confiscated from Paul after his sentencing. The response was that Paul owned nothing and was not even listed in public records. The name Paul may refer to a Christian, but there is no indication he was a Christian or that he was being persecuted by the judgment against him.

G. The "Apology" of Phileas
(ca.) 307

Edition: P Bodmer XX

G. Lanata. "Gli atti dei martiri come documenti processuali." *Studi e testi per un Corpus Iudicorum* 1 (Milan, 1973): 227-41.

H. Musurillo. *The Acts of the Christian Martyrs*. Oxford: Clarendon Press, 1972, 328-44.

S. R. Pickering. "The Importance of P. Bodmer XX, the *Apology of Phileas* and Its Problems." *Prudentia* 7 (1975): 95-103.

The "Apology of Phileas" recounts the defense given by the bishop of Thmuis who was executed during the persecution of Diocletian. It appears to be closer to the court records than most hagiography. Nevertheless, though very valuable for historical reconstruction of the time, it should be considered "literature" rather than archaeological documentation.

III. CONTRACTUAL DOCUMENTS

E. A. Judge. "Papyrus Documentation," 64-66.

A. Will of the Husband of Aurelia Chaeremonis
Early Third Century; Oxyrhynchus

Edition: P Oxy XXVII 2474

In this recorded will, the husband of Aurelia appoints his son-in-law, Aurelius Achillion, to be executor. The husband speaks well of his wife Aurelia, and in line six speaks of her qualities in terms of θεῷ καὶ ἀνθρώποι[ς]. The twin reference to God and humanity indicates the two-virtue system of the Roman social matrix. We have already noticed how early Christians picked up on this system in the use of the Orante (piety toward God) and the Good Shepherd (kindness or hospitality toward humanity; see above, p. 24).

B. Will of Aurelius Hermogenes
A.D. 276; Oxyrhynchus

Edition: P Oxy VI 907

A will, written on a sheet from a Christian document, that praises the wife, Isidora, in terms compatible with Christian thought, that is, "for fitting conduct in married life."

IV. PRAYERS, LITURGIES, HOMILIES, AND HYMNS

Giovanni Ausenda. "Contributo allo studio dell'omiletica cristiana nei papiri greci dell'Egitto." *Aegyptus* 20 (1940): 41-47.

F. Cabrol and H. Leclercq. *Monumenta ecclesiae liturgica. Relliquiae liturgicae vetustissimae.* Paris: Didot, vol. 1, sectio primo, 1900-1902, sectio altera, 1913.

C. del Grande. *Liturgiae, preces, hymni christianorum e papyris collecti.* Neapoli: P. Federico et G. Ardia, 1928.

A. Hamman. *Early Christian Prayers.* Chicago: Regnery, 1961.

Josef A. Jungmann. *The Early Liturgy.* London: Darton, Longman and Todd, 1959.

Francesco Pedretti. "Introduzione per uno studio dei papiri cristiani liturgici." *Aegyptus* 35 (1955): 292-98; 37 (1957): 23-31.

Johannes Quasten. *Monumenta eucharistica et liturgica vetustissima. Florilegius patristicum* 7. Bonn, 1935.

――――――――――. *Musik und Gesang in den Kulten der heidnischen Antike und christlichen Frühzeit. Liturgiegeschichtliche Quellen und Forschungen* 25. Münster, 1930.

C. Schmidt and W. Schubart. *Altchristliche Texte. Berliner Klassikertexte* Heft 6. Berlin: Weidmannsche Buchhandlung, 1910, 110-28.

C. Wessely. "Le plus anciens monuments du Christianisme écrits sur papyrus." *Patrologia orientalis* 4 (1908): 181-210; 18 (1924): 343-509.

A small number of liturgical pieces are preserved for us on papyri; these can be located in the above resources. Precision in dating is difficult, but here are some fairly well-established items. In prayers, one thinks of P Oxy III 407 (Hamman, #92) or B.K.T. 9794, which contains several rather lengthy prayers (Hamman, #s 89, 90, 91). Quasten lists seven sources for the liturgical practice of the Eucharist prior to Constantine. Of these, two are "archaeological": the Epitaph of Abercius, which we have discussed on pp. 139-40, and the Papyrus of Der-Balyzeh, a liturgical papyrus in the Bodleian Library published by Flinders Petrie in 1908. The language of the latter stands in the traditional language structure of the Church and the New Testament. Ausenda has listed some sermon fragments that do not add to our understanding of the local church in the period before Constantine. These documents belong primarily to the translocal or great tradition and should be considered literary in nature. Probably the only extant nonliterary hymn we now possess would be that of P Oxy XV 1786 (Hamman, #98a).

Bernard P. Grenfell and Arthur S. Hunt. *The Oxyrhynchus Papyri*, part 15. London: Egypt Exploration Society, 1922, 21-25.

A. W. J. Holleman. "The Oxyrhynchus Papyrus 1786 and the Relationship between Ancient Greek and Early Christian Music." *VigChr* 26 (1972): 1-17.

This earliest-known piece of church music was printed on the back of a corn account from the third century. The editors have estimated it was written down during the latter decades of that century. The hymn was written with musical notations. After judicious transcribing and editing, and with two apparent lacunae, the hymn reads as it appears below.

A loose translation (see Hamman, #98a) might be:

Let not the Prince be silent.

Nor bright stars . . .
Sources of rushing waters,
Let all sing hymns through the
Father, Son and Holy Spirit.
Let all powers call out:
Amen. Amen.
Eternal sovereign . . .
to the only giver of all good things.
Amen. Amen.

V. MAGICAL PAPYRI

Karl Preisendanz. *Papyri graecae magicae.* Leipzig: Teubner, 1, 1928; 2, 1931; 3, 1941.

More appropriate to the formation of Christianity within the local tradition would be the use of magical materials, as we have already noticed at Dura-Europos and in some of the private letters. It was a custom in Egypt to carry lengthy papyrus documents that listed divine names. They presumably would assist one with the supernatural powers. In volume one of his famous work on *Zauberpapyri*, Preisendanz lists twelve Christian magical papyri, none of which are pre-Constantinian. In volume two he lists twenty, of which one likely can be dated *ante pacem*.

A. P Heidelberg 1359

An *onomasticum sacrum* that lists and interprets certain magical names. One of the names and interpretations is Ἰησοῦς Ἰω σωτηρία.

In the third volume Preisendanz mentions with approval the papyri collected by Wessely in *Patrologia orientalis*. In that article Wessely refers to three more pre-Constantinian magical papyri that have Christian divinities:

B. Bibliothèque Nationale n° DLXXIV

The author adjures the aid of the God of Abraham, Isaac, and Ja-

cob, then shifts to Ἰησοῦς πι Χρηστός πι ἅγιος ν πνεῦμα (line 1230). In line 3020 he adjures Ἰησοῦ (God of the Hebrews?).

C. P Lugd-Bat V

In column 6ᵃ, lines 15-17, there is a reference without context to Ἰησοῦς Ἀνου[η], presumably Jesus Anubis.

D. P O 4 (1908) (no. 19, p. 191)

Wessely edits a passage in Greek from a magical papyrus. The author invokes διὰ τοῦ χυρίῳ ἡμῶν Ἰηυ Χρου ἀγαπημένου παιτός.

CHAPTER EIGHT

SUMMARY

These previous chapters contain all the material, or at least, examples of all the types of material available to us as archaeological, nonliterary data, from the early Christian Church up to the time of Constantine. As can be seen, these are materials produced by the early Christians. Many more volumes could be written about archaeological remains that document Christianity from its beginning to the time of Constantine.

It should also be clear that the Christian culture began to appear at approximately the end of the second century. There is no need to be dogmatic about this date. Some of the earliest materials can be dated more or less at 180; however, there could be items that are earlier. We need not worry about such individual manifestations. There may be a few crosses in a private tomb in Palestine, or there may be Christian evidences in Pompeii or Herculaneum. The presence of these individual items cannot greatly alter the general impression that the so-called Christian culture became visible about 180. As I have already noted, this does not mean that Christians were not present in large numbers in various cities, but simply that their presence had not reached a level of public visibility. This visibility was achieved when Christians

began to repeat certain symbols more frequently than their non-Christian neighbors; when they invented a few symbols to indicate their attitude toward their existence in the Roman Empire; when they utilized the Judeo-Christian tradition as a backdrop for their symbolic art; when they became involved with legal title to land and property; when they used organized labor; when they appeared in block lists; when their letters could be distinguished from those of their neighbors; when their celebrations were centered around their own saints and leaders rather than Greco-Roman heroes; when their church had public functions such as buying and selling; when the Church had visible, known leadership; and, above all, when Christians were willing to make their presence known to the larger public. The evidence for these things points overwhelmingly to the end of the second century.

With hindsight, we can see the great importance of these events. Whether the early Christians were aware of the significance of it or not, they successfully avoided two options that would have prevented them from becoming a universal religion. First, they did not eschew accommodation to the social matrix. That was the importance of the gnostic debate. While gnosticism leaned to-

ward a Jesus devoid of historical specificity, a life-style that avoided community life, decision making, and care, and an anthropology that upheld personal fulfillment rather than family and community mutuality, the early Christians promoted such values as the goodness of creation, the necessity of historicalness, the value of institutions, the importance of family, and a pattern of community caring. While one can see the struggle occurring already in such letters as 1 and 2 Corinthians, or even Romans, one would be more inclined to say that the Pastoral Epistles have adapted Pauline theology to the social matrix; or in terms of the highly spiritual Johannine theology, the Johannine letters have adapted that gospel the gnostics loved most to a viable community life. Without this adaptation or conventionalization, early Christianity might have shifted into a nonviable spiritualization. It is significant that the formation of the canon includes those books that call for such social adaptation.

The second option was that of intellectualism. Fortunately for Christianity, it attracted incredibly competent intellectuals from the beginning. The Apostle Paul, the author of the Gospel of John, and the author of the Epistle to the Hebrews attested this high-level beginning. Clement, Justin Martyr, Irenaeus, and Tertullian stand out as second-century thinkers who could publicly clarify the meaning of Christianity in a broader context. The presence of the original genius of Christianity and the ability of Christianity to attract intellectual leaders surely set the stage for the universal acceptance of the Church, but it was the rapid accommodation to and alteration of the social matrix that enabled Christianity to become a universally practiced religion.

Understood in light of these two alternatives, we must look very closely at what happened in A.D. 180. Was it simply the eventual culturalization of Christianity? Was it the point at which the nascent Christian faith became a cultural religion? That can hardly be the case. Actually, to the contrary, it is the point at which Christianity differentiated itself from culture. While the form of the new cultural expressions came out of the social matrix, the content has some elements of the revelation. Because of our methodological orientation, we can see that both assimilation and differentiation occurred at the same time. A.D. 180 was the date

at which the Christian subculture was willing to say to the majority culture that it existed and had a right to exist. Because of that courage, we now may discover those symbols and other remains that mark the self-consciousness of the early Christian Church. From about A.D. 180 to A.D. 313 the early Christian Church gave to the Mediterranean world a religious alternative of considerable depth that was expressed in activities and symbols that were readily understood by that culture. This, then, was the period of greatest growth for the early Church.

The power of that theological assimilation attracted many, but threatened many others. Non-Christians saw in the nascent Christian culture an inclusive religion that would not tolerate their religious pluralism. Calling the Christians atheists, during the period 180-313 they attempted to destroy the new faith. Persecutions failed and the inclusive, monolithic faith became the favored religion of the Roman state.

One ought not suppose, however, that this simultaneous process of assimilation and differentiation was a simple one. At least two clear options appeared in the Church at Rome. One group, the urban group, placed more emphasis upon the growing tradition of the Christian faith and at the same time held a more flexible attitude toward personal and social ethics. On the other side was an extra-urban group that identified strongly with the social matrix, but held a very inflexible attitude toward personal morality and state policies. In the incredible battle between the "cemetery leaders" and the "city church leaders," persons like Hippolytus accused Callistus of sheer immorality. Yet Hippolytus represented the group that had most assimilated to the social matrix. But as I have noted, the social matrix needs a very high moral authority. Hippolytus and other "cemetery leaders" offered that kind of moral authority, while at the same time they adapted to the social matrix much more than the urban leaders. Perhaps there was no more crucial event in this period of church history than when Callistus was elected bishop of Rome over his "cemetery" opponent.

Seen in this way, the end of the 180-313 period must also be understood in quite a different light. As I have shown in this study, Constantine built his great edifices in order to promote the cultural side of early Christianity. It has been held by some that

Constantine tried to cover up the so-called scandalous cultural practices of early Christianity. But that argument does not agree with the known data. Constantine built great edifices throughout the Christian world in order to promote popular Christianity. His reasons for doing that may have been highly political, but the result is the same. The Christianity established by the first Christian emperor was based upon popular Christianity derived from the social matrix. It remained for the great leaders of the fourth and fifth centuries to attempt to reverse that process. Near the end of the fourth century Pope Damasus, an heir of the urban leadership, attempted to replace the saints of the social matrix with bishops of the city churches. This action accounts for the epigrams of Damasus and the movement of remains of the saints into the edifices of the urban churches. Through Damasus's policy, the bishops were elevated and the cult of the dead was controlled. That policy was placed on even stronger footing by Augustine and Ambrose. It was under their leadership that the "cemetery" Christianity was eventually brought into the city, where the tradition of memory and recall was melded with the tradition of fellowship in the social matrix. Liturgically speaking, the celebration of the ἀνάμνησις over the relics of a social matrix saint formed the basis for Western Christianity. At the same time, Roman Christianity formulated a theological structure that encompassed the prior multiplicity in such a way that a consensus was achieved. We know that consensus as orthodoxy, and we often suppose it was a product of the New Testament period. But in fact it is a product of the "peace."

I. CHRISTOLOGY

The development of Christology follows very much the direction noted in the overview. Gerke's observations on Christology in early Christian art could be even more useful than what he suspected. Insofar as Jesus was understood as a philosopher or teacher, this contradicts, on the one hand, the fact that the earliest Christian art pictures him as a young wonder-worker. In one form or another, the young wonder-worker was the dominant Christology through the Constantinian period. The portrayals of Jesus as a philosopher must give us a clue to the local Christology prior to 180. Jesus and the apostles are clearly portrayed in the New Testament as charismatic wanderers. This model matches quite well the model of the wandering philosopher during the Hellenistic period. One can see hints of translocal leaders as wandering charismatics. This is particularly true in such a document as the *Didache* and in all of the apocryphal acts. Portrayals of Jesus as a philosopher or wandering charismatic would not really differ from such portrayals of teachers in the Greco-Roman social world. Consequently, there are these lingering evidences of Jesus as a wandering charismatic. But in 180, when Christianity became visible, Jesus was portrayed as a heroic, redeemer figure. As we have seen, the Old Testament depicted its heroes as people who were delivered from difficult situations, while in the New Testament Jesus is represented as a young heroic deliverer. In fresco and plastic art Jesus appears as a youth, often nearly nude, who performed remarkable acts—events described artistically in a New Testament context. This had appeared by A.D. 200.

It is remarkable that the Constantinian era kept that picture of Jesus. That fact confirms the argument that Constantine was attempting to buttress popular religion. It was only after Constantine, about the time of Damasus, that the picture of Jesus was changed from the youthful wonder-worker to the royal or majestic Lord. At that time, Jesus shifted more to a bearded, elderly, dominant figure.

Two other observations are important: from 180 to 400 artistic analogies of self-giving, suffering, sacrifice, or incarnation are totally missing. The suffering Christ on a cross first appeared in the fifth century, and then not very convincingly. Second, with the advent of the Byzantine Christ, the local concept of Jesus as a social and personal deliverer disappeared. One might argue that the price for orthodoxy was the ultimate loss of this attractive young Jesus.

With the evidence at hand there appears a clear Christology for the *ante pacem* era. Jesus was not understood in a promise-fulfillment nexus, nor in a guilt-redemption pattern, but in an alienation-deliverance structure. Understood in this manner, we can

see why motifs of the fulfillment (eschatology) or self-giving (the cross and sacrifice) cannot be found in the data except by those who insist on cryptosymbol systems. Rather than a pantheon, Christianity offered a single figure, Jesus, who could bring peace and opportunity to those in desperate circumstances. The effective agent of that deliverance was none other than the early Christian faith community.

II. ECCLESIOLOGY

The New Testament Church began as a small group house church (Col. 4:15) and it remained so until the middle or end of the third century. There are no evidences of larger places of meeting before 300. Indeed, evidence of any kind remains surprisingly sparse. Christians must have met in homes or other small edifices without sufficiently altering the structures for us to determine their presence. What we have as evidence points only to the house church. At mid-third century we have in Dura-Europos a house remodeled to function as a church; in Rome we have in SS. Giovanni e Paolo a single room serving as the church edifice until near the turn of the century, when a larger complex was formed. Street lists in Egypt indicate some homes were used as churches. Thousands of Christians met throughout the Mediterranean basin for two centuries without leaving us solid data regarding their places of assembly. Those places of assembly must have been private homes not owned by the "church" and, therefore, not remodeled. We can only surmise that an occasional fish or calix might have marked such a home.

Without denying the formal presence of ministers and elders or bishops in the governance structure of a local church, it must be maintained that the pre-Constantinian Church was remarkably democratic. In the letters and inscriptions there are very few references to clergy, and those are late. Only in the Crypt of the Popes in Rome do we have a clear interest in "leadership" figures, but we understand the political nature of this attempt to replace saints with bishops. Still, even the presence of this struggle in Rome and such evidence as the letter to the brothers at Arsinoe indicates that there was a hierarchy in place. There was leadership, but clergy were not divided from laity, nor religious act from religious actor. Not until the end of the fourth century can we find church edifices with a choir or confession.

Not only were religious distinctions minimalized, but social class structures were all but destroyed. The first Christians abetted that shift within the Roman world but obviously moved well ahead of society itself. One can see this fact in two distinct ways: the rapidity with which Roman family names were dropped and the total lack of reference to slaves. In both cases the Christian community demonstrably differed from Roman society at large.

The characteristics of the house church noted in the period's art match our picture of the Christians as a democratic, close-knit group. People found in the new faith community a place of deliverance and peace. Most of the symbols from 180 reflect this deep sense of security. At the same time the Church extended itself by offering hospitality not only to its members but to society at large. We find this in the *philanthropia* of the Good Shepherd and the function of the meal as social *diakonia*.

III. WORSHIP

From the data presented here it would be difficult to present a comprehensive picture of the early local church at worship. Not only do we lack evidence, but it is difficult to deal with the several locations of worship. Regardless of these problems, some observations are self-evident. The initiatory rite was adult baptism. Baptism was portrayed by the New Testament picture of Jesus' baptism. The small, nude Jesus does not reflect the New Testament, but the practice of baptism in the Church before Constantine. The presence of the dove signifies the peace that comes from becoming a member of the faith community. In fact, the presence of the dove in this New Testament scene may well be the source of the early Christian dove symbol. From inscriptions we know that baptism was originally limited to adults, but toward the end of the third century the age of baptism must have shifted toward childhood.

The other major community function was the agape. While baptism was surely a function of the house church, the nature of the agape beyond the cemetery cannot be ascertained. We have seen that the agape—likely based on the Feeding of the Five Thousand, but derived, in practice, from the meal for the dead—was eaten in cemeterial situations. It appears in cemetery art pictured as an actual meal. Structures for its celebration have been found in martyria, covered cemeteries, and the catacombs. Its symbols—fish, bread and wine—pervade all of early Christian symbolism and art. Despite the basic nature of this meal, there is no reason to suppose it was practiced outside the cemetery situation, just as there is no way to determine by archaeology the nature of any meal in the house church. From the literature one would suppose the ἀνάμνησις eucharist was celebrated there. Furthermore, it would seem undeniable that the fifth-century mass developed as a political compromise between celebrants of the agape and celebrants of the ἀνάμνησις, or at least, a compromise between the same people in two different situations. In any case, the development in the cities of edifices much like the covered cemeteries, with confessions for the relics of the martyrs, indicates the cemetery practice was combined with the house church. In this compromise the new building was almost never built over the older house church or a martyria. The new post-Constantinian liturgical pattern also began with a new locus for worship. Little wonder we cannot find any examples of continuity between house churches and parish churches—the compromise was thorough.

Most of the prayers we possess come from the cemeterial agape context. The faithful formally seek divine intervention or presence for themselves or, more likely, for companions and family members. The most popular form of the intervention would be for God to keep in mind the person prayed for or praying. Usually the request was made in the names of significant dead; however, occasionally direct address is used (for example, Lord). At Dura-Europos a blessing occurred prior to the request for intervention ("Christ be with you"). Praying through the significant dead shows how deeply the local Christian church stayed in the Hellenistic milieu, with its strong faith in the daimon of heroic dead.

At death each person was remembered in the meal for the dead. Inscriptions often carried the information for that celebration. In any case, the prayers and acclamations, such as "In Peace, In Christ, In God," reflect the faith that the same peace that marked the faith community in life also marked the faith community with its extended family (in death). There is no sign of a more sophisticated immortality, nor does resurrection, at least as revivification or resuscitation, play any role. One must assume then that the popular story of Lazarus, and perhaps even Jonah, refers to the Christian peace (Orante) in the face of death.

IV. RURAL AND URBAN CHRISTIANITY

The Christianity described by the majority of these data belongs to a common Mediterranean social structure variously called here Hellenistic, Greco-Roman, or even Roman. Though not always included in the above data, evidences for the same type of Christianity occur in such varied places as Dura-Europos, Carthage, Alexandria, Naples, Aquileia, Arles, Trier, Bonn, London, Newcastle, Split, Salonika, and many others. Just as the Roman culture had pervaded the cities of the Mediterranean world, so Roman Christianity developed the same manner of expression through the cities of the Empire. Christianity was city-oriented: the images of the New Testament had shifted from an Old Testament land-orientation to an eschatology of the city. Christianity grew where the culture could be sufficiently suspended, adapted, and reformed to create yet another cultural alternative. This happened primarily in the cities of the Empire. It did not easily occur among the country people, the pagans.

Fortunately, we possess the data of at least one section of Christianity that was not responsive to Roman cultural influence: Phrygia. The inscriptions of Phrygia belong to a rural Christianity. As a political area it was not Roman and as a Christian area it shows little resemblance to the pre-Constantinian culture we have seen everywhere else. There are several differences. First, some "Christians for Christians" inscriptions are dated before 180. This means the culture not only appeared before

180, but it appeared with an unabashed Christian character. Second, if we take the Abercius inscription as an authentic expression of local Phrygian Christianity, theology advanced much more quickly here than in the cities. Rural Christianity reflects more readily the characteristics of the Christian social matrix: the total community converted, the name of the faith is more explicit, and the theology is more advanced and less flexible. This likely accounts for the rise of Montanism in such rural areas. We have already seen that the "cemetery group" represented a less flexible, albeit more acculturated, Christianity. The "urban group" represented more historical Christianity and more flexibility toward repentance and toward the State. Insofar as rural Christianity stood for the solidarity of the social matrix, it held to strong social sanctions. Insofar as urban Christianity stood for the merciful act of God in Christ, it could stress forgiveness and repentance. The Christianity of Phrygia may well represent the extreme of this rural attitude. Some similar observations could be made of Celtic Christianity, a group that also lacks the Roman influence.[1]

Even more important would be the development of early Christianity in Greece. There, too, Roman influence seems minimal. Unfortunately, nonliterary data regarding the period 180-310 seem totally lacking or negligible. Archaeological studies have rightly concentrated on remains that might illuminate the period of the New Testament (especially the cities of Paul), and on the early beginnings of the Byzantine or domed-church edifice. The life and condition of Greek Christians has not been documented prior to the late fourth century or early fifth (for example, prior to H. Demetrious in Salonika).[2]

[1] See Charles Thomas, *The Early Christian Archaeology of North Britain* (London: Oxford University Press, 1971).

[2] Ralph F. Hoddinott, *Early Byzantine Churches in Macedonia and Southern Serbia* (London: Macmillan, 1963). For the more recent work in early Christian archaeology, see Demetrios J. Pallas, *Les monuments paléochrétiens de Grece decouverts de 1959 a 1973* (Città del Vaticano: PIAC, 1977).

V. THE STATE

Attitudes toward the official social structure may be discerned only obliquely. Several of the key symbols (anchor, boat, and fish) indicate a conscious awareness that the rising Christian culture was not coextensive with the State and society at large. These symbols do not place any value judgment on the State, but simply express the consciousness of differentiation. The fresco art makes a sharper judgment. There we find Daniel between two lions provided by the State, three young men in a furnace stoked by the State, and Susannah falsely accused by two local officials. In each case the Christian finds security in the Christian fellowship (Orante). After Constantine these symbols and paintings either took on a theological meaning (as the fish) or were eventually dropped (three young men in the fiery furnace).

The Christian conflict with the State has been overemphasized by later generations. There were persecutions, but the picture of early Christians cowering in the Colosseum or hiding in the catacombs better represents later martyrologies than it does any known archaeological data. If anything, the data reflect an unconcern for police or State activities. The original κατάκυμβος was constructed opposite a police station on the Via Appia. Property rights in the catacombs and agreements with the diggers or fossores were registered when appropriate. House churches in Egypt were registered for tax purposes. Christians executing legal affairs did not hide their faith stance. Again, without denying the historical evidence from the literature, one must temper the later picture with the apparent fact that local Christians were fairly open about their faith and its public ramifications.

The most obvious demonstration of the public nature of early Christianity comes from those letters (F and I) that show an economic structure developing parallel to the Jewish economic system (and in some competition with Rome itself). No matter how one assesses the development of these systems, it cannot be denied that Christians were engaged in buying and selling and banking, qua Christians. The Christianity made official by Constantine had already developed public structures. The "conversion" of Con-

stantine must have also included a consciousness of the political usefulness of these structures.

VI. LANGUAGE

For those who had supposed the Greek of the New Testament reflected the language of the common people, this collection of data will come as a surprise. *Ante pacem* one looks nearly in vain for the type of language one finds in the New Testament, the Apostolic Fathers, and the Apologists. There are practically no reflections of biblical language (though see G and K in the letters), and the language we have designated as Christian simply reflects the way in which the Christian of 180 to 310 expressed himself or herself vis-à-vis his or her neighbors. So we find *theos* or *kurios* substituted for Serapis; but the general language field has not been altered. Only after Constantine can one speak of a local language game that expresses the Christian culture. Until then, the formation language was Hellenistic. Conversion language was not yet basic, so only with the advent of an official Christianity did some Christian language occur in the formative years. We see the same phenomenon with Christian names. Until Constantine they were infrequent, because people were not particularly "born" Christian, or at least the tradition of the language field was not yet set sufficiently to influence local people.

Finally, during the two hundred and eighty years from 30 to 310, the Christian faith stood in sharp dialectic with the Hellenistic social matrix of the Mediterranean basin. During that time it assimilated most of its expressions from that culture: its symbols, its art, and even its faith paradigms. But likewise, the revelation deeply influenced the social matrix. It created a new Christian community that knew it had been differentiated from that Hellenistic society, expressed itself in terms of small-group caring and hospitality, offered deliverance from the personal and social entrapments of life, and infused people with a vision of cross-cultural universality. Constantine catapulted this new faith community into a larger public role, but it was the Church of the late fourth century that tried to compromise, and therefore alter, the Christianity of the *ante pacem* period.

INDEX

REFERENCES TO SCRIPTURE
AND EARLY CHRISTIAN LITERATURE

MUP *Ante Pacem*

Designed by Margaret Jordan Brown
Composition by MUP Composition Department

Production specifications:
 text paper—60-lb. Warren's Olde Style
 endpapers—Legendry 80-lb. text (natural)
 covers—(on .088 boards) Holliston Kingston #35401 natural finish
 dust jacket—Legendry 80-lb. text (natural)
 prints one color PMS 186 (red)
Printing (offset lithography) and binding
 by BookCrafters of Chelsea, Michigan